GREAT SMALLER MUSEUMS OF EUROPE

© Scala Publishers Ltd, 2003
© Text James Stourton

First published in 2003 by
Scala Publishers Ltd
140a Shaftesbury Avenue
London WC2H 8HD

ISBN: 1 85759 284 0

Edited by Matthew Taylor
Designed by Misha Anikst and Alfonso Iacurci

Printed by CS Graphics, Singapore

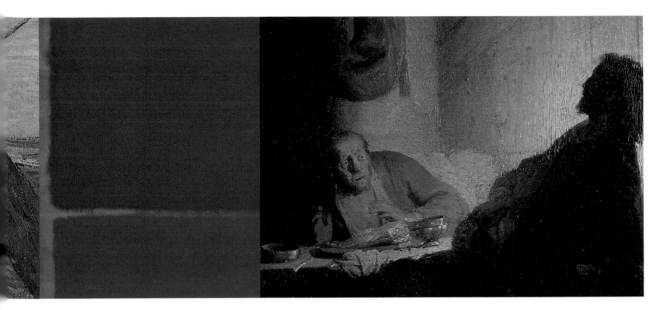

GREAT SMALLER MUSEUMS OF EUROPE

JAMES STOURTON

CONTENTS

PREFACE

CHARLES SAUMAREZ SMITH

There are many guides to museums, and I find that I possess a number of them. But, hitherto, they have been invariably factual indications of different types of museums, the systems of arrangement of their contents, and how and when to visit them. It is odd to realise that there do not currently exist, so far as I know, any guides to museums that give a personal account of the pleasures of visiting them, their peculiar histories and what lies in store for a visitor who is prepared to seek out those smaller museums and galleries which lie off the beaten track. This is, after all, one of the great pleasures of travelling – the discovery of a museum or gallery that one did not previously know existed and which is likely to be less frequented than the great museums have now become and more secretive about the treasures it contains.

So I pricked up my ears when I heard that James Stourton, an old friend and urbane traveller who has long worked for Sotheby's and is now its deputy chairman, was writing a guide to the museums of Europe, which was not going to concentrate on the major national institutions – the Louvre in Paris, the Alte Pinakothek in Munich or the National Gallery in London – but instead on the second division, those that offer more individual pleasures and are known only to those who are connoisseurs of the genre.

The book that follows is the result of his travels. It does not tell you about the Kunsthistorisches Museum in Vienna, with its great collection of Bruegels, its Giorgiones and works by Velázquez, but, instead, encourages those who are presumed to be already familiar with the collections of the Kunsthistorisches Museum to seek out the lesser-known collections of the Academy of Fine Arts (Akademie der Bildenden Künste) on the Schillerplatz near by. In Antwerp we are rightly directed not to the main museum in town, the Koninklijk Museum, which is one of Europe's gloomier museums in spite of its great collection of works by Van Eyck and Rubens, but instead to the much less well known, but infinitely more pleasing, Museum Mayer van den Bergh, with its antiquarian collections of tapestries, paintings and coins, down a side-street near the Rubenshuis. In Denmark I think I would have expected to be directed to the Thorvaldsen Museum, one of the great monuments of Danish Neo-classicism, but perhaps it is excluded on the grounds that it is really more of a shrine to the work of a single artist than a museum in the conventional sense. Instead, we are sent out on the train north of Copenhagen to visit the Louisiana Museum, a great collection of post-war art, displayed in a museum that has had a huge effect internationally by laying out its rooms so informally, with views out across to Sweden.

By concentrating only on those collections which he knows particularly well and likes, the author is able to give a much more discursive account of how museums came into being, the tastes and foibles of their collectors, the ones who were dominated by their mothers and the ones who made their money out of trade. I did not previously know the story of how Henri d'Orléans, Duc d'Aumale, acquired the *Très Riches Heures du Duc de Berry* in 1856 for Chantilly on the advice of Anthony Panizzi, the great librarian of the British Museum. Nor, for example, did I know that the Mauritshuis had been burnt out in 1704, while the Duke of Marlborough was staying, and that the foundation of its great collection of paintings was owing to the involvement of the Duke of Wellington in securing their return from Paris.

What does one learn about the history of museums from this account? Two things, I think. The first is the

amazing range of collecting that was going on during the nineteenth century throughout Europe, with antiquarians competing against artists and rich private collectors as they scoured the auctions and antique shops of France and Italy, the back streets of Florence and Rome, including such disreputable stories as the fact that all the pictures left by the Emperor Ferdinand to the Academy of Fine Arts in Vienna had been looted from the churches of Venice and had, therefore, to be returned.

The second thing that this book makes evident is the extent to which many of the best museums are the result of private whim and personal benefactions. They have not been formed by intermediaries of the state for purposes of public education, but are instead the result of private individuals seeking out objects for personal delectation and then hoarding them. We owe many of our museums not to ministers of state but to individuals, who may have led lives that were in some cases disreputable but who, none the less, bequeathed institutions that retain an element of idiosyncrasy, so that one can view the works on display not simply as items in a narrative of the history of art but as works that cumulatively add up to a history of taste. Looking at art is not simply an exercise in the acquisition of knowledge, but an experience that is deeply influenced by one's surroundings and by the company that works of art keep with one another.

I remember some time ago being told that the late Francis Haskell, Professor of History of Art in Oxford, and Noel Annan, the former Provost of King's College, Cambridge, used always to exchange postcards when they discovered a museum that they thought the other might not know. How they would have enjoyed this book, from which everyone, even the most experienced of museum-goers, will learn useful tips. I have certainly enjoyed the Proustian experience of recalling my first visit to the Musée Gustave Moreau upstairs behind a bland façade in a street in the 9ème in Paris. And, now, I am looking forward to an opportunity to pack my bags to go to Kassel.

Charles Saumarez Smith
Director
National Gallery, London

ACKNOWLEDGEMENTS

A large number of people have given me help with the writing of this book. The museums themselves have been very helpful, and the following were kind enough to read the texts and make many useful suggestions: Dr John Murdoch (Courtauld Institute); Ros Savill (Wallace Collection); Desmond Shawe-Taylor (Dulwich Picture Gallery); Amy Barker (Bowes Museum), Dr Arthur MacGregor (Ashmolean); Duncan Robinson (Fitzwilliam); Marie Dubrulle (Picasso); Nicole Garnier (Chantilly); Michel Hilaire (Montpellier); Nicolas Sainte Fare Garnot (Jacquemart-André); Marianna Delafond (Marmottan); Marie-Cecile Forest (Gustave Moreau); Dr Francesco Rossi (Accademia Carrara); Lavinia Galli (Poldi Pezzoli); Prince Jonathan Doria (Doria Pamphilj); Dr Anna Coliva (Villa Borghese); Filippo Pedrocco (Ca' Rezzonico); Dr João Castel-Branco Pereira (Gulbenkian); Bettina Hagen (Vienna Academy); Hans Nieuwdorp (Mayer van den Bergh); Susanne Hartz (Louisiana Museum); Dr Bernhard Schnackenburg (Kassel); Dr Vinzenz Brinkmann (Glyptothek); Brigitte Kölle (Lenbachhaus); Professor Rolf Bothe (Weimar); Ernst Beyeler (Beyeler); Mariantonia Reinhard-Felice (Oskar Reinhart); Hortense Anda-Bührle (Bührle); Piet de Jonge (Kröller-Müller); Peter van der Ploeg (Mauritshuis); and Margaret Richardson (Soane).

I was assisted by several distinguished specialists: Professor David Watkin (Soane, and the German museums); Professor Sir John Boardman (Glyptothek); Dr Jean Michel Massing (Colmar); Hugh Honour (the Italian museums); Adam Zamoyski (Czartoryski); and Dr Christopher Lloyd (Ashmolean).

Others whom I consulted, who read various texts or who gave me useful tips and information were: Alexandre Pradere; Philip Hook; Neil MacGregor; Meredith Etherington-Smith; Nicolas Barker; Terence Rodrigues; George Watson; Clémentine Gustin; Professor Andrew Ciechanowiecki; and Gill Coleridge, my agent at Rogers Coleridge and White.

I am particularly grateful to my colleagues at Sotheby's, who have been extremely supportive and helpful during the writing of this book. Those who gave me specific help were Liesbeth Heenk, Hanne Wedell-Wedellsborg, Beatrice Viennet, Oliver Barker, Hubert d'Ursel, Nina Bühne, Heinrich von Spreti, Andrea Jungmann and Claudia Steinfels.

My greatest thanks are to David Campbell, the publisher, who from the first moment that I suggested the project took it up with great enthusiasm; to Clémence Jacquinet, Miranda Harrison and Matthew Taylor at Scala, who patiently brought the book together; to Misha Anikst and Alfonso Iacurci, who designed the book; and above all to Alan Bell, who corrected my English, and to David Ekserdjian, who corrected my art history. And finally to Charlotte Fenwick, who has lived with the book and been a patient and dedicated assistant.

INTRODUCTION

What is a smaller museum? The problem has always lain in the title. The book should properly be called *Great Smaller and Middle-sized Museums,* but no publisher would accept such a turkey. I struggled with definitions and set guidelines, which I cheerfully abandoned in the face of a particularly desirable entry. One distinguished decorative arts historian gave the most practical and useful definition of a smaller museum as one you could see in a morning. This, however, would certainly not be possible at the Ashmolean. I was looking for three things: great works of art, an interesting history and a good setting. I believe that all the museums I have chosen met these criteria to a greater or lesser extent.

What about size? Size is relative, and it occurred to me that this was less important than where and what the museum might be. To some extent this is a book about small museums in large places and large museums in small places. I shoehorned the Bowes Museum and Schloss Wilhelmshöhe at Kassel into the book because I felt they were sufficiently unknown outside England and Germany to stretch a point.

Early on I realised that I could not deal with specialist museums, of which there must be several hundred throughout Europe, and it was necessary to keep to fairly mainstream art collections. This means that there may be too many paintings in the book, but this also reflects my own background and training. Any choice in the end had to be personal. Sometimes there would be a particularly difficult choice in order to avoid repetition. In Paris, for instance, there are three excellent and much loved museums: the Musée Cognac-Jay, the Nissim de Camondo and the Jacquemart-André. They are all broadly based around the art of eighteenth-century France, and I chose the last only because it offers more variety – but I know that I shall disappoint the many readers who love the other two.

One rule that should have proved easy to follow was to include only museums with a permanent collection. This meant two things: that the collection couldn't be sold and that you would be able to see what I have described. The first point excluded private collections, but I took comfort from the Pamphilj entail and slipped in the Palazzo Doria. The second point proved more troublesome and excluded a number of otherwise interesting twentieth-century museums, such as the Guggenheim at Bilbao and the Tate St Ives, which depend entirely on rotating loans from Head Office. An additional problem in some museums was summer exhibitions and the amount of gallery space they fill. Excellent as they are for visitor numbers, they pose a problem for those of us trying to describe what a visitor might actually see on a visit. The Maeght Foundation at St Paul-de-Vence sadly failed this test.

The museums in this book fall neatly and evenly into six categories. The earlier-formed collections are for the most part of royal or aristocratic origin. These are essentially dynastic or family collections. Sometimes the line had come to an end, as for example at Chantilly, but more often the collection was placed into public ownership in order to protect its future. They form the largest and most splendid group of museums in the book. The two Roman entries, the Villa Borghese and the Palazzo Doria, were the creation of papal families. The Mauritshuis, the Schlossmuseum in Weimar, Schloss Wilhelmshöhe, the Glyptothek and the Musée Condé at Chantilly all have a royal or princely provenance, while the Wallace Collection is nothing if not aristocratic. The Czartoryski Collection introduces the first female collector, Princess Izabela Czartoryska, and the novel idea of a collection in the service of nationalist aspirations.

A surprisingly rich group of collections emerged in the seventeenth and eighteenth centuries out of links with art schools and universities, which include the comparatively unknown collections in Vienna and Bergamo as well as the justly famous ones in Oxford and Cambridge. The most recent of these is the Courtauld Institute Gallery in London, which has lately been so splendidly rehoused.

The nineteenth century saw the rise of museums formed out of patrician or bourgeois collections. There are six of them in the book, which were all formed by collectors in a single lifetime and usually with the specific aim of founding a museum. The exception is the Dulwich Picture Gallery, of eighteenth-century origin. Its collection was intended for princely consumption (albeit to create a national gallery) and became by default the first in this category. The Poldi Pezzoli, the Bowes Museum, the Jacquemart-André, the Meyer van den Bergh and the Marmottan are magnificent examples of this type. Interestingly, all the founders in this category died childless.

I am delighted by the number of museums in the book that were formed by artists. The only rule for inclusion here was that the artist had lived or worked in the place, and it might therefore have some bearing on their life. This excluded the Musée Rodin in Paris, about which I was frequently asked. The point is stretched for the Musée Fabre, but Fabre figures more as collector than artist, and his museum would fit equally well into the previous category. Canova, Soane, Moreau and Lenbach all spent an important part of their lives in the museums described. For Picasso it was only a season and for Dalí, although never a dwelling, the theatre at Figueres was the place where 'all my earliest remembrances and erotic events happened', which to a Surrealist artist was probably more important.

This book is principally about privately created

museums, but I included two that owe their existence to state and civic patronage. In the chapter on the Musée Fabre I allude to the 1801 Bonaparte decree that created the great provincial museums of France. I have included the Musée d'Unterlinden in Colmar, although it owes its place more to the fact that it contains one of the greatest treasures of any small museum in the world. The Venetian city council created the Ca' Rezzonico, but part of that museum's appeal lies in the fact that it has none of the predictability and frozen grandeur that characterise so many state- and civic-sponsored museums.

Although the nineteenth century was the heyday for the creation of most of the museums in this book, the twentieth-century foundations prove that small museums are still alive and well, for they are among the most enjoyable in the book. With the exception of Gulbenkian's great assemblage – which introduces an important Eastern element – the twentieth-century foundations are all essentially Impressionist and Modern in their collecting. Oskar Reinhart and Emile Bührle both collected Old Masters, but their heart lay with Impressionist paintings. Mrs Kröller-Müller was a modernist to the core and that tradition has continued after her death at her museum with the creation of the sculpture park. The only living founder at the time of writing is Ernst Beyeler, who provides a classic overview of the twentieth century, while the recently deceased Knud Jensen, at Louisiana, created one of the most attractive environments in which to enjoy post-war art.

Finding a reasonable geographical spread did not prove too difficult, but I was defeated by Spain. It is a truism that Anglo-Saxons generally fail to give to Spain the place it deserves in cultural and historical matters, and I appear to have done it again. I identified six good candidates. The

first, the Valencia de Don Juan in Madrid, seemed promising, but it has no opening hours (and the publisher had nightmares about Americans reading the book and travelling to Spain to see it, only to be thwarted). Then I went to see the Santa Cruz Museum in Toledo, which has removed all its contents for restoration for two years. Alas the Sorolla House and the Lázaro Galdiano, both in Madrid – the favourites of many – were closed for the same reason. The honour of Spain was saved only by Dalí's eccentric creation at Figueres. If the book is fortunate enough to be reprinted, I hope to make amends. Greece appears only through the filter of German Hellenism, and I would like one day to increase the German section, perhaps with the addition of the excellent Folkwang in Essen.

Anthony Hobson, the author of *Great Libraries,* warned me that the most difficult problem in a book of this kind was to avoid repetition over so many chapters. With this in mind, when I found a good subject, whether it is Sydney Cockerell at the Fitzwilliam, or the *Isenheim Altarpiece* at Colmar, I felt they were subjects worthy of digression.In the meantime I can only hope that the book encourages readers to visit the museums described – which after all is its whole point – and that they derive as much pleasure from the experience as I have.

London, June 2003

ACADEMY OF FINE ARTS

VIENNA

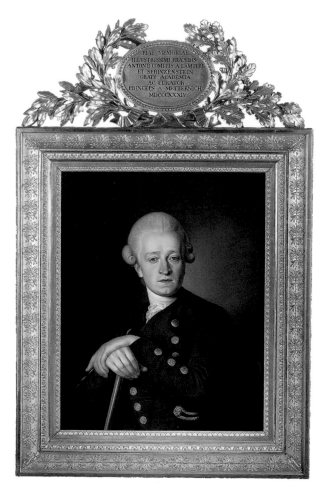

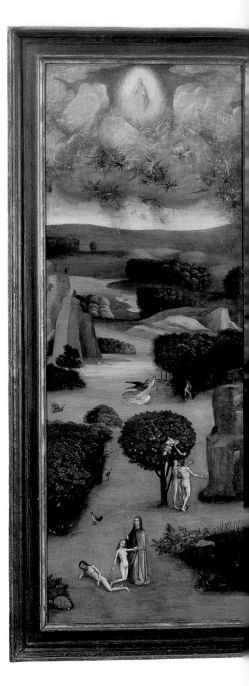

Christian Kollonitsch
Portrait of Count Anton Lamberg
1770
oil on canvas
78 × 62 cm

Hieronymus Bosch
The Last Judgement Triptych, 1504–8
mixed media
side panels each 160 × 60 cm
centre panel 164 × 127 cm

Several important museums in Europe began their life attached to academies of art. One of the very few that survives encased within an art school is the picture gallery of the Academy of Fine Arts (Akademie der Bildenden Künste) in Vienna. The school was founded in 1692, and based on the Académie Royale in Paris. Its statutes were revised during the reign of Maria Theresa, when it was decreed that 'members shall bestow upon the academy as an everlasting memorial an example of their work' and in this way the collection was born. What little money that was available for purchases during the eighteenth century was spent on the plaster cast collection, which was seen as the most useful component for the students. Thus the collection might have remained, but for the bequest of 740

Old Master paintings from Count Anton Lamberg in 1822. The richness of this extraordinary gift, with its great Bosch, Rubens sketches and Dutch Italianate landscapes, transformed the collection into one of international importance. It became the first public museum in Vienna and it remains the greatest collection of paintings in Austria after the Kunsthistorisches Museum.

Count Lamberg (1740–1822) was a diplomat who served as Imperial Ambassador to the courts of Turin and Naples. At the latter court he befriended artists and formed an important collection of Greek vases, which he later sold to the Emperor Francis I. He gave the proceeds to charity. Lamberg did not start to collect paintings in earnest until he returned to Vienna. The collection was sufficiently

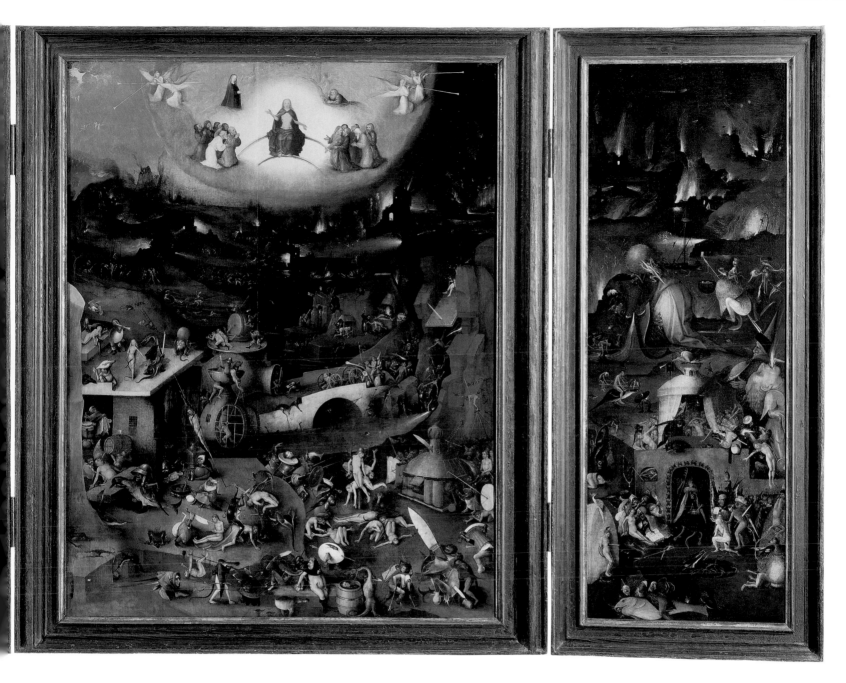

famous by 1801 to be included in a travel guide to Vienna, and Count Lamberg no doubt began to ponder its future. What kind of man was he? In his portrait by Christian Kollonitsch he appears as a stiff, alert Mozartian doll. Judging by the elaborate notes he left concerning the future of his collection, one has the impression of an intelligent, philanthropic, rather fussy bachelor with a strong sense of public duty.

Count Lamberg chose the Academy of Fine Arts as a body that would keep the collection together and maintain it properly. But there was a problem: it had insufficient space. Lamberg therefore petitioned the Emperor Francis I in 1820 to ask if after his death the collection could be housed by the academy next to the

Imperial paintings on the ground floor of the Upper Belvedere Palace. He worked everything out in extraordinary detail, but his letter was couched in such diplomatic terms that the Emperor got the wrong end of the stick and thought that the Count was giving it all to him. When Count Lamberg died, it was Metternich who had to disabuse the Emperor of this misunderstanding, and Francis I graciously acquiesced.

As it turned out, the rooms in the Upper Belvedere were inappropriate and the collection was therefore installed in the cramped – and fairly inaccessible – quarters of the academy in the St Anna Gasse. The artist Waldmüller was the first curator with the rank of professor of what became known as 'Count Lamberg's Painting Gallery'. The same

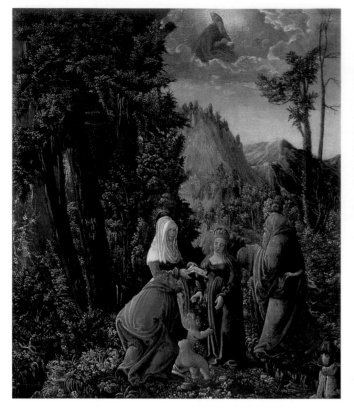

Monogrammist HP
The Holy Family in a Forest, 1514
oil on panel
33 × 29 cm

Peter Paul Rubens
Apotheosis of James I, early 1630s
oil on panel
64 × 47 cm

rooms were also used for teaching and we get a good impression of the general chaos from a painting by Danhauser. The situation remained a minor scandal until the vast new Italianate academy building by Theophil Hansen was constructed between 1872 and 1876 as part of the public works programme with the creation of the Ringstrasse. The picture gallery was given spacious premises and remains to this day installed within the same building.

Count Lamberg was not the only benefactor of the academy. In 1838 the Emperor Ferdinand gave over 80 Italian paintings, which turned out to be something of a poisoned chalice. They had all been looted from Venetian churches and palaces and by the time the academy had finished an expensive restoration programme, it was forced to hand them all back in 1919. The other notable donation of Italian pictures – which still happily hangs *in situ* – was by Prince Johann II of Liechtenstein of 58 paintings, including most of the Cinquecento panels in the collection as well as some nineteenth-century works. Today there are 1500 paintings in the collection but only a small proportion can be hung. Most of the Austrian works are on loan to the Österreichische Galerie and the emphasis today is on Count Lamberg's paintings rather than the output of the academy.

The academy reveals its most famous treasure early: The *Last Judgement* triptych (1504–8), by Hieronymus Bosch. This is Bosch the moralist, and in it he gives little hope for mankind. The majority are damned to terrible tortures, described by the artist in excruciating detail. The real subject of the central panel is the Seven Deadly Sins, and if you have the stomach for it you can identify them: the use of knives represents hate, forced feeding is gluttony, the humans are being cooked for avarice, and so forth. On the left wing is Paradise with Adam and Eve, a green and verdant land, but most of mankind – it has to be said – is consigned either to Hell (in the right panel) or torture (in the centre panel). The triptych is enormous (164 × 127 cm) and makes a memorable if ghoulish impression. On the back of two wings are beautiful *grisaille* paintings of St James the Great, the pilgrim who walks through the sinful world with righteousness, and St Bavo, the aristocrat who gave all his wealth to the poor. There is one other important early Netherlandish painting, Dieric Bouts's *Coronation of the Virgin* (c. 1450). This and the Bosch were both Lamberg paintings; in purchasing them the Count was ahead of his time.

If Count Lamberg came back today, his main disappointment would be that modern scholarship has downgraded most of his Italian fifteenth- and sixteenth-century paintings. The Liechtenstein bequest partly makes up for this with many appealing works, such as the *Coronation of the Virgin,* by Antonio da Fabriano (1452), Giovanni di Paolo's *Miracle of St Nicholas* (1456) and the striking Botticelli workshop *Madonna and Child with Two Angels* (c. 1490). Sitting rather isolated in the collection is Titian's very late *Tarquin and Lucretia* (c. 1570–76), which the academy bought at auction in 1907. Count Lamberg is revealed as a much better connoisseur of German

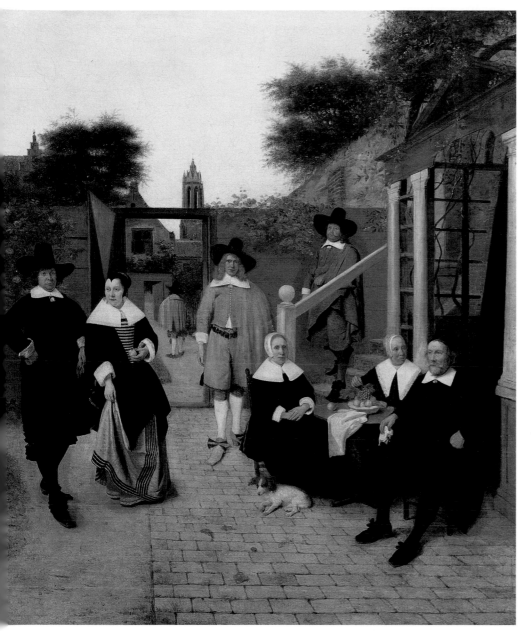

Pieter de Hooch
*Family Group in a Courtyard
in Delft*, c. 1658
oil on canvas
114 × 97 cm

Samuel van Hoogstraten
Interior of a Cupboard, 1655
oil on canvas
92 × 72 cm

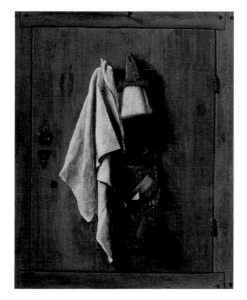

Renaissance paintings. There are five works by Cranach the Elder, Hans Baldung Grien's *Holy Family in the Open* (c. 1512) and several interesting paintings by lesser-known masters: *The Holy Family in a Forest* (1514), by the monogrammist HP, and the grand *Portrait of a Man Aged 34* (1525), by the monogrammist HF.

The Flemish seventeenth-century section is important by virtue of Lamberg's collection of 19 of Rubens's sketches, nine of which are accepted as autograph. There is the *modello* for his altarpiece for the Jesuit church of Sant Ambrogio in Genoa, *The Circumcision of Christ* (1605), and several sketches for the great lost cycle of the Jesuit church in Antwerp. The most surprising sketch to find here is that for the central panel of the Banqueting House in Whitehall (the only one of Rubens's great decorative schemes to remain *in situ*), *The Apotheosis of James I* (early 1630s). There is even a rare Van Dyck oil sketch and the sensitive, youthful *Self-portrait Aged 16* (1615).

Besides Austrian paintings the most comprehensive and distinguished section is that of the Dutch seventeenth century. There are good still lifes by de Heem, van Aelst, Fyt, Ruysch, Weenix and Hondecoeter, and two *trompe l'oeils* by Hoogstraten. When it came to Dutch figurative painting, Lamberg acquired three superb examples. There is a major work by Pieter de Hooch, *Family Group in a Courtyard in Delft*, painted around 1658, the year of his artistic maturity, and Rembrandt's surprisingly conventional *Portrait of a Young Woman*, painted in 1632, shortly after his arrival in Amsterdam. Among those artists working in Rembrandt's style, none is more interesting than the Fabritius brothers and there is a superb *Self-portrait as a Shepherd* (c. 1654–6) by Barent Fabritius, the most memorable seventeenth-century portrait in the collection.

The area of seventeenth-century Dutch painting for which the academy is best known is Italianate landscapes. Perhaps because Count Lamberg had himself been a foreigner in Italy, he rather specialised in this genre. As a prelude to this section there are two small pictures by Claude Lorrain, including the *Flock of Sheep in the Campagna* (1656). Both are curiously 'natural' and not at all like the romantic southern landscapes, bathed in golden light, that Lamberg collected by Jan Both, Karel du Jardin, Pynacker and Berchem, but it is likely that these were the only Claudes the Count could afford. He particularly liked the work of Jan Asselijn, and today there are ten of his works in the collection, including the *Mountainous Landscape with Travelling Hersdsmen*. Moving from the country into the town is Johannes Lingelbach's *Piazza del Popolo* (1664), a painting so atmospheric that it cannot really be classed as a *veduta*.

Count Lamberg also collected seventeenth-century Italian works, particularly Neapolitan. There is Mattia Preti's *Release of St Peter* and two great works by Luca Giordano, *The Judgement of Paris* and its companion piece, *Mars and Venus Caught by Vulcan*. From the eighteenth century Lamberg liked Francesco Guardi and bought religious paintings by him, as well as numerous Venetian views. The most arresting *veduta* is Locatelli's *Market in the Piazza Navona, Rome* (1733), which admirably conveys the contrast between the grand palaces and the chaotic tented market. The most remarkable eighteenth-century painting in the collection is Pierre Subleyras's *The Artist's Studio* (1746). Subleyras was an expatriate French artist in Rome and this is his artistic testimony and autobiography. In the painting we see all the major commissions of his career: Subleyras is busy painting in the centre with his back to us, and he is there again in the bottom left holding a self-portrait as a young man. The oddest thing about the painting was hidden to modern eyes until restoration in the 1960s revealed yet another *Self-portrait,* this time life-size, painted on the back. It appears to have been painted on a whim by Subleyras after he had finished and stretched *The Studio* and this accounts for its informality and directness, with clear signs of the artist's terminal illness.

Some of Count Lamberg's commissions from contemporary Austrian artists are on view, notably landscapes by Michael Wutky, who lodged with Lamberg

Jan Asselijn
Mountainous Landscape with Travelling Herdsmen
late 1640s
oil on canvas
43 × 67 cm

Claude Lorrain
Flock of Sheep in the Campagna
1656
oil on canvas
35 × 45 cm

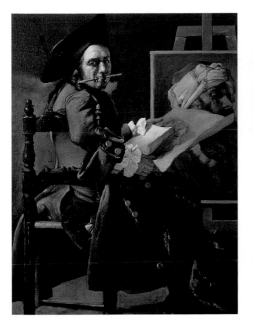

Pierre Subleyras
Self-portrait, after 1746
oil on canvas
125 × 99 cm

Pierre Subleyras
The Artist's Studio, 1746
oil on canvas
125 × 99 cm

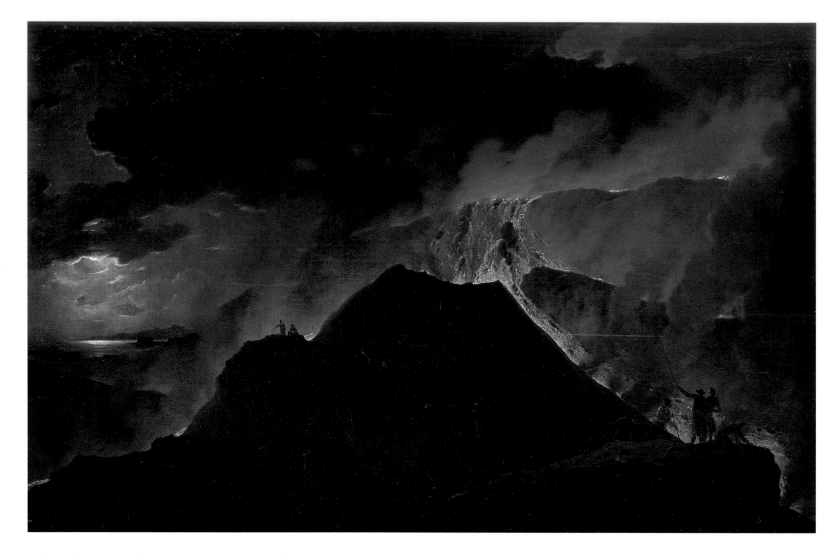

in the embassy in Naples. The artist was fascinated by Mount Vesuvius, which he perilously ascended with Sir William Hamilton to watch an eruption. The result may be seen in *The Summit of Vesuvius Erupting*. One of the artists Lamberg patronised was the cosmopolitan painter Martin Ferdinand Quadal, who travelled round the capitals of Europe providing whatever was required, usually horse paintings. His masterpiece is The *Life Class at the Vienna Academy in the St Anne's Building*, which hangs in a splendid room at the end of the picture gallery dedicated to artists associated with the academy. It is a reminder to the visitor that this museum is part of a working art school.

The Academy of Fine Arts reached its zenith of power and influence under Metternich, when it briefly became the authority for all matters artistic in Vienna until these powers were transferred to the Education Ministry in

1849. The academy schools continued to flourish, however, and most of the great names of Austrian painting were at one time affiliated to them. Egon Schiele was accepted in 1906, but the academy earned an unwanted footnote in history when it rejected Adolf Hitler for admission in 1907, thereby posing one of the great 'ifs' of history. The picture gallery perhaps today no longer serves the same didactic purpose within the academy, but Count Lamberg would be delighted to find that so many of the suggestions he laid down for his museum have been adopted and that his bequest is so well preserved and appreciated.

Michael Wutky
The Summit of Vesuvius Erupting
c. 1780
oil on canvas
95 × 146 cm

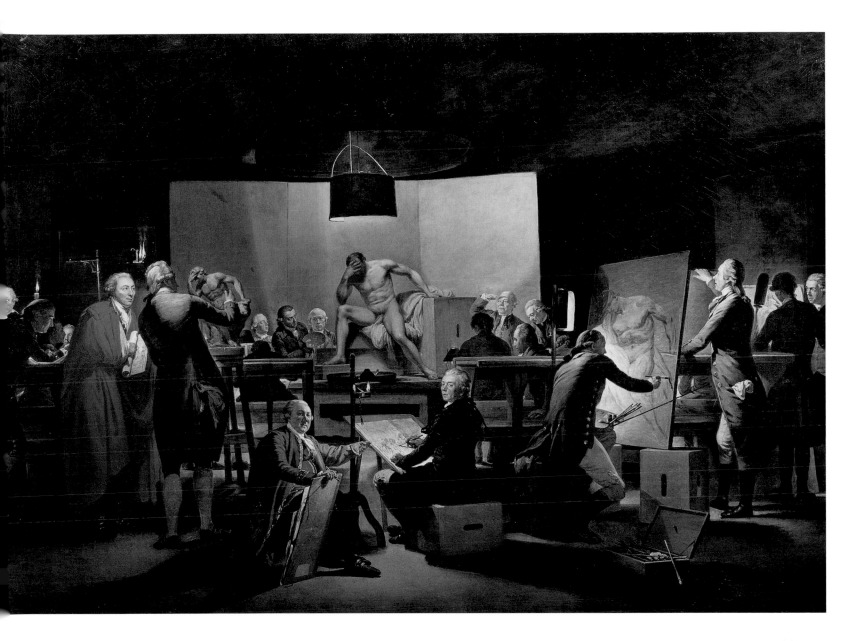

Martin Ferdinand Quadal
*Life Class at the Vienna Academy
in the St Anne's Building*, 1787
oil on canvas
144 × 207 cm

MUSEUM MAYER VAN DEN BERGH

ANTWERP

Antwerp in the sixteenth century was the hub of European trade and the leading arts centre north of the Alps. The defeat of Antwerp in 1585 by the Spanish Habsburgs precipitated a long period of political and cultural subjugation from which Flanders did not fully emerge until the creation of Belgium in 1830. Gradually during the nineteenth century Antwerp began to revive its sense of cultural identity and a group of writers, intellectuals and art historians emerged to give expression to these aspirations. Nowhere can this better be seen than in the Museum Mayer van den Bergh.

Fritz Mayer van den Bergh had a short life of only 42 years, from 1858 to 1901, and although he was the most formidable Belgian collector of his time and managed to leave behind over 3,000 objects (excluding coins), we must see his collection as a foundation of what might have been. Even so, we can glean from his legacy an overview, however fragmented, of that broad cultural territory the South Netherlands from the days of the Burgundian dukes through to the seventeenth century, with excursions into Holland, the Rhineland and elsewhere.

Mayer's father, Emile Mayer, was of German origin – from Cologne – and in 1849 he settled in Antwerp, where he made his fortune dealing in spices and pharmaceuticals. In 1857 he married Henriette van den Bergh, the daughter of a well-to-do Antwerp businessman, and it was she who was to be the greatest influence on Fritz and founded the museum in her son's memory. Like Gian Giacomo Poldi Pezzoli – whom Fritz Mayer in many ways resembles – he was a mother's boy, and when his father died in 1879 he broke off his studies to go and live with her. Out of their mutual devotion was born the museum, and in 1887 he even adopted her name, becoming Fritz Mayer van den Bergh.

Mayer began as an antiquarian collector of archaeological material, coins and textiles and was regarded as a great

The Museum Mayer Van den Bergh

expert in the last two fields. One of the great specialist strengths of the collection is textiles, as might be expected in a country that produced such fine examples. He set great store by this part of the collection, perhaps because it was also his mother's passion, and it covers the South Netherlands in the fourteenth and fifteenth centuries. Mayer gradually expanded to paintings and sculpture, but by 1891 he seems to have tired of his early acquisitions and held two sales. The collection as we see it today mostly dates from between 1892 and his death in 1901; his emphasis shifted towards South Netherlandish painting and sculpture and in particular the school of Antwerp. That he was something of a Flemish patriot is evident from his membership of local cultural bodies, and – unusually in the Francophile social milieu of rich Belgians – he translated Rhenish legends into Flemish. It is not absolutely clear what his intentions for his collections were, but the fact that in sale catalogues he marked items '*musée*' and bought large interior fittings, fireplaces, ceilings and so on, suggests the direction he was going. It was left to his formidable mother to accomplish this after his death, and it was she who commissioned the Antwerp architect J. Hertogs to create a museum building

Fritz Mayer van den
Bergh's study

The main room on the
ground floor

Cornelis de Vos
Portrait of Elizabeth [or
Cornelia?] *Vekemans*
c. 1624
oil on panel
123 × 93 cm

reflecting sixteenth-century Flemish style but built to
modern museum standards.

The main room on the ground floor is a large and
evocative space dominated by seventeenth-century

portraits. There are four delightful images of the
Vekemans family (c. 1624) by Cornelis de Vos, the main
Antwerp portraitist after the departure of Van Dyck.
Rubens utterly dominated Antwerp painting during this
period and his influence is very evident. Interestingly,
Mayer did not own an autograph Rubens or Van Dyck
painting and this demonstrates one aspect of his
collecting. Although he was operating at a time when art
history was in its infancy, he generally liked to buy
unattributed works and identify the artists. This he largely
did by a voluminous correspondence with museums and
scholars around the world, above all with Max
Friedländer, the great Berlin scholar, who was even
younger than Mayer. One of his methods was to trace the
objects as far back as he could. He would bother the sellers

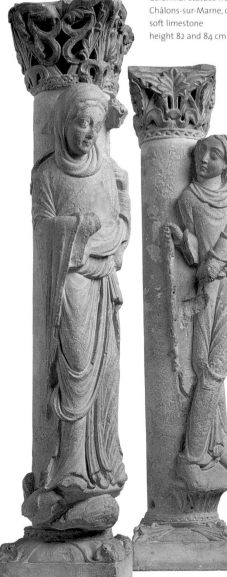

Columnar statues from
Châlons-sur-Marne, c. 1170–80
soft limestone
height 82 and 84 cm

Quinten Metsys
Christ on the Cross with Donors
c. 1520
oil on panel
centre panel 156 × 93 cm

for information on the provenance of items he bought, to the point where he once received a reply: 'I recovered the gold pendant from an old monstrance along with several other pieces of old gold … Your departing question as to whether I came by it honestly was deeply offensive to me.' Among other portraits on the ground floor there is the mid-seventeenth-century Dutch group of the Meyndert-Sonck family by Jan Albertsz Rootius, which has a provincial charm. There are portraits by Jan Mytens and Cornelis Ketel, and many pleasing small Flemish genre pieces. The most unexpected painting Mayer bought is by Gérard de Lairesse, of *Venus Presenting Weapons to Aeneas* (1668). Although he was a Dutch painter, Lairesse devoted his life as a painter and theoretician to promoting French classicism and had a low opinion of Flemish art.

The ground floor has two other rooms of note. The first contains an unusual purchase, the earliest painting on panel in Belgium: *The Virgin and Child Enthroned, with Four Scenes from the Virgin's Life* (thirteenth century) by Simeone and Machilone of Spoleto, painted by these itinerant Umbro–Sienese masters still working in a Byzantine tradition. In the same room are the beautiful sinuous columnar statues from Châlons-sur-Marne. Although these predate the painting by 100 years (*c.* 1170–80), they have a life and grace that illuminate this great age of sculpture.

Beyond this is a Brussels–Antwerp room, with a set of mid-fifteenth-century Brabant woodcarvings of angels, and one of the great paintings of the collection, Quinten Metsys's triptych of *Christ on the Cross with Donors* (c. 1520). As the first great name in Antwerp painting and the leading sixteenth-century artist of the city, Metsys was a natural for Mayer to collect. He celebrated old Flemish traditions but was equally fascinated by Italian

The Mayer van den Bergh Breviary
early 16th century
illuminated manuscript
22 × 16 cm

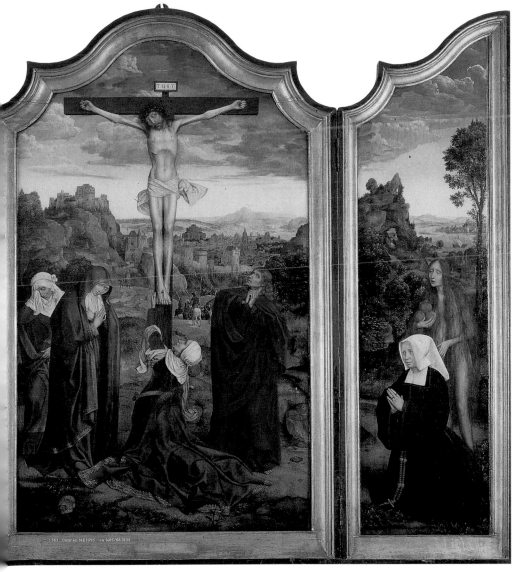

Renaissance art, and brings them all together in this great altarpiece. Mayer approached the priests of the church of Our Lady in Bergen-op-Zoom to buy it; initially they refused to sell until permission had been granted by the bishop.

The first floor has a still-life room with examples by well known-artists such as Willem Claesz, Heda and many interesting lesser-known masters, such as the small pair by the monogrammist H.D.F. Here also is to be found Mayer's most expensive single purchase: the *Mayer van den Bergh Breviary*, an illuminated manuscript that he bought in 1898 in London for 35,000 francs – the price of a major painting by Rubens at that time. Created 60 years or so after the invention of printing, it was a luxury book whose various miniatures have been attributed to Simon Bening and Gerard Horenbout, and even to Jan Provoost.

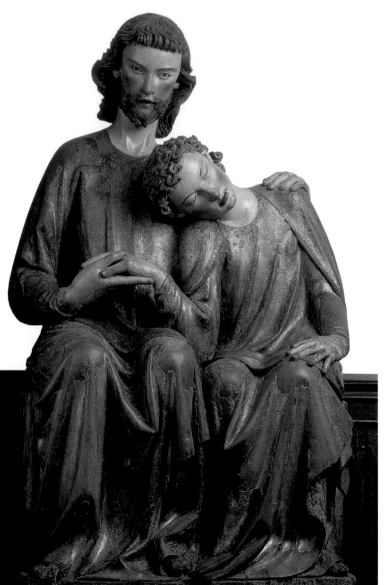

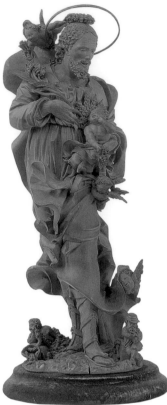

Master Heinrich of Konstanz
St John Resting on Jesus's Breast
early 14th century
walnut
141 × 73 × 48 cm

Monogrammist I.M.H.P.
St Joseph
17th century
pearwood
height 25 cm

Next door is a so-called Gothic room, with ivories, stained glass from Notre-Dame in Paris and at least one very important sculpture: the walnut *St John Resting on Jesus's Breast,* by Master Heinrich of Konstanz, carved for the Swiss convent of Sankt-Katharinenthal. So lifelike and moving was this devotional sculpture, which amazingly still retains its original polychromy, that miraculous powers were attributed to it, and art historians have been equally enthusiastic since. There is a good supporting cast of Netherlandish paintings on the first floor by, among others, Juan de Flandes, Vrancke van der Stockt, Jan Mostaert, Pieter Aertsen and the masterpiece of the Master of Hoogstraten.

Beyond the paintings lies the sculpture gallery. In 1898 Mayer bought the remarkable collection of Carlo Micheli, who was an unknown craftsman with no money, making plaster casts at the Louvre. Mayer sold on many of the Micheli purchases, keeping 165 pieces that today form the core of the sculpture gallery: a feast of small-scale objects in bronze, alabaster, wood, lead and ivory from the Byzantine and Carolingian periods until the seventeenth century, with a propensity towards Flemish artists working in northern France. Two remarkable statues that were not Micheli's are the Bruges *Virgin and Child* (c. 1380–90), which still has much of its original colouring, and the south German seventeenth-century *St Joseph* group in pearwood bearing the monogram I.M.H.P.

The sculpture gallery is varied and fascinating, but for many visitors the climax of the collection is the Bruegel room. In 1894 Mayer went to an auction in Cologne, where he saw an entry in the catalogue: 'Hell, Bruegel [i.e. Pieter Bruegel the Younger], *Fantastic Scene, Landscape with a Crowd of Ghostly Figures*'. He bought the work for only 488 francs and immediately wrote to Henri Hymans (who is often considered as the rediscoverer of Bruegel) at the Antwerp museum. He identified it as a lost work by Pieter Bruegel the Elder, described by Karel van Mander in 1604 as *Mad Meg (Dulle Griet) Pillaging at the Mouth of Hell*. This strange, ghoulish and unexpected painting has taken its place as one of the masterpieces of Bruegel. What is it all about? Many people have attempted to unravel its subject matter but it remains speculative to this day. Probably it is an allegory of Madness, which in the sixteenth century covered many vices, including anger, gluttony, lust and avarice. The figure in the centre, it is suggested, is Folly, and

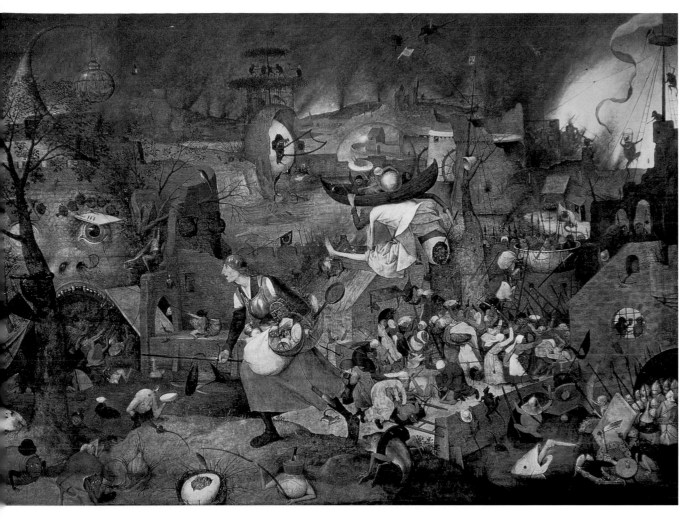

Pieter Bruegel the Elder
*Mad Meg (Dulle Griet) Pillaging
at the Mouth of Hell*
16th century
oil on panel
117 × 162 cm

Pieter Bruegel the Elder
The Twelve Proverbs
16th century
oil on panel
74 × 98 cm

the ghoulish scenes around it illustrate the consequences of
these vices. It may even illustrate the play *Dulle Griet,* which
was staged around this time in Antwerp. Whatever its
meaning, it was a bold and daring purchase by Mayer,
especially as Bruegel did not then enjoy the reputation he
has today. He owned another unusual Pieter Bruegel the
Elder, *The Twelve Proverbs*, and further works by his son
Pieter Bruegel the Younger, who formed his career making
good copies of his father's work, and by his other son, Jan
(or 'Velvet') Bruegel.

When Mayer died in 1901, it was a remarkable decision by
his 63-year-old mother to set about creating the museum. It
was built with astonishing speed, given the extraordinary
quality of the period rooms. The new museum building was
opened in December 1904, with Madame Mayer van den
Bergh as the first keeper. In 1920, the year of her death, she
handed the museum over to five regents or trustees with an
endowment, and thus it remains today as a private museum.
Most visitors to Antwerp hasten to the Rubens House and
miss this jewel of a museum, which has been a well-kept
secret for far too long.

LOUISIANA MUSEUM

HUMLEBÆK

Copenhagen is blessed with several delightful small museums, but the favourite of the Danes lies one hour north along the coast, on the road to Elsinore, near the village of Humlebæk. It began life as a country estate with a pleasant 1840s house overlooking the sea, which a previous owner named Louisiana after his three wives, who were all called Louise. After the Second World War the place was abandoned, and in 1954 a 38-year-old Danish entrepreneur, Knud W. Jensen, who had made a fortune out of his dairy business, stumbled on the estate by accident while walking his dog. It was a 'complete wilderness', he later wrote, 'like penetrating the garden around Sleeping Beauty's castle'. He bought the property and had the inspired idea of turning it into a museum of modern art.

Knud Jensen's first idea was to create a museum of twentieth-century Danish art, and this was how the museum opened in 1958. The following year, however, he made a visit to Documenta in Kassel, where he was bowled over by what he saw. Here for the first time he observed the richness and variety of modern art, which he described as 'the greatest shock of my life', and decided

that he must extend the range of his own museum. Today Louisiana constitutes the most important collection of post-war international art in Denmark.

What distinguishes Louisiana from every other museum of modern art is its glorious setting overlooking the Sound. Knud Jensen wanted to keep the ambience of a country house and left the villa at the centre of the

View of the old house
from the park

Alexander Calder
Slender Ribs, 1963
iron
358 × 305 × 346 cm

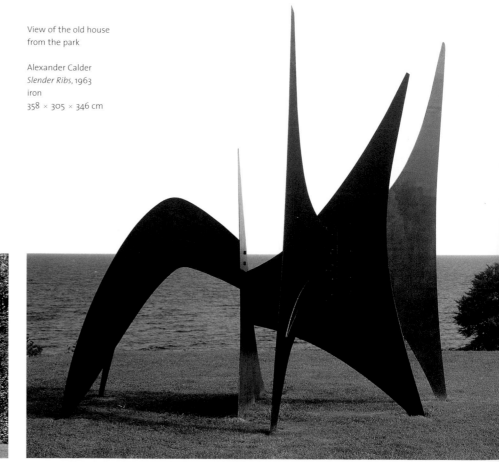

View of the lawn
leading to the Sound,
with Henry Moore's
Reclining Figure No.5
1963–4

Alexander Calder
Little Janey-Waney
1964–76

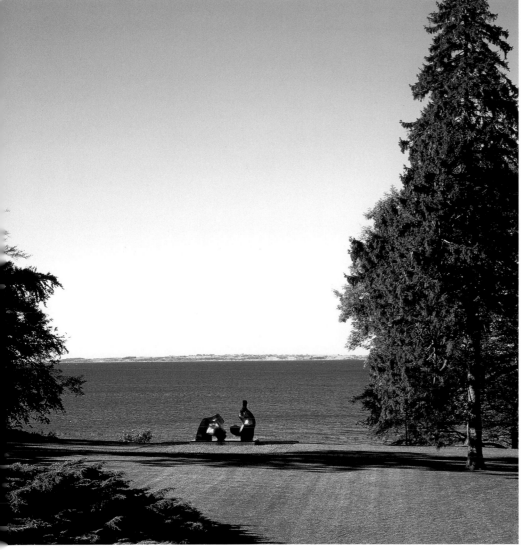

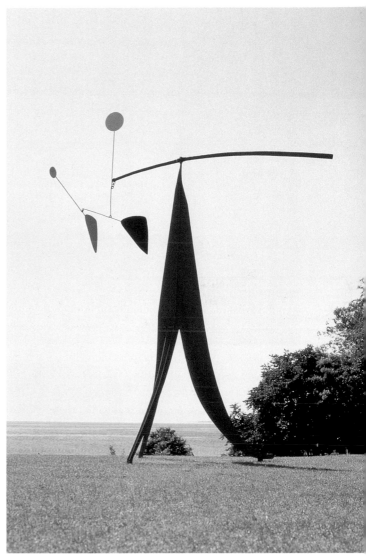

estate. He simply extended it with two enormous arms that reach out to beautifully designed pavilions and embrace the view across the water to Sweden. The garden is full of flowering shrubs and mature trees, with lawns that gently slope towards the sea. The view is broken only by Henry Moore's *Reclining Figure No. 5* (1963–4), which has become almost the emblem of Louisiana. The museum has been extended seven times since 1958, and today spreads its fingers organically round the landscape. Many of the most famous works are outside but can be seen from inside, and the museum moves naturally from one to the other.

In the garden there are four major works by Henry Moore, and the museum's literature appropriately quotes

the artist's view that 'a strong and moving sculpture must express something of the power and energy that a great mountain possesses'. This is certainly true for Moore, but sitting on a bluff by the edge of the water are three elegant works by Alexander Calder, whose preference was for grace and movement. These are his two jagged iron stabile sculptures with imposing silhouettes against sky and sea, and an important mobile, *Little Janey-Waney* (1964–76). The effect of the three works displayed so close to the water's edge is liberatingly beautiful. Continuing the walk through the woods and around the museum, passing an old lake, we come across many delightful surprises: several works by Jean Arp; a figurative work by Miró: *Personnage* (1970); Serra's

27

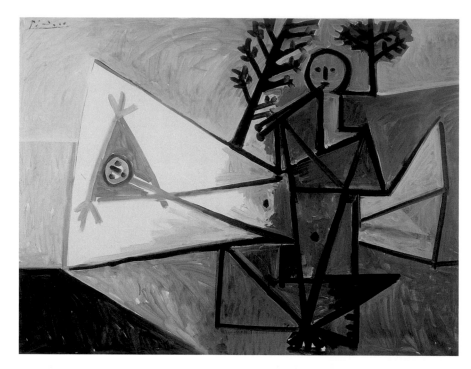

Pablo Picasso
Woman and Piper III, 1956
oil on canvas
89 × 116 cm

Jean Dubuffet
Les Implications Journalières, 1977
acrylic
222 × 290 cm

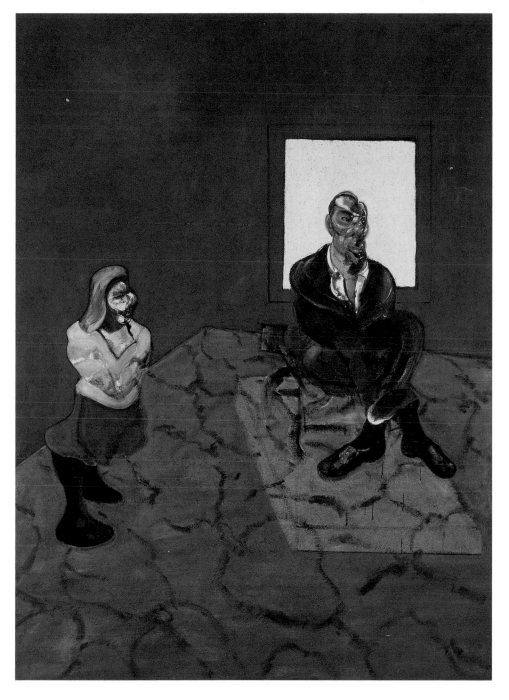

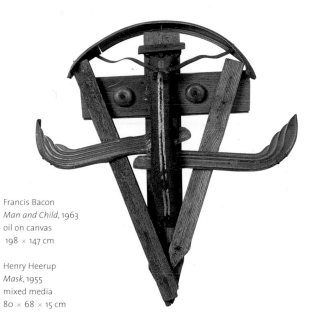

Francis Bacon
Man and Child, 1963
oil on canvas
198 × 147 cm

Henry Heerup
Mask, 1955
mixed media
80 × 68 × 15 cm

characteristic *Gate in the Gorge* (1986); and some larger-scale works. Nestling under the museum walls are Gunger Förg's *Seven Bronze Steles* (1988) and Henry Heerup's evocative group of stone sculptures placed like the ancient primitive remains of some long-abandoned temple. The garden is perhaps the key to Louisiana, the essential co-existence of art and nature. The founder remained extraordinarily faithful to his ideas and demonstrated his tirelessness in analysing and revising the interplay of these elements.

Entering the museum buildings, the exhibition opens with European figurative art from the 1950s onwards. There are three good late Picassos, including *Le Déjeuner sur l'Herbe* (1961). In the same room are life-size bronzes by Germaine Richier (given by the artist's family), and Francis Bacon's *Man and Child* (1963) as well as his *Three Studies of George Dyer* (1969). Louisiana has a good collection of Jean Dubuffet, particularly his late works, which include *Les Implications Journalières* (1977).

From figurative to abstract, the museum continues with the work of Lucio Fontana and Yves Klein and then back to figurative with Giacometti. He was a special favourite of Knud Jensen, who wrote to the artist to ask if the 1965 Tate Gallery retrospective could travel to Louisiana. The artist turned him down, but undaunted Jensen flew to meet him, secured the exhibition, and thus began a relationship which resulted in the museum today owning

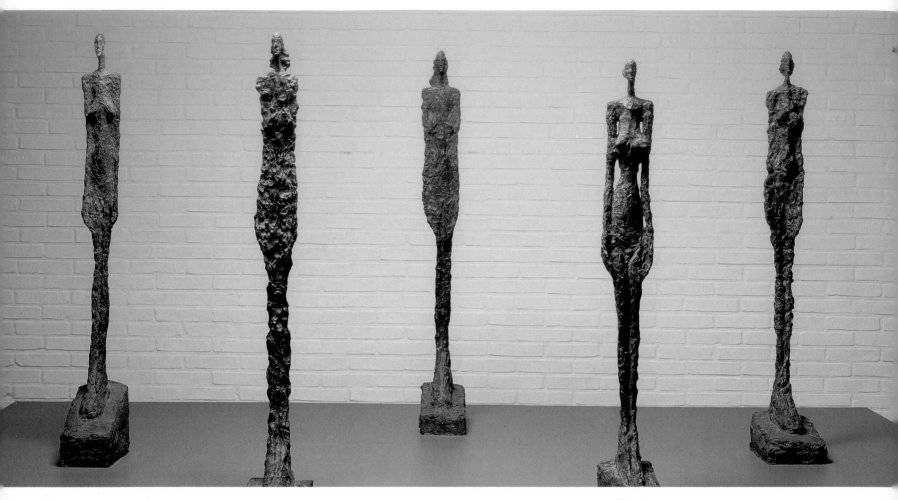

25 of Giacometti's works from various owners, an exceptional collection by any standards. There are several busts of the sculptor's brother Diego, but the most memorable group is that of the six stationary *Venice Women* (1956), which has a static, archaic quality. For those who like his early work, there is the bronze *Spoon-Woman* (1926).

As you would expect, Danish artists are well represented at Louisiana and there are works by Jorn, Bille, Egill Jacobsen and Carl-Hennig Pedersen. There are several more of Henry Heerup's whimsical sculptures, of which *The Mask* (1955) is a typical example, and of more recent Danish sculptors the work of Svend Wiig Hansen particularly stands out. There are some good pieces by Köpcke, including the mixed media *Picture Puzzle: Like Father Like Son* (1964). The largest group of any contemporary Danish artist is that of Per Kirkeby, for whom the museum has staged several major exhibitions.

Pop art is one of the specialities of Louisiana, with an excellent selection of pictures by Rauschenberg, Lichtenstein, Jim Dine and several by Warhol. The museum has an outstanding collection of two American artists whose work Clement Greenberg labelled as 'Post-Painterly Abstraction': Morris Louis and Sam Francis.

Alberto Giacometti
Venice Women, 1956
bronze
height 118–122 cm

Morris Louis
Omega IV, 1959–60
acrylic on canvas
366 × 265 cm

Anselm Kiefer
Jason, 1989
lead, glass, teeth and snakeskin
265 × 630 × 650 cm

Sam Francis decorated the concert hall with his *Big Red II* (1979) and *Untitled (1981–3)*. Morris Louis is also often described as a 'Colour Field' painter on the strength of paintings such as *Omega IV* (1959–60), and there are works by Rothko, Stella and Noland in the same vein.

Modern German art makes a good showing with Joseph Beuys's *Honey Pump* (1974–7), several works by Baselitz, and above all, a group of huge canvases by Anselm Kiefer, full of historical reference and myth. Sometimes these are overt, as in the Albert Speer-like *Columns* (1983) or the *Battle of Teutoburg Forest* (1988–90), or more diffuse, as in his *Outpouring* (1982–6). There is even an engaging lead sculpture by Kiefer of an early jet aeroplane: *Jason* (1989).

If you find the gigantism of contemporary art overwhelming, you can escape into a room of small-scale works on paper and Constructivist art, given by Joseph and Celia Ascher. It consists of a group of perfectly chosen works by Sonia Delaunay, El Lissitzky, Moholy-Nagy, Malevich and others.

The Louisiana is a completely humanised museum. The scale, the buildings, the café overlooking the sea, all proclaim this to be a place of enjoyment. There is nothing solemn or pious about it and the result is a museum so popular that you are advised to take care in choosing the time of your visit. Frequent temporary exhibitions mean that the works of art are constantly shifting and you may not find on show everything that has been mentioned. The list of exhibitions held since 1959 is simply astounding, and they are one reason for Louisiana's enduring popularity. They have also enabled the museum to form close relationships with artists, which in turn has led to gifts and acquisitions. Additionally, since being built in 1976 the concert hall has provided the setting for Louisiana's weekly concerts. Panel discussions, author meetings, poetry readings and discourses on a broad spectrum of cultural issues also take place here. Knud Jensen gave up his business career to run his museum and continued until 1995, when he retired as the Director. The year before he published a book about the museum, *The Spirit of the Place,* and justifiably concluded that 'only when unity is achieved – when art, architecture and landscape come together to heighten our experience of a place – do we get that indefinable feeling: this is special'.

MUSÉE FABRE

MONTPELLIER

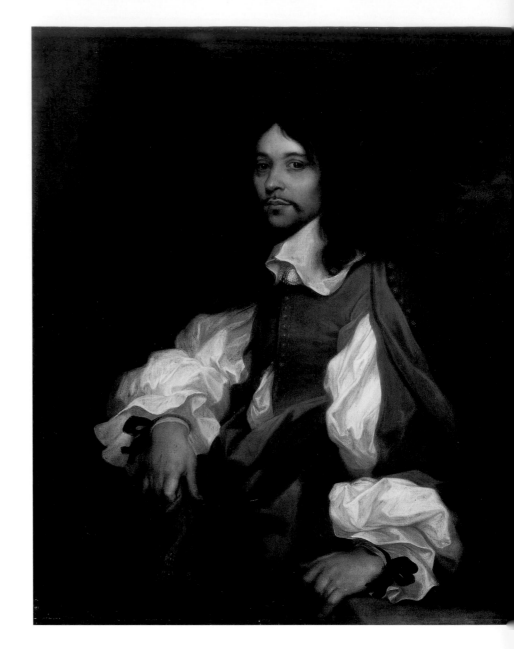

The great provincial museums of France are largely the creation of the revolutionary decree signed by Bonaparte in 1801 that distributed paintings – mostly confiscated – to 15 regional cities. The magnificent museums in Lille, Lyon and Rouen bear witness to this. Montpellier was not included in the 1801 distribution but received 30 paintings the year after, which laid a respectable foundation of works by Monnoyer, Coypel, de Troy and others. What distinguishes the Musée Fabre in Montpellier from its older and grander siblings, however, has been its good fortune in attracting fascinating bequests. Moreover, several exceptionally interesting artists came from Montpellier – one of them being the eponymous founder – and the result is a French provincial museum of unusual character and charm.

Montpellier, capital of the Languedoc, is a pleasant town, which still has an eighteenth-century air. In a side street lies the chaste 1820s Neo-classical façade of the Musée Fabre, to which was added in 1870 a more flamboyant wing with statues of three native painters – Bourdon, Raoux and Vien – but strangely enough none of its founder. This was the painter François-Xavier Fabre, who was born in the town in 1766. He started life working in the kitchen of a local nobleman, and it is said that the local curé spotted the boy's talent for drawing. He entered David's studio at the age of 17 and four years later won the coveted Prix de Rome, which took him to Italy, where he was to live until 1824.

Initially Fabre lived in Rome, where he attracted the attention of the Earl–Bishop of Bristol and was joined by his impoverished family, who were Royalists in exile. It was Florence, however, that was to be his home. He settled there in 1793 and became the devoted friend of the poet Alfieri and his mistress, Louise, Countess of Albany, the separated wife of the Young Pretender. When the poet died, Fabre was to remain her faithful *cavaliere servente,*

and he became the heir of the last of the remaining Stuarts. As well as painting the international society of Florence, Fabre was also a collector, particularly of sixteenth- and seventeenth-century Italian and French paintings, with a leaning towards classical landscape. Today in the museum there are works from Fabre's collection by Veronese, Dolci, Ribera, Orizzonte, Moucheron, la Hyre, Poussin and Dughet. Among his contemporaries he bought works by Girodet, his friend from David's studio, and by his fellow Frenchman in Florence, Gauffier. He was also a distinguished collector of drawings.

After the death of the Countess of Albany in 1824, Fabre returned to Montpellier and gave his collection to the town, which converted an old mansion for this purpose. It also deposited the State's 1802 allocation of 30 paintings, which at last had a permanent home. Fabre was made the first Director when the museum was inaugurated in 1828. Both

Sébastien Bourdon
Portrait of a Man with Black Ribbons, c. 1657
oil on canvas
108 × 89 cm

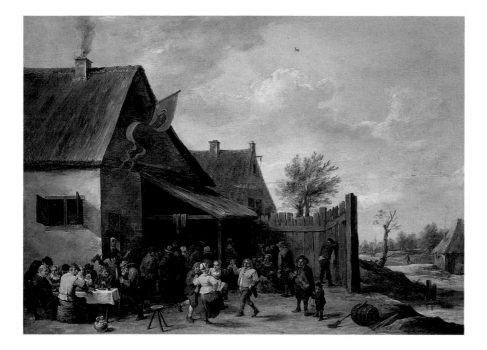

David Teniers the Younger
The Village Fair, c. 1645–50
oil on panel
43 × 58 cm

Jean Ranc
Vertumnus and Pomona
c. 1720
oil on canvas
171 × 119 cm

for himself and the museum he continued to collect works by Bourdon, Greuze, Vincent and David until his death in 1837.

Many of the more important sixteenth- and seventeenth-century works in the collection come from Fabre. Henry James, who visited the museum in 1877, said 'the Italian pictures have little value', which is rather unfair when they include (from Fabre's gift), Veronese's *Mystical Marriage of St Catherine* (c. 1560), Allori's *St John the Baptist* (1586), Cigoli's *Flight from Egypt* and Carlo Dolci's *Virgin with the Lily* (1642), along with one that the museum bought in 1900, Domenichino's *Portrait of Cardinal de Bonsy* (c. 1615–20). Curiously, some of the best early paintings are Spanish. Although Pedro de Campaña was Flemish, in the 1540s he became the leading artist in Seville, where he executed the powerful *Descent from the Cross*, which came to France as Peninsular War loot. There is also Ribera's *Mary of Egypt* (1641) and – the favourite of Paul Valéry, himself a native of Montpellier – Zurbarán's *St Agatha*, which Marshal Soult brought back from Spain.

Sébastien Bourdon (born 1616) was the first important native Montpellier artist, and the museum has eight of his works. The Musée Fabre has one of his early *bambocciate* in the manner of Van Laer, *Halt of the Gypsies and the Soldiers* (c. 1640–43), and we can observe the transformation resulting from his discovery of Poussin in *The Curing of the Man Possessed by a Demon* (c. 1660). There is also the very fine *Portrait of a Man with Black Ribbons* (c. 1657). France

in the seventeenth century is additionally represented by Simon Vouet and Laurent de la Hyre and an important early Poussin fragment, *Venus and Adonis*.

The Dutch seventeenth-century section is outstanding, thanks to the second great benefactor to Montpellier, Antoine Valedau. He was a contractor to the Revolutionary army, was born in the town, and in 1836 left it his collection of 79 paintings and 345 drawings. These were mostly very high-quality Dutch and Flemish cabinet pictures, which included Jan Steen's *As the Old Sing so the Young Squawk* (c. 1663–5), Dou's *The Mousetrap* (c. 1645) and 11 paintings by Teniers, notably *The Village Fair* (c. 1645–50), as well as works by Seghers, Potter, Cuyp and Ruysdael. He also left Rubens's unexplained *Allegory* (c. 1620–22).

The eighteenth century produced many interesting native artists in Montpellier. There was Jean Raoux and Jean Ranc, the latter a generally dull artist who excelled himself only once, in the great painting (which happily sits in the museum) *Vertumnus and Pomona*, a delightful Rococo masterpiece. Another native was Joseph-Marie

Jacques André Joseph Aved
*Portrait of Madame
Antoine Crozat*, 1741
oil on canvas
138 × 105 cm

Jean Baptiste Greuze
Little Lazybones, 1755
oil on canvas
65 × 54 cm

Vien, one of the early French Neo-classical painters, and there are works by him and his brilliant pupil Vincent. From beyond Montpellier there is one outstanding eighteenth-century French portrait: the masterpiece of another *petit maître* (which was attributed throughout the nineteenth century to Chardin), Jacques Aved's *Portrait of Madame Antoine Crozat* (1741). Thanks to Valedau there is a fine collection of Greuze. He left six

works by this artist, including *Little Lazybones* (1755), and one by Sir Joshua Reynolds, which manages to look exactly like a Greuze, *The Infant Samuel* (1777).

There are three important works by David, starting with his early *Hector* (1778), which has a Baroque drama. We see the great portraitist emerge in the *Portrait of Alphonse Leroy* (1783), a new type of bourgeois professional portrait, direct and devoid of flattery, and once again in David's *Portrait of Philippe- Laurent de Joubert* (c. 1792), a patron of Fabre. One of the greatest surprises of the museum is a terracotta and plaster version of Houdon's famous statue of *Voltaire*. There is also Houdon's pair of statues *Summer* (1785) and *Winter* (1783).

Then we come to Fabre himself. There are several rooms of his own paintings and they make a very civilised enclave. One of the most important of these is the *Saul* (1803), inspired by Alfieri's tragedy and commissioned by the Countess of Albany, which appears today a little too theatrical. The museum happily contains his masterpiece in portraiture the very Davidian *Portrait of Antonio Canova* (1812), showing the sculptor in his studio as though in mid-conversation with the artist. Landscape was always a

Jacques-Louis David
Portrait of Alfonse Leroy
1783
oil on canvas
73 × 93 cm

François-Xavier Fabre
*Portrait of Antonio
Canova,* 1812
oil on canvas
91 × 70 cm

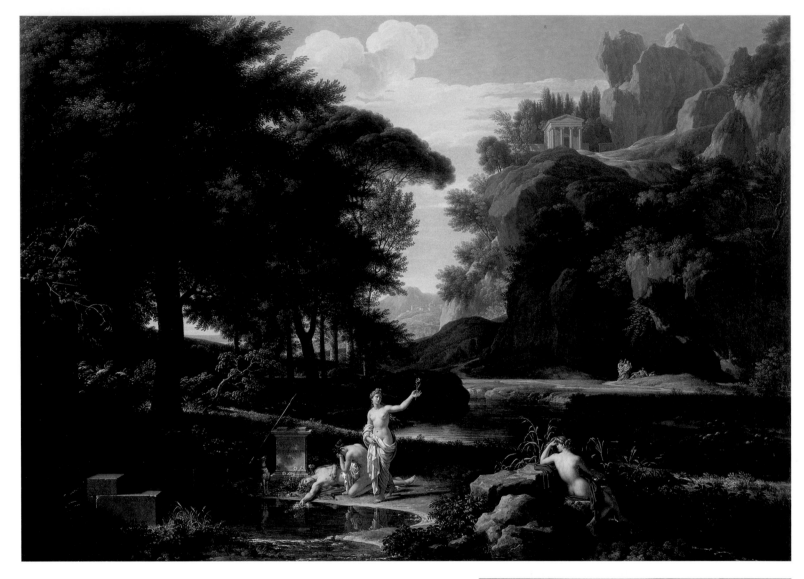

favourite theme for Fabre, and there is his fine classical rendering of *The Death of Narcissus* (1814). His friend Louis Gauffier took landscape painting a stage further towards Romanticism. Thanks to Fabre, the museum has a fine collection of Gauffier's works. One of the most appealing is *Vallombrosa and the Arno Valley Seen from Paradisino*.

The nineteenth century introduces the third – and in some ways the oddest – of the great benefactors to the museum, Alfred Bruyas, born in 1821 into a rich Montpellier Protestant banking family. He tried to paint, but poor health prevented him from taking up any occupation. In Rome in the 1840s he befriended and patronised a young rising star from Montpellier, the painter Alexandre Cabanel, who was later to become the darling of the Paris

François-Xavier Fabre
The Death of Narcissus
1814, oil on canvas
119 × 168 cm

Louis Gauffier
*Vallombrosa and the Arno Valley
Seen from Paradisino*
late 18th century
oil on canvas
39 × 50 cm

Eugène Delacroix
Women of Algiers, 1849
oil on canvas
85 × 112 cm

Gustave Courbet
The Bathers, 1853
oil on canvas
227 × 193 cm

Salon. In 1849 Bruyas went to live briefly in Paris and there his taste took a different direction. In the same year he bought the second version of Delacroix's view of a harem *Women of Algiers* (1849). Bruyas was to buy several more paintings by Delacroix, including the *Moroccans Conducting Military Exercises* (1832), and the artist took the rare step of painting Bruyas's portrait, which Van Gogh admired and thought looked amazingly like himself. Bruyas must have had considerable vanity because there is an entire room of 19 of his portraits by different artists, showing his long, melancholy features, and even one as Christ with a crown of thorns, by Verdier.

The artist with whom Bruyas will always be associated, however, is Gustave Courbet. It is difficult to think of two men less alike: Bruyas the dandy, refined and sensitive, while Courbet was generally described as coarse and full of animal spirits. The friendship began when Bruyas bought *The Bathers* (1853), which caused a scandal in Paris and an even bigger outcry in Montpellier. People thought Bruyas had gone mad when he declared. 'This is what free art means! This picture is for me.' Delacroix – who liked it – summed up the problem with the painting: 'It's incomprehensible, there's no subject.' Undaunted, Bruyas was to invite Courbet down to Montpellier, a visit that inspired one of the greatest of all Courbet's paintings,

Gustave Courbet
Bonjour Monsieur Courbet, 1854
oil on canvas
129 × 149 cm

Gustave Courbet
The Beach at Palavas, 1854
oil on canvas
37 × 46 cm

Bonjour Monsieur Courbet (1854). It shows the arrival of the artist looking every inch the Bohemian, being greeted with formality and deference by Bruyas – the rich patron – with his servant and dog. Courbet chose the iconography of the Wandering Jew and the manner of Dutch seventeenth-century Italianate landscape painters such as Cuyp to create what remains one of the icons of nineteenth-century painting and the greatest treasure of the collection.

Courbet stayed five months, painting several pictures for Bruyas, of which the most liberated is *The Beach at Palavas* (1854), which is sometimes called *The Artist Saluting the Mediterranean*. Bruyas left 14 paintings by Courbet, including his own portrait, and they are the glory of the museum. Among the important paintings by other artists Bruyas acquired was Géricault's *Study of Feet and Hands* (c. 1818–19) for his great canvas *The Raft of the Medusa* (The Louvre). After Bruyas left Rome he kept in touch with his old friend Cabanel, who had an enormously successful career in Paris, but it was the artist who gave to the museum his large painting *Phaedra* (1880). There is an entire gallery of similar conventional Salon paintings, which make an interesting comparison to the Bruyas bequest.

Montpellier's representative among the Impressionists was Frédéric Bazille, who, like Bruyas, was born into a wealthy Protestant family in the town. He studied medicine to please his family before insisting on his right to paint, and entered the studio of Gleyre in 1862. Because he died young, at the age of 29, Bazille has always been best known for his close friendship with Monet and Renoir, both of whom he met in Gleyre's studio. Bazille's family gave a superb group of his works after his death. There is his light and sunny *Village View* (1868), which Berthe Morisot admired so much in the Salon the following year. Between 1869 and 1870 Bazille painted what is sometimes regarded as his masterpiece, a work that at first glance could be by Manet: *La Toilette* (1869–70). There are many delightful smaller works by him, including the atmospheric painting of his *Studio in the Rue de Furstenberg* (1865–6). There is a small supporting cast of Impressionists by Caillebotte, Morisot and Degas, and a twentieth-century gallery, whose distinction is still in the making, with good examples of Staël, Richier and Soulages. One delightful local artist represented is Jean Hugo. This designer for the theatre and friend of Cocteau

Alexandre Cabanel
Phaedra, 1880
oil on canvas
194 × 286 cm

Frédéric Bazille
La Toilette, 1869–70
oil on canvas
131 × 127 cm

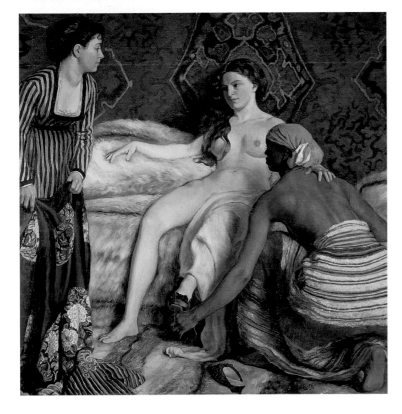

and Picasso was to make his home near by at Lunel, and there is his characteristic *L'Imposteur* (1931).

From the beginning the Musée Fabre was a success. In 1837 Stendhal wrote, 'On ne peut pas être une heure à Montpellier sans qu'on vous parle du musée Fabre, situé sur l'Esplanade.' It became – particularly after the Bruyas bequest –a place of pilgrimage for artists. In December 1888, when Gauguin was staying with Van Gogh at Arles, they interrupted their work to make a trip over to see the Courbets and the Delacroixes. Vincent van Gogh wrote to his brother: 'How I wish that you could see the gallery in Montpellier some time, there are some very beautiful things there!' Afterwards he and Gauguin had 'electric arguments' over the paintings and 'came out of them with our heads as exhausted as an electric battery after it is discharged'. Van Gogh's reaction was, as always, extreme but the museum remains a many-layered delight. It has a slightly eccentric personality – rare in great French museums – which is the result of its idiosyncratic benefactions, and long may this Montpellier tradition continue.

MUSÉE D'UNTERLINDEN

COLMAR

Of all the small museums of Europe this one packs the heaviest punch: not a shower of golden arrows like the Mauritshuis in The Hague, but one knock-out blow straight between the eyes. It is the Isenheim altarpiece by Mathias Grünewald, a work of such raw emotional force that it has taken its place as the supreme masterpiece of the Northern Renaissance and is to many the greatest altarpiece ever painted. Grünewald took up his brushes around 1512, at almost exactly the moment that Michelangelo was putting the finishing touches to the Sistine Chapel ceiling, but it is difficult to think of two works of art less similar in intent or execution. Michelangelo's is a confident, humanist world where man is on equal terms with God, while Grünewald's is a world of demons, forest fears, suffering and plagues. It is one of the great paradoxes that Grünewald's world with its fear of hell and faith in redemption is so remote from our own, and yet he has been substantially a twentieth-century discovery.

There is no great Western painter about whom we know so little. Grünewald's working life appears to have been spent around the Rhineland and in the towns and monasteries made rich by its trade. His resurrection has been slow and his correct name was not even established

until 1938 as Mathis Gothart Nithart, known as Meister Mathis, a common enough sobriquet in the sixteenth century to give rise to further confusion. The quest for Grünewald began in 1675, when Sandrart, the Vasari of Northern painting, identified his works, but in the absence of a name called him Grünewald, a label that has stuck, and he recorded the few facts known about this painter. This did not clear matters up because the altarpiece was attributed during the eighteenth century to Dürer and in the nineteenth to Hans Baldung Grien. It was only at the end of the nineteenth century and the beginning of the twentieth that Grünewald began to be more widely known and understood, and this was largely due to the French novelist J.-K. Huysmans, who included a description of the *Crucifixion* in his novel *Là-bas* (1891). In 1904 he published a critical essay, 'Les Grünewalds du Musée de Colmar', which for the first time described to a wide public the existence of the altarpiece and its emotional impact: 'There, in the old Unterlinden Convent, it looms up the moment you venture in, stunning you with its horrific nightmare of Calvary. It is as if a whirlwind of art has been let loose, and you need a few minutes to recover to get over the impression of pitiful horror evoked by that huge crucified Christ, erected in the nave of the old, disused monastery chapel, now converted into a museum.'

The altarpiece had been removed in 1793 to Colmar, a medieval town close to the river Rhine in the heart of Alsace. It was painted for Guido Guersi, preceptor of the monastery belonging to the order of St Anthony at Isenheim, a few miles away. The Antonites were a hospitaller order who in 1300 established a commandery in Isenheim, where pilgrims and the sick came to worship the relics of St Anthony. In particular, this order was associated with the miraculous cure of a virulent disease

The Cloister

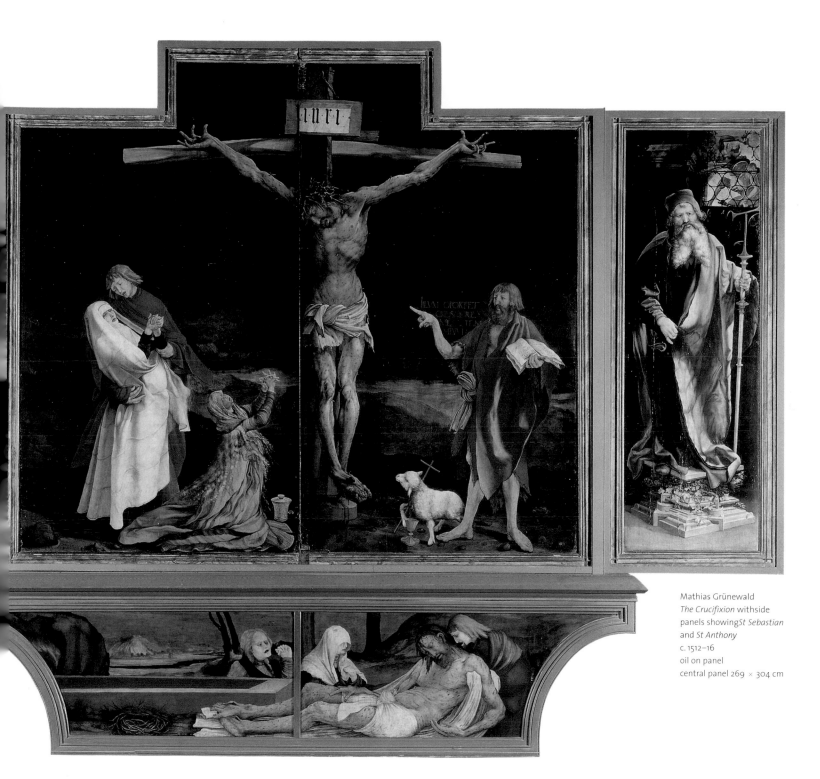

that became known as St Anthony's fire, caused by ergot or rye-fungus, whose victims were described by one contemporary with their 'intestines eaten up by the force of St Anthony's fire, with ravaged limbs, blackened like charcoal, either they … die miserably, or they … live more miserably seeing their feet and hands develop gangrene and separate from the rest of their body'.

In fact, the sick or the pilgrims who came to Isenheim would have had difficulty in seeing Grünewald's altarpiece at all, since it was partly hidden in the choir behind a rood screen and only visible through an open door. It is a complex polyptych, which offers three layers of presentation and imagery, depending on the Christian feast and time of year. The first layer of images, when the

Mathias Grünewald
The Resurrection and
the Annunciation
c. 1512–16
oil on panel
each panel 269 × 141 cm

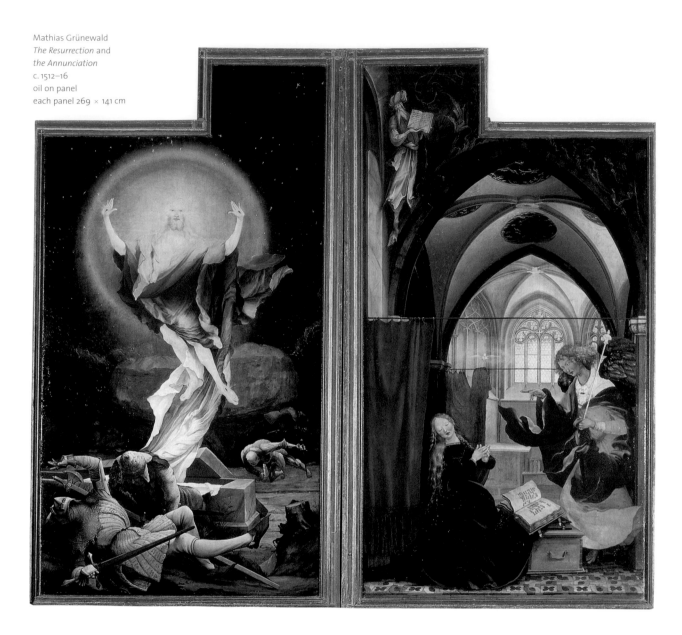

altarpiece was closed, on weekdays and typically for Advent or Lent, is the *Crucifixion* with the side panels showing *St Sebastian* and *St Anthony*, which is how Huysmans first saw it. The impression is much the same today when you enter the chapel. The first thing you feel is the intensity of pain, both spiritual and physical. Never was the pain of the Crucifixion more vividly portrayed, with twisted hands and feet, but the eye is drawn towards St Mary Magdalene, who is the spiritual centre of the picture. Christ is already dead and through the gesture of the wringing hands of the Magdalen and the Virgin, Grünewald gives us the most unforgettable portrayal of grief in Western art. But what is St John the Baptist doing there and looking so unconcerned? He was of course not

there, having been beheaded by Herod four years earlier. The clue to his presence may lie in the book of Scriptures he is holding and in his pointing finger, with the Latin words 'He must increase but I must decrease'. Many interpretations have been put on his presence, making the connection between the Old and New Testament and his pivotal role as the Baptist, with its implications of redemption.

Gradually the eye moves around the polyptych, and it is a shock to see the elegant, almost Italianate figure of St Sebastian. This is balanced on the other side by St Anthony, a Düreresque old man with a beard, and here we come to the heart of the function of this masterpiece: St Anthony as the healer of sick, with St Sebastian, the

Mathias Grünewald
The Temptation of St Anthony and
The Meeting of St Anthony and St Paul
c. 1512–16
oil on panel
each panel 265 × 137 cm

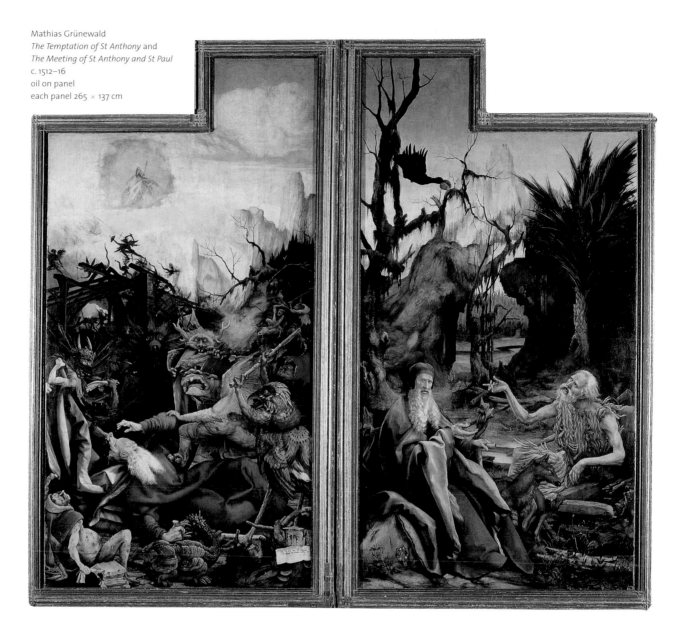

saint most commonly invoked in time of plague.

By opening up the second layer of images, for Christmas or feasts of the Virgin, we see the *Annunciation,* the *Concert of Angels,* the *Nativity* and the *Resurrection.* The last of these is startling, in strange vivid colours, perhaps a memory of illuminated manuscripts with their gold leaf, and closer to the traditional iconography of the Transfiguration. The *Annunciation* is touchingly human, showing the Virgin turning away, an innocent for whom the news is crushing and incomprehensible, and the *Concert of Angels* shows the Virgin in the Temple, with the angels playing music to her. The altarpiece was opened on the patronal feast, St Anthony's day, for a final set of images revealing a statue

of the saint enthroned between St Augustine and St Jerome, with two painted side panels by Grünewald, *The Meeting of St Anthony and St Paul* and *The Temptation of St Anthony*. The sculptural parts were by Nicholas of Haguenau, but the busts below of Christ and his Apostles are by an anonymous later carver.

Grünewald's two side panels are among the most striking of the altarpiece. The first shows *St Anthony Visiting St Paul in the Wilderness.* St Anthony was led by a wolf, and God sent down the raven with bread in two parts to feed the hermits. It is the winter of Gothic imagination, and never was nature more desolate. But Grünewald unleashes his most terrifying repertoire for *The Temptation of St Anthony,* a strange ghoulish world of

Mathias Grünewald
The Concert of the Angels and
The Nativity, c. 1512–16
oil on panel
265 × 304 cm

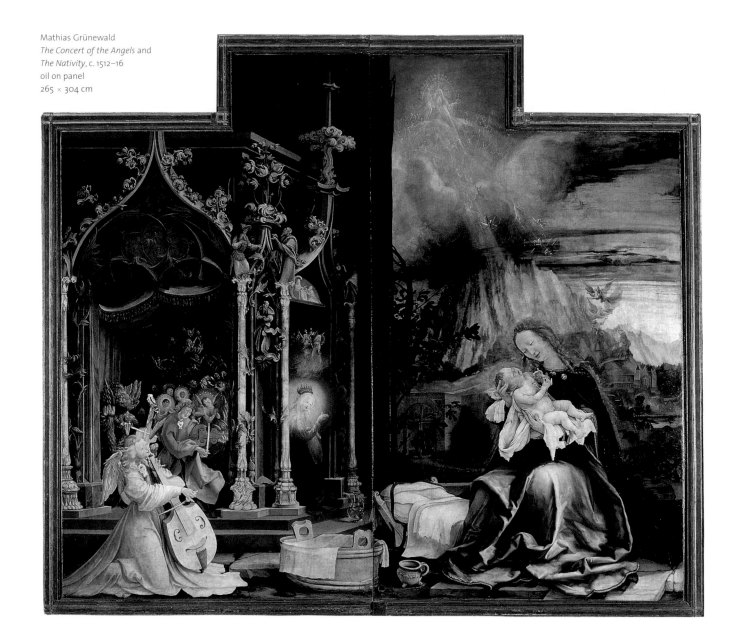

snarling creatures and goblins that make one reflect that the imagery of horror in Western culture has not progressed since Grünewald, as these are still recognisably the creatures of our nightmares today. The message is clear that to the sufferer, like St Anthony, only faith can deliver us from hell. Although pictorially the Isenheim altarpiece is impossible without the Italian Renaissance, it is spiritually the last great manifestation of medieval Europe.

The fate of the altarpiece was eventful. There had been several attempts to purchase it, first in 1597 by the Emperor Rudolf II and later by Maximilian of Bavaria, all of which were resisted by the Antonite order. When it was commissioned, the Antonites were at the height of their power and influence, which gradually waned until the order was abolished in 1790, and two years later the commissioners of the French Revolution removed the altarpiece for storage until, in 1852, it became the centrepiece of the newly formed Musée National de Colmar, housed in the old Dominican convent of Unterlinden – 'Under the Lime Trees'. The former chapel made an ideal setting for the altarpiece, where, with interruptions, it has remained ever since. In 1917 it was sent for safe keeping to the Alte Pinakothek in Munich, where it was exhibited and much admired by the German intellectuals of the time. It also became something of a German national icon and the defeated nation appeared to sublimate its suffering through the painting. It was with great reluctance that it was returned to what was by then French territory, and France had to press for its return.

After the First World War much scholarly attention was given to the altarpiece: the Surrealists admired it, Picasso copied it and may have even had it in mind when he painted *Guernica*. The strangest event between the wars was an opera composed around 1932 by Paul Hindemith and proposed for a season of German National Opera, *Mathis der Maler*, inspired by the life of Grünewald. It wove a complex story of an artist at a time of political unrest during the peasant wars of the early Reformation, but the Nazis sensed an ambiguity and stopped the project. With the outbreak of the Second World War the altarpiece was on the move again for safe keeping in the Périgord. After 1940 it was hauled back to Colmar, briefly again part of Germany, and then in 1942 it was off again to Haut-Königsburg, a castle in Alsace, before finally returning to Isenheim in 1945.

Today it remains the centrepiece of the Colmar museum. The same revolutionary commissioners who removed the altarpiece from Isenheim collected together all the works of any distinction they could find from the Upper Rhine region. The museum now shows a good supporting cast of twelfth- to sixteenth-century German sculpture, and fifteenth- to sixteenth-century German painting, which to all intents and purposes then jumps to the twentieth century. Martin Schongauer was a native of Colmar and although his most important altarpiece in the town, *The Virgin of the Rose Bower* (1473), is in the Dominican church near by, the museum contains works by him, as well as an important collection of his engravings. There is much else besides, but for most of the visitors to the Old Dominican convent of Unterlinden the memory of the Isenheim altarpiece will live with them and be, as the Grünewald scholar Andrée Hayum put it, an active presence in their lives.

MUSÉE CONDÉ

CHANTILLY

The glory and spirit of France are seen nowhere, except at Versailles, to greater advantage than at Chantilly. The surroundings are spacious and noble, the racecourse, the stables – the most splendid ever conceived – and the

landscape marvellously tamed. In the middle of it all the château sits magnificently on its lake. Romantically asymmetric and filled with memories of the great families of France, it looks every inch a royal château. Enter and you discover the finest small museum in France, a princely collection *par excellence.* This serenity is deceptive, however, because the history of the château accurately mirrors the turbulent history of France, and it has played host to many of the country's leading personalities. The complex history of seizure and inheritance need not detain us, but mention must be

made one or two of these great personages before we come to the main character in our story.

The dominant theme of the owners of Chantilly is that of great soldier–aesthetes. The first of these was that larger-than-life figure of Renaissance France Constable Anne de Montmorency (1493–1567), who built the Renaissance château over a medieval fortress. The greater part of this was later dismantled, except what is known as the Petit Château, built by Jean Bullant, which has contained the family apartments ever since. The second great figure of Chantilly is Louis XIV's brilliant soldier and cousin the Prince de Condé, known as Le Grand Condé. He rebuilt the château and brought in Le Nôtre to design the gardens. Evidence of his activities both on and off the battlefield are everywhere at Chantilly, which he made his main residence, thereby confirming its status as one of the great addresses of France. The Great Condé's great-grandson Louis-Henri, Duc de Bourbon (1692–1740), Louis XV's prime minister, built the great stables, set up the porcelain factory and created the eighteenth-century rooms in the Petit Château. These contain one unexpected masterpiece: the Rococo *singerie* or Monkey Room, painted in 1737 by Christophe Huet, which shows monkeys engaged in all of the Condé favourite occupations of hunting, painting, music and war. His grandson Louis-Henri-Joseph, Duc de Bourbon (1756–1830), the richest landowner in France, turned out to be the last in the line after his only son was shot on Napoleon's orders. In consequence, the Duc cast around for an heir and he chose his young godson Henri d'Orléans, Duc d'Aumale (1822–1897), the main figure in our story.

Never was an heir more fortunately chosen, or more aware of the great mantle he had inherited. He devoted his life to restoring and saving this heritage and, it must

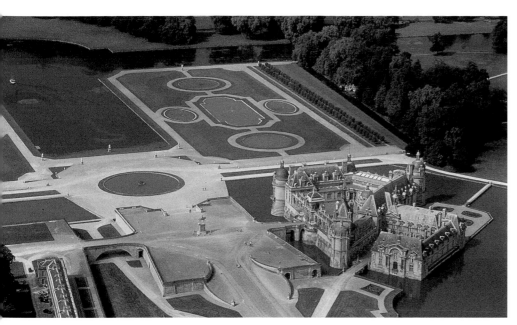

Léon Bonnat
Henri d'Orléans, Duc d'Aumale, 1890
oil on canvas
60 × 51 cm

Aerial view of the château

The château from the English Garden

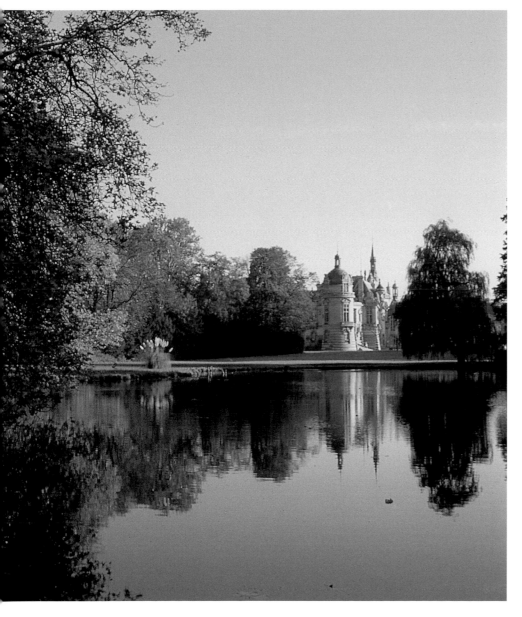

be said, hugely augmenting it. The fifth and youngest child of Louis Philippe, Aumale followed the Chantilly tradition of being a brilliant soldier, builder and collector. He was commissioned in the army at the age of 15, began an affair with the actress Alice Ozy and dreamt of military glory. This was not long in coming for this paragon among men. In 1840 he went to Algeria as an aide-de-camp to his elder brother, quickly rose to his own command and in 1843, aged 21, led his troops to a spectacular victory against the smalah of Abd-el-Kader. For this he was made lieutenant-general, became a popular hero and the following year married Marie-Caroline, daughter of the Duke of Salerno. He returned to Algeria as Governor-General and was there during the 1848 revolution, which forced him into exile in England.

Aumale settled at Twickenham in a pleasant house on the Thames near London, which he renamed Orleans House, and where Lord Houghton found him living in 'sumptuous and studious exile'. It was the enforced leisure of his 20 years in England that turned him into a scholar and collector of the first rank in the fields of paintings, books and drawings. He became a member of learned bibliographical societies, wrote a history of the Condé princes and was visited by Dr Waagen, who was greatly impressed by his increasingly famous library. Looking back at the Duc's earliest purchases of paintings, it is probably fair to say that the initial stimulus of his collecting was dynastic, to restore things to the family collection that had been dispersed, but this rapidly and spectacularly expanded to collecting French and Italian art for its own sake. He was certainly in the right place, for so much displaced French art had come to England, which at that time offered great opportunities for collectors.

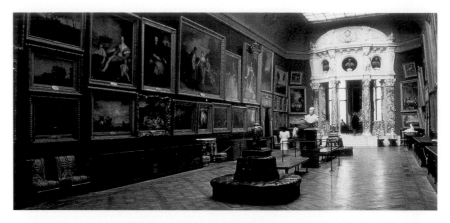

The Picture Gallery

Raphael
The Madonna of Loreto
c. 1510
oil on panel
120 × 90 cm

Aumale was able to return to France after the battle of
Sedan and Napoleon III's downfall, and began the task of
reconstructing the château in a manner fitting its
illustrious history, and to accommodate his by now
considerable collection. He appointed the architect
Daumet, who turned out to be an inspired choice. He
created a masterpiece that perfectly expressed the needs
of both a family and a museum. The château had suffered
grievously under the Revolution, when its main part had
been demolished, leaving only the *petit château,* which
Daumet carefully incorporated without dwarfing it,
creating an unforgettable monument to the Condé family.

Inside the château the first impression is of luxury, that
sumptuous, oak-panelled, marbled, tapestried,
chandeliered nineteenth-century luxury which exported
so well to Newport, Rhode Island. The château really
contains two hearts, the library and the picture gallery,
but we will concentrate on the latter, where the objects
are more visible to the visitor. The gallery, which is very
similar to the top-lit galleries Aumale saw in the great
London houses during his exile, encapsulates most of the
Duc's interests. Here we find views of Algeria, family
history, elements of the history of France, the French
army, Italian art and above all French art, dominated by
Nicolas Poussin.

The hanging arrangement of the gallery, which to the
modern eye is eccentric, is frozen under the terms of the
Duc's will; nothing may be moved or lent. The only
discernible logic is that French art is hung on the right
wall and Italian art on the left wall, with Poussin as an
honorary Italian. There are five of his paintings in the
collection, which represent different periods from the
lyrical *Infancy of Bacchus* to the star of the group, the
powerful *Massacre of the Innocents* (1628–9), where

Raphael
Orléans Madonna, c. 1506
oil on panel
29 × 20 cm

Nicolas Poussin
Massacre of the Innocents
1628–9
oil on canvas
147 × 171 cm

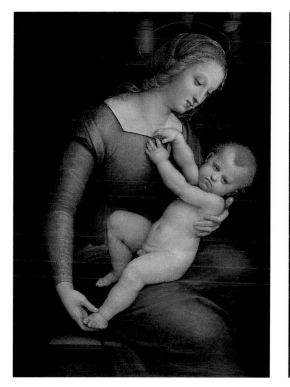
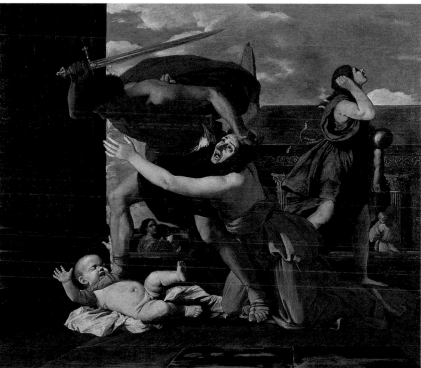

Poussin comes closest to Guido Reni. Both these canvases were bought in London in the 1850s. The landscape style of his early Roman period can be seen in *Numa Pompilius and the Nymph Egeria*, to be compared with the late elegiac style of the *Landscape with two Nymphs and a Serpent*. Poussin is the pivot of the classical elements of the Duc's collecting, with Raphael on one side and Ingres on the other.

The most important Italian paintings are to be found not in the gallery but elsewhere in the château. The first of three Raphaels is in the Rotunda, *The Madonna of Loreto (c.* 1510), which was only recently recognised as

the missing original. It came into the collection with the Duc's greatest single purchase of Italian paintings, when his father-in-law died in 1851. He bought the entire Salerno collection of 175 paintings *en bloc*. He sold on many items but was still left with seven Annibale Carraccis and nine Salvator Rosas, laying the foundations of the Italian collection which made Chantilly a museum of international importance.

Two of the most delightful Italian paintings that bring warmth to the collection came much later from the Frédéric Reiset collection: Piero di Cosimo's famous profile portrait of *Simonetta Vespucci* (late 15th century)

49

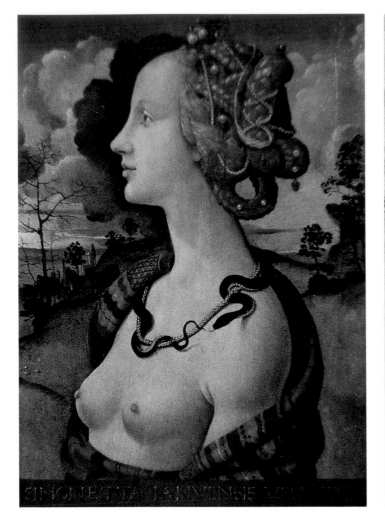

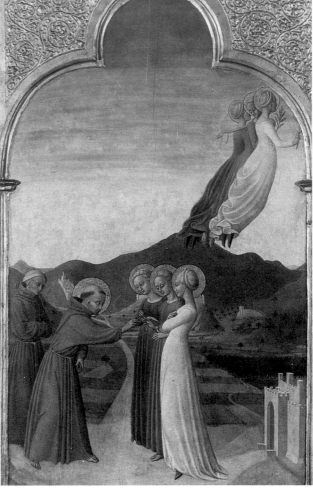

Piero di Cosimo
Simonetta Vespucci
late 15th century
oil on panel
57 × 42 cm

Sassetta
*Mystical Marriage of St Francis
of Assisi to Poverty*, c. 1440
oil on panel
94 × 56 cm

Antoine Jean Gros
The Plague-stricken of Jaffa
1804
oil on canvas
91 × 116 cm

Jean-Auguste-Dominique Ingres
Venus Anadyomene
1808–48
oil on canvas
163 × 92 cm

and Sassetta's justly famous *Mystical Marriage of St Francis of Assisi to Poverty* (c. 1440). The Piero di Cosimo portrait hangs beside the *Madonna of Loreto* in the Rotunda, but the Sassetta takes us into the Tribuna of the château, an octagon room based on the Tribuna of the Uffizi in Florence. Here are to be found many masterpieces, but none is as bewitching as the Sassetta. For many visitors to Chantilly this tender image is the most memorable of all the paintings in the collection. It is part of a large polyptych of scenes from the life of St Francis, with other sections in the National Gallery in London and the Louvre in Paris, but this panel has a special appeal as it goes to the heart of the Franciscan story with his marriage to Lady Poverty. The Sassetta rubs shoulders in the Tribuna with paintings by Perugino, Poussin and Watteau, but it is the nineteenth-century paintings that stand out. There is Baron Gérard's simple

1803 portrait of Consul Bonaparte and there are four paintings by Ingres, including the *Venus Anadyomene* (1808–48) and the *Self-portrait* (1804–48), one of the greatest ever painted. Ingres began the painting at the age of 24, and worked on it for 40 years until it reached the classical perfection that we see today. There are many other important rooms at Chantilly, but no account of the paintings would be complete without mention of the Sanctuary, where the other two Raphael masterpieces hang: the *Orléans Madonna* (c. 1506), which the Duc bought on account of its family provenance, and *The Three Graces*, a small early work based on Antique models.

Aumale acquired several collections *en bloc*. In addition to the Salerno paintings he bought Alexandre Lenoir's collection of French historical portraits, which occupy an entire room devoted to sixteenth-century French portraits by Clouet and his school. Until 1861 there were no

Jean-Auguste-Dominique Ingres
Self-portrait, 1804–48
oil on canvas
77 × 61 cm

drawings in the collection, but in that year he made the spectacular purchase of 380 amassed by Frédéric Reiset, curator of the Louvre, which included works by Raphael, Dürer and above all his favourite Nicolas Poussin. Eighteen years later he acquired all 40 of Reiset's paintings, which brought into the collection the Piero di Cosimo, Sassetta and five paintings by Ingres, including the *Self-portrait*.

Apart from the paintings there are several important pieces of furniture, which are mostly in the family apartments. The most unusual is the extraordinary *Muséum Minéralogique* (1773–4), designed by Johann Erich Rehn and made by Georg Haupt, which was given by Gustav III of Sweden to the Prince de Condé in 1774. Historically the most important piece at Chantilly is the writing table (c. 1756) by Louis-Joseph Le Lorraine, which is usually seen to mark the introduction of the Neo-classical style in furniture. There is also a Reisener commode, made in 1775 for the bedchamber of Louis XVI.

At the core of Aumale's collection was, of course, the library. He inherited great books, particularly from Constable Anne, 'who loved literature and wise men' and left behind some outstanding bindings. Aumale's book-

collecting got off to a good start when in 1851 he bought the entire library from Louis-Philippe's estate, which included 340 incunables that had been bequeathed to the King by the English collector Frank Hall Standish. His greatest moment came in 1856, when he acquired the *Très Riches Heures du Duc de Berry*, on the advice of Panizzi, the British Museum librarian, from a Genoese aristocrat whose *palazzo* had become a girls' boarding school.

Today the *Très Riches Heures* is one of the most famous manuscripts in the world, but it was completely unknown when Aumale bought it. It was started by the Limbourg brothers in about 1411 for Jean Duc de Berry on a scale grander and more ambitious than any previous Book of Hours, but what sets it apart is the extraordinary window it opens on to a late Gothic court, and the unusual sensibility to life, landscape, architecture and the passing of the seasons. Although it is a devotional work, it is really a celebration of life itself. If we have an idealised vision of the Middle Ages, it is probably because of the exquisite refinement of courtly life as expressed in this most beautiful of manuscripts. To his already astonishing collection Aumale later added the celebrated library of Armand Cigogne, and in 1891 he bought the 40 dismembered miniatures of Etienne Chevalier's *Book of Hours* by Fouquet, and this crowned his achievement as one of the greatest book collectors of all time.

Edmond de Goncourt visited Chantilly in 1874 and left a pen portrait of the Duc: 'There is only one way to describe the Duc d'Aumale: he is an old colonel of the light cavalry. He has the slender elegance, the haggard appearance, a grey beard, thinning hair and baldness; he even has the voice, a voice hoarse from command … the prince is simple, friendly, did not try to overwhelm me, and despite my antipathy for the Orléans, I must give him the credit

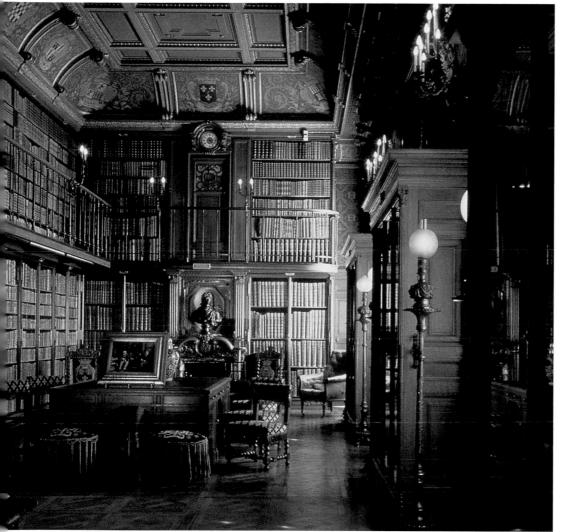

View of the Library

From the *Très Riches Heures du Duc de Berry*, early 15th century illuminated manuscript
29 × 21 cm

for the distinction of his manners.' The Duc was by then already a sad figure, since in 1873 his wife had died. He wrote the same year to Cardinal Mathieu in a melancholy vein: 'I have lost my wife and my six children; I have only my country to love.' He made immediate arrangements to leave his collection to the nation he had served so gallantly, but given the turbulence of its politics during the Duc's lifetime he gave the château and contents, which by now constituted the greatest small museum and library in France, to the Institut de France as an 'illustrious body' that would maintain 'its independence in the midst of political upheavals'. The Duc died in Sicily in 1897, leaving, as he put it, 'a complete and varied monument of all branches of French art and history from the glorious periods of my country'.

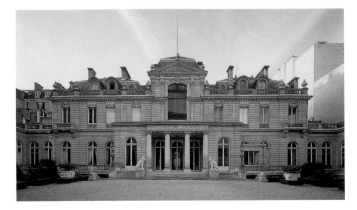

The Musée Jacquemart-André, entrance front

Felix Winterhalter
Portrait of Edouard André in the Uniform of the Guides of the Imperial Guard, 1857
oil on canvas
147 × 102 cm

Jean-Marc Nattier
Portrait of Mathilde de Canisy Marquise d'Antin, 1738
oil on canvas
118 × 96 cm

Jean-Baptiste-Siméon Chardin
Attributes of the Arts, 1730–31
oil on canvas
140 × 215 cm

Behind a swaggering Second Empire façade on the Boulevard Haussmann lies the Musée Jacquemart-André. It was formed as a result of the alliance between a rich Protestant banker, Edouard André, and a fashionable artist of modest origins, Nélie Jacquemart. They met in 1872, when she painted his portrait, and married in 1881, when he was 48 and she was 40. Together they turned his already spectacular *hôtel particulier* into an impressive museum that reflects his interest in the art of *ancien régime* France and hers in Renaissance Italy.

Edouard André was born in 1833, the scion of one of the richest banking families in France. He initially chose a military career in a regiment personally attached to the Emperor Napoleon III, and he enjoyed all the pleasures of court life. He briefly flirted with politics, but in 1872 the direction he was taking became clear when he bought the *Gazette des Beaux-Arts* and became chairman of the Union Centrale des Arts Décoratifs. Edouard left the bank in the hands of his cousin Alfred André and devoted the rest of his life to the arts. He had already commissioned the architect Henri Parent to create an enormous *hôtel particulier*, which was built between 1864 and 1875 in the fashionable area near Parc Monceau. He began to furnish the house by purchasing, mostly at auction, judicious examples of French decorative arts, but had got no further than the ground floor by the time of his marriage to Nélie.

Edouard thought he might use the first floor to create a studio for Nélie to continue her painting, and he got his architect to make one secretly while they were on honeymoon. This accounts for the large disfiguring window above the front door that gives this façade a rather municipal appearance. Alas, it was all for nothing; having married a rich man, Nélie had no intention of continuing her portrait painting. She retained an interest in collecting portraits, however, and there are many outstanding examples in the museum. Curiously, she did not like contemporary art and not only made Edouard dispose of this part of his collection but in her will forbade any additions created after 1811. It has been darkly suggested that she wished to avoid any comparisons with her own painting.

Nélie's tastes were more international than Edouard's and she was a great traveller. While he favoured auctions, she preferred buying from dealers and in particular patronised two Italians, Bardini and Ciampolini, both in Florence. This was a town for which she had a special affection and one that she visited every summer. She even tried for several years to buy a villa there but, unable to

find what she wanted, she decided to recreate Florence in Paris on the empty first floor.

Almost the first thing that greets the visitor to the Jacquemart-André is the *Portrait of Edouard André* by Felix Winterhalter, whose flashy brilliance sets the tone for the ground floor of the mansion. The Red Salon introduces us to the fine collection of French eighteenth-century painting, with characteristically sensuous pictures of *Venus* (1760) by François Boucher as well as admirable portraits by Roslin, Vigée-Lebrun, J. F. de Troy and Drouais, and Nattier's *Portrait of Mathilde de Canisy, Marquise d'Antin* (1738). The most impressive paintings are the two unusually large still lifes by Chardin *Attributes of the Arts* and *Attributes of the Sciences* (both 1730–31). They were commissioned by Konrad von Rothenburg for his Paris house and were the first important commission Chardin received for decorative still lifes.

The Grand Salon has a group of marble portrait busts that include Jean-Baptiste Lemoyne's *Marquis de Marigny* (1757), the great arbiter of taste during the reign of Louis XV, and a bronze of *Henri IV* (1605) by Barthélémy Tremblay, set against eighteenth-century panelling from the Hôtel Samuel Bernard in the rue du Bac. Despite this, the effect is curiously nineteenth-century, probably on account of the anonymous painted ceiling. The ground floor continues with a series of sumptuous and well laid-out rooms displaying mostly Louis XV period French paintings, tapestries and furniture (including works by or attributed to Riesener, Jacob, Othon and Baumhauer), together with Chinese porcelain and paintings by Guardi and Tiepolo. The Tapestry Room, which is Louis XIV in style, was specially created to hold the important Beauvais series called *Russian Games,* based on Orientalist designs by Jean-Baptiste Leprince. In the Boudoir the mood subtly

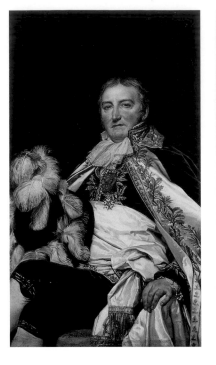

Jacques-Louis David
Portrait of Count Antoine François de Nantes, 1811
oil on panel
114 × 75 cm

Anthony van Dyck
Time Clipping Cupid's Wings, c. 1630
oil on canvas
175 × 110 cm

Rembrandt van Rijn
Supper at Emmaus, c. 1629
oil on canvas
39 × 42 cm

changes to the reign of Louis XVI. Here are two distinguished self-portraits by Alexandre Roslin and Joseph Ducreux, but the room is dominated by the *Portrait of Count Antoine François de Nantes* (1811) by David, a majestic portrait of this servant of the French state and the most modern item in the collection.

The climax of the ground floor is the Library. It has no books, but its cabinets contain French and German porcelain and Egyptian artefacts. Above all, it contains superb seventeenth-century Flemish and Dutch paintings, three good Van Dycks, including the *Portrait of a Judge* (1620) and *Time Clipping Cupid's Wings* (c. 1630), Frans Hals's rather thoughtful *Portrait of a Man* (1660) and three works by Rembrandt. There is his conventional profile *Portrait of Amalia van Solms* (1632), the woman who gave away so many of the paintings from the Dutch royal collection, the powerful *Portrait of Doctor Arnold Tholinx* (1666) and – one of his most brilliant early works – the small panel *Supper at Emmaus* (c. 1629). It is a haunting painting, in which Rembrandt uses the clever conceit of placing the light source behind Christ, leaving him in darkened profile while illuminating the startled Apostle.

The staircase, which is a *bella figura* piece of flamboyance on the part of the architect, is situated at one end of a winter garden and one might easily be in the Ritz Hotel. Upstairs the surprises come thick and fast. The first

is to find Tiepolo's fresco from the Villa Contarini at Mira in the Veneto, which represents *Henri III Being Welcomed by Doge Contarini* (1745). Unfortunately, as usually happens when frescos are transferred, they lose their magic and sparkle, and these have a rather ghostly quality.

The first floor is almost entirely given over to Italy and a series of atmospheric rooms laid out to recreate a Florentine *palazzo*. The first of these is the Sculpture Gallery, which occupies the studio that Edouard created for his wife. Together they collected about 200 works of Italian sculpture, probably the largest private collection of its kind outside Italy. These included not just free-standing figurative works but also door surrounds, columns, plaques, coats of arms and anything that might contribute

to the ambience. Thanks to Edouard's ownership of the *Gazette des Beaux-Arts,* they had access to excellent advice and the archives are full of letters from authorities such as Charles Yriarte and Wilhelm von Bode.

There are many fascinating treasures among the sculpture. There is the stylised marble *Bust of a Princess* – which has the simplicity of a Modigliani – by the Croatian-born Renaissance sculptor Francesco Laurana, a characteristic white glazed terracotta *Virgin and Child* by Luca della Robbia and the remarkable pair of bronze *Cherub Cressets* that have puzzled art historians and been regularly attributed to both

della Robbia and Donatello. For many the most exquisite piece is the bronze plaque attributed to Donatello of *The Martyrdom of St Sebastian* (c. 1440s). One of the greatest curiosities is the bronze bust of *Ludovico Gonzaga* (c. 1460), traditionally attributed to Leon Battista Alberti; in the absence of any conflicting evidence it has usually been accepted as virtually his only known sculpture.

The Florentine Gallery is the heart of Nélie's painting collection, and there are even choir stalls, fifteenth-century stone doorways and a wooden ceiling. The majority of the paintings represent the Virgin and Child, and there are attractive examples attributed to Perugino, Baldovinetti and Botticelli. Her greatest Florentine purchase – which she found in London – was Paolo Uccello's *St George and The Dragon* (c. 1465). According to Vasari, Uccello painted 'a number of small pictures in perspective for the sides of couches, beds and other things', and this is one of them. It has a fairy-tale charm that belies its careful geometric structure, and it remains the most celebrated picture in the museum. Edouard's taste in Italian painting ran more towards Venice, and the Venetian gallery is a sumptuous creation with a *grisaille* ceiling attributed to Girolamo da Santa Croce. There is a beautiful *Ecce Homo* (c. 1495–1500) by Mantegna as well as paintings by Crivelli, Schiavone and an important Carpaccio, *The Visit of Hippolyta, Queen of the Amazons, to Theseus* (c. 1500), but it must be said that Nélie and Edouard did not always pay enough attention to condition. Apart from the Carpaccio, several of the best

Francesco Laurana
Bust of a Princess, c. 1470s
marble

Andrea Mantegna
Ecce Homo, c. 1495–1500
distemper on canvas
54 × 42 cm

Donatello (attrib.)
The Martyrdom of St Sebastian
c. 1440s
bronze
26 × 24 cm

Paolo Uccello
St George and the Dragon
c. 1465
panel
52 × 90 cm

paintings, including a large *Virgin and Child* (c. 1510) attributed to Giovanni Bellini, suffer from this problem. Nevertheless, by the standard of private collections, what they assembled was very remarkable.

The private apartments on the ground floor complete the tour of the house and revert to French eighteenth-century decorative arts. The rooms are intimate and contain several modest treasures, including a commode disguised by a fake signature of François Garnier that has recently been shown to be by Charles Cressent.

Edouard died in 1894, but Nélie continued unabated in her travels and collecting and even acquired a taste for the East, making long trips to India and China. She bought a country house, the château de Chaalis, where she began to spend more and more of her time until her death in 1912. In her will she bequeathed the house and collections in Paris to the Institut de France, following the example of the Duc d'Aumale at Chantilly, to be preserved under the

name Jacquemart-André. In the same document she wrote: 'Ces collections, leur arrangement, ont été le but de mes études, mes travaux y ont mis aussi leur empreinte … J'espère qu'elles serviront aux études de ceux qui se dévouent à l'art et à son histoire.' Today the Jacquemart-André is beautifully restored and is one of the best-loved and most popular museums in Paris.

MUSÉE GUSTAVE MOREAU

PARIS

'Now that Gustave Moreau is dead, his house is to become a museum. This is as it should be. Even during his lifetime, a poet's house is never quite a home', wrote the young Marcel Proust, an admirer of Moreau, after he visited the house in 1898. Those who have seen Puccini's *La Bohème* or read George du Maurier's *Trilby* will have an image of bohemian life in late nineteenth-century Paris: artists huddling over wood stoves in romantic garrets surrounded by unsold paintings. We are so accustomed to this imagery that when we visit the Gustave Moreau house, the best-preserved artist's studio in Paris, we are surprised by the bourgeois spaciousness of it all. There are some 1,200 paintings here, mostly unsold and unfinished, and 15,000 drawings, but this was Moreau's choice. He did not like selling his paintings and hence left behind one of the most complete collections of any artist's work in existence.

Gustave Moreau is one of art history's stand-alones. He is often described as a Symbolist and although it is possible to discern his influence on a number of distinguished painters, such as Odilon Redon and Puvis de Chavannes, he is essentially a one-off literary painter who lived within his own world of dreams and mythology – what J.-K. Huysmans, author of *À Rebours,* described as 'a unique and extraordinary artist, a mystic, shut away in the centre of Paris in a cell where not the slightest sound of contemporary life can penetrate'.

Moreau's life was uneventful. He was born in 1826, the son of an architect, and attended the École des Beaux-Arts. He became a devoted disciple of Théodore Chassériau and on his master's death went to Italy for two years to complete his long training; there he copied Michelangelo, Raphael, Veronese, Correggio and, most interestingly, the then unknown Carpaccio. He returned to Paris to live the rest of his life quietly at the house his parents bought for

The façade of the museum, on rue Gustave Moreau

Gustave Moreau

him in 1852 – and shared with him – at 14 rue de la Rochefoucauld. It was this house he transformed in 1895 to very much its present shape, to become his museum. He occasionally exhibited at the Salon and, rather surprisingly, in 1892 became professor at the École des Beaux-Arts, where he had many devoted pupils. He was

Gustave Moreau
The Suitors, begun 1852
oil on canvas
343 × 385 cm

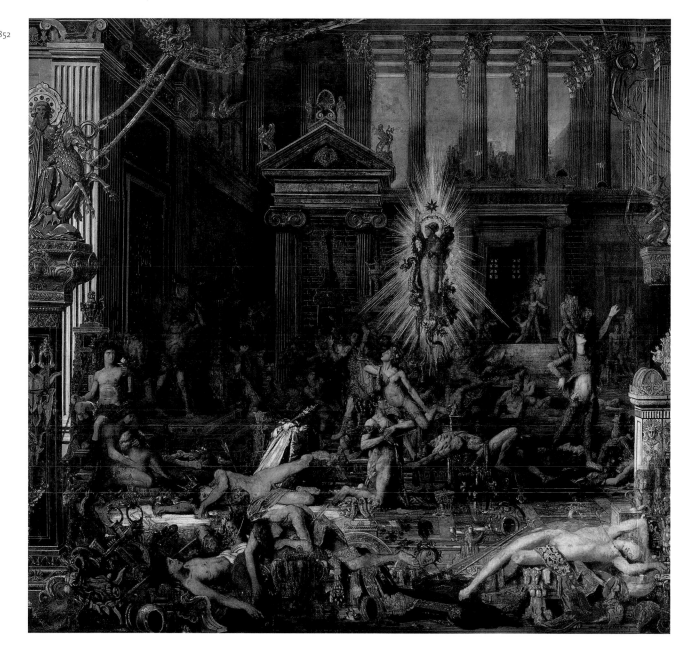

something of a celebrity in literary circles and, although much in demand, he remained slightly aloof. He had many clients for his work but put such a high price on his paintings that he sold very few.

There is a sealed-off quality about the Musée Moreau. It lies behind a rather conventional façade in the 9th *arrondissement* of Paris, a bourgeois area of quiet artistic pretension. The entrance gives little away and it is a considerable surprise to come up the narrow staircase into the main gallery created by Moreau. This is a

cathedral-like space, a little overwhelming, reverential and crowded with rich images. The atmosphere is mystical and not dissimilar to the womb-like experience of being in a Rothko room – the sense of a private meditation. The eye becomes aware of strange naked forms, apparitions, mythical beasts and *fin-de-siècle* aestheticism. In fact, most of the great unfinished canvases in this room were started much earlier. The largest, *The Suitors*, which dominates one end of the room, was begun in 1852 and Moreau was still adding to it 30

The main gallery and the
iron staircase leading to the
second floor

Gustave Moreau
The Unicorns, c. 1885
oil on canvas
115 × 90 cm

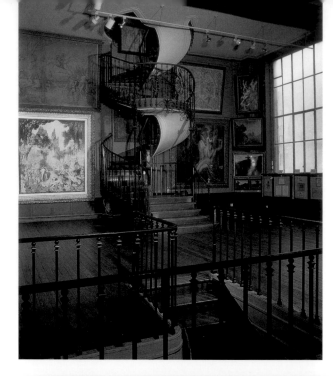

years later. The subject, as so often is the case with
Moreau, is a private meditation in which he uses the
ostensible scene, the massacre by Ulysses on his return to
Ithaca, as a point of departure. The reality is a great
bewitching muddle of a canvas. The whole of this
enormous room – except one wall with large studio
windows – is taken up floor to ceiling with huge, mostly
unfinished paintings, hung against salmon pink walls.
Sometimes, as in P*romethée Stricken*, the paint is applied
in thick expressionist strokes, while others, such as *The
Chimerae* (1884), show exquisite pencil line, lightly filled
in with almost heraldic detail.

Aside from the paintings, there are large, old-fashioned
radiators, racks of drawings, and a cabinet of casts that
give a pleasant, nineteenth-century studio feel. The
dominant architectural feature is the elegant spiral
staircase that Moreau had built in 1895 – a piece of pure
theatre that takes you up to the top-floor studio. There
the paintings are smaller and hung floor to ceiling in
three rows. This was his actual painting studio and
although the easel, the drapes and the smell of turpentine
have gone, the atmosphere is marvellously evocative, as
Salvador Dalí recognised. You have the feeling of being a
spectator in a private place. 'Tread softly because you
tread on my dreams', said W. B. Yeats; certainly few will
identify with the arcane subjects or be able to enter fully
this world of personal images, but many will enjoy the
surface charms. A painting such as *The Unicorns* (c. 1885)
is, like the medieval tapestry from which the inspiration
for it came, diffused, atmospheric, full of symbolism but
also very decorative. Moreau is also capable of being
powerful: *The Apparition* (c. 1876) is magnificent, with
the sword-like defiant gesture of Salome (with whom he
was obsessed). In *The Life of Mankind* (1886), a polyptych

Gustave Moreau
The Life of Mankind, 1886
oil on wood
each panel 33 × 25 cm
semicircular frontispiece
diameter 94 cm

Gustave Moreau
Jupiter and Semele (detail)
1895
oil on canvas
212 × 118 cm

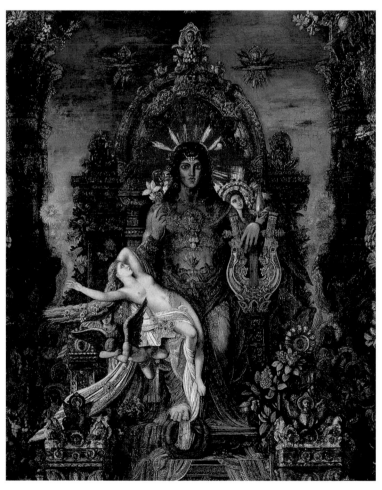

Gustave Moreau
The Apparition, c. 1876
oil on canvas
142 × 103 cm

of nine panels that has a delicacy and charm, Moreau finds a perfect expression for his considerable talent as an illustrator. Nearly all the paintings in the museum are unfinished, and when you see a finished painting such as *Jupiter and Semele* (1895), which was sold by the artist but came back to the museum after his death, it is a shock and rather difficult to take seriously. It reminds me of the story told by Paul Valéry about Degas: 'Moreau took him up one day by saying – "Do you think you can revive art through dance?" – "And you," retorted Degas, "do you think you can revive it through jewellery?" '

The museum is a pantheon to these private dreams, a world of gods and biblical heroes seen through the stained-glass prism of Symbolism. It must be said that overt eroticism is the prevailing tone, and despite the fact that he had a long, happy relationship with his mistress, Alexandrine Dureux, the male nudes have strong homoerotic tones. It is the eroticism of illustrations to the *Kama Sutra* – a little too stylised for an age brought up on Renoir.

Whatever Moreau's private dreams, his own living apartments, squashed into four rooms on the first floor, are cosily bourgeois. In reality he lived mostly in his third-floor studio but, taking outward respectability very seriously, preserved these rooms where his parents had lived, and he preferred to receive people here. They are a window on to Parisian life at the end of the nineteenth century, comfortable and filled with objects and bric-à-brac. The prints are indicative of Moreau's taste: Titian, Raphael, Rembrandt and Chassériau.

When he died in 1898, Moreau left the house and collection to the state, and his friend Henri Rupp saw to it that the will was faithfully executed. The first curator was Moreau's favourite pupil, Georges Rouault, and since

The bedroom in Moreau's
apartment on the first floor

The dressing-room in
Moreau's apartment
on the first floor

then the popularity of the museum has waxed and waned. It has remained a beacon for Surrealists, French intellectuals who found it a marvellously quiet place to meet, and anyone seeking a glimpse of an authentic Paris atelier of the period. The last word should go to Moreau himself, who in 1862 wrote: 'On this evening … I think of my death and of the fate of all these works and compositions I have taken such trouble to collect. Separately, they will perish, but taken as a whole, they give an idea of what kind of an artist I was and in what kind of surroundings I chose to live my dreams.'

MUSÉE MARMOTTAN

PARIS

It is difficult not to feel a measure of sympathy for Paul Marmottan. In 1932 this fastidious and slightly obsessive collector and historian of the Empire style bequeathed his house and collection to the Académie des Beaux-Arts as a monument to his hero Napoleon and to the art of that era. He no doubt hoped that it would rekindle interest in that then unfashionable style, but in 1957 a part of the celebrated painting collection of Georges de Bellio – whose claim to fame was as doctor to the Impressionists – was given to the museum by his daughter, altering the course of the Marmottan for ever. The De Bellio benefaction in turn attracted the dazzling bequest from Monet's youngest son, Michel, of the works left in his father's studio at Giverny, and gave the museum at the time the largest and most important collection of the artist's work in the world.

Let us start with Paul Marmottan (1856–1932). His father, Jules, was a collector of medieval and Renaissance art who bought the pleasant villa at 2 rue de Boilly in Paris's 16th *arrondissement* where the Musée is housed today. Paul Marmottan was to transform it into a temple of the Empire style. There is an evocative, almost Proustian, account by Mario Praz of a visit to Marmottan in which he describes this 'kind, rather shabby old man moving among all (his) treasures like an amiable miser among his gold'. In fact he was the species of collector a novelist might describe: scholarly, reclusive, obsessed with his world of sphinxes, lyres, swans and acanthus leaves, which encrusted every chair and table.

Marmottan was a distinguished scholar, who wrote an excellent book on the painter Boilly and enjoyed rediscovering artists such as Fabre and Gauffier. His magnum opus was *Les Arts en Toscane sous Napoléon*. Praz admired the works of art and the passion of the man, but

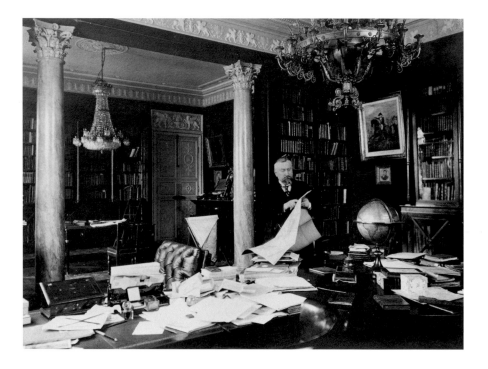

Paul Marmottan in his study

François-Xavier Fabre
Portrait of the Duchesse de Feltre and her Children, 1810 oil on canvas
227 × 276 cm

Sèvres Workshop,
Geographical Clock, 1813
carved porcelain and bronze
height 228 cm

admitted he was 'a sealed-up soul in a sealed-up house'. The profusion of objects and richness of the house and the collection Marmottan left behind did not survive his death. The first curator, Hector Lefuel, the author of the standard work on Jacob furniture, began the pruning and in the interest of purity many of the objects and much of the effect disappeared. This process was completed as the various bequests claimed more and more of the museum. Today only a small part of the Marmottan bequest is shown, in three or four rooms on the ground floor. The study shows Empire furniture at its most exuberant, with works by the Jacob brothers and Bellangé. The hall contains Fabre's masterpiece, the enormous *Portrait of the Duchesse de Feltre and her Children* (1810), while the

bedroom has a collection of portraits by Boilly and Napoleon's bed from the Palais Impérial at Bordeaux. Lefuel said that Marmottan liked to boast about the origin of a great number of his works of art made for Napoleon and his family. The most spectacular of these is the *Geographical Clock* made in 1813, depicting differently painted time zones.

The mood shifts along the passage (which leads to the lower galleries, created for the works of Monet) and here are some of the fifteenth- and sixteenth-century tapestries, paintings and carvings from Marmottan's father's collection. Along the way is a darkened room with the Georges Wildenstein collection of manuscript illuminations. Whatever you may feel about the morality of such a collection of single sheets taken from whole

books, it is a formidable assemblage. The lion of the collection is a page from the *Hours of Etienne Chevalier* (1452–60) by Fouquet, part of the Chantilly set, but there are also miniature masterpieces by Jean Perréal, Giulio Clovio and many others.

A later curator, Jacques Carlu, who happened to be an architect, created the lower gallery in the 1960s. It is invisible from the outside – but daylight is certainly not one of its virtues. Here are Monet's paintings from the De Bellio and Monet bequests. Georges de Bellio was the youngest son of a Romanian patrician family who settled in Paris and practised medicine for his friends. He became the financial life support for several Impressionist painters, as Renoir explained: 'Whenever one of us

urgently needed money, he ran along to the Riche Café, where he was sure to find M. Bellio.' He met Monet in 1876 and was for a time virtually his only buyer. When De Bellio died in 1894 he owned over 30 works by the artist, and it was his daughter Victorine Donop de Monchy who gave a part of his collection to the Marmottan. This included Monet's celebrated *Impression: Sunrise* (1872), which gave the movement its name.

Impressionism as a style had been born a few years earlier, when Monet and Renoir painted together at La Grenouillère, but the term was not coined until the exhibition at Nadar's old studio in the Boulevard des Capucines in 1874. The hostile critic Louis Leroy picked up on the title of Monet's sketchy atmospheric view of the port of Le Havre in his notorious review: 'Impression – too right – and I was just saying to myself that if an

impression has been made on me, something must be making it. What freedom and ease in the brushwork! Wallpaper in its raw state is more finished …'. The sketch had become the finished painting and the moment had become eternal. No reproduction can quite do justice to this most beautiful painting. It was originally bought by Ernest Hoschedé (the first husband of Alice Monet), who went bankrupt, and De Bellio bought it at his sale in 1878.

Most of the paintings in the lower gallery are from the Michel Monet bequest and we see his father's work in many phases. There is Monet at the height of the first phase of Impressionism, with the poppy field entitled *Promenade near Argenteuil* (1873). Around the same time he began to paint trains for the wonderful diffusion that steam brought to the sharp lines of the man-made world. In 1877 Monet announced himself to the surprised

stationmaster of the Gare St-Lazare 'I have decided to
paint your station', and, being France, the stationmaster
allowed him full access. One of the results is the majestic
Pont de l'Europe, Gare St-Lazare (1877), which Monet
always kept in his own collection. Around 1890 Monet
developed his exploration of the effects of light on surface
through his 'series' paintings, which were to culminate in
the *Nymphéas*. His most intensely observed subject was
Rouen Cathedral and the museum has one of the
paintings from 1892. As success slowly came to Monet, he
took to travel, and one of his favourite subjects was the
Houses of Parliament in London. He always insisted that
in his work he was only 'striving to render my impressions
in the face of the most fugitive effects', and in *Parliament,
Reflections on the Thames* the building almost ceases to be
tangible.

Claude Monet
Impression: Sunrise, 1872
oil on canvas
48 × 63 cm

Claude Monet
*Pont de l'Europe
Gare St-Lazare*, 1877
oil on canvas
64 × 81 cm

Claude Monet
Parliament, Reflections on the Thames, 1905
oil on canvas
81 × 92 cm

In 1890 Monet bought Giverny and its garden, and thus began the final and – to judge by the number of books on the subject – to many the most interesting period of his life. Monet belongs among the handful of great painters, including Titian and Rembrandt, whose late style achieved a special poetry. The garden and lily pond became his universe, and through these paintings we can follow the convulsions of his old age. In his own words, 'it took me some time to understand my waterlilies. I had planted them for pleasure … without thinking of painting them … and then suddenly I had the revelation of the magic of my pond. I took up my palette. Since then I have hardly had another model.' The earliest paintings are of

the Japanese footbridge, but soon his attention focused on the water. One of the earliest is the 1903 *Nymphéas,* which still maintains an opaque solidity that gives way to the watery translucence of the 1916–19 *Nymphéas,* in which the elements merge into a symphony of greens and blues. Around 1918 Monet's immersion in his subject led to a strange new development with a series of canvases with the furnace-like colours of *The Japanese Bridge* (1919–24). They leave the eye slightly dazzled and have a compulsive character.

What happened? Alice Monet died in 1911, their son Jean died in 1914, the war moved dangerously close to Giverny, and yet Monet still painted pictures with a

Claude Monet
Nymphéas, 1903
oil on canvas
73 × 100 cm

Claude Monet
Nymphéas, 1916–19
oil on canvas
150 × 197 cm

Claude Monet
The Japanese Bridge, 1919–24
oil on canvas
89 × 100 cm

Berthe Morisot
The Cherry Tree
(*'The Cherry Picker'*), 1891
oil on canvas
154 × 84 cm

Edouard Manet
Portrait of Berthe Morisot
1873
oil on canvas
26 × 34 cm

Gustave Caillebotte
Rue de Paris. Temps de Pluie
1877
oil on canvas
54 × 65 cm

strange tranquillity. The turning-point came when he began to lose his eyesight. He wore thick spectacles but could be sure of the colours only by reading the labels on the paint tubes. The results were a series of fearful images – with a certain loss of articulation – in which the colours became a tangle of flames. The dating of these works to between roughly 1918 and 1923 is more complicated than it seems, owing to Monet's habit of working on canvases over a long period. He nearly gave up, but was persuaded not to by his friend the Prime Minister, Georges Clemenceau, who celebrated the armistice by visiting his friend at Giverny. He urged him to have an eye operation. Monet finally had one in 1923; it was a complete success and enabled him to complete for Clemenceau the great *Nymphéas* series in the Orangerie in Paris. 'I spent all summer working with a new feeling of joy', he wrote in 1925, and the museum has the large painting *of Roses* (1925–6) as evidence of this. At any one time there are 26 paintings of Giverny on show in the museum, of which half come from the period of 'hot' colours.

The Marmottan continues on the first floor with paintings from the Denis and Annie Rouart Foundation. He was the grandson of Berthe Morisot and left a large representative group of her work, as well as several by

Renoir, Monet, Manet and Degas. Morisot was Manet's sister-in-law and he painted her on ten occasions, never more strikingly than in the tiny portrait of her painted in 1873. Her own work has the soft gentle charm of late Manet, as can be seen in *The Cherry Tree,* also known as *The Cherry Picker* (1891). In addition to these, there are works from the various other bequests by Sisley, Boudin, Pissarro, a major Gauguin (*Bouquet of Flowers,* 1897) and Caillebotte's characteristic *Rue de Paris. Temps de Pluie* (1877), as well as groups by lesser-known artists such as Armand Guillaumin, Henri Le Sidaner and Albert Lebourg.

The Marmottan has one of the best small collections of Impressionist paintings in France. The fact that it came straight from Morisot's and Monet's own collections – as well as from that of such a closely connected figure as De Bellio – makes it additionally fascinating. The museum remains an extraordinary dichotomy between Marmottan, who wanted time to stand still and to live in his enclosed, bookish world, and Monet, for whom history had no use and who rarely stayed indoors when he could be out in nature. It is left to the visitor to bridge the gap.

MUSÉE PICASSO

ANTIBES

There are several Picasso museums in the world, probably more than are devoted to any other artist, but the first and the only one that has an intimate connection with a creative period of his life is that housed in the Château Grimaldi in Antibes. The period is short, mostly 1946, but significant, since a confluence of events led to a burst of creativity that can be traced directly to Picasso's life and surroundings at the time. It was the end of the war; he had a new love; it was the Mediterranean; and the old château became the stage for this idyll of sun, sea and sex.

The muse was a beautiful young painter called Françoise Gilot, who later wrote a very good account of their love affair, *Life with Picasso,* which began: 'I met Pablo Picasso in May 1943 during the German occupation of France. I was twenty-one …'. The place was Paris; Picasso was 63 and he had spotted her across a restaurant. She was intelligent, strong-willed and beautiful in a Latin way, with large, luminous, chestnut eyes, and Picasso began inviting her to his studio. She disconcerted him by laughing at him when he was angry, and he begged her to come and live with him. When she tried to leave him, he berated her: 'Words, words, words. You are developed only on an intellectual level. Everywhere else you're retarded. You won't know what it means to be a woman until you have a child.' She went on to have two by Picasso over the next few years, Claude and Paloma, and then Picasso left her.

Picasso spent the war in Paris in defiance of the Germans, refusing favours from them and high on their list of degenerate painters. At the end of the war the return to the Mediterranean with his young new love Françoise was like a rebirth of life itself. He settled in 1946 in a small house at Golfe-Juan and, although he enjoyed the beach life, soon became restless without a proper

Picasso and Dor de la Souchère in front of *Satyr, Faun and Centaur with Trident,* 1948

View of the Château Grimaldi from the Square

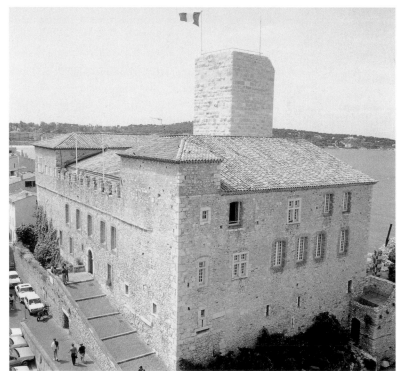

Dor de la Souchère came down to the beach and offered Picasso a large, light room with views over the town. Picasso went to see it the next day and was excited. The medieval château sits raised like a crown on the edge of the *vieux port* of Antibes, both venerable and beautiful. A stone's throw from the busy markets, on the Mediterranean sea front, it has superb views over both the town and the sea. Inside large, noble, whitewashed beamed rooms made a superb studio as they make a superb museum. The austere beauty of this fortress setting impressed Picasso enormously. 'While I am here I am not just going to paint some pictures, I am going to decorate your museum for you', he told the delighted curator.

He set to work immediately, but one of the main problems of the period was the lack of painting materials. Picasso therefore went down to the harbour and bought a supply of boat paint which he used, on plywood and fibro-cement as the best materials to hand, with house painter's brushes. When all these things were delivered to the museum he spent the next two months busily painting, and almost all the works are to be seen there today.

The museum at the time was filled with Roman remains and old sarcophagi, and Picasso was impressed by the sense of antiquity in Antibes. He was later to say, 'Every time I come to Antibes, it takes hold of me; over and over again … at Antibes this antiquity seizes hold of me every time … I have painted centaurs and satyrs before; I did plenty of them at Ménerbes, but I had come to Antibes long before.' These mythical classical creatures were to dominate. Typical is the 'Antipolis' series, a set of a dozen drawings on the theme of dancing fauns, nymphs and centaurs. The nymph, unsurprisingly, resembles Françoise Gilot. There are at least three paintings on the theme of fauns. One of the most important was the large

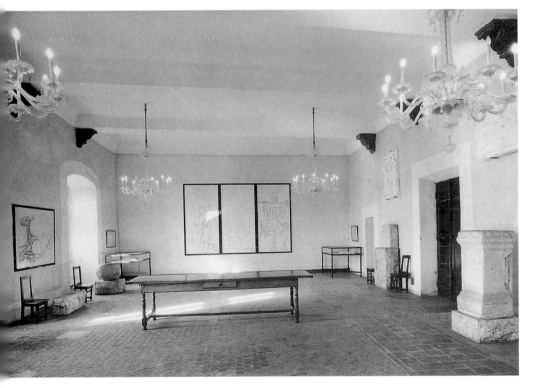

View of the museum with works by Picasso and Roman remains, 1950s

studio to work in. One day on the beach the photographer Sima mentioned the Château Grimaldi in Antibes, at the time a rather forlorn archaeological museum in a wonderful position, where the curator Dor de la Souchère, a classics teacher from Cannes, had been trying to fill the large empty rooms. 'All right,' said Picasso, 'if you want to bring the curator here to see me one morning, and he really wants me to work there, I'd be delighted because I don't have any space where I am now.' Interestingly, he had been offered the château 20 years earlier, when it was being sold by the army, but the town of Antibes stepped in and created the museum.

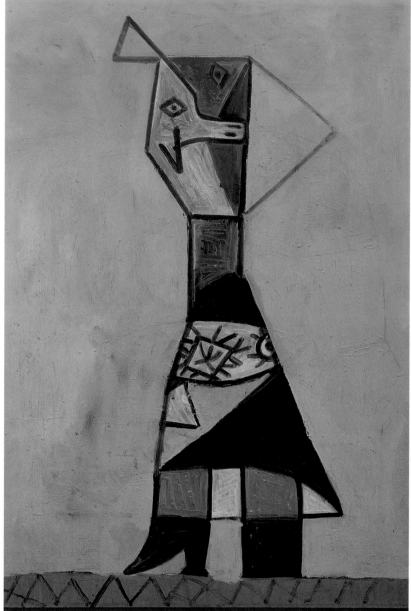

monochrome triptych entitled *Satyr, Faun and Centaur with Trident,* an arcadian hymn to the Mediterranean that well expresses Picasso's light-hearted feelings at the time.

The life around the château was to prove another great inspiration: the restaurants, tables of food, the fishermen and the sailors. A good example is the *Woman with Sea Urchins.* Françoise Gilot describes this woman, who ran a small café in Golfe-Juan where they ate nearly every day: 'She was so wide and her café so narrow there was hardly room enough inside for her, so she stood outside trying to drum up trade. Since there was almost no one to buy from her she kept dipping into the stock all day long … She would dip into the basket, open up one of the sea urchins and suck the contents so greedily that we would watch her, fascinated by the contrast between her soft, round red face and the spiny green-violet sea urchins.' Picasso

began this painting in a conventional manner but gradually, as Gilot describes, he eliminated each day more of the naturalistic details until only the vertical forms remained. There is another odd, almost primitive, painting, *The Man Gulping Sea Urchins,* showing one of the local fishermen, one of the very few works painted on canvas because he took it from the storeroom of the château and painted over an old picture. One day Sima found an injured owl in a corner of the museum and Picasso made a haunting composition, *Still Life with Owl and Three Sea Urchins,* reconstructing the owl with sea urchins to resemble a human form. Still lifes formed a major part of the work of this period and he left behind several good examples of table still lifes, with bottles, fruit and so on. The most enigmatic pictures he painted were two nudes, *Nude Lying on a White Bed* and *Nude*

Pablo Picasso
Satyr, Faun and Centaur with Trident (from the 'Antipolis' series), 1946
pencil
51 × 66 cm

Pablo Picasso
Woman with Sea Urchins
1946
oil on plywood
119 × 83 cm

Pablo Picasso
Faun's Head, 1946
oil and china ink on paper
66 × 51 cm

Pablo Picasso
Tanagra with Amphora
1947–8
ceramic
45 × 33 x 11 cm

Lying on a Blue Bed. Matisse, when he visited the museum in 1948, was particularly puzzled by these paintings and remarked of one of them: 'I understand the way you have done the head, but not what you've done with her bottom. The two parts of it turn in a strange way. They don't follow the other planes of the body.' Matisse took out a notebook and sketched it several times to try and understand the forms.

While he was in Antibes, Picasso went over to visit the pottery in Vallauris and began experimenting with this medium. At first he was dissatisfied, until he gradually began to gain technical mastery over the form and created revitalised classical pieces such as *Tanagra with Amphora* and *Standing Bull*. He also created several sets of plates, starting with a simple but striking set of *Fauns' Heads,* then a set of still lifes and finally the ever-popular bullfighting series.

Pablo Picasso
The Joy of Life, 1946
boat paint on fibro-cement
120 × 250 cm

Pablo Picasso
*Still Life with Owl and Three
Sea Urchins,* 1946
oil on wood
81 × 79 cm

Behind all this creativity and happiness lay Françoise Gilot, who is to be found in many of the paintings. *Woman in an Armchair* is recognisably her, an important painting that Picasso kept and which came to the museum after his death. There is also a beautiful melancholy lithograph of Gilot, *Woman with Hairnet,* done several years after their Antibes idyll. But the masterpiece of this period and the perfect expression of Picasso's feelings at the time is *The Joy of Life.* It is an arcadian classical painting of fauns and centaurs dancing and playing pipes around the figure of Gilot, and as in most of the work in Antibes he used boat paint on fibro-cement, which reinforces the primitive simplicity.

By December 1946 Picasso had moved on and left behind the greater part of his work of the previous year, including 23 paintings, 78 ceramics, 33 drawings, 11 oils on paper, 27 lithographs, 1 tapestry and 2 sculptures. He said to Dor de la Souchère: 'When we started, we did not know what we were up to. If you had said to me "We are making a gallery", I would not have come. But you said, "Here's a studio!" Even you yourself did not know what you wanted to do; that's why it has come off, simply because you did not try to make a museum'. Like so many

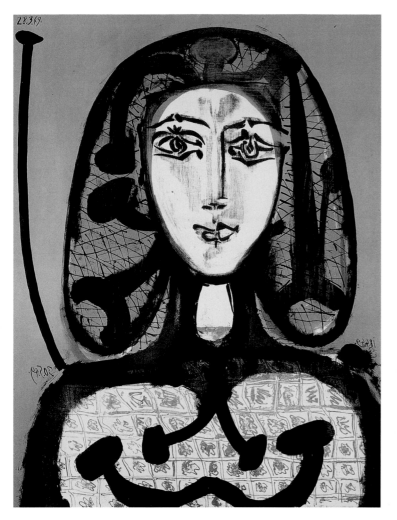

Pablo Picasso
Woman with Hairnet
1949–56
lithograph
66 × 50 cm

people who came into contact with Picasso, Dor de la Souchère wrote a book about the experience, *Picasso in Antibes,* which has photographs that show how beautiful the museum was in its early days, when the works of Picasso were displayed over two floors, along with the Classical remains of the Archaeological Museum. Today the archaeological pieces have been largely moved to another museum and temporary exhibitions in the summer take up the ground- and first-floor rooms.

The studio on the second floor where Picasso worked is now dedicated to Nicolas de Staël. In 1954 de Staël had a studio next door to the château, and Dor de la Souchère offered him an exhibition. Over the next six months De Staël produced an astonishing 354 oil paintings. Unfortunately, such activity resulted in a breakdown and in March 1955 he committed suicide by jumping from his studio window. The museum acquired several works from this period, including the monumental unfinished canvas *Large Concert,* which now dominates Picasso's old studio.

The modern art collection was begun in 1951 by Dor de la Souchère and has grown thanks to gifts from artists whose works have been exhibited in the museum and acquisitions made over the years by the City of Antibes.

Each subsequent curator has pursued the policy of encouraging local artists, and they have now taken a dominant position in the museum. It includes artists representative of the main movements of the twentieth century: Gleizes, Ernst, Magnelli, Picabia, Hartung, Atlan, Balthus, Brassaï, Music, Tàpies, Klein, Hains, Arman, César, Spoerri, Raysse, Viallat, Dezeuze, Pagès, Buraglio, Pincemin. The terrace overlooking the sea shows work by Germaine Richier.

The museum even preserves some archaeological fragments but, although Picasso hoped that they should never leave the museum, they are not always in evidence. The heart of the museum remains the Picasso collection, now swollen to 300 pieces thanks to donations made by the artist and others at different times. What is striking and perhaps unique at Antibes is the possibility of seeing virtually all the major works by Picasso from a particularly fertile season and to observe the extent to which he took inspiration from his surroundings and companions. It is to be hoped that, despite the enormous increase in its holdings, the museum will not lose the purity and austere beauty that Picasso found there in 1946.

SCHLOSSMUSEUM

WEIMAR

The Schlossmuseum, Weimar

Lucas Cranach the Elder
Portrait of Martin Luther as Junker Jörg
c. 1521–2
mixed media on wood
53 × 37 cm

Lucas Cranach the Younger
Charity, c. 1540
mixed media on wood
120 × 82 cm

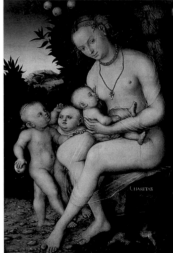

There is no place name more resonant in German culture than Weimar. Since Lucas Cranach the Elder settled there in 1552 Weimar has been a magnet for painters, poets and musicians. Above all, it is the figure of Goethe who strides like a colossus over Weimar's past. He presided over its late eighteenth-century golden age, when Wieland, Schiller and Herder flourished at the Weimar court. Although Weimar's was primarily a literary culture, Goethe was passionately interested in the visual arts, fancied himself as a draughtsman and attracted artists to the city, and the museum was founded on his suggestion.

Weimar is a town of small museums. When Goethe urged a friend to pay him a visit, he said, 'where else can you find so many good things in such a small place?' Goethe's injunction remains true today, and to understand Weimar you must visit at least Goethe's house, along with the Belvedere Palace, the Anna Amalia Library and the Bauhaus Museum. At the centre lies the Schlossmuseum,

the former royal palace of the Grand Dukes of Weimar, which when Goethe arrived in 1775 was a smouldering ruin, having burnt down the year before, taking with it much of the early ducal collections. Goethe gradually began to make his presence felt. The palace was slowly rebuilt, initially by his protégé the architect August Arens, then by Nikolaus Thouret, and finally in a pure Neo-classical style by Heinrich Gentz. The art collections today sprawl round two wings of the palace.

The Ernestine branch of the Wettin family of the Dukes of Saxe-Weimar rose to prominence under Frederick the Wise (1463–1525), the patron of Martin Luther, who had his capital in Wittenberg and patronised both Dürer and Lucas Cranach the Elder. Frederick's nephew John-Frederick moved his court to Weimar in 1547. Lucas Cranach the Elder followed him, and there are stylish and colourful portraits by Cranach of him and his bride, Sibylle of Cleves, from 1526, when they were both young.

Albrecht Dürer
Hans Tucher, 1499
oil on wood
27 × 23 cm

Albrecht Dürer
Felicitas Tucher, 1499
oil on wood
30 × 24 cm

Although there are over 30 works in the collection today by Cranach, his son and his workshop, one of the very few probably from the original ducal collection is the *Portrait of Martin Luther as Junker Jörg* (c. 1521–2).

Cranach found himself with a front-row seat on the Protestant Reformation, and there are several religious works supporting Lutheran ideas, such as the *Allegory of Law and Mercy* (c. 1534–40). He and Luther were close personal friends and godparents to each other's children. We see Luther young and earnest in the 1521 portrait, and later by Cranach the Younger around 1546 looking fat and swollen. Lucas Cranach the Younger continued the family enterprise, turning out portraits of reformers or electors and other more appealing subject matter, such as the blatantly erotic *Charity* (c. 1540).

The greatest treasures from the Renaissance period are a pair of portraits by Albrecht Dürer of *Hans Tucher* and *Felicitas Tucher* (1499), which may have been part of the old ducal collection. There is a poem by Goethe which, although written with something else in mind, admirably describes their qualities:

No false flourishes and no false scribbles
No false comfort and no false wit
But the world should stand before your eyes
As Albrecht Dürer saw it.

On the ground floor there is the Renaissance ducal Kunstkammer, which happily survived the 1774 fire, a gallery of strange and beautiful Franconian and Thuringian medieval art, some remarkable Carolingian ivories and, surprisingly, a collection of Russian icons. One

Anton von Maron
Portrait of Johannes Winckelmann
1768
oil on canvas
136 × 99 cm

Caspar David Friedrich
Hutten's Grave, c. 1823–4
oil on canvas
93 × 73 cm

of the grand duchesses, Maria Pavlovna, was the daughter of the Russian Tsar Paul I and with Goethe's encouragement had ordered some icons from Russia, but they were lost. As a consolation Goethe bought two ivory icons for the ducal collection in 1814, while staying at Marienbad. There is a melancholy postscript; in 1945 George Haar, a Weimar collector of icons, left his collection to the museum after he had committed suicide at the approach of the Russians.

Weimar's story really gets going in the eighteenth century with the appearance of Anna Amalia, Duchess of Saxe-Weimar, who became regent in 1754 and imbued her son Carl-Augustus with the love of literature and wise men

that caused Weimar to blossom into its golden age. It was Carl-Augustus who summoned Goethe to Weimar, and on the first floor of the palace are the staterooms he built, interspersed with gallery rooms where we can see some of the art acquired during the Goethe era. There is a collection of *vin ordinaire* Dutch paintings that includes many of those dark still lifes by Willem Kalf so beloved of German princelings. Sophie of Orange had married into the grand-ducal family and brought with her many Dutch paintings, and also a large Rubens of *God the Father with St John and St Paul* (c. 1616). Apart from the Dutch paintings, there is a small group of Old Master paintings by – among others – Tintoretto, Ribera, Pittoni and Tiepolo.

Philipp Otto Runge
The Little Perthes, 1805
oil on canvas
143 × 95 cm

The Goethe Gallery

The classical age in Weimar opens with Anton von Maron's *Portrait of Johannes Winckelmann* (1768), a collector portrait of the man who more than any other was to bring scholarly understanding to Greek art and therefore became the father of Neo-classicism. As Goethe wrote in his Italian diary: 'It was Winckelmann who first urged on us the need of distinguishing between various epochs and tracing the history of styles.' Goethe's own interest in the visual arts stemmed from his desire to be an artist, and he took drawing lessons from Winckelmann's friend Adam Friedrich Oeser. Although Goethe was only ever to be a mediocre artist, he spent a great deal of time seeking out artists and encouraging them. Among the older

classical generation he met in Italy he greatly revered Angelica Kauffmann, who is represented in the collection by *Pompey's Wife Julia Hears the News of her Husband's Reputed Death* (1785). Goethe got to know Jakob Philipp Hackert in Naples in 1786, and was later to edit Hackert's autobiography, and there is his characteristically Claudian *Landscape with Lake Nemi* (c. 1800).

It is, however, Goethe's fascination with the younger painters of German Romanticism that gives the Schlossmuseum particular interest. Although Goethe refused to associate himself with the Romantics, he greatly admired Caspar David Friedrich's talent as a painter, even if he was disappointed by his subject matter. Goethe thought 'that he had gone down the wrong path'. Despite that, Carl-Augustus acquired five paintings by Friedrich in 1810, almost certainly on Goethe's advice. Three of them are still in the collection, including the cool and milky *Bohemian Landscape* (1810). Friedrich used landscape as a vehicle for mutability, mystery and sadness. The most important of his paintings at Weimar, which Goethe bought for the collection in 1826, is the highly political *Hutten's Grave* (c. 1823–4). It is vintage Friedrich: silent, awesome, full of symbolism and imbued with his characteristic pessimism. The other leading figure in German Romanticism is Philipp Otto Runge, that strange artist who foreshadows so much twentieth-century German art and who corresponded with Goethe about colour theory. His finest portraits are invariably of children and the museum has *The Little Perthes* (1805), in which the child has an intensity and oddity that prompted Goethe to say of his art that: 'it is enough to drive one mad, beautiful and at the same time nonsensical … It tries to embrace everything and in doing so it always loses itself in the elementary, but yet with infinite beauties in details.'

Georg-Friedrich Kersting
The Embroideress, 1811
oil on canvas
47 × 37 cm

Georg-Friedrich Kersting
Man at his Desk in a Study, 1811
oil on canvas
47 × 37 cm

Wilhelm von Kobell
Three Hunters on Horseback, 1822
oil on panel
40 × 52 cm

A close friend of Caspar David Friedrich was Georg-Friedrich Kersting, who was recommended to Goethe by Louise Seidler. Goethe asked to see Kersting's work and on his suggestion Grand Duke Carl-Augustus bought *The Embroideress* (1811), for which Louise Seidler had posed. There are three Kerstings in the collection which have a fragile beauty and show those simple, elegant, scholarly interiors that you can still enjoy today in the Goethe House in Weimar. Friedrich's Norwegian friend – if not follower – Johan-Christian Clausen Dahl is represented by *Waterfall* (1832), which Grand Duke Carl-Friedrich won in a lottery.

Another fascinating painter, one who endows traditional sporting subjects with an intensity bordering on the surreal, is Wilhelm von Kobell, the painter of cool clear sunlight and long shadows in *Three Hunters on Horseback* (1822). From the tail end of the Romantic period one other painter deserves mention: Friedrich Preller, a local boy of whom Goethe said, 'I am certain that [he] will one day succeed admirably in the solemn, grand and perhaps also the wild'. Alas he never rose above the theatrical, as we see in *Rocks in the Waves* (1846), but he

participated in a project of Grand Duchess Maria-Pavlovna to create the four poets' rooms in the Ducal palace to glorify the literary achievements of Weimar. Under Goethe's recommendation the palace art collection had been organised by school and opened to the public, and the poets' rooms became part of the tour: the Goethe Galerie, for which Schinkel made the designs, the Schiller Room, where Neo-classicism meets Romanticism, the Wieland Room and the Herder Room.

The main interest in the Schloss collection after the German Romantic era lies in the creation of the Weimar school and the various artists – such as Albert Brendel, Max Liebermann, Theoder Hagen, Paul-Wilhelm Tübbecke and Max Beckmann – who came to teach or study at the Weimar School of Art, founded in 1860 by Grand Duke Carl-Alexander. Franz von Lenbach and Arnold Böcklin were among its first teachers. Perhaps the most important painting in the collection from this interesting group is Max Beckmann's *Young Men at the Sea* (1905). Some years after leaving the Weimar art school Beckmann told his publisher: 'I came to Paris for the first

Max Beckmann
Young Men at the Sea, 1905
oil on canvas
150 × 237 cm

Henri Van de Velde
Landscape at Dusk, 1892
oil on canvas
45 × 61 cm

time in 1903, where I developed a strong aversion to the flood of Impressionist imitations there. These were my feelings which must have made me paint *Young Men at the Sea*.' In 1902 Count Harry Kessler had come to take over the Weimar Arts and Crafts Museum, and it was he who purchased Beckmann's painting in 1906.

Count Kessler was a cosmopolitan collector who introduced Weimar to many new artistic trends and in 1905 bought an 1894 Monet of Rouen Cathedral for the museum. Thanks to Kessler, the Belgian designer Henri van de Velde came to Weimar in 1902 and took over the art school two years later. There is one of his last paintings, *Landscape at Dusk* (1892), which reflects the influence of Seurat and Van Gogh before Van de Velde turned mainly to architecture. It should be mentioned that he created several Art Nouveau masterpieces in Weimar, particularly the Nietzsche Archiv. Kessler and Van de Velde both ran into trouble with conservative elements in Weimar, but the town had one more trick to pull. In 1919 Walter Gropius became Director of the Weimar Staatliches Bauhaus, the new revolutionary art school that brought Paul Klee, Lyonel Feininger, Wassily Kandinsky, László Moholy-Nagy and many others to Weimar, until the school moved to Dessau in 1925. Some, such as Klee, lent works to the museum until they were removed by the Nazis. Today the separate Bauhaus museum in Weimar brings together many artefacts of this movement. Recently the Kunstsammlungen were able to acquire two paintings by Feininger and Klee, but the town still has no works by Kandinsky.

Weimar has played host to so many of the greatest figures in German culture, be it in music, literature or philosophy, but in the end it must be admitted the visual arts have always come second. Even during the golden age of Weimar collecting paintings was never a priority, and perhaps a clue is offered by the correspondence of Goethe, whose constant pursuit was of Old Master prints and drawings. For all that, Weimar remains a very attractive town in which the whole may be greater than the parts, but the Schlossmuseum and its dependencies provide an extraordinarily interesting story of a small court that managed to be a dynamo of German cultural history.

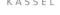

SCHLOSS WILHELMSHÖHE

KASSEL

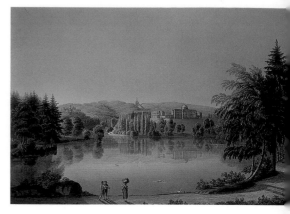

The Schloss Wilhelmshöhe

View of the park on to the cascade and octagon

J. H. Bleuler
View of the Schloss and Lake
1825
gouache
43 × 61 cm

Schloss Wilhelmshöhe is one of the most impressive sights in Germany. It sits half-way up a hill in the middle of an enormous park dotted with numerous monuments and follies. In one direction the Schloss looks straight down a three-mile avenue that runs into the middle of Kassel; in the other it looks up to a giant Baroque octagon on the crest of the hill that serves as a reservoir for the ornamental cascade and is crowned by a monumental copy of the Farnese *Hercules.* Inside the Schloss is to be found a fine collection of antiquities and one of the greatest collections of Dutch and Flemish paintings in Europe.

The art collections were in fact only installed in the Schloss in the aftermath of the Second World War. The Hesse-Kassel family were among the richest of German princes and married into the royal families of Britain and the Netherlands. The end of the Thirty Years' War marked the beginning of a long period of prosperity that saw the formation of the collection and the creation of the gardens at Wilhelmshöhe. It was Landgrave Karl (1654–1730) who first turned his attention to the site after a visit to Italy in 1699–1700. He commissioned Giovanni Francesco Guerniero to create a fabulous Baroque garden with the cascade and the octagon as the climax. There is a series of paintings in the collection by Jan van Nikkelen showing views of the magnificent gardens with an imaginary Schloss. One of Karl's most beneficial decisions was to give asylum to the Huguenots, which enormously stimulated the prosperity of Kassel and also supplied a family of court

architects: the Du Ry family, who were later to build the Schloss and many fine buildings in the town. In addition to gardens Karl's main interest was in antiquities, and he bought coins, gems and cameos on his Grand Tour.

It was his second son, later to become Landgrave Wilhelm VIII (1682–1760), who was to be the greatest collector in the family. As a younger son he became a soldier and went to serve in the army of the Netherlands and fought with distinction in the War of the Spanish Succession. As a reward he was made governor of Breda (1713) and Maastricht (1723), and the resulting income enabled him to indulge his passion for Dutch and Flemish painting. At first it was contemporary painters who attracted him, but he also began to attend auctions. He returned to Kassel in 1727 and with the death of his father three years later was made regent since his elder brother had become king of Sweden, and it was not until his death in 1751 that Wilhelm finally became landgrave. In Kassel he kept in touch with Dutch auctions, but at such a distance he inevitably found himself increasingly reliant on dealers and agents, particularly Govert van Slingerlandt and Gerard Hoet in The Hague.

By 1750 Wilhelm was able to write that he owned 527 paintings (excluding court portraits) but, as he said himself, only two or three hundred were really good. Later in the same year he achieved his greatest *coup* with the help of Hoet and Slingeland: the acquisition of the Valerius Röver collection, which was considered the greatest

The 'Kassel Apollo'
Roman copy, c. AD 100
after Greek original of
c. 450 BC
marble
height 200 cm

Bowl in *terra sigillata*
Roman, c. AD 100–300
ceramic
height 13 cm

Lucas Cranach the Elder
Resurrection Triptych
c. 1508–9
oil on panel
central panel 38 × 26 cm
side panels 38 × 10 cm

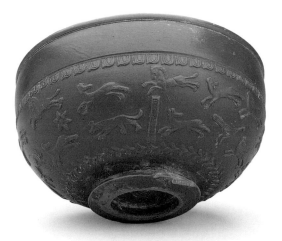

cabinet of paintings in the Netherlands. It contained eight Rembrandts and this purchase made Wilhelm's collection of Rembrandts the largest in the world at the time. The finest of them, *Jacob Blessing the Sons* of Joseph, came two years later from an unknown source. Wilhelm increasingly turned his attention towards Italian art to give some balance to the collection and in 1756 made his last great purchases, Titian's *Commander-in-Chief* and Giampietrino's *Leda* (c. 1530–35), which was believed at the time to be by Leonardo and considered Kassel's greatest treasure. The outbreak of the Seven Years' War prevented any further purchasing. Between 1749 and 1751 Wilhelm had commissioned the Bavarian court architect François de Cuvilliés I to build a gallery in Kassel, where the pictures were housed until 1877. They were then moved to the new Gallery 'An der Schönen Aussicht', where they remained until 1939.

Wilhelm's son Landgrave Friedrich II (1720–1785) also bought paintings but was much more interested in antiquities. He bought the Kassel *Apollo* in Rome and in 1779 established a museum to house his antiquities – the Fridericianum, one of the first purpose-built museums in Europe and today the home of Kassel's contemporary art fair Documenta. The architect was Simon Louis du Ry, whom Friedrich's son Wilhelm IX asked to build a Schloss in his great-grandfather's park on the hill. Du Ry built the two wings, but it was his pupil Christoph Jussow who was responsible for the central block at Wilhelmshöhe, in the English Palladian manner.

There is a prophetic drawing by Jussow that shows the Schloss with its central block as a picturesque

ruin and the two wings left intact. Strangely, this is exactly what happened in the Second World War. The two museums in the town, like most of Kassel, were destroyed by allied bombing in 1943, and a decision was made after the war to create a new museum in the rebuilt central block of Wilhelmshöhe. This was an excellent idea but sadly, after two restorations, this important building is still a travesty of its former self. The dome was never replaced, and dark sheet-glass windows have completely altered the character of the Schloss, giving it an impenetrably gloomy appearance. These decisions were made to increase the amount of light in the galleries. Internally the rooms are adequate, if rather characterless.

The collection opens with antiquities on the ground floor, mostly small-scale works, beginning with Egypt. The most important section contains the art of ancient Greece and the Kassel *Apollo* (a Roman copy of c. AD 100 after a Greek original of 450 BC). Its fame lies in the fact that the original was very probably by Phidias, the most important and versatile sculptor of Athens in the fifth century BC. This is the best version out of 27 copies from Roman times. Imperial Rome is well represented with good portrait busts and the very striking *Victoria* or *Winged Victory* (c. AD 150). One of the fascinating minor treasures is the remarkable undamaged bowl in *terra sigillata* (c. AD 100–300). The patterns, which were moulded, and the thinness followed silverware; this example has two rows of animals with horses, hares, a peacock, and deer being chased by a hound.

The painting collection begins on the first floor, with fifteenth- to seventeenth-century European painting (except Dutch and Flemish). There is Dürer's *Portrait of Elsbeth Tucher* (1499), one of four portraits he painted of this family, two others being at Weimar and the fourth lost.

Titian
*Portrait of a
Commander-in-Chief*
1550–55
oil on canvas
229 × 155 cm

Nicolas Poussin
Bacchic Scene, c. 1627
oil on canvas
96 × 74 cm

Johann Heinrich Schönfeld
The Great Flood
c. 1636–7
oil on canvas
137 × 209 cm

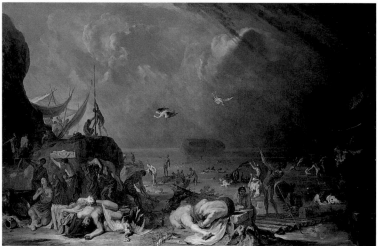

The earliest known commission by the Kassel court was Cranach the Elder's triptych of *The Resurrection* (c. 1508–9), which is small and jewel-like and shows *St Barbara* and *St Catherine* in the wings. Wilhelm never got far in his purchasing of Italian paintings, but nevertheless there are several interesting works: two Giorgionesque panels by Romanino of *St Peter* and *St Paul* (both c. 1513–15), and above all the great Titian *Portrait of a Commander-in-Chief* (1550–55), one of the greatest and most impressive full-length portraits of the Renaissance. The sitter remains unknown but is probably a member of the art-loving family of soldiers the Gonzaga of Mantua. The Italian painting that made the most impression on

Goethe, who visited Kassel several times, was Antonio Bellucci's *Antiochus and Stratonice* (c. 1700) and he even described it in one of his novels, *Wilhelm Meisters Lehrjahre* (1795–6). Sitting rather isolated is Poussin's *Bacchic Scene* (c. 1627), a humorous painting showing a nymph being piggy-backed by a satyr. One of the finest later German paintings is Schönfeld's *The Great Flood* (c. 1636–7), a subject perfectly suited to this artist's brand of Baroque painting.

The second floor is given over to Dutch and Flemish cabinet paintings. One of the earliest is the rather unusual *Portrait of Pieter Jan Foppeszoon and his Family* (c. 1530), by Maerten van Heemskerck, which was acquired as a

Peter Paul Rubens
*Mary with Jesus and
St John Worshipped
by Penitent Sinners*
c. 1619
oil on canvas
258 × 204 cm

Adriaen van de Velde
Beach at Scheveningen
1658
oil on canvas
53 × 74 cm

Jan Cossiers
Adoration of the Shepherds
(detail), c. 1630
oil on canvas
165 × 191 cm

Holbein. On this floor there are perfect examples of Steen, Metsu, Ostade and Ter Borch. One of the Dutch artists most popular with German princely collectors in the eighteenth century was Wouwermans, and there are 20 examples of his work. There were once 29 of his paintings in the collection, and the Dresden gallery still has 60. The most beautiful seventeenth-century landscape is Adriaen van de Velde's *Beach at Scheveningen* (1658), which has a *plein-air* freshness that immediately brings Boudin to mind.

It is on the third floor that the main masterpieces are to be found, and here are Flemish paintings by Jan Bruegel the Elder, Frans Francken the Younger, Vrancx and, above all, Jordaens and Rubens. There is an entire room of

Jordaens at his most boisterous; Kassel has the greatest collection of his works outside Belgium, of which the *Twelfth Night* – on which he spent the best part of 20 years (c. 1635–55) – is a good example. The Kassel collection of Rubens, along with that of Rembrandt, is the glory of the museum. There is the classical *Venus, Amor, Bacchus and Ceres*, the monumental Baroque *Triumph of the Victor* (c. 1614) and the sweet Counter-Reformation *Mary with Jesus and St John Worshipped by Penitent Sinners* (c. 1619). There are several other Rubenses and a superb collection of works by his followers: a room of good Van Dycks and two masterpieces by lesser-known artists: Abraham Janssen's *The Sleeping Diana and Nymphs Spied on by*

Frans Hals
Man in a Slouch Hat, c. 1660
oil on canvas
79 × 66 cm

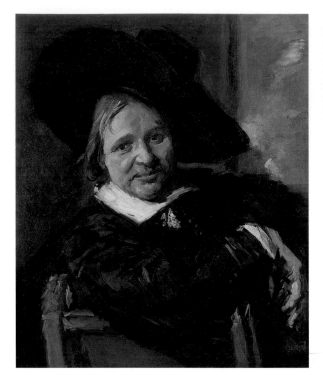

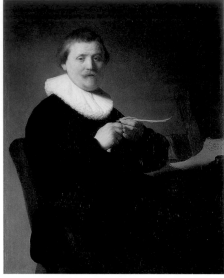

Rembrandt van Rijn
Portrait of a Man Sharpening a Quill
1632
oil on canvas
101.5 × 81.5 cm

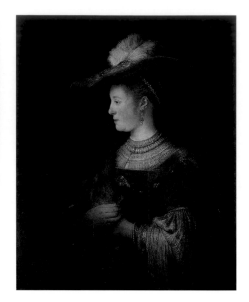

Rembrandt van Rijn
Saskia in Profile, c. 1634–42
oil on canvas
99 × 79 cm

Satyrs (c. 1620) and Jan Cossiers's *Adoration of the Shepherds* (c. 1630). Teniers is represented by one of his most important and largest works, *The Peasant Dance by a Tavern* (1660–70). Moving from Flemish to Dutch painting, there are five works by Frans Hals, of which the most important is the *Man in a Slouch Hat* (c. 1660), which so impressed Lovis Corinth that he copied it.

There are 12 Rembrandts in the collection and we see him in all his variety. There is the early *Old Man with a Gold Chain* (1632) and the poised *Portrait of a Man Sharpening a Quill* (1632). Then we see the extraordinary *Self-portrait with Helmet* (1634), in which he combines his interest in his own physiognomy with that in history painting. One of the most celebrated Rembrandts is the *Saskia in Profile* (c. 1634–42), which the artist worked on until his wife's death in 1642. He painted her in rich Renaissance costume and follows a Renaissance profile manner to create one of his most memorable and personal portraits. One of the most unusual works is the *Holy Family with a Cat* (1646), seen through an illusionistic curtain, which has been described as 'a poem of domestic happiness'. From the same year is the rare *Winter Landscape* (1646), but the most remarkable painting of all is *Jacob Blessing the Sons of Joseph* (1656). This is one of Rembrandt's largest biblical paintings, executed it in the

same year that he was forced to sell his house and treasures. It is a profoundly moving scene, as the dying Jacob gives his benediction to the sons of Joseph. He blesses the younger boy first and in the story Joseph moves Jacob's hand to correct the mistake, but the almost blind patriarch says, 'I know, I know ... but this younger brother shall be greater ... and his seed shall grow into nations'. It is Rembrandt at his most spiritual and undoubtedly one of his finest works.

The south or Weissenstein wing of the Schloss reminds us of the brief Napoleonic occupation of Kassel. Napoleon's army swept through the town and took 48 important paintings back with them to Paris, including works by Claude, Andrea del Sarto and Rembrandt. They were mostly given to the Empress Josephine, whose heirs sold them to the Hermitage, where they remain to this day. Napoleon's brother Jerome was installed as king of Westphalia and between 1807 and 1813 lived at Schloss Wilhelmshöhe. It was he who decorated the Weissenstein wing with several pleasant Empire-style rooms and filled it with French furniture. He also ordered Klenze to build the theatre, which is now the ballroom in the park. The most striking building at Wilhelmshöhe, however, must be the Löwenburg, which can be glimpsed on one side of the hill from the Schloss windows. It was built between 1793

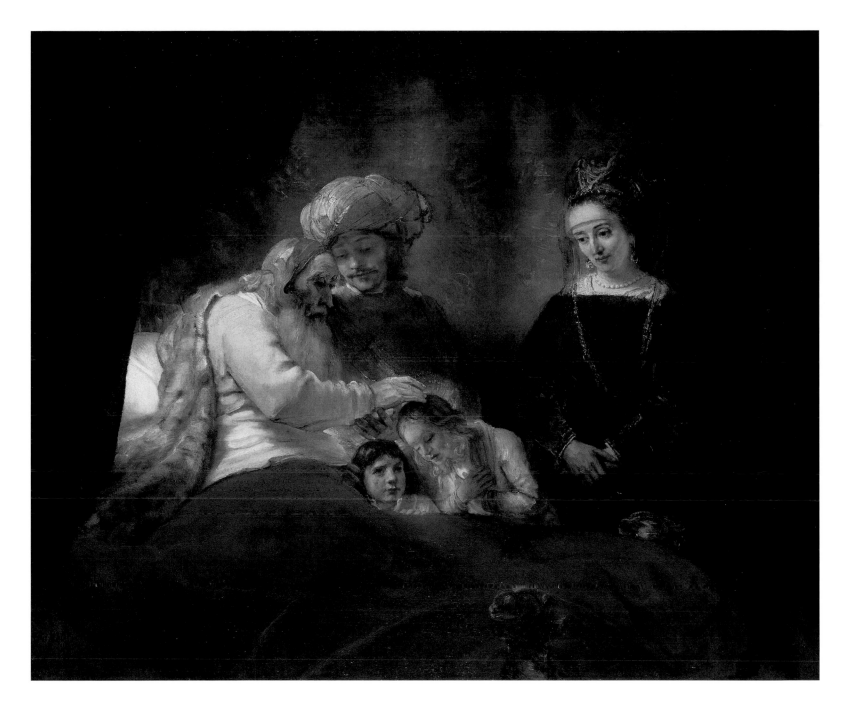

and 1802 by Wilhelm IX as an enormous picturesque English castle ruin in which the king lived with his mistress. The garden was gradually transformed during the same period from the Baroque showpiece into the largest *jardin anglais* in Germany. Taken as a whole, Schloss Wilhelmshöhe, its park and collections, present one of the most dazzling survivals of German princely magnificence.

Rembrandt van Rijn
Jacob Blessing the Sons of Joseph
1656
oil on canvas
173 × 209 cm

GLYPTOTHEK

MUNICH

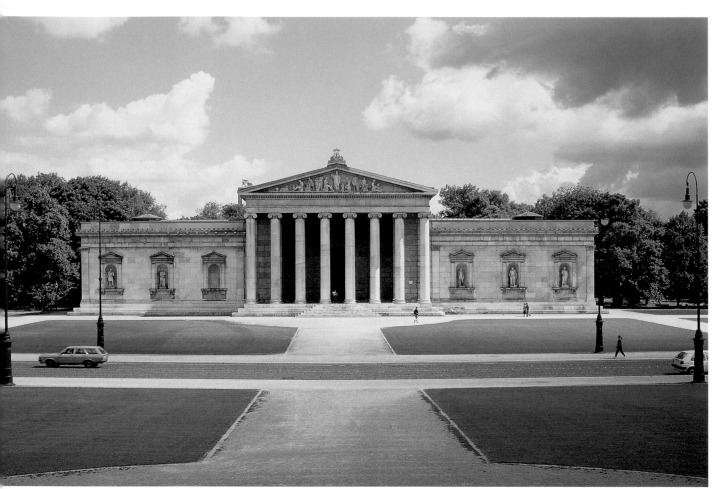

The Glyptothek is one of the noblest of all museum buildings. It was the gift to his people of Ludwig I of Bavaria (1786–1868; reigned 1825–48), and is usually regarded as the first public sculpture gallery ever built. It represents the high-water mark of that extraordinary passion for ancient Greece that took hold of the German intelligentsia in the late eighteenth and early nineteenth century. For King Ludwig an interest in the Antique was born not out of reading or even from an acquaintance with Greek art but, interestingly, from seeing Canova's *Hebe* in Venice at the age of 18. 'Everything changed for me', he wrote, and as a result he became the most formidable collector of antiquities in Europe.

Our modern admiration for Greek art has its origins in the writings of Winckelmann and his studies of Greek art, based mainly on the papal collections in Rome (he had never been to Greece itself). Winckelmann's belief that 'liberty alone was the reason for the power and majesty that Athens achieved', and his tendency to equate the development of Greek art with the development of liberty culminating in the age of Pericles, struck a chord with Ludwig. He became an avid reader of Winckelmann's works and saw Greek art and architecture as possessing a moral authority that he wished to put into the service of the emerging sense of German nationalism. He was fortunate in finding an architect, Leo von Klenze, to realise these ideas with extraordinary clarity and purity.

While still on his Grand Tour in 1804–5, as crown prince, Ludwig expressed the wish to found a museum of antiquities. In 1814, through the Munich Academy, he

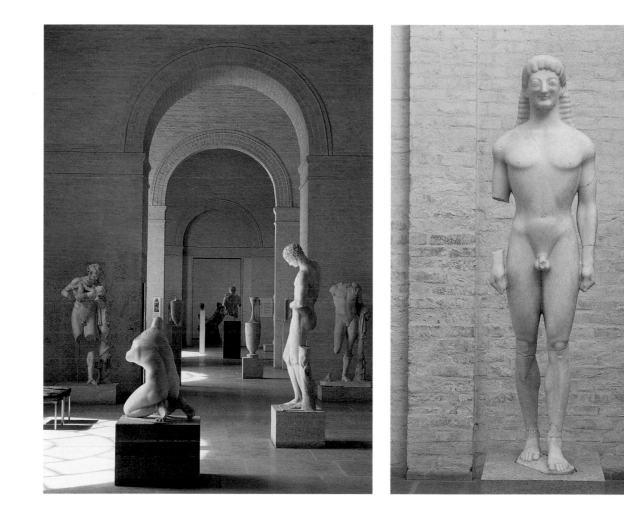

announced an architectural competition for several buildings, including a 'Glyptothek' (the word was coined for the purpose from the Greek) or sculpture gallery. Klenze won the competition and it was the beginning of one of the most impressive and complete transformations of any European city. Ludwig's aim was simple: 'I want to turn Munich into a town which will be such a credit to Germany, that nobody who has not seen Munich can claim to know Germany.'

The Glyptothek was the first of Klenze's Munich buildings and incorporates Greek, Roman and Renaissance elements, and the effect is one of Ionic simplicity and elegance. Behind the portico is a square building around a courtyard. The interiors were rich and colourful, painted with scholarly decorative detail and scenes from Greek

history by the Nazarene painter Peter Cornelius. The north range was reserved for royal dining facilities, because although Ludwig had given the Glyptothek to his people, it was in some ways an extension of the palace, with servants in Wittelsbach livery. The collection Ludwig formed was by any standard extraordinary and has been augmented with distinguished gifts and bequests. It remains a perfect place to come and discover Greek art.

'Of the Greek city-states', says Ernst Gombrich, 'Athens became by far the most important in the history of art. It was here, above all, that the greatest and most astonishing revolution in the whole history of art bore fruit.' This revolution happened fitfully and was connected with the desire to portray the human form in a manner more noble and interesting than the schematic Egyptian statues that

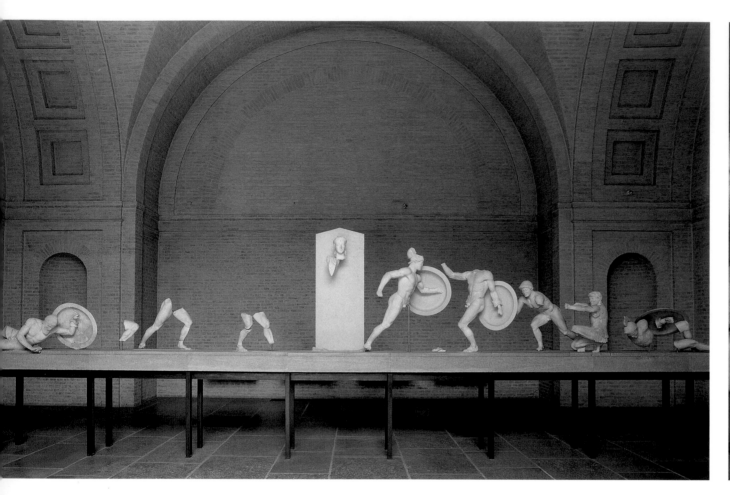

went before. Among the earliest free-standing statues from the first or Archaic phase of Greek sculpture (c. 700–c. 480 bc) are the *Kouroi*, of which there are two superb examples in the Glyptothek. These used to be referred to as 'Apollos', which, although wrong, is not entirely misleading; they are memorials to brave young people or athletes, frequently set up by rich parents, and would have often stood in cemeteries. They are idealised and intended to be 'godlike'. Sometimes they are identified on the base with inscriptions such as the one on the *Kouros* in the Athens museum which reads, 'Stop and lament at the tomb of Kroisos, who died one day fighting in the front rank, slain by violent Ares'. As Gombrich reminds us, the Egyptians approached the human form through knowledge, whereas the Greeks used their eyes. Their quest was not so much for realism as for idealism and the perfect body. The *Kouros* from Tenea (c. 560–550 bc) is characteristic: half smile, left foot forward for stability – a little formal, but with an awareness of the contours of the body. As John

Reconstruction of the east pediment of the Temple of Aphaia at Aegina

Herakles Firing a Bow from the east pediment of the Temple of Aphaia at Aegina

Dying Warrior from the east pediment of the Temple of Aphaia at Aegina

Boardman has explained, 'life was beginning to be as important a factor as geometry.' The centrepiece of the Glyptothek, and one of the main reasons for its being built at all, was Ludwig I's purchase (against strong competition from Britain and France) of the pedimental sculptures from the temple of Aphaia at Aegina, discovered in 1811 by an international team of archaeologists and scholars. After the Parthenon marbles in London, they are the most important surviving group of free-standing Greek narrative sculptures. The pediments depict mythical battles in the two legendary sackings of Troy, by Herakles and that of Agamemnon, as told by Homer. The low triangular shape suggests certain natural poses, from the standing divinity in the centre, with the kneeling figures on either side such as the magnificent *Herakles Firing a Bow*, and in the corners collapsing figures such as the *Dying Warrior*, struggling to support himself with his shield.

These are among the most ambitious attempts in Greek art to depict heroic combat. Death is conveyed with pathos

and dignity for both victor *and* vanquished, which was a novelty. They illustrate well the Homeric idea of the importance of 'a good death'. The pediments date from c. 490–480 bc. The west pediment, in which the figures show a centrifugal movement, embodies the transition from the Archaic to the Classical style, whereas the more fragmentary east pediment, very slightly later, with its heightened drama and pathos and centripetal movement, is early Classical in spirit. The great Danish sculptor Bertel Thorvaldsen was brought in by Ludwig to restore them.

In the Diomedes Room we can observe the development of free-standing statues during the Classical period (c. 480–323 bc). The figures – still naked, a characteristic of Greek civilisation – begin to move and twist, and we perceive a sense of mood. The statue of *Diomedes* (c. 430 bc) is probably a copy after Cresilas, a Cretan sculptor who worked in the circle around Phidias. Although we know the names of some sculptors, artists were, with a few exceptions, a surprisingly low form of life

Diomedes
c. 430 BC
marble
height 102 cm

Statue of a Boy
c. 410 BC
marble
height 83 cm

Medusa, c. 440 BC
marble
height 40 cm

Grave Relief of Mnesarete
c. 380 BC
marble
height 166 cm

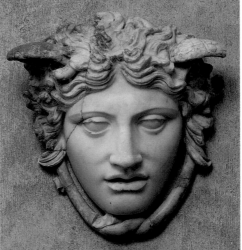

in ancient Greece. Diomedes was a very different matter: he was a successful warrior and king, and his statue, although certainly not a portrait in the modern sense, exudes authority and importance. It was probably part of a group, and Diomedes may easily be turning to defend himself. This new freedom was partly the result of an important change in technique: building figures up from inside out to be cast in bronze. Ever since Michelangelo's misleading statement about the figure nestling within the block of marble, we have tended to see antique statuary the wrong way round, that is to say, conceived from the outside in. This is mainly because the majority of Greek

Classical statues were cast in bronze and have perished, and all we see are the Roman marble copies. In the same room is the *Statue of a Boy* (*c.* 410 BC), in which the weight is shifted (signalling the end of the simple Archaic conventions of portraying the body) and he is leaning against a pillar, a pose that has suggested to some writers that he is an athlete resting after victory in the Games.

In a different vein is the *Medusa* (*c.* 440 BC), which sent Goethe into such rhapsodies. To us it might look decorative, but to the Greeks the *Medusa* could turn you to stone. When in Rome, Goethe went several times to see it in the Palazzo Rondanini and thought it was a 'marvellous

mysterious and fascinating work, which represents a state between death and life, pain and pleasure'. He owned a cast of it, 'but nothing is left of the magic of the original. The yellowish stone, which is almost the colour of flesh, has a noble, translucent quality.' In fact of course, this *Medusa* is not, as Goethe suggested, the original but a copy, albeit a very good one, from Roman Imperial times of the Gorgon-head on the shield of the great 36 foot statue of Athene that stood inside the Parthenon.

One of the most touching treasures of the Glyptothek is the *Grave Relief of Mnesarete* (c. 380 bc). These *stelae* or grave slabs depicting the dead (in idealised form), sometimes with a maid or companion, are among the most affecting monuments to have survived from antiquity, and they have a quiet dignity and serenity. The deceased has her head bowed, and an epitaph on the architrave tells us, 'This woman left behind husband and brothers and child, sorrow for her mother and the undying glory of her great virtue.' Another very striking depiction of a woman is the large High Classical sculpture of *Eirene and Ploutos* (c. 375–370 bc). She is the goddess of peace and is holding Ploutos, the god of prosperity or plenty, with a maternal affection (although she is not his mother), an early example of an iconography that was to be of enormous importance in Western art. This is the best-known copy of an original that stood as a cult statue in the market-place in Athens.

The last phase of the Greek sculpture was the Hellenistic period, from the death of Alexander the Great (323 bc) until almost the birth of Christ, by which time the Roman empire was ascendant. The museum has two of the best surviving portraits of Alexander the Great. The first, the so-called *Alexander Rondanini*, is a full-length monumental naked sculpture, while the second is a head,

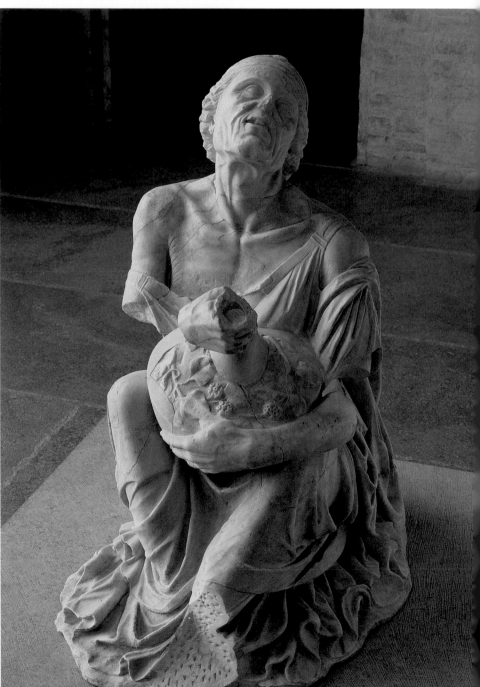

no doubt an idealised type that Alexander approved.
According to tradition, Lysippos was Alexander's favoured
sculptor and only he, said Plutarch, could capture the
'leonine mane, melting gaze and tilting neck'. Alexander
the Great was a small man, and it was his gaze and beauty
that impressed contemporaries. If the statues of
Alexander represent a leap forward towards portraiture
in the modern sense, it was the singular achievement of
the Romans over the Greeks in sculpture to bring this art

Head of Alexander the Great
C. 330 BC
marble
height 36 cm

*Bust of the Emperor
Septimius Severus* (detail)
C. AD 200–210
marble
height 82 cm

Drunken Old Woman
200–180 BC
marble, height 95 cm

Munich Votive Relief
C. 200 BC
marble
height 62 cm

One of the oddest works in the museum is the *Drunken Old Woman*, a Roman copy of a Hellenistic original (200–180 BC). She is ugly, rather *décolletée*, and nurses her wine jar with a leering smile. Although the statue is a good example of Hellenistic interest in the grotesque and exotic, similar to a seventeenth-century Dutch low-life genre painting, it is probably a votive statue for the temple of Dionysos and the cult occasion of the *Lagynophoria,* when citizens could get drunk respectably. What is certain is the pleasure the artist has taken in the caricature, and it can be seen as the beginning of art for art's sake.

A delightful provincial piece is the *Munich Votive Relief* (c. 200 BC), which shows a sacrifice in a rural shrine. The scene takes place under a sacred plane tree, from which an awning is tied, and the lively, rather clumsy attempts at perspective remind us of the provincial elegance of early eighteenth-century English conversation-piece painters.

By far the most famous sculpture in the Glyptothek during the nineteenth century was the *Barberini Faun* (c. 220 BC). At one time this even had its own entry in dictionaries of art. It is a rare Greek original from the Hellenistic period at its most baroque. It represents a drunken satyr and was probably a votive offering at a sanctuary of Dionysos. It was first recorded in the collection of Cardinal Francesco Barberini in 1628 and according to a plausible tradition was restored by Bernini, whose work it superficially resembles. The sale of the statue to Ludwig in 1814 – a story full of Roman intrigue – was controversial, and only after an appeal from the king's sister the Empress of Austria could he secure the necessary export licence. Admiration of the *Faun* has waxed and waned. It was most admired in the eighteenth century, when the Marquis de Sade called it 'cette sublime statue grecque' and scholars considered it on the same level as

to maturity. Roman portraits remained largely symbolic rather than artistic, and although they were more realistic than their Greek predecessors, the busts were primarily commemorative.

The largest gallery of the Glyptothek is given over to the important collection of Roman portrait heads. If we could walk back into the ancient world, it would be the sheer amount of statuary (and its colourfulness) that would take us by surprise, and something of this profusion is achieved in this gallery. Typical among the impressive Roman portraits is the *Bust of the Emperor Septimius Severus* (c. AD 200–210). There are several interesting pieces of Roman public sculpture. The statue of *Artemis* (first century AD) is a curiously eclectic work, with borrowings from Greek models. Being Artemis, she is clothed, but in any case the Romans did not share the Greek passion for nudity.

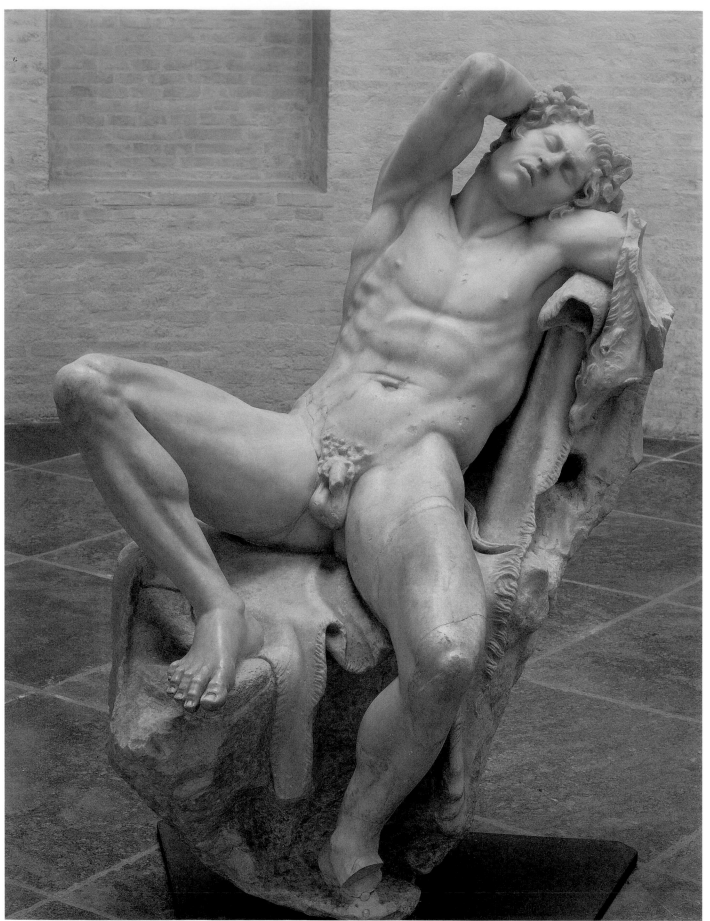

the Apollo Belvedere. In the nineteenth century some found the pose indecent, but Ludwig had a special room created for it. The museum's most recent literature describes the sculptor as 'a veritable Greek Michelangelo', and indeed it is so startlingly modern that it is difficult not to read it as a work of the sixteenth or seventeenth century.

Ludwig opened the Glyptothek in 1830 and it was an immediate success. The past and present merged two years later, when Ludwig's second son, Prince Otto, was given the throne of Greece by the Congress of London. As for Ludwig, the austere monarch who made his children live on black bread had a weakness for beautiful women. He succumbed to the charms of the Irish adventuress Lola Montez and in the ensuing debacle was forced to abdicate in favour of his eldest son. Despite this, he continued to support Klenze's public building projects out of his private purse. Klenze created the Königsplatz around the Glyptothek, and almost the last thing that he built for Ludwig was the monumental gateway or Propylaën (to commemorate the Greek war of independence) that completed the architectural ensemble. It was the final touch to his extraordinary transformation of Munich from a small Baroque court into an Athens of the North.

Unfortunately the Königsplatz was so successful in its transmission of 'Aryan' values that the Nazis paved it with granite slabs and used it as a backdrop for their rallies. The Second World War saw half the museum destroyed, and the inevitable question arose as to how it should be restored. After much debate the curators reconstructed the architecture but not the rich painted interiors, so today its galleries present a cool lime-washed background. Given that all Antique sculpture was once highly coloured but has been reduced to the same monochromatic cream-greys, it is not uncurious that a similar fate should have overcome the Glyptothek. Today the majority of visitors to the museum arrive in art classes armed with pad and pencil to make drawings of the sculpture. Most tourists hurry past on the way to the Alte Pinakothek, which is a shame because the Glyptothek provides one of the best introductions to Greek art anywhere in the world.

LENBACHHAUS

MUNICH

Munich is an Italianate town full of great Florentine palazzos standing shoulder to shoulder like soldiers on parade, but there is one corner where the architects relaxed and gave us a true rendering of a Tuscan villa complete with shutters, fountain and box hedge: the Lenbachhaus. It was the home created between 1887 and 1891 by the so-called 'Prince of Painters' Franz von Lenbach. His widow sold the villa to the city of Munich in 1924 and it was opened in 1929 as the city art gallery to display the work of local artists from the nineteenth century onwards. Surprisingly, neither this transfer nor the destruction in the Second World War altered the charm of the place, and in 1957 came the benefaction of Gabriele Münter, which would for ever define the museum as the greatest collection of works by the Blue Rider movement, and in particular by Wassily Kandinsky.

Franz von Lenbach (1836–1904) is chiefly known today for the house he built. As a painter he is remembered for one masterpiece of German naturalism, *Shepherd Boy* (1860; Schackgalerie, Munich), and the many portraits he made of Otto von Bismarck. He first painted the German chancellor in 1879, the beginning of a long lucrative career as a society portrait painter. In 1882 Lenbach was raised to the nobility and saw himself in the image of those princes of his profession Titian and Rubens, whose works he so avidly copied. Some years earlier, he had written to a friend, 'I intend to build a palace that will overshadow everything that has gone before.' It was Lenbach himself who suggested to his architect, Gabriel von Seidl, the form of a Tuscan villa, and it paid homage to the time he spent in Italy and his love affair with Italian art. Lenbach's studio formed the left wing of the courtyard and the central block was internally decorated in a heavy sixteenth-century Florentine *palazzo* manner.

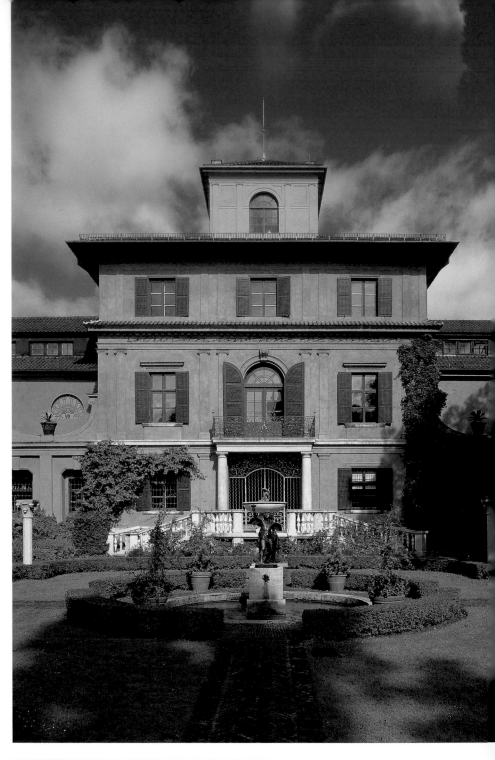

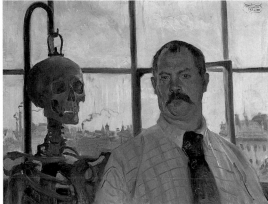

The Lenbachhaus

Lovis Corinth
Self-portrait with Skeleton,
1896
oil on canvas
68 × 88 cm

Franz von Stuck
Salome, 1906
oil on canvas
121 × 123 cm

The right wing was added on very sympathetically between 1924 and 1929 to house the Städtische Galerie of Munich painters, and it is here that the tour of the museum begins.

There are several galleries of nineteenth-century painters who worked in Munich, notably Wilhelm von Kobell, Carl Rottmann, Wilhelm Leibl and, of course, Lenbach himself. Although the 1860s through to the 1880s were seen as the heyday of the Munich school, many of the most interesting paintings in the Lenbachhaus date from the 1890s onwards, just as Berlin and other towns were threatening the city's position as the leading arts centre in

Germany. In 1880 Lovis Corinth arrived in Munich, where he was to live on and off until his move to Berlin in 1900. He revitalised portraiture in works such as *Self-portrait with Skeleton* (1896), with its parody of a *memento mori* and utterly modern form. Corinth was famous for his lively wit and the group portrait *Die Logenbrüder* (1898–9) is a straight take-off of the iconography of the Last Supper, although he was careful to include only twelve figures. We see the architect and furniture designer Richard Riemerschmid turn from being a painter of pleasant meadows into the creator of the Art Nouveau fantasy *Cloud Ghosts 1* (1897). The artist who best exemplifies this movement in Munich is Franz von Stuck, another all-round artist and painter of the rather theatrically decadent *Salome* (1906). His house in Munich remains a place of pilgrimage for lovers of *Jugendstil*, but he is also interesting to visitors of the Lenbachhaus as the teacher of Kandinsky.

The main international reputation of the Lenbachhaus is based on its extraordinary collection of the Blue Rider movement, centred on Kandinsky, Franz Marc and Paul Klee. Kandinsky gave a laconic description of the origin of the name during a conversation with Franz Marc: 'We both liked blue, Marc liked horses and I liked riders.' Despite its casual origins the movement was, with Die Brücke, the most important to emerge in twentieth-century Germany. It began with an exhibition at the end of 1911, after Kandinsky's work had been rejected by the jury of the Neue Künstlervereinigung München, and was followed by the appearance of the art almanac *Der Blaue Reiter,* which has achieved classic status as one of the most important artistic manifestos of the twentieth century. Its aims were put succinctly by Kandinsky: 'None of us seeks to reproduce nature directly ... we are seeking to give artistic form to inner nature, i.e. spiritual experience.'

Wassily Kandinsky
Railway near Murnau, 1909
oil on canvas
36 × 49 cm

Wassily Kandinsky
Red Patch II, 1921
oil on canvas
131 × 181 cm

Wassily Kandinsky
Study for Composition VII (Version 2)
1913
oil on canvas
100 × 140cm

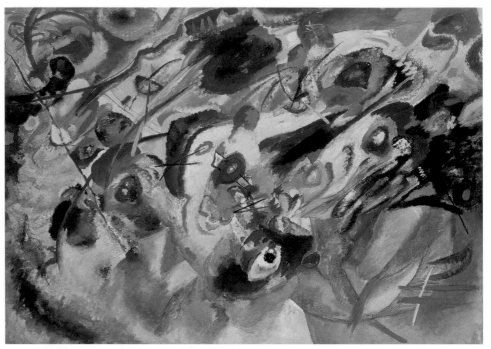

Wassily Kandinsky
*Improvisation 26
(Rowing)*, 1912
oil on canvas
97 × 108 cm

Kandinsky was a Russian-born law student who began to paint at the age of 30. He arrived in Munich in 1896, attracted by the city's village-like atmosphere, and in 1901, along with others, founded the Phalanx art school. One of the pupils was Gabriele Münter, who became his mistress (Kandinsky was married at the time) and eventually the main benefactor to the Lenbachhaus. The earliest of Kandinsky's paintings are small naturalistic landscapes on board from around 1901–2. After a brief flirtation with fantastic figurative paintings such as the *Couple on Horseback* (1907) we can observe the turning-point around 1908, when Kandinsky went to paint at Murnau in the Alpine foothills with Münter and his fellow Russian Alexei Jawlensky. The following year Münter bought a house there, which became known locally as 'The Russians' House' and was to be the backdrop for the Blue Rider circle. Here Kandinsky discovered the local folk art, and something of its naïve toy-like character can be seen in *Railway near Murnau* (1909). There are also several

Gabriele Münter
Portrait of Marianne von Werefkin
1909
oil on board
32 × 22 cm

Alexei Jawlensky
Portrait of the Dancer Alexander Sakharov, 1909
oil on board
69 × 66 cm

this formed the eventual bequest to the Lenbachhaus. There is one major post-1914 work in the museum, *Red Patch II* (1921; on permanent loan), which is precise, rational and clear, revealing the influence of Russian Constructivist artists such as Malevich and Popova, whom he tended to criticise as mere 'mechanics'.

In addition to Kandinsky, all the Blue Rider group artists are superbly represented. There is Münter's *Portrait of Marianne von Werefkin* (1909), the painter and fourth member of what Kandinsky called 'our Murnau colony'. It is one of the best portraits of the group and has affinities to the Fauves. The most striking portrait, however, to come out of the Blue Rider is Jawlensky's androgynous *Portrait of the Dancer Alexander Sakharov* (1909). It came about one evening when the dancer visited the painter in his studio in costume and make-up before a performance. Jawlensky hurriedly painted his friend, and Sakharov removed it still wet, before the artist could change it or paint over it. The human head was to remain at the centre of Jawlensky's art – which he saw as an aspect of the divine – and there is also his modish study entitled *Meditation* (1918).

The best-known paintings in the museum after the Kandinskys are those of Franz Marc. They were joint editors of the *Blaue Reiter* almanac. Marc's main interest was in animals, which he painted as almost quasi-religious symbols of natural purity. *The Blue Horse I* (1911) and *The Tiger* (1912) are Marc's two most celebrated works today,

Murnau paintings by Jawlensky and Münter, and we can see how close their works of this period are.

For Kandinsky the move towards abstraction began around this time, first with his *Improvisations,* which he called 'spontaneous expressions of inner character', then with *Impressions*, which he described as 'direct *impressions* of nature'. That he meant *impressions* in the broadest sense is evident from *Impression III: Concert* (1911), painted shortly after hearing a concert of Schönberg's music. The black grand piano is still recognisable, and the following year we can just follow the forms in *Improvisation 26 (Rowing)* (1912). It was with his *Compositions* that Kandinsky explored abstraction most profoundly, and there is the important *Study for Composition VII: (Version 2)* (1913).

With the outbreak of the First World War Kandinsky, as a Russian citizen, was forced to leave Germany. He left a large body of his work behind with Münter, and a part of

Franz Marc
Blue Horse I, 1911
oil on canvas
112 × 84 cm

Paul Klee
Fruit on Red, 1930
watercolour on silk
61 × 46 cm

and both came to the Lenbachhaus in 1965 as part of a bequest by Bernhard Koehler that completed its unrivalled collection of Blue Rider masterpieces.

Paul Klee took part in the second Blue Rider exhibition in 1912. He and Kandinsky were neighbours in Munich and then again in Weimar, and retained a strong respect for each other. There is an exceptionally fine group of Klee's work – small, delicate and carefully constructed, like visual sonnets. There is *Fruit on Red* (1930; on permanent loan), which the artist painted on the red silk cloth he used for protecting his violin. Over on the right Klee even places a treble clef symbol, but the main subject of the painting is natural growth.

Beyond the Blue Rider are the works of *Neue Sachlichkeit* (New Objectivity), by artists such as Georg Schrimpf, Rudolph Schlichter and Christian Schad. And then appears a darkened glass door, which leads us – like Alice through the looking glass – into the inner sanctuary of Lenbach's rooms, or at least the few that were restored after the Second World War. They are an oasis of richness:

Florentine furniture, crimson silk walls, marble door cases and Lenbach's copies of the Old Masters as well as his own portraits. There is the *Portrait of Bismarck* (1895) in old age, as well as *Lenbach with his Wife and Daughters* (1903); distinguished as they are, they represent almost everything that the Blue Rider movement sought to change in art.

Why Gabriele Münter chose the Lenbachhaus for her donation is not entirely clear, but it was probably the persuasive powers of the then Director, Hans Conrad

The Galleria Borghese

The Main Hall

The Egyptian Hall

Gian Lorenzo Bernini
Aeneas and Anchises, 1618–20
marble
height 220 cm

collection of antiquities is no longer there, but what remains gives us a peerless window into that extraordinarily creative period in Rome. The Cardinal's painting collection, which was housed in his palace in the city, was brought to the villa in 1891. It constitutes the greatest assemblage of masterpieces in any small museum in Europe.

The ground floor of the villa is not large, containing only nine rooms, eight of which are today devoted to sculpture. The collection of antiquities that Borghese formed, which included the *Borghese Gladiator* and the *Hermaphrodite*, was the most famous in Rome but Prince Camillo Borghese (1775–1832), who married Napoleon's sister Pauline, sold the collection to the Louvre in 1807, at Napoleon's insistence. The present collection of Antique sculpture was brought in to fill the gaps, and serves to enhance the astonishingly rich decorative scheme. It also acts as a backdrop to the works of Bernini, of which the museum has the finest collection anywhere. Bernini's sculpture is dealt out like a pack of cards across the ground floor and takes centre stage in each of the highly decorated rooms.

The interiors as we see them today, although mostly the work of Antonio Asprucci, are in fact a conglomeration of the seventeenth and eighteenth centuries; and both centuries, it must be said, threw everything they had at them, creating an effect of unusual luxury. Whatever

space was left by the seventeenth century, the eighteenth cheerfully filled with a combination of *grotteschi*, painted ceilings, antique reliefs, marble, mosaics and rich furniture. This meeting of the Baroque with the Neo-classical reproduces, on a large scale, the richness of a bejewelled gold box. One interior that deserves special mention is Asprucci's Egyptian Room, a beautiful essay in this genre of Neo-classical taste, which was widely admired.

At the beginning of his career Bernini (1598–1650) was virtually on exclusive contract to Scipione Borghese. It was obvious from the start that he was prodigiously talented. Trained by his father, he was probably aged sixteen (some critics think he was as young as nine) when he completed his first work for the Cardinal, *The Goat Amalthea with the Infant Jupiter and Faun* (c. 1615), heavily influenced by Hellenistic models. His first mature work was *Aeneas and Anchises* (c. 1618–20), which shows great technical mastery but lacks the fluidity of later works. A year later, with the *Pluto and Proserpine*, the movement is there, but it follows the style of Giambologna, and it is only with the *Apollo and Daphne*

Gian Lorenzo Bernini
Apollo and Daphne, c. 1622–5
marble
height 243 cm

Gian Lorenzo Bernini
David, c. 1623–4
marble
height 170 cm

Antonio Canova
Pauline Borghese, 1805–8
marble
length 200 cm

Gian Lorenzo Bernini
Scipione Borghese, 1632
marble
height 78 cm

(c. 1622–5) that Bernini achieved the combination of warmth, grace and movement that is the hallmark of his genius. He chose the moment of greatest tension, as Apollo catches the chaste nymph and she begins to turn into a laurel tree. From about the same time is Bernini's *David*, the last statue he made for the Cardinal, which reveals the new naturalism that Borghese was already patronising in painting. Graceful and fluid, *David* illustrates well Bernini's desire to give marble the malleable quality of wax.

By 1623 Scipione's uncle Paul V was dead and Bernini was summoned by the new Barberini pope to work on St Peter's. The story does not end here, however, because in 1632 Bernini carved the famous and spirited bust of *Scipione Borghese*, which, like that of Innocent X, developed a crack. He was forced to make another – in a

matter of days, it was said – and both busts remain in the collection. As portraits they tell us everything; Scipione appears greedy, jovial, forceful and shrewd, which is how most contemporaries saw him. The last work by Bernini in the collection, *Truth*, came to the museum only in the twentieth century. It was a personal work, which the artist bequeathed to his son, and designed to demonstrate his eventual vindication when he was in temporary disgrace after the Barberini papacy with Innocent X, the new Pamphilj pope. Such was papal politics.

Prince Camillo Borghese may have sold the antiquities, but he did leave behind one work that for many would partly make up for that loss: Canova's reclining *Pauline Borghese,* executed between 1805 and 1808. Unusually for a noble lady, she was portrayed without much covering drapery. As a result she became the high priestess of Neo-classicism. Legend surrounds this extraordinary statue, which is even more beautiful from behind. When asked how she could have thus posed, Pauline is said to have replied, 'Oh, but the studio was heated.' Years later, when Camillo

111

and Pauline had separated, she objected to the public viewing the statue, as it was meant for his eyes only. Even Canova had difficulty gaining access, and when he did so he preferred to see it at night, by the light of a single candle.

The ground floor has one further attraction, the Caravaggio Room. Scipione Borghese owned twelve paintings by the artist, and six are still in the collection. When we are inclined to think of Scipione Borghese as nothing more than a rich, rapacious bully, his talent-spotting of both Bernini and Caravaggio sings for the defence. Caravaggio, like Bernini, was prodigiously talented, but his character was very different. At times dark and difficult, he did much to annoy his patrons and was what Cardinal del Monte called 'a very odd genius indeed'. Probably the first work to come into the collection was the *Madonna dei Palafrenieri* (1605), painted for the chapel of St Anne in St Peter's but then rejected by the confraternity on grounds of decorum. Borghese, without any hesitation about its uninhibited realism, stepped in and bought it, which must have delighted the artist. The two early works in the collection, *Young Bacchus III* (c. 1592) and *Boy with a Basket of Fruit* (c. 1594), reveal Borghese at his most ruthless. When the Cavaliere D'Arpino, who had worked for the Cardinal, was in trouble with the tax authorities, Borghese, instead of helping his old friend, simply seized 105 of his paintings, including the two Caravaggios. The *St Jerome* (c. 1605–6) was the Cardinal's only direct commission to Caravaggio. There are two late works, *St John the Baptist* (c. 1609–10), and *David with the Head of Goliath* (c. 1605–10), which was sent to the papal court to plea-bargain against the death penalty after the famous duel in 1605 in which Caravaggio killed Ranuccio Tommasoni. This room brings together the best group of Caravaggio's paintings in the world.

Caravaggio
Young Bacchus III, c. 1592
oil on canvas
66 × 52 cm

Caravaggio
Boy with a Basket of Fruit, c. 1594
oil on canvas
70 × 67 cm

Caravaggio
David with the Head of Goliath
c. 1605–10
oil on canvas
125 × 100 cm

Raphael
Lady with the Unicorn, c. 1506
oil on panel
65 × 51 cm

Raphael
Deposition, 1507
oil on panel
184 × 176 cm

Caravaggio apart, the main collection of paintings is to be found on the first floor of the villa, where it is divided into its various schools. The central Italian room shows Perugino, Fra Bartolommeo, Piero di Cosimo, Andrea del Sarto, Lorenzo di Credi and three masterpieces by Raphael: the *Portrait of a Man* (c. 1502), for years thought to be by Holbein, the *Lady with a Unicorn* (c. 1506), which is the sort of Raphael that the Victorians loved, and the *Deposition* (1507). The latter, with its echoes of Michelangelo's famous *Pietà*, was a great prize for Borghese, but on this occasion he almost went too far. He arranged for it to be stolen at night from the Baglione family chapel in Perugia and then sent to the Pope, who handed it over to Borghese. The inevitable row nearly caused Perugia to leave the Papal States.

Borghese had a particular fondness for Ferrarese painting, and there is an entire room devoted to Garofalo and at least one masterpiece by Dosso Dossi, *Circe*. Nearly every Italian school is represented in the collection, and some non-Italian – for instance, a large and exceptionally fine Cranach that Borghese bought, and Rubens's *Deposition*, painted during his first stay in Rome in 1602. Borghese patronised many contemporary painters and

there is a fine Baroque room, dominated by Lanfranco's *Norandino and Lucina Discovered by the Ogre* (c. 1624), which he commissioned for his villa at Frascati. Opposite is Domenichino's *Diana* (c. 1616–17), which was in fact painted for Cardinal Aldobrandini; when the artist

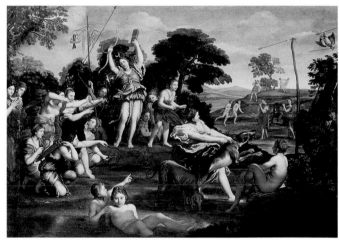

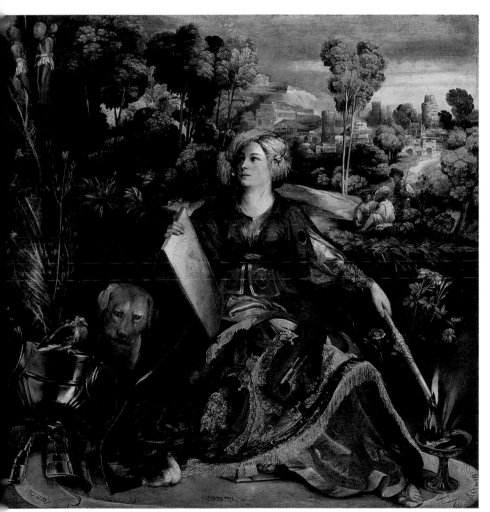

Dosso Dossi
Circe, c. 1520
oil on canvas
176 × 174 cm

Domenichino
Diana, 1616–17
oil on canvas
225 × 320 cm

refused to break his contract with Aldobrandini, Borghese
had him imprisoned and acquired the painting by force.

By far the most famous painting in the collection is
Titian's *Sacred and Profane Love*, one of the supreme
masterpieces of Venetian art. Titian was 25 when he

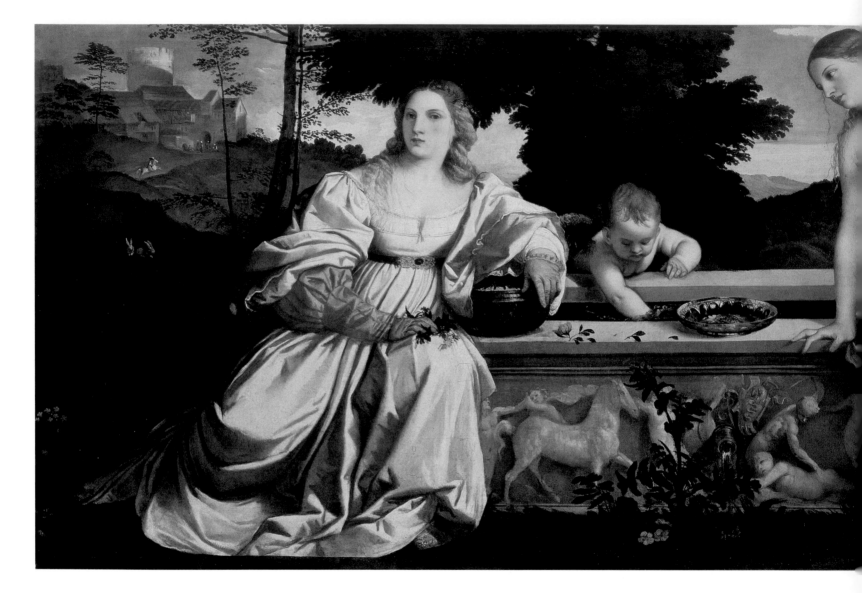

painted it in 1514 for a noble marriage celebration. It displays earthly and heavenly love, and has everything you can ask of a Venetian painting: beautiful fabric, an antique relief, and a Giorgonesque landscape, with one of the most beautiful nudes Titian ever painted. It is no wonder the Rothschilds offered to buy it at the end of the nineteenth century for more than the entire value of the villa and its contents.

Borghese put an entail on his collection, which more or less preserved the villa and its contents. Prince Camillo was responsible for one other addition to the collection, apart from the Canova. In 1827 he found in a Parisian antique market Correggio's famous *Danae*. This erotic image, which so fascinated the courts of Europe, was

Titian
Sacred and Profane Love
1514
oil on canvas
118 × 279 cm

Correggio
Danae, c. 1531
oil on canvas
161 × 193 cm

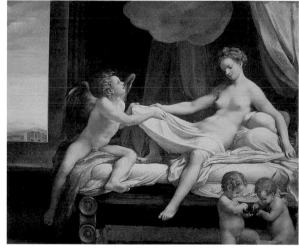

commissioned by Federico Gonzaga in Mantua around 1531, and had been around virtually every capital in Europe before it came to rest in Rome.

The gardens were constantly changed and the villa received additional decorations, courtesy of Prince Marcantonio Borghese, by Antonio Asprucci from the 1770s to the 1790s. In 1902 the house and its contents passed into state ownership. The villa has lost the reliefs from the façade (the Louvre has the best of the Cardinal's antiquities), but what remains is by any standard extraordinary. We can salute the taste of this pleasure-loving Cardinal and, even if we cannot always support his methods, we may be grateful that his energies were directed to collecting art. The result is, as Johann Caspar

Goethe (the father of the celebrated writer) described it in 1740, 'the most delicious and remarkable place in the whole of Italy'.

GALLERIA DORIA PAMPHILJ

ROME

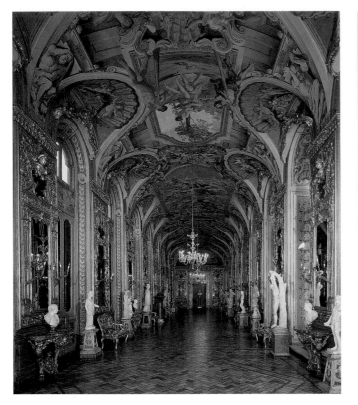

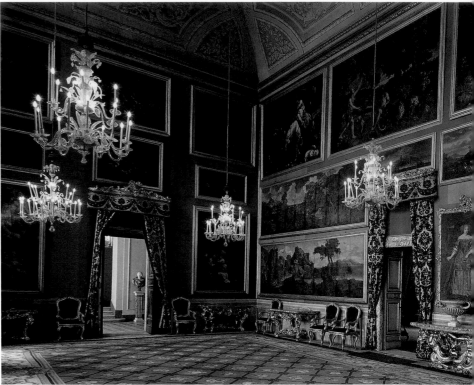

If there was a moment when the Doria Pamphilj Collection was born, it was in 1647, when Cardinal Camillo Pamphilj threw away his Cardinal's hat to marry the heiress Olympia Aldobrandini. This caused a considerable scandal, Camillo being the favourite nephew of Pope Innocent X, and at first everybody opposed the marriage. The couple were forced for a couple of years to go and live in the beautiful Villa Aldobrandini at Frascati in the middle of the Roman Campagna. When the couple returned to Rome, they chose not to live in the Pamphilj palace on the Piazza Navona but to go instead to Olympia's family *palazzo* on the via del Corso, which is the site of the present Palazzo Doria Pamphilj.

The creation of the *palazzo*, and of the collection as we know it today, was a gradual and evolutionary process, but the most important foundations were laid as a result of this alliance. Olympia provided not only the *palazzo*, which Camillo immediately began to expand, but also the nucleus of the art collection, including many of the masterpieces

The Gallery of Mirrors

The Salone di Poussin

Alessandro Algardi
Bust of Pope Innocent X
c. 1650
marble

Gian Lorenzo Bernini
Bust of Pope Innocent X
c. 1650
marble

we recognise by Raphael, Titian, Parmigianino, Beccafumi and Annibale Carracci. Camillo for his part loved art and was to be an important patron of Bernini, Borromini, Pietro da Cortona and Algardi, and he bought the works of many contemporary painters, including Caravaggio, Claude Lorrain and Gaspard Dughet.

In 1654 Camillo started to create the *appartamenti nuovi* and today these are the starting-point of any visit to the Palazzo Doria, as it is generally known. The tone is set in the first room, the Salone di Poussin, a large gallery of considerable grandeur that introduces us to one of the main themes of the collection – outstanding Roman landscape painting during its golden age, at a time when the Roman Campagna was being discovered and celebrated as an earthly paradise. Gaspard Dughet was one of Prince Camillo's favourite painters, and there are 20 of his works in this room, some painted in collaboration with Courtois. The one that was most admired in the eighteenth century was *Landscape with the Lucanian Bridge* and today we may

see it in exactly the same position, as the hanging of this room has not been altered for 250 years.

Camillo's apartments, which were largely redecorated in the eighteenth and nineteenth centuries, contain many splendid works of art and at least one that deserves to be mentioned, Algardi's bust of his uncle Innocent X. The election of this Pamphilj pope at first looked like being a disaster for the arts. After the free-spending Barberini papacy Innocent X was neither able to afford such patronage nor inclined by nature to support it. The papacy was bankrupt, and the new pope even allowed Bernini to leave papal employment under a cloud. He chose instead the more sober and classical Algardi as his sculptor, and these are the qualities we find in the portrait bust of Innocent X. Bernini came back into favour later in the pope's reign, and there are in fact two busts of the pope by him in the collection. The marble cracked on the first attempt and Bernini was forced to make another, but both show great warmth and vigour.

119

Simone Cantarini
Rest on the Flight into Egypt
early 17th century
oil on canvas

Claude Lorrain
View of Delphi with Procession
1650
oil on canvas
151 × 198 cm

The main collection of paintings is housed in the Gallery and constitutes one of the finest private art collections in the world. By the mid-eighteenth century the scattered collections of Camillo and Olympia were concentrated in the palace on the Corso, and a later Prince Camillo Pamphilj commissioned Gabriele Valvassari between 1731 and 1734 to create the present galleries around a courtyard with a Gallery of Mirrors as well as three wings of paintings.

The first wing contains Emilian school paintings and above all Seicento (seventeenth- century) landscapes. Here are the incunabula of classical landscape painting, the six so-called Aldobrandini lunettes, including Annibale Carracci's *Rest on the Flight into Egypt* (1603–4), in which classical landscape painting came of age. It is one of those important historical paintings that we respect rather than love, and if we find it a little academic, we have only to turn to the four Claude masterpieces, which include the *Landscape with Windmill and Dancing Figures*

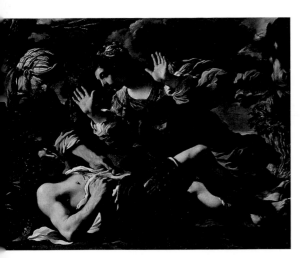

Guercino
Erminia Finding the Wounded Tancred
1619
oil on canvas
145 × 187 cm

Diego Velázquez
Portrait of Innocent X, 1650
oil on canvas
141 × 119 cm

and *View of Delphi with Procession,* to see that the golden age has arrived. Camillo loved landscapes, and elsewhere in the collection he owned good examples by Paul Bril, Domenichino, the Brueghels and Jan de Momper.

Among the 164 paintings in the first wing are many masterpieces, including Guercino's *Erminia Finding the Wounded Tancred* (1619), but the greatest aesthetic experience awaits the visitor on the corner, in the form of Velázquez's *Portrait of Innocent X* (1650). For many the

first sight of this painting is through a mirror. Walking down the gallery, the eye is caught by the reflection of something strangely real and very familiar. The mirror, which provides something of the diffusion that Francis Bacon later achieved, is at the entrance to the small room where the portrait hangs alongside the second Bernini bust. It was commissioned by the family, but no doubt with the approval of the pope, who was a Hispanophile: 'only on Spain could the Holy See rely', he is reported to

have said. He was not an easy subject. As Giacinto Gigli said, 'his face was the most deformed ever born among men', but Velázquez didn't flinch. 'Troppo vero' was the pope's comment, but he nevertheless rewarded the artist with a gold chain and a portrait medal. It is ironic that today we have the clearest image of the seventeenth-century pope who probably loved art the least. 'There's no art to find the mind's construction in the face', says Shakespeare, but Velázquez almost persuades us that he could be wrong, for what we see here is missing in Bernini's otherwise brilliant bust – the slightly weak and shifty expression that Morelli said was like 'a cunning lawyer'.

The Gallery of Mirrors, which gives a moment to pause, is a delicate masterpiece of white and gold with antique

Raphael
Portrait of Andrea Navagero and
Agostino Beazzano
1516?
oil on canvas
77 × 111 cm

Titian
Judith with the Head of
Holofernes, c. 1515
oil on canvas
89 × 73 cm

Annibale Carracci
Rest on the Flight into Egypt
1603–4
oil on canvas
121 × 230 cm

sculpture, its harmony shattered only by the noise from the via del Corso. The other two sides of the courtyard contain a further 183 paintings; some among them are famous, and there are many quiet voices, such as the Parmigianino panels of *The Madonna and Child* and *The Nativity,* which were originally back to back. One of the most restful paintings in the collection is Cantarini's unexpected masterpiece *The Rest on the Flight into Egypt.*

The greatest concentration of important paintings in the collection is to be found in four rooms just off the Gallery of Mirrors, each named after the century they exhibit. The 1500s Room shows much of the Aldobrandini inheritance, including the enigmatic Raphael *Portrait of Andrea Navagero and Agostino Beazzano* (c. 1516), whose identity and purpose have often been questioned. Aside from the Velázquez, many regard Titian's *Judith with the Head of Holofernes* (c.1515), known as *Salome*, as the masterpiece of the collection, which came to Olympia by descent from Titian's patrons the Este family. If the 1500s Room is the bounty of Olympia, the 1600s Room shows Camillo Pamphilj's perspicacity in buying two very early works by Caravaggio. The *Rest on the Flight into Egypt* (c.1598) — how they loved that subject – is the earliest of his religious paintings and has a Pre-Raphaelite appearance. Caravaggio treated the figures as if they were portraits, but by introducing the angel in the middle foreground of

Caravaggio
Rest on the Flight into Egypt, c. 1598
oil on canvas
136 × 166 cm

Caravaggio
Mary Magdalene, 1598
oil on canvas
122 × 98 cm

the composition he created a pictorial confusion that he never repeated. Next to this extraordinary work is the *Mary Magdalene* (1598), in which Caravaggio interestingly used the same model and in a similar position. To enhance the sense of realism he painted her in contemporary clothes and added the shadow line in the corner. Pamphilj owned a third Caravaggio, *The Fortune Teller*, which he presented to Louis XIV, and which is now in the Louvre.

Camillo Pamphilj left behind a great art collection, and yet, despite this, history has not always been kind to him. He commissioned many artists for various villas and chapels, but he was mean, and – as Passeri put it – 'though he more than anyone of his time gave opportunities to painters and sculptors, he was always having trouble with them over questions of money'. For the preservation of Camillo's collection we may thank Innocent X, who by papal brief placed a primogeniture entail on the Pamphilj heirlooms.

While there were other patrons and collectors among the Pamphilj family after Camillo, the story of the collection since then has been essentially one of rationalisation and of bringing the scattered art

collections together in the palace on the Corso. The main branch of the Pamphilj family died out in 1760 and the inheritance jumped to the Genoese Doria family, who had married a daughter of Camillo and Olympia. They were the descendants of Andrea Doria, the hero of Lepanto, whose great portrait by Sebastiano del Piombo has been returned to the family villa in Genoa.

The gallery has been open to visitors since the nineteenth century. The collection has been universally praised since that time, but the building has not fared so well. Stendhal in 1827 found 'the great Palazzo Doria … much more interesting for the superb pictures kept there than for the architecture', and Ruskin in 1841 agreed, finding the *palazzo* 'a horrid cavern, dim and gloomy'. However, they saw it before the sensitive nineteenth-century alterations of Prince Filippo Andrea IV and his architect Busiri Vici, and the visitor today sees many more staterooms. The Palazzo Doria remains one of the greatest pleasures of Rome. The paintings, which have been rehung to their eighteenth-century positions, are one of the wonders of the city. We owe their preservation to that much maligned pope whose image we know so well.

ACCADEMIA CARRARA

BERGAMO

'What makes the Accademia Carrara special is the fact that this is a picture gallery made up almost exclusively of private collections and of works created for private use', wrote Andrea Emiliani. What he omitted to mention was that many of these collectors were among the great names of Italian art history. The Accademia Carrara in Bergamo is very much an art historian's museum, covering Italian painting from the fourteenth century to the nineteenth, with a sideways glance at the Dutch and Flemish schools. Its greatest strength lies naturally enough in Bergamesque painting and its two important neighbouring schools, the Lombard and Venetian.

The founder, Count Giacomo Carrara (1714–1796), whose father had been ennobled, came from a Bergamesque merchant family. His first interest was the history of Bergamo, on which he started to form a library in the 1730s. His interests broadened to painting and sculpture through friendship with Francesco Maria Tassi, with whom he was eventually to collaborate on a history of the lives of Bergamo artists. The death of his father in 1755 gave Carrara full rein financially to collect works of art. He made friends with artists such as Giandomenico Tiepolo, Ghislandi and the sculptor Fantoni, and began to collect both old masters of the Bergamesque school of painting and contemporary Italian art.

In 1756–8 Carrara made a journey south, visiting Naples, Florence and Rome, where he met Batoni, Mengs and Kauffmann. He bought 72 paintings on this trip and began to extend his collecting to other Italian schools, particularly those of Venice and Emilia. On the way south he passed through Parma, where, inspired by the local academy of painting, Carrara began to consider the need for something similar in Bergamo. By 1780 he had acquired the present site of the Accademia Carrara, where

he established both an art gallery and a school, which opened in 1785 and 1793 respectively. The school was founded with an old-fashioned curriculum to provide 12 places a year to poor students, and the gallery to provide inspiration and models. The school later became affiliated to the Accademia di Brera in Milan, but it was the gallery that was to become famous.

When Carrara died in 1796, he had already given the gallery 2,000 paintings, including Foppa's *Crucifixion*, Lotto's *Mystic Marriage of St Catherine* and Moroni's *Portrait of an Old Man*. Unfortunately today we do not see Carrara's collection as a whole, because in 1855 the gallery sold two-thirds of its entire holdings, particularly depleting the then unfashionable Baroque and Rococo schools. Amazingly, such an act did not deter future donors, and in 1866 came the bequest of Guglielmo Lochis, which brought outstanding works by Giovanni Bellini, Titian, Tura and Raphael. Lochis was a friend of

Sandro Botticelli
The Story of Virginia Romana
c. 1500
tempera on panel
86 × 165 cm

Fra Angelico
Virgin of Humility
early 15th century
tempera on panel
33 × 28 cm

Raphael
St Sebastian, c. 1502–3
oil on panel
44 × 35 cm

Eastlake, Burckhardt and Bode, and his gift transformed the picture collection at one stroke into a gallery of international importance.

This gift was followed in 1891 by that of Giovanni Morelli, which, although not as important, was equally prestigious. Morelli was the most innovative Italian art historian of the time and a leading intellectual of the Italian Risorgimento. He had studied comparative anatomy in Germany and began to apply a similar scientific method of classification to the study of painting through details such as hands and drapery. An entire school of art history was born using the Morellian method or connoisseurship, as it is sometimes called, of which the most famous practitioner was Bernard Berenson. The paintings Morelli gave the museum therefore have unusual interest and include important works by Botticelli and Giovanni Bellini.

Today the collection is housed in a classical building completed in 1810 by Simone Elia, which has the appearance of a provincial French lycée with its simple

pediment and railings. The main collection is situated on the second floor, where over 500 paintings are displayed across 16 rooms. The collection opens with International Gothic painting. There are many early Renaissance paintings, including a rare work by Pisanello, his *Portrait of Lionello d'Este* (1441). There is a small group of Florentine paintings. Morelli gave the striking *Portrait of Giuliano de Medici*, which today is generally regarded as coming from Botticelli's studio. More certain is Morelli's other Botticelli, *The Story of Virginia Romana* (c. 1500), which has the distinction of being one of the paintings mentioned by Vasari: 'In the house of Giovanni Vespucci, now that of Piero Salviati, [Botticelli] painted all around the room several pictures with vivid figures, framed in walnut for benchbacks and woodwork.' Fra Angelico is represented by the *Virgin of Humility* – part of the Lochis bequest – though the attribution is still debated. Lochis also gave one of the greatest treasures of the museum, the beautiful and tender early Raphael *St Sebastian* (c. 1506), which shows the influence of Perugino and Pintoricchio.

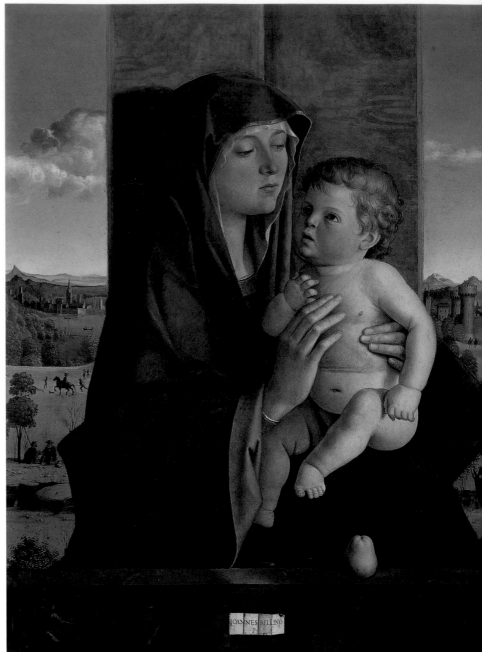

From the other Italian schools there is a *Virgin and Child* by that strange Ferrarese painter Cosmè Tura, and from Brescia there is Vicenzo Foppa's *Crucifixion* (1456), his first signed and dated work and one in which he reaches artistic maturity. One of the most beautiful paintings in the collection is Mantegna's luminous *Virgin and Child* (c. 1480).

Given Bergamo's political and artistic domination by

Venice in the early sixteenth century it is not surprising that the Venetians are well represented. There are works by Carpaccio and a fine group of paintings by Giovanni Bellini starting with the *Dead Christ* (1450), one of his earliest surviving works, painted under the influence of Mantegna. There are two Virgins by Bellini: the Lochis *Madonna* (c. 1470), and – one of the freshest and most beautiful of all – the *Alzano Madonna* (c. 1488). The two Titians left to the museum by Lochis are both as early as can be. *The Orpheus and Eurydice* was for years attributed to Giorgione, but despite its poor condition it is today often considered to be the first painting in Titian's known and accepted oeuvre. The *Madonna and Child* (c. 1515) has had a rougher ride from art historians but is sometimes

Giovanni Bellini
Alzano Madonna, c. 1488
oil on panel
83 × 66 cm

Andrea Mantegna
Virgin and Child, c. 1480
tempera on canvas
43 × 31 cm

Marco Basaiti
Portrait of a Man
1521
oil on canvas
84 × 66 cm

Lorenzo Lotto
*The Mystic Marriage
of St Catherine*, 1523
oil on panel
115 × 81 cm

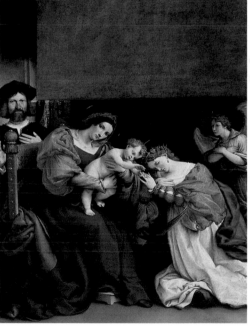

Titian
Orpheus and Eurydice, c. 1508
oil on panel
38 × 47 cm

accepted as autograph. There is no portrait by Titian in the museum, but there is a superb *Portrait of a Man* (1521) by Marco Basaiti in his manner.

The Bergamesque paintings are – as one would expect – outstanding, with fine examples by Andrea Previtali and Giovanni Cariani. Previtali was the first important painter to be born in Bergamo (c.1480) and went to Venice for his training in the studio of Bellini. He returned around 1511 to Bergamo, where he might have dominated the scene, producing competent devotional paintings such as the *Virgin and Child Reading* (1514) but for the arrival of Lorenzo Lotto from Venice in 1513. Lotto was by far the most important artist to work in Bergamo, and the museum has an important group of his works starting with

the three panels that made up the predella of the altarpiece painted for the Dominican church of Santo Stefano in Bergamo between 1513 and 1516. They represent *A Miracle of St Dominic, The Entombment and The Stoning of St Stephen.* There is his Portrait of *Lucina Brembati* (c. 1518) and, from Count Carrara's bequest, perhaps the best Lotto in the collection, *The Mystic Marriage of St Catherine* (1523). The figure on the left is the artist's landlord, Nicolò Bonghi. Lotto gave him the painting as payment for a year's rent. The last important Lotto is *The Holy Family with St Catherine* (1533).

After the 1550s it is the portrait painter Giovanni Battista Moroni who dominates Bergamesque painting, and there is a room devoted to his work. He was trained in the studio

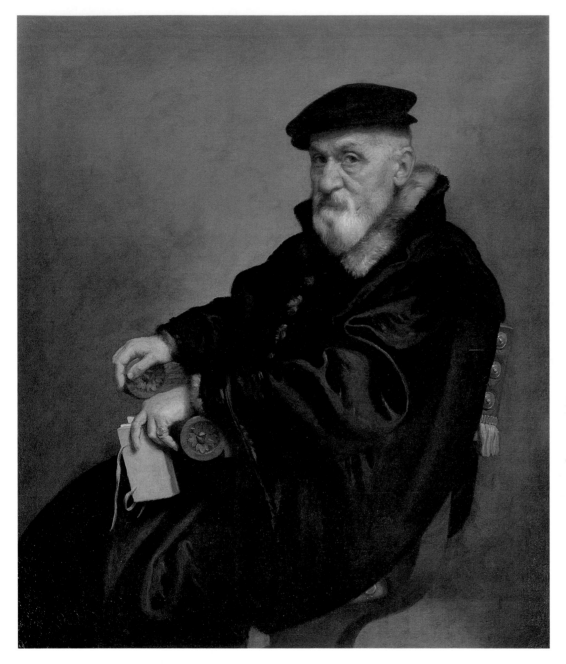

Giovanni Battista Moroni
*Portrait of an Old Man
with a Book*, 1570
oil on canvas
98 × 80 cm

Giovanni Battista Moroni
*Portrait of a 29 year-old
Nobleman*, 1567
oil on canvas
48 × 38 cm

of Moretto, whose work he sometimes resembles.
Berenson had rather a down on Moroni, calling him 'the
only mere portrait painter that Italy had ever produced …
these people of his are too uninterestingly themselves …
Moroni, if he were as brilliant, would remind us of Frans
Hals.' The Accademia Carrara is certainly the place to
come to make up your own mind about Moroni since there
are 16 of his works. There are the two imposing and
austere full-length portraits of *Bernardo and Pace Rivola*

Spini, and the memorable *Portrait of an Old Man with a
Book* (1570), which show how striking Moroni could be. In
a different vein is the *Portrait of a 29-year-old Nobleman*
(1567), which has a directness and simplicity that make it
today one of Moroni's most admired works. Although he is
best known as a portrait painter, the museum also has
some of his religious works, which particularly depressed
Berenson, including the *Deposition* (1566) and the *Virgin
and Child* (1567).

Vittore Ghislandi
Portrait of Francesco Bruntino
1737
oil on canvas
93 × 81 cm

Vittore Ghislandi
Count Carrara as a Scholar
early 18th century
oil on canvas
89 × 74 cm

The seventeenth-century painter Evaristo Baschenis reveals another aspect of Bergamesque painting with his group of *Still Life with Musical Instruments* (late 1660s). The most important Bergamesque artist of the eighteenth century was Vittore Ghislandi, who was the finest Italian portrait painter of his day, and he painted the founder Count Carrara as a scholar in his dressing gown. Ghislandi gave a florid Baroque and Rococo twist to Moroni's austere portraits, and we can see not only his own *Self-portrait* (1732) but also many colourful and lively portraits of Carrara's contemporaries, including that of his great friend and art dealer *Francesco Maria Bruntino*.

Unusually for an Italian museum, there is a group of Dutch and Flemish paintings, and more predictably a fine collection of Venetian eighteenth-century works by Longhi, Ceruti, Zuccarelli, Carlevaris, Canaletto, G. B. Tiepolo and Guardi. The collection continues into the nineteenth century centred on the Bergamo painter Giovanni Carnovali, *il Piccio*. Most of the nineteenth-century paintings are to be found on the ground floor, while on the first floor there is a study collection of paintings hung from floor to ceiling, as well as cabinets containing 5,000 prints and 3,000 drawings.

Donations continued to pour into the museum during the twentieth century. The most recent noteworthy bequest – in 2000 – was part of the collection of the eminent Italian art historian Federico Zeri, who saw himself as the natural heir of Morelli. Appropriately the museum today still has a slightly academic atmosphere, and many of the paintings still present fascinating questions for scholars. Although the collection is dominated by works of the Bergamo school, paintings by Lotto and portraits by Moroni, the Accademia Carrara is without doubt a museum of international importance.

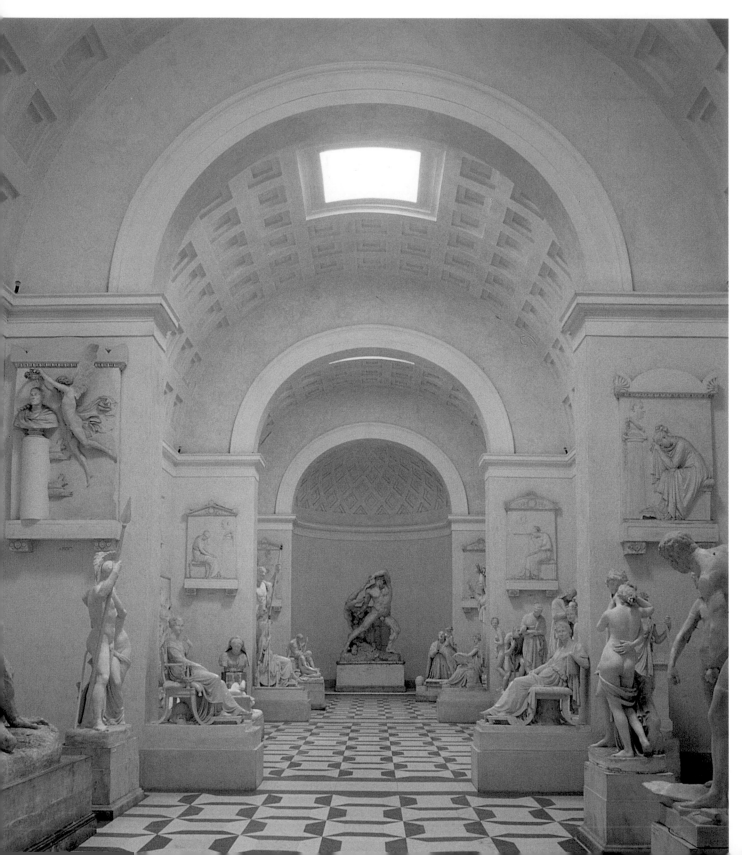

View of the Gallery, looking towards *Hercules and Lichas*

Antonio Canova
Pope Clement XIV, 1783
terracotta
45 × 40 × 24 cm

Plaster casts once formed an important component of European museums and were regarded as an essential tool in the education of young artists. Most cast galleries have disappeared, but one important survivor is to be found at the village of Possagno, a few miles out of Asolo in the Veneto, on the edge of the Dolomite mountains: La Gipsoteca Canoviana. Here are the working casts and the clay and plaster models of the greatest of Neo-classical sculptors, Antonio Canova (1757–1822).

Possagno is first and foremost the family home in the village where Canova was born and to which he returned at various points of his life, particularly towards its end. After his death the gallery was added in a suitable Neo-classical style, and his stepbrother brought the casts and clay models from Canova's Roman studio. It is all pleasingly unspoilt and rural: the garden is full of blossom, the air is filled with the sound of hens and cockerels, and all is set against the background of breathtaking mountains. In this delightful backwater rests the evidence of a career lived at the forefront of European life.

Canova's career began in a humble manner. He was brought up by his grandfather, a minor sculptor, and sent to Venice for training. Here he studied the casts in the Farsetti Collection, which remained for him the greatest education in antique imagery. It was not until he went to Rome in 1779 that his style of 'noble simplicity and calm grandeur' fully emerged, with *Theseus and the Minotaur* (1781–3; marble in V&A, London). This established Canova's reputation as a modern master to equal the ancients. It was followed by his first great public commission, the *Monument to Pope Clement XIV* (1783–7) for the Church of the Santi Apostoli in Rome, for which we can follow some of the early stages at Possagno. Canova's working methods were invariably the same. Clay, as Winckelmann pointed out, is to the sculptor what drawing is to the painter. Canova would model the first idea in a small *bozzetto,* which would then be developed to a more finished *modellino,* which is what we see in the terracotta of *Pope Clement XIV*. It is a model to be shown to the client for approval. Then came the full-scale *modello,* from which the plaster casts were made and fixed with tracing points for the assistants to hew the marble. This accounts for the numerous holes in the casts at Possagno. The

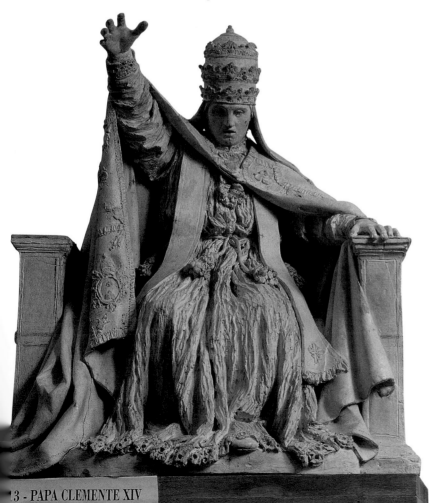

13 - PAPA CLEMENTE XIV
terracotta, modellino.

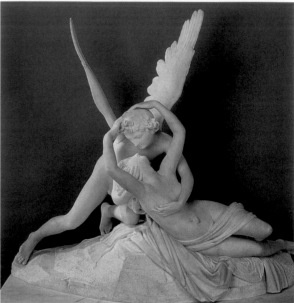

assistants would translate Canova's ideas from clay to marble to the point at which he would give the crucial finishing touches, using special tools by candlelight. Canova then usually employed his *formatore* to make moulds in which a limited number of casts could be executed, one for him to keep as a record, others to be sold or given away. At Possagno there are as many of these casts from finished marbles as those from the full-size clay *modelli*.

'Sketch with fire and execute with phlegm' was Winckelmann's famous maxim, of which Canova is the supreme example. The result is that the *bozzetti* have a vitality and spontaneity that have often made them more attractive to modern eyes than the fastidious finished marbled works, an idea that would have appalled Canova. We can observe this difference in the little terracotta *bozzetto* for *Cupid and Psyche* (1787) and compare these expressive writhings with the tender and almost sublime finished marble sculpture in the Louvre.

With the success of the Clement XIV monument Canova became Europe's foremost sculptor, and commissions poured in from the great and the famous. Entering the gallery at Possagno we are immediately aware of Canova as the public sculptor and recorder of history. It is like stumbling into some ancient imperial vault where time has stood still. The whiteness and classical purity of this noble barrel-vaulted space are offset by the slightly giddy impression of so many gods, heroes, beauties, poets and grieving figures. Some are reposeful, some are dynamic, but

all are conceived with fantastic skill and panache. Canova saw the past and present through the same heroic eyes, and he was probably the last European artist who could translate the present in such heroic terms, a fact that caused his decline in critical opinion in the twentieth century.

The gallery is divided into three bays, with a recessed apse and three roof lanterns, which provide the only light source. In the apse is the great dynamic *Hercules and Lichas* (1795–1815; marble in Galleria Nazionale d'Arte, Moderna, Rome), which, a Frenchman suggested to Canova, must represent France throwing out the monarchy. Canova, who remained all his life above politics, retorted that not for all the gold in the world would he represent such a theme and that the figure of Lichas could equally represent 'licentious liberty'. Among the most striking cast monuments is the *Funeral Monument to Maria Christina of Austria* (1798–1805; marble in Augustinian church, Vienna), in which Canova broke away from the Baroque sarcophagus theme for a radical pyramidal structure with a cortège of mourners. There is also the *Monument to the Poet Alfieri* (1804–10), commissioned by the Countess of Albany for Santa Croce in Florence, with its novel personification of Italy mourning.

Of portraits there is the over-life-size head of the Rezzonico pope *Clement XIII* (1784–6) and a headless *Pauline Borghese* (1804–8; marble in Villa Borghese, Rome). During the First World War the village was just behind the front line, and in 1917 a shell landed on the

Antonio Canova
bozzetto for *Cupid and Psyche*,1787
terracotta
16 × 29 × 13 cm

Antonio Canova
Cupid and Psyche, 1787
marble
(Musée du Louvre, Paris)

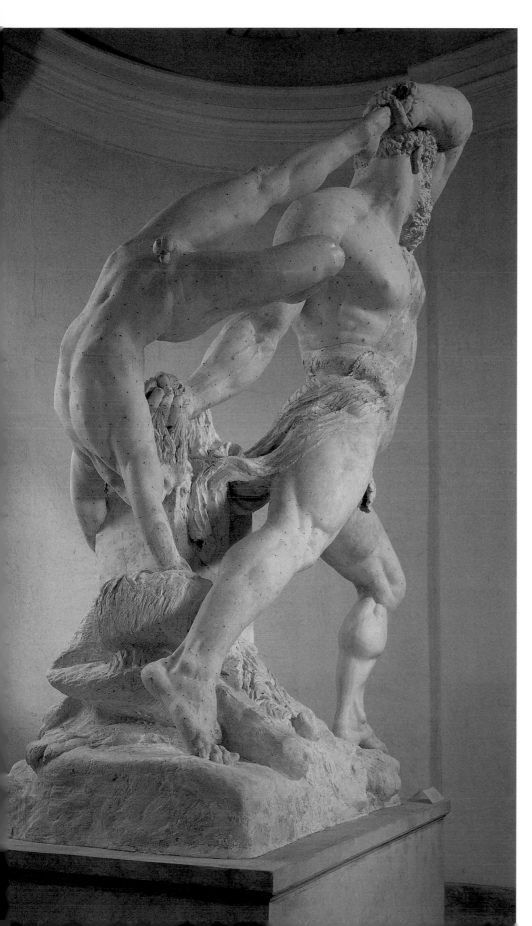

Antonio Canova
Hercules and Lichas
1795–1815
gesso
335 × 220 ×130 cm

Antonio Canova
Stuart Monument
1817
relief in gesso
65 × 58 × 12 cm

gallery; among the casts damaged was *Pauline Borghese*, who lost her head and right hand, giving her a slightly Dalí-esque appearance. Her brother *Napoleon as Mars* (1806; marble in Apsley House, London) is also there, as is a galaxy of Classical heroes and mythological characters: Ajax, Theseus, Hector, Bacchus (being born), Venus and Adonis, Adonis dying and so forth.

The side galleries, designed by Carlo Scarpa and opened in 1957, are smaller in scale, showing many of the *bozzetti*. Particularly fascinating are the small-scale terracotta funerary monuments which look like toys. There is the original plaster model for the *Stuart Monument* (1817) in St Peter's, with profiles of the Old and Young Pretenders and Cardinal Stuart. There are three *bozzetti* (1790–92) for an unexecuted *Titian Monument* and another of 1806–7 for Nelson, showing the Admiral – rather oddly to English eyes – as a Roman hero. Canova did the same to George Washington in another small plaster model (1817–18). There is a group of cast portraits of members of Napoleon's family, a very spotted plaster original of Cardinal Fesch and numerous Bonaparte women. Napoleon is there again, this time as First Consul and (is this a curatorial joke?) gazing down on the naked bottom of *The Sleeping Nymph* (in gesso; 1820). The placing of the casts and terracottas is excellent, with the exception of *The Three Graces* (1812–16; marble in Hermitage, St Petersburg), which is in a corner against a window.

Entering Canova's house is an equal delight. Canova gradually altered the artisan house where he was born, creating a few simple and evocative Neo-classical interiors. The Grand Salone shows some of his rather weak paintings, while upstairs there is the room of his engravings, all hung close together, with a showcase for his carving equipment. There is also his superb portrait by Sir Thomas Lawrence.

Throughout his life Canova kept in close touch with Possagno and enjoyed its gossip. In 1816 he answered a call from the villagers to finance the restoration of the old church, but promised them instead a great new church in the form of a Neo-classical pantheon. This he designed himself, with the help of Antonio Selva and Pietro Bosio. The construction began in 1819, and it became Canova's main interest and eventually his mausoleum. It is an enormous surprise, completely out of scale in this small village but nevertheless magnificent. Built at the end of a long rising avenue that is set against the mountainous backdrop, the temple with its grand Doric portico looks straight down on to the rather simple cluster of buildings that form Canova's house. The interior is equally magnificent, with its great dome and cool Neo-classical fixtures. The villagers provided the labour and praised their famous son for his generosity.

Canova died in 1822. His heart was placed in the Frari and his right hand in the Accademia in Venice, but his body was brought back to Possagno. Canova's stepbrother Monsignor Giovanni Battista Sartori-Canova completed the temple, commissioned the gallery to be built on to the house by Giuseppe Segusini and brought the artist's possessions from Rome. While some of the casts were given to Bassano, the vast majority were kept for Possagno. Since that time Canova's reputation has see-

The interior of the
Grand Salone

Sir Thomas Lawrence
Portrait of Canova
1815
oil on canvas
91 × 71 cm

The Mausoleum

sawed, but with the reappraisal of Neo-classicism from the 1960s onwards he began once again to be understood and admired. Jacques-Louis David – with whom he is sometimes compared – rightly described him as that 'seductive worker in marble', and although this element is missing from Possagno, it remains with that limitation the best place to understand the phenomenon that was Antonio Canova.

MUSEO POLDI PEZZOLI

MILAN

In a quiet courtyard off the Via Manzoni, the main fashion thoroughfare of Milan, lies the Museo Poldi Pezzoli. It is a place of great charm, containing some considerable treasures, and still has the feel of a patrician collector's house. There are a few such collections in Italy: Venice has the Galleria Querini Stampalia and Florence the Herbert Horne Foundation and the Museo Stibbert. They are all a delight to visit, but by a short head the Poldi Pezzoli wins, by virtue of the masterpieces among its paintings, the variety of its contents and its associations with the intellectual movement at the time of the Risorgimento.

Gian Giacomo Poldi Pezzoli was born in Milan in 1822, the only child of a 50-year-old father, who died when the boy was only ten. The Poldi were rich bourgeois who married into the aristocratic Pezzoli family and inherited their Milan *palazzo* where Poldi Pezzoli was brought up and the museum is housed today. His mother, Rosina, came from another famous Milanese aristocratic family;

The staircase

The entrance to the museum

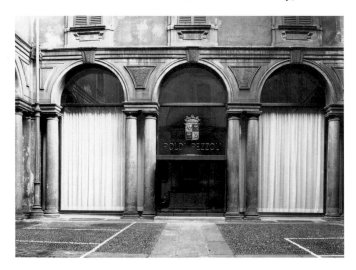

she was the daughter of Prince Trivulzio and hers was probably the chief influence on the young boy. Poldi Pezzoli's first collecting interest was antique arms and armour, and his collection grew so fast that when he was still only 24 he commissioned a set designer from La Scala, Filippo Peroni, to design an armoury. Judging from old prints and photographs, this setting had the look of an old baronial castle but unfortunately, like most of the museum's rich interiors, it was destroyed by allied bombing in 1943. This was not the first calamity to affect the arms collection. It was raided in 1848, the year of

Limoges caskets, 13th century

Neopolitan cabinet
1619–20
ebony with engraved ivory
plaques
68 × 96 × 62 cm

revolutions, probably by the Austrians on account of Poldi Pezzoli's involvement with the rebels. As a patriot, he was forced abroad to Switzerland, but used his exile to travel to London and above all Paris, where he acquired a taste for French medieval art.

By the 1850s Poldi Pezzoli was re-established in Milan and started collecting in earnest. He began to remodel the *palazzo* in what the German art historian Otto Mündler described as 'modern Milanese taste', a series of rooms of fantastic ornateness. These rooms were in the style of neo-everything: Romanesque, Moorish, medieval and Renaissance. Alas, they were all destroyed in 1943 and for the most part rebuilt after the war in a pleasant, if much more sober, manner (except the Dante Study, the only fully reconstructed room), to Poldi Pezzoli's original scheme. The guidebook is particularly beguiling in this respect, as it describes each room as it was before 1943. There was one further interruption, in 1859, for the second Italian war of independence, when Poldi Pezzoli fled again to Switzerland. By the time he returned not only had his mother died, allowing him full use of the *palazzo*, but Italian unification had taken place.

Poldi Pezzoli was in the right place at the right time during the Risorgimento. Italy was enjoying an extraordinary period of confidence and a revival of interest in its past, which greatly stimulated collecting and scholarship of Italian art. Milan was at the centre of this intellectual movement and Pezzoli enjoyed the advice of several of the greatest antiquaries of the time: Giuseppe Molteni, Giovanni Morelli (the pioneer of scientific method in connoisseurship), Giuseppe Baslini and, most important of all, the painter Giuseppe Bertini,

who designed many of the museum's rich interiors and was its first Director. Tuscan art was the most fashionable in the 1860s, and Poldi Pezzoli was able to acquire some very fine examples despite the strong competition from the growing English and German museums. He was also active in encouraging contemporary arts and crafts by exhibiting his collection as well as commissioning craftsmen for his elaborate decorative schemes.

There is a huge variety of decorative arts. The ground floor of the museum contains specialist collections: the arms and armour room, with its natural emphasis on spectacular sixteenth-century Milanese armour, and three rooms devoted to tapestries, carpets, lace and fabrics. Two treasures in particular must be mentioned: the late fifteenth-century cope hood showing the Coronation of the Virgin, to a design by Sandro Botticelli; and a Persian carpet, one of the very few surviving examples securely dated to the mid-sixteenth century.

The staircase strikes a Baroque note. An elaborate oyster-shell fountain, designed by Pezzoli's friend Bertini, six Baroque statues by Carabelli and three large Magnasco landscapes whirl the visitor up to the first floor. Here is the Bruno Falck collection of clocks and watches, and rooms containing collections of bronzes, compasses and navigational materials. It is difficult to think of many areas in which Poldi Pezzoli did not collect or that were not later acquired by the museum. There is a distinguished *Schatzkammer* with a particularly good group of Limoges caskets, crucifixes and enamels. Other rooms contain a bust by Algardi of *Ulpiano Volpi*, two important seventeenth-century Neopolitan cabinets, some good Rococo furniture and a fine collection of Meissen porcelain.

Francesco Guardi
A Gondola on the Lagoon
c. 1780
oil on canvas
31 × 42 cm

Givanni Battista Cima da
Conegliano
Theseus Killing the Minotaur
late 15th/early 16th century
oil on panel
38 × 31 cm

The paintings, for which the collection is most famous, begin with the Lombard Galleries. Here we may observe the growth of this school from gold-ground painting through to the sixteenth century, with important examples by Vincenzo Foppa, Andrea Solario and the Milanese followers of Leonardo da Vinci, including Boltraffio and Luini. They represent a respectable showing of Poldi Pezzoli's slightly disappointing local school. There is a good Venetian room, with several works by G. B. Tiepolo, an unusual Canaletto of Padua and a beautiful twilight Guardi of A *Gondola on the Lagoon*, almost like a Whistler nocturne. Next door we find Perugino's *Madonna and Child with Angels* and three paintings by Cima, including his very appealing *Theseus Killing the Minotaur*, and, beyond, a fifteenth-century room containing works by Daddi, Crivelli and Bastiani.

The heart of the museum is without doubt the Golden Room, where the greatest paintings in the collection are to be found: the profile *Portrait of a Lady* attributed to Pollaiuolo, Giovanni Bellini's *Imago Pietatis* and Piero

Piero della Francesca
St Nicholas of Tolentino
c. 1465
oil on panel
139 × 59 cm

Antonio Pollaiuolo (attrib.)
Portrait of a Lady
late 15th century
tempera on panel
45 × 33 cm

della Francesca's grave and beautiful *St Nicholas of Tolentino,* part of a polyptych (along with the *St Michael* in the National Gallery, London), executed for the high altar of San Agostino in Borgo San Sepolcro, which Vasari says was much praised. Here is also one of the most beautiful of all Botticelli's *Madonna and Child* paintings and the very last painting Poldi Pezzoli bought a few days before his death, Botticelli's *Lamentation,* which was found lying on a floor. Although Morelli himself bought the Mantegna *Virgin and Child,* I can't suppress the irreverent feeling that the Virgin is about to throttle the child. From the Renaissance the collection leaps to the Trivulzio Room, where we meet good Baroque paintings by Magnasco, Ribera and Strozzi.

The Poldi Pezzoli is probably most famous for a painter very different from all of these, Vittore Ghislandi, known as Fra' Galgario. There is an entire room devoted to his work, which offers the greatest surprise of the collection.

Sandro Botticelli
Madonna and Child, c. 1483
tempera on panel
58 × 40 cm

Vittore Ghislandi
*A Portrait of a Knight of the
Constantinian Order*, c. 1740
oil on canvas
109 × 87 cm

Ghislandi was the leading portraitist of north Italy during the
first half of the eighteenth century, and most of the portraits in
the collection are of solid old gentlemen who offered little
scope for stylistic elaboration. But when he came to *A Portrait
of a Knight of the Constantinian Order*, he created the most
famous of all eighteenth-century Italian portraits, an
astonishing image that seals in our mind forever the image of
decadent aristocracy. Interestingly, it is painted in almost
monochromatic tones of blue, grey and white, with a dash of
red ribbon. It is a swagger portrait *par excellence*, sensual and
effeminate, almost to the point of being comical.

Poldi Pezzoli died a bachelor in 1878, at the age of only 56,
probably of a heart attack, in the Dante Study. He left his
collection to a foundation, sensibly allowing treasures to be
added at the discretion of the Director. If Poldi Pezzoli came
back today, he would find that many fine purchases and gifts
had augmented his original bequest, but this would only
partly console him for the loss of all his fine rooms by Bertini
and Scrosati. It remains, however, the best patrician
collection of its type in Italy, and an oasis of calm and pleasure
in the middle of a hectic city.

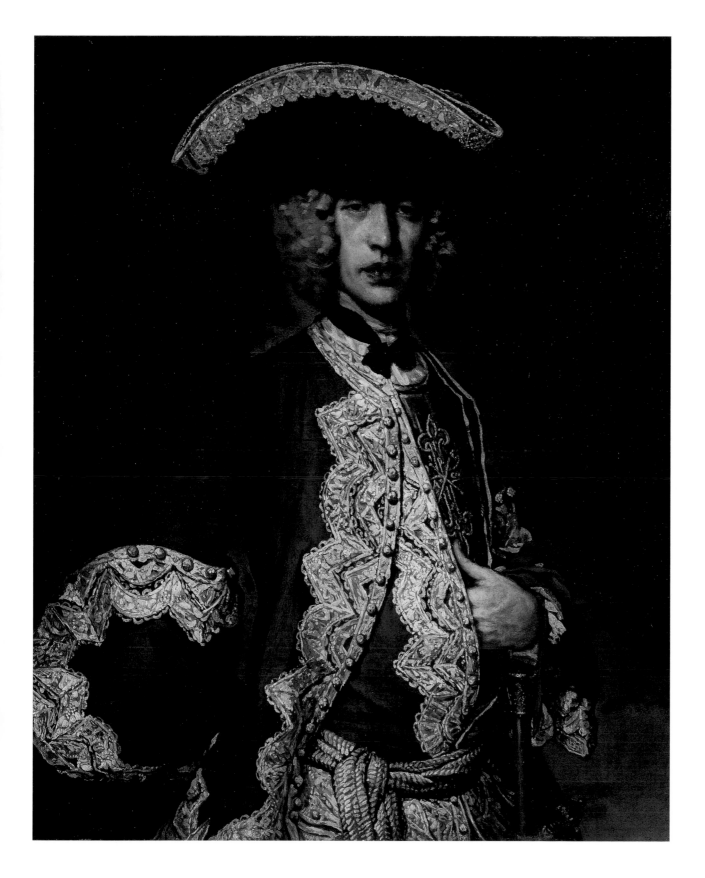

CA' REZZONICO

VENICE

One of the greatest and rarest pleasures of Venice is to see inside a furnished *palazzo*. As we sail down the Grand Canal, our curiosity is aroused, and for the most part we can only imagine what lies behind their beautiful façades. Canaletto left us no record of their interiors, and Venetian nobility do not open their palaces. Although some are open to the public as museums or exhibition centres, there is only one on the Grand Canal where you can see exactly what a

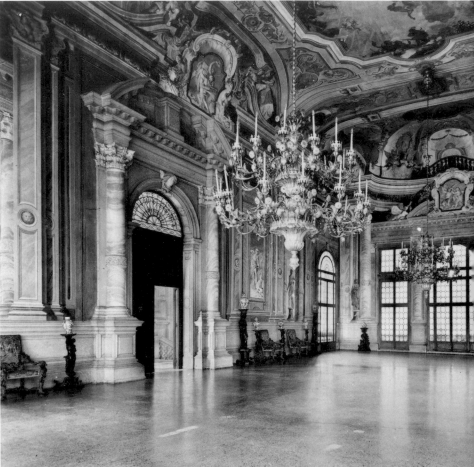

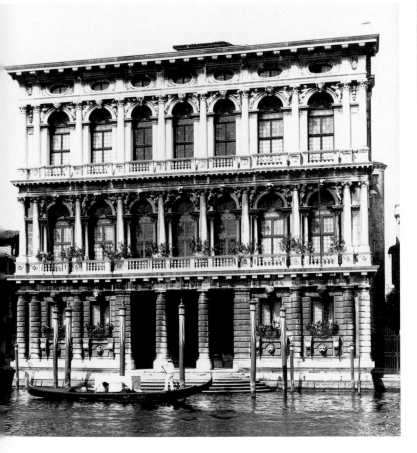

great *palazzo* looked like in the eighteenth century. Although this is now a municipal museum, it is so skilfully put together that you might reasonably believe that this is how the Rezzonico family left it – which is far from being the case.

For most visitors the sun shines brightest on the sixteenth century in Venice, the city of Palladio, Titian and Tintoretto. The decline of Venice was long and slow, but artistically the city had an extraordinary eighteenth-century sunset, the age of Tiepolo, Guardi, Canaletto and Longhi, an age when Venice was politically inconsequential, the foreigners were already taking over and Venetians had taken to hiding behind their domino masks. Nowhere can this splendid twilight be seen to better advantage than in the Ca' Rezzonico, now the city museum of eighteenth-century Venice.

The Ballroom

The Ca' Rezzonico,
from the Grand Canal

Giam Battista Tiepolo
The ceiling of the Nuptial
Allegory Room, c. 1760

144

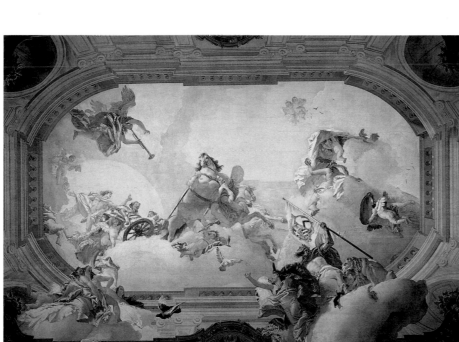

Conceived in the 1660s as a *bella figura* for the Bon family, the *palazzo* was begun by the greatest of Venetian Baroque architects, Baldassarre Longhena. When the Bons fell from fortune, the unfinished building was picked up by the fabulous Rezzonico family. They were Lombard bankers, whose appearance in Venice from the mid-seventeenth century was like a brief and brilliant firework. They bought their way into the Venetian aristocracy, took over the unfinished *palazzo* in 1751 and seven years later reached their apogee with the election of Carlo Rezzonico as Pope Clement XIII. Within little more than half a century they had disappeared completely.

The Rezzonico family engaged Giovanni Massari to finish the *palazzo* in a princely manner, and this is immediately evident from the staircase which leads the visitor straight into the enormous ballroom, the grandest eighteenth-century room in Venice. The *trompe l'oeil* fresco decoration, by G. B. Crosato, assisted by Pietro Visconti, is a triumph of fantasy and architectural whimsy. The *palazzo* was fully restored in 2000–01, and all the rooms on the *piano nobile* have been redone with well-chosen silk, damask and velvet to enhance the paintings and furniture. This series of grand rooms is beautiful on its own but also contains fine ceilings, some by G. B. Tiepolo. The best of these is the Nuptial Allegory Room, a sweet confection of trumpets and white horses, to celebrate a Rezzonico wedding into a noble Venetian family. Beneath this, sitting on an easel, is a fleshy portrait of *Clement XIII* by Anton Raphael Mengs. There is a pretty pastel room with works by Rosalba Carriera, but where the Ca'

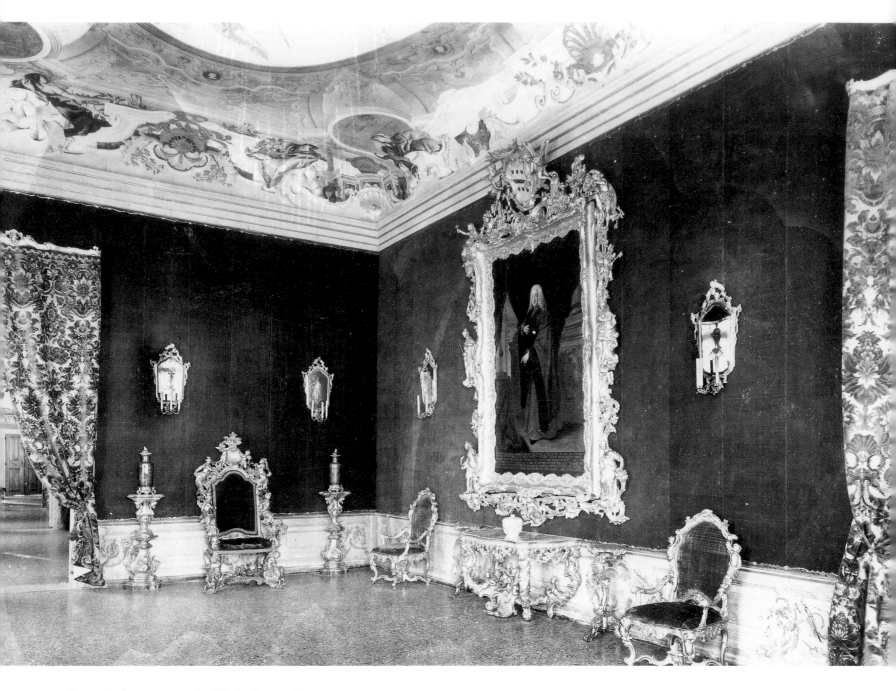

Rezzonico becomes most itself is the Throne Room, a great
trumpet blast of red velvet and gilt furniture. In the
middle of it all is a portrait of Pietro Barbarigo, but the
show-stopper is a frame of such exuberance that it
upstages everything else. It used to be attributed to the
Este sculptor Antonio Corradini, as were the very
elaborate chairs, but they have all been shown to date
from the 1780s – surprisingly, in view of their Rococo
appearance.

The Throne Room, with the
portrait of Pietro Barbarigo

Andrea Brustolon
Chair
1706

Pietro Longhi
The Rhinoceros, c. 1751
oil on canvas
62 × 50 cm

Apart from the ceilings, it is generally the furniture on the *piano nobile* that is memorable, and this is largely because of the work of Andrea Brustolon, a sculptor who designed furniture. There is a room devoted to his astonishing set of masterpieces of eighteenth-century Veneto woodcarving. The centrepiece is a console plant-stand, supported by an *Allegory of Strength* in ebony and boxwood. Twelve matching chairs are held up by blackamoors, but each one is made differently and they present a dazzling imaginative scheme in which the sculptor got the upper hand over the furniture maker.

The most important part of the painting collection is on the second floor, where in the *portego* we are introduced to many of the great names of eighteenth-century Venetian painting: Luca Carlevaris, Zuccarelli, Antonio and Francesco Guardi, Pellegrini, Zais, Marco Ricci and Piazzetta. There are two rich and brooding early views of Venice by Canaletto, but the painter who tells us most about life in eighteenth-century Venice is Pietro Longhi, and there is an entire room devoted to his work. It is a set of 28 scenes from everyday life, one of the glories of the museum. Some, such as *The Rhinoceros,* are very famous, but all are colourful, amusing and wonderfully observed. In another delightful room hang two early masterpieces by Francesco Guardi,

Francesco Guardi
The Nuns' Parlour at San Zaccaria
late 1750s
oil on canvas
108 × 208 cm

Francesco Guardi
*Ridotto of Palazzo Dandolo
at San Moisé*
1755
oil on canvas
93 × 174 cm

Giandomenico Tiepolo
The New World, 1791
fresco
205 × 525 cm

Giandomenico Tiepolo
Two Men and a Woman Walking
(detail from *The Promenade*)
late 18th century
fresco

The Nuns' Parlour at San Zaccaria and the *Ridotto of Palazzo Dandolo at San Moisé*. Nothing conveys better the high noon of eighteenth-century Venice than these two ravishing but rather strange paintings. The first shows visiting time at this apparently very profane convent, where people of fashion meet and talk through the grille, while children watch a puppet show. The second represents a masked ball which has all the sinister excitement of *Don Giovanni*.

Perhaps the most interesting of all the paintings in the collection lie in a small series of rooms at the back of the second floor which reconstruct a fresco cycle by Giandomenico Tiepolo. He was the son of G. B. Tiepolo, the greatest ceiling painter of eighteenth-century Europe, and for a long time his father's assistant and collaborator in the days when art in Italy was still a family business. At the end of his life Giandomenico painted, entirely for his own pleasure, a set of wall frescos in the Tiepolo family villa at Zianigo on *terra firma*, which make fun of a lifetime spent painting gods and goddesses. Some are subtly subversive, such as the haunting *New World,* in

which the characters have their backs turned to us watching a peep show, but there in the corner a Pulcinello is looking mischievous. Other panels confirm this sense of gentle parody, a trio in the spirit of *Candide* walking confidently towards the future. But is that man in the tricorn hat, who has turned his head, winking at us? The Pulcinellos certainly are, and in the farthest room they have the show all to themselves: dancing, flirting, feasting and playing acrobatics, but as in the early tapestry cartoons of Goya, the Rococo has already turned macabre,

and the eighteenth century has come to a close.

The Ca' Rezzonico generally brought bad luck to its owners. The history of the *palazzo* after the Rezzonico family was chequered, and nobody could really afford to maintain it. The most surprising resident was Pen Browning, the English painter who was such a disappointing offspring of the brilliant union between the poet Robert Browning and Elizabeth Barrett. 'Don't be a little man in a big house', his father told Pen, but the advice was ignored and he bought the *palazzo*. Henry James, who was a frequent visitor, caustically observed that even 'ushering in friends from pensions won't fill it'. The *palazzo* languished and passed from owner to owner. By the end of the nineteenth century it had became dilapidated, although a number of famous artists had studios there, including Whistler, Boldini and Sargent. Cole Porter rented the *palazzo* in the 1920s but even that couldn't revive it, and it went into Venetian city council ownership in 1935. Treasures were brought in from all over Venice by Nino Barbantini, who arranged them with Giulio Lorenzetti, the first director and author of the guide to Venice. Today, restored and refilled with works of art, the *palazzo*, which even at the lowest point of its history was described by Henry James as 'this great seventeenth-century pile, throwing itself upon the water with a peculiar florid assurance', has never looked prouder.

MAURITSHUIS

The Mauritshuis is small and perfectly formed. The building is the seminal example of seventeenth-century Dutch domestic architecture and contains the greatest concentration of masterpieces of Dutch seventeenth-century painting outside the Rijksmuseum in Amsterdam. The collection is substantially the royal collection of the House of Orange, who became the stadholders and rulers of the Netherlands in the aftermath of the Dutch revolt. One of the surprises of the Mauritshuis is that the majority of the paintings were acquired in the eighteenth and nineteenth centuries, and even more surprising is the continuation of purchasing in the twentieth century at the same extraordinary level of quality. The result is a collection of highlights that to many people is the most perfect idea of a European small museum.

The early collections of the stadholders have been largely scattered. Willem the Silent, the hero and victor of the Dutch revolt, lost his greatest treasure, Bosch's *Garden of Earthly Delights,* when the Spanish carried it off, and it may be seen today in the Prado. The first real collector in the family was William's son Frederick Henry (1584–1647), who had the benefit of one of the most intelligent advisers ever given to a ruler, Constantijn Huygens, who negotiated several Rembrandt commissions on his behalf. Alas, there are very few paintings today in the Mauritshuis from Frederick Henry's time, since his wife, Amalia van Solms, gave much of the collection to her four daughters. Their grandson Willem III became by marriage king of England, and is better known to history as William of Orange. He devoted the majority of his patronage to his great rebuilding projects in Britain, but he took a number of paintings from the English royal collection to his palace, Het Loo, which eventually came to the Mauritshuis. These included

Holbein's *Portrait of Robert Cheseman* (1533) and Dou's *Young Mother* (1658); the latter was in fact given to Charles II of England by the Dutch States General. William of Orange's cousin, who became Willem IV (1711–1751), had a strong inclination towards seventeenth-century cabinet artists such as Dou, van Mieris and Schalcken, but he made two spectacular purchases out of this mould: Rembrandt's *Presentation in the Temple*, which today is called *Simeon's Song of Praise,* and Paulus Potter's *Young Bull*, for many years the most celebrated painting in the collection.

His son Willem V (1748–1806) was mainly a collector of gems, coins and medals, but he made one crucial purchase in 1768, when he bought the Govert van Slingerlandt collection *en bloc*. This brought to the Mauritshuis great works by Rubens, Rembrandt, Holbein, Metsu, Potter and Steen, in a purchase that is sometimes seen as its founding moment. Shortly afterwards, in 1771, Willem V bought two houses on the Buitenhof in The Hague to create a picture gallery to show the collection to the public on a permanent basis.

Willem V had the misfortune to live during the Napoleonic era, and he lost most of the collection after the French invasion in 1795, when 193 paintings were taken to Paris. It was left to his son, who rather confusingly became Willem I King of the Netherlands, to press for their return. This eventually took place after the Battle of Waterloo, when 125 paintings were recovered as a result of the personal intervention of the Duke of Wellington. In 1816 Willem presented the entire collection to the nation, and four years later the Dutch state purchased the Mauritshuis in order to accommodate the king's gift.

A word on the history of the building. It was built by one of the Netherlands' most attractive heroes, Johan Maurits, Count of Nassau-Siegen (1604–1679), who was

Hans Holbein
Portrait of Robert Cheseman
1533
oil on panel
59 × 63 cm

View of the Mauritshuis
from the water

Jan Vermeer
View of Delft, c. 1660–61
oil on canvas
97 × 116 cm

Carel Fabritius
The Goldfinch, 1654
oil on canvas
33 × 23 cm

German by birth. He was brought up in The Hague during its golden age in the second decade of the seventeenth century and was a close friend of Huygens, who probably inspired his interest in architecture. Maurits was sent at the age of 33 to rule Brazil, which the Dutch had recently captured from the Portuguese, and took with him scholars and artists, two of whose works executed in Brazil can be seen in the museum today, Frans Post and Albert Eckhout. Maurits commissioned the house to be built in his absence, and Huygens supervised the architect Jacob van Campen and later Pieter Post (brother of Frans). By the time Maurits returned to the Netherlands in 1644 the house was virtually finished. Simple, classical, built in unpretentious brick, the Mauritshuis was a new kind of palace, and of such grace and perfection that it was for 50 years probably the most influential domestic building in northern Europe. Maurits lived in the house

only between 1644 and 1647, and after his death it was leased by the States General, who used it for hospitality. In 1704, when the Duke of Marlborough was staying, a fire destroyed the interiors; those seen today are of eighteenth-century origin.

To marry this masterpiece of seventeenth-century Dutch domestic architecture with the paintings of the golden age of Dutch art was an inspired idea, but when the museum opened in 1822 it still had no works by Hals, Vermeer, De Hooch, Hobbema, Ruisdael or Saenredam. This was soon rectified. The first Vermeer came later that year, when with Willem's support the museum bought the *View of Delft* for the enormous sum of 2,900 guilders. Willem I continued to be very active on behalf of the new museum and in 1827 purchased Van der Weyden's *Lamentation of Christ* (c. 1438) and Rembrandt's *Anatomy Lesson of Doctor Tulp* (1632). However, the Belgian

Jan Vermeer
Girl with a Pearl Earring
c. 1665
oil on canvas
44 × 39 cm

Jan Steen
Portrait of Margriet van Raesfelt (?)
known as *The Poultry Yard*, 1660
oil on canvas
107 × 81 cm

uprising of 1830 and its economic consequences precipitated a long, fallow period for the museum, from which it did not emerge until the appointment in 1889 of Abraham Bredius as Director. An internationally famous scholar, Bredius bequeathed his own collection to the museum in 1946; it included five Rembrandts, with the *Homer* (1663) among them.

Today the museum is divided, with mostly sixteenth-century paintings on the ground floor and the seventeenth century on the first. Apart from Willem I's Van der Weyden, on the ground floor, there are portraits by Hans Memling, Jan Gossaert (called Mabuse) and two by Hans Holbein that William of Orange brought from England. The first floor opens spectacularly with a room of Vermeer. There is the early history painting *Diana and her Companions* (c. 1655), purchased by the museum as a Nicholaes Maes and usually described as showing the influence of

Venetian art on Vermeer. Here we also have the great *View of Delft* (c. 1660–61), a mesmeric painting, larger than expected, in which Vermeer gives us the sober visual facts mysteriously reinterpreted into great art. Then there is his *Girl with a Pearl Earring* (c 1665), with that impenetrable stillness that surrounds Vermeer's human figures. In the same room are two luminous paintings by Pieter Saenredam, *The Interior of the Church of St Cunera, Rhenen* (1655) and the *Mariaplaats with the Mariakerk in Utrecht* (1659). Finally there is one of the smallest and most appealing of all Dutch paintings, Carel Fabritius's *The Goldfinch* (1654).

The next room is devoted to the work of Jan Steen. The Mauritshuis owns 13 of his works of the highest quality, but two stand out. *The Oyster Eater* (1658–60) is his smallest painting but was always one of his most prized, and passed through several famous Dutch collections.

Paulus Potter
Young Bull, 1647
oil on canvas
235 × 339 cm

Jacob Ruisdael
View of Haarlem, c. 1670–75
oil on canvas
55 × 62 cm

Frans Post
View of Itamaraca, 1637
oil on canvas
63 × 88 cm

Probably the most attractive Steen to modern taste is the *Portrait of Margriet van Raesfelt* (?) known as *The Poultry Yard* (1660), which has a picture-book quality, opening an enchanting window on to the young girl's life at a country house. In the same room are first-rate works by Van Mieris and Ter Borch, and Frans Hals's spontaneous *Head of a Young Boy* (c. 1627).

The Paulus Potter Room is dominated by his life-size *Young Bull* (1647). For years this was the most famous painting in the collection. It caused a sensation when exhibited at the Louvre in 1795, and the concentration of detail and hyper-realism still enthral modern visitors. There are many fine landscapes in this room by Hobbema, Van der Heyden, a De Koninck on long loan from the London National Gallery, and a moody Jacob Ruisdael *View of Haarlem* (c. 1670–75). One of the most fascinating is the *View of Itamaraca* (1637), by Frans Post, one of only seven known paintings made while the artist was out in Brazil with Maurits. He spent the rest of his life painting views of Brazil from memory, but this is the earliest known of his views actually painted in Brazil (on loan from the Rijksmuseum).

The collection of 14 Rembrandts is for many the climax of the Mauritshuis. From the end of the artist's Leiden period is *Simeon's Song of Praise* (1631), an important painting where, although the influence of Lastman is still discernible, the drama and light are recognisably Rembrandt. The following year he painted the celebrated *Anatomy Lesson of Doctor Tulp,* which established his reputation in Amsterdam. Rembrandt once more uses light to dramatise the subject: the intense brightness of the body, the riveted concentration of the onlookers and the studied calmness of Doctor Tulp himself. This was a new kind of group portrait, atmospheric, quizzical and

Rembrandt van Rijn
The Anatomy Lesson of Dr Tulp
1632
oil on canvas
169 × 216 cm

Rembrandt van Rijn
Self-portrait, 1669
oil on canvas
63 × 58 cm

Rembrandt van Rijn
Susanna, 1636
oil on panel
47 × 39 cm

Pieter van Anraad
*Still Life with Earthenware,
Jug and Pipes*, 1658
oil on canvas
67 × 59 cm

psychologically tense. Then there is Rembrandt's *Susanna* (1636), which so puzzled Sir Joshua Reynolds when he saw it in Willem V's collection: 'It appears very extraordinary that Rembrandt should have taken so many pains and have made at last so very ugly and ill-favoured a figure; but his attention was principally diverted to the colouring and effect, in which … he has attained the highest degree of excellence.' There are several portraits by Rembrandt. The most moving is the *Self-portrait* (1669), the last of Rembrandt's series of self-portraits, which has been described as the greatest autobiography ever presented to posterity.

If I have failed to mention many masterpieces at the Mauritshuis, it is simply a question of where to stop. The still lifes are a separate study with perfect examples by (among others) Claesz, Bosschaert, Van der Ast, De Heem and Adriaen Coorte, and a recent acquisition: Pieter van Anraadt's almost Vermeer-like *Still Life with Earthenware, Jug and Pipes* (1658). Purchasing at the Mauritshuis continues at this high level. In 1999 the museum bought from an English private collection Rembrandt's *Portrait of an Elderly Man* (1667).

The Mauritshuis today provides the most agreeable introduction to Dutch seventeenth-century painting anywhere. The explosion of talent that took place within eight or nine towns after the foundation of the Dutch republic remains one of the miracles of Western art. It forms the basis of many of the world's finest museums, but after a visit to the Mauritshuis one cannot help feeling that the Dutch kept the best for themselves.

KRÖLLER-MÜLLER MUSEUM

GELDERLAND

It was hunting that first led the Kröller-Müllers to the Hoge Veluwe. This beautiful expansive forest in the Netherlands' largest nature reserve in the province of Gelderland, one and a half hours east of Amsterdam, is the setting of the Rijksmuseum Kröller-Müller and sculpture park. The Kröller-Müller comprises two collections: the first is that formed by Helene Kröller-Müller between 1907 and 1939, which primarily covers European paintings from the Barbizon school up until the

Helene Kröller-Müller

Second World War. The second collection was a brilliant solution to extend the museum, making use of the natural setting without disturbing the integrity of the first collection: the creation of a sculpture park in the forest, which picks up where Mrs Kröller-Müller left off.

The Kröller-Müller fortune began with Helene's father, Wilhelm Müller, who started a shipping and trading firm in Düsseldorf. He opened a branch in Rotterdam and appointed Anton Kröller as its manager. In 1888 Kröller married his boss's daughter Helene, and when her father

died the following year, Kröller found himself in charge of the firm, aged 27. Helene chose well because he was not only a good businessman who turned the firm into a mighty international concern but also a sympathetic and generous husband who vastly indulged his strong-minded wife in her passion for art.

This passion was born, or at least stimulated, in the autumn of 1906, when Mrs Kröller-Müller attended art appreciation classes by the Dutch art historian H. P. Bremmer. He opened her eyes, and was to remain 'my adviser on all aesthetic matters'. As always with Mrs Kröller-Müller, the relationship had its ups and downs, and after a particular down she wrote to soothe him in somewhat exaggerated terms: 'Your share in my collection was greater than mine. You were the guiding force, I was only the instrument and possessed the courage and patience to defend your insights.' It was courage more than anything else that Mrs Kröller-Müller needed in 1907, when, stimulated by Bremmer's classes, she made her first purchases of modern art. She began fairly conservatively with the Dutch artist Paul Gabriël's *Il Vient de Loin* (c. 1887) but the following year bought her first painting, *Faded Sunflowers* (1887), by the artist with whom more than any other her name would be associated, Vincent Van Gogh. It is unusual in his oeuvre as a symbol of decay, but has all the power and intensity of vintage Van Gogh.

The collection grew at an astonishing rate. Bremmer acted as scout and agent, and 1911–14 were heady years for the growth of the collection. Nineteen-twelve was annus mirabilis, and something of this excitement is conveyed by the visit to Paris that year by Mrs Kröller-Müller with Bremmer. She described Bremmer buying five paintings in a morning: 'he bought them with an offer

Vincent Van Gogh
Faded Sunflowers, 1887
oil on canvas
60 × 100 cm

Claude Monet
The Artist's Boat, 1874
oil on canvas
50 × 65 cm

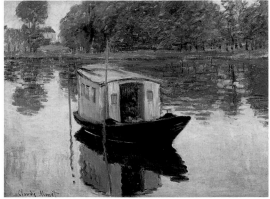

– a third of the asking price – and he went out trembling like a leaf, so pleased was he with this haul.' After lunch he bought two more Van Gogh drawings and a Seurat. The next day they visited Signac together, from whom they bought a painting and another by Seurat. They left Paris with six paintings by Van Gogh.

Mrs Kröller-Müller was something of an intellectual. She began to build on Bremmer's teaching some ideas of her own, and in this she was influenced by the physiologist Max Verworn. *Spiritus et materia unum* was her motto: spirit and matter are one. She divided artists into *realists* and *idealists*. Millet, Courbet and the Impressionists were realists whereas, typically, the Cubists and Symbolists were idealists; and she saw the history of art as an oscillation between these two in accordance with the 'spirit of the age'. The only problem was that Van Gogh, at the centre of her collection, did not fit these definitions, but she allowed that 'there are great spirits of our modern art on whom the spirit of the age had no hold'. She put these ideas into a book published in 1925, *Observations on Problems in the Development of Modern Painting,* which was both an attempt to understand intellectually what she felt instinctively, and a justification of modern art and her collecting to a still hostile and incredulous world.

The idea of a museum grew out of her desire in 1910 to build a new country house at Ellenwoude with galleries for the collection. She commissioned several architects,

including Mies van der Rohe, to make designs, but rejected them all. In the meantime Anton Kröller had bought the hunting estate at the Hoge Veluwe, and between 1916 and 1919 he commissioned H. P. Berlage to build the extraordinary modernist shooting lodge St Hubertus, which today is also open to the public. The beauty of this forest worked its magic. The Kröller-Müllers decided to transfer their Ellenwoude plans to the Hoge Veluwe, and Henri van de Velde came from Weimar to take over the project. His ambitious first scheme was started in 1920, but an economic crisis halted work the following year and there the matter remained until 1935, when the Kröller-Müllers handed the entire collection over to the Dutch state on condition they supplied the building. Van de Velde produced a temporary building, which is rather a shock: austere, windowless, strictly utilitarian and by modern standards very closed in. It was, nevertheless, so successful internally with its simple, top-lit white galleries that it has never been replaced.

The collection opens with three rooms of Mexican, Oceanic and African art and Chinese ceramics, followed by a small group of mostly northern Old Master paintings. It picks up with the French nineteenth century, with Corot, Millet, Courbet, Fantin-Latour and a small but distinguished group of Impressionist paintings. The most striking of these is Renoir's full length *The Clown* (1868), and the most typical is Monet's *The Artist's Boat* (1874), on the Seine at Argenteuil. The strongest element in Mrs Kröller-Müller's collecting was always Dutch (and occasionally Belgian) artists, and there are fascinating works by George Breitner that illustrate the cultural background of Van Gogh's painting.

Van Gogh's work is the glory of the collection. Today there are some 92 paintings and 183 drawings in the

Vincent Van Gogh
The Potato Eaters, 1885
oil on canvas
73 × 95 cm

Vincent Van Gogh
The Sower with Setting Sun
1888
oil on canvas
64 × 80 cm

Vincent Van Gogh
Interior of a Restaurant, 1887
oil on canvas
46 × 56 cm

museum, representing nearly every phase of the artist's
troubled life. Although he was to become the supreme
painter of dazzling and violent sun, Van Gogh began as a
dark painter. The desire to understand peasants, to
preach and to paint, the three motivating elements of his
early life, converge in his first set-piece painting in the
Netherlands, *The Potato Eaters* (1885) – 'I wanted it to
make people think of quite a different way of life from
that of us cultivated people.' Clumsy and awkward
though it is, Van Gogh set great store by this painting, had
it etched, and was disheartened by the criticism it
received. Fortunately for us, the urge to paint was too
strong for Van Gogh, and we can follow the agonising
fluctuations of his life in his letters to his brother Theo.

A year later he was in Paris and through his brother met
Monet, Pissarro and Seurat. We can observe the abrupt
changes of style in *Le Moulin de la Galette* (1886), and the
Interior of a Restaurant (1887), painted under the
influence of Seurat. Van Gogh never had the
temperament to go much further with the disciplined
techniques of 'divisionism', and by the summer of 1887 he
was weary of Paris: 'I shall retire to somewhere in the
south so as not to see so many painters who repel me as

Vincent Van Gogh
Café Terrace by Evening, 1888
oil on canvas
81 × 65 cm

people.' The following year he was in Arles, and there began the series of passionate canvases in which we can read both joy and intimations of tragedy. Landscape is often their theme – 'Je mange de la nature' – and we see this appetite in *The Sower with Setting Sun* (1888). The sun was not to set, however, but to shine with an ever greater intensity in the *Wheatfield with Reaper and Sun* (1889), which he painted from the window of the asylum at St Rémy after his depression had driven him to the edge of insanity. Van Gogh wrote to his brother: 'I am struggling with a canvas of a reaper … I saw in him an image of death in the sense that humanity is the corn that

is being reaped. It is therefore … the opposite of the sower I made earlier.'

One painting by Van Gogh that Mrs Kröller-Müller specially mentions was *The Olive Orchard* (1889), 'so tender and profound … in most people's eyes it will be the most beautiful painting because it does not disturb you in any way'. In fact that accolade has generally gone to the starry *Café Terrace by Evening* (1888), which Van Gogh described to his sister as 'a night picture without any black in it'. It remains the best-known and best-loved painting in the museum, although not many people outside the Netherlands realise it is there. There are also

Vincent Van Gogh
La Berceuse, 1889
oil on canvas
92 × 72 cm

Georges Seurat
Canal at Gravelines, 1896
oil on canvas
73 × 92 cm

several portraits by Van Gogh, his *Self-portrait* (1887) and the two showing the influence of Gauguin: *Monsieur Roulin* (1889), and his portrait of his wife, known as *La Berceuse* (1889), which Van Gogh said he wanted to be the kind of picture that 'a sailor who cannot paint might imagine when, out at sea, he thinks of his wife ashore'.

After Van Gogh the most memorable group of any artist's work in the museum is by Seurat. Starting with *Honfleur Harbour* (1886) we observe stillness develop through these silent paintings: *Sunday, Port-en-Bessin* (1888) and the *Canal at Gravelines* (1896), but then as if to surprise us, Seurat brings on the band and the dancing girls in the enchanting *Le Chahut* (1889–90). In fact, *Le*

Georges Seurat
Le Chahut, 1889–90
oil on canvas
169 × 139 cm

Odilon Redon
Screen with Pegasus, 1908
tempera on canvas
173 × 238 cm

Chahut, for all its gaiety, is as disciplined and scientific as a painting by Poussin.

Seurat was for a while admired by the Symbolists, and Mrs Kröller-Müller had a taste in this direction. She had a special affection for Odilon Redon and bought several characteristic works, including the dreamy *Screen with Pegasus* (1908). There are six paintings by Ensor and good examples of Maurice Denis and Puvis de Chavannes. Particularly interesting are the groups by the two Dutch artists Johan Thorn Prikker and Jan Toorop. The latter moves from the naughty-nineties symbolism of *The Vagrants* (1891) to the *pointilliste* divisionism of *The Sea* (1899). The Thorn Prikker paintings are pure Art

Jan Toorop
The Vagrants, 1891–2
Ink, chalk, crayon and
pencil on paper
65 × 76 cm

Piet Mondrian
*Composition No. 10
(Pier and Ocean)*, 1915
oil on canvas
85 × 108 cm

Nouveau. Symbolism reached its outer limits with Piet Mondrian, who was born in Amersfoort, not far away from the museum. It was Bremmer who first persuaded Mrs Kröller-Müller to buy his work in 1914, and for four years the artist was put on contract; but she lost interest when Mondrian went completely abstract. There is a fine group of his works from 1912 onwards. Mondrian painted *Composition No. 10 (Pier and Ocean)* (1915) for Mrs Kröller-Müller and wrote to Bremmer that 'it had been my intention to do it in colour, but I had no more time and I found that it nevertheless expressed what had to be expressed'.

Bremmer was an early promoter of Bart van der Leck, another Dutch artist who was on contract, and the museum

has the greatest collection of his work: 42 paintings and 400 drawings. In 1916 Van der Leck met Mondrian, an important meeting for both artists, and we can see Mondrian's influence in his *Composition 1917: No. 4*. Severini and the Italian Futurists are well represented and there is a strong group of Cubist paintings. Picasso, Braque and Léger are all present but Mrs Kröller-Müller particularly liked Juan Gris. There is a room with many small examples of his work, starting with his *Still Life with Oil Lamp* (1912).

Mrs Kröller-Müller died in 1939. She had already given to the museum 800 paintings, 5,000 drawings and prints and 275 sculptures. One can puzzle over the artists missing from the collection: no Matisse or Kandinsky, no

Juan Gris
Still Life with Oil Lamp, 1912
oil on canvas
50 × 34 cm

Bart van der Leck
Composition 1917: No. 4 , 1917
oil on canvas
95 × 102 cm

Surrealists, no Fauves and (Van Gogh apart) no Expressionists, but what is there is one of the finest collections of modern art in the world. We must also remember that it was one of the first. We can only marvel at how many winners Mrs Kröller-Müller picked. After her death the collection continued to grow and Henri van de Velde added the sculpture gallery, this time opening it towards nature with a huge window. The decision by the curators in the 1950s to extend the collection further into the forest was a very happy one. The Director of the museum, A. M. Hammacher, collaborated with the landscape architect J. T. P. Bijhouwer to design the first permanent sculpture garden in Europe – and still the best.

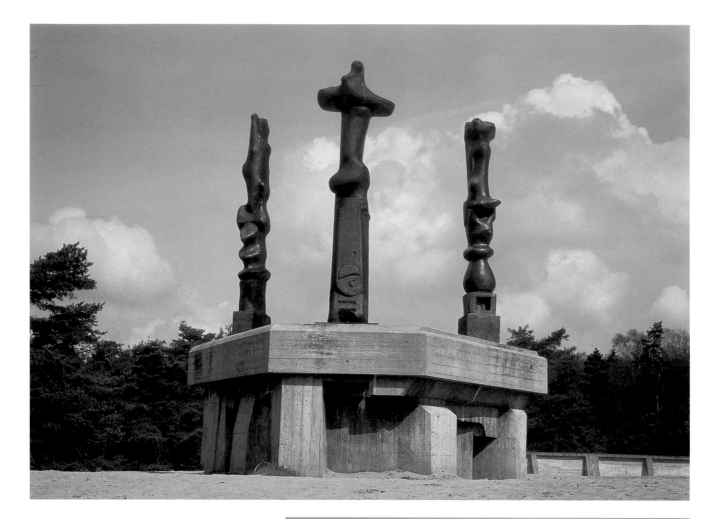

Henry Moore
Three Standing Motifs Nos. 1, 2 and 7
1955–6
bronze
height 334, 320 and 320 cm

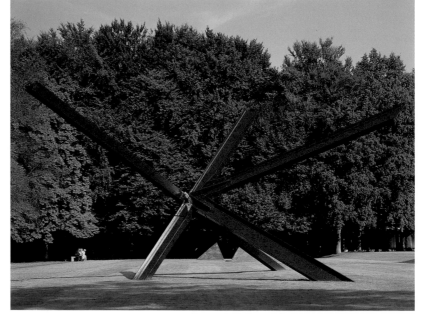

Mark di Suvero
K-piece, 1972
steel
12 × 12 × 6.3 m

Evert Strobos
Palissade
1973 (executed 1991)
steel
height 8 m

It begins with works by Rodin, Maillol and a good group of Lipchitz but gets going in the 1950s and '60s. Barbara Hepworth is well represented, and Henry Moore chose his own setting for the powerful, totemic *Three Standing Motifs: Nos. 1,2,7* (1955–6), but it is the American construction sculptures that steal the show: Mark Di Suvero's emphatic *K-piece* (1972), Claes Oldenburg's huge *Trowel* (1971), and Kenneth Snelson's elegant *Needle Tower* (1968). Dutch sculptors hold their own with Evert Strobos's *Palisade* (1973) and works by Cornelius Rogge and David van de Kop. The largest work is Dubuffet's adventure playground *Jardin d'Émail* (1974) and one of the most intriguing corners of the forest is Ian Hamilton Finlay's historical pantheon *Five Columns for the Kröller-Müller* (1980–82), each one dedicated to a revolutionary.

The sculpture garden is a delight ,with over 100 works, put together with wit and style, an antidote to the high seriousness of Mrs Kröller-Müller's collection. What would she make of it all if she came back today? Fortunately she gave us the answer: Seeing modern things always has a very painful side, because they throw us off balance inwardly, almost subvert us, and compel us to look at the old afresh, to fathom the new and to estimate both at their true value. In all probability as a result, one may have to bid farewell to much that one previously thought beautiful.

Claes Oldenburg
Trowel, 1971
painted steel
11.7 × 3.65 m

Jean Dubuffet
Jardin d'Émail, 1974
20 × 20 × 30 m

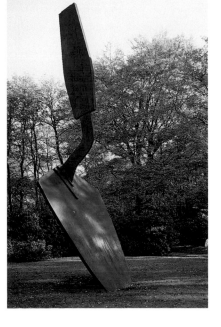

The Princes Czartoryski Museum

Maria Cosway
Princess Izabela Czartoryksa, 1790?
oil on canvas
84 × 42 cm

The Czartoryski Collection has the most dramatic history of all the museums in this book and introduces us to the most remarkable woman, Princess Izabela Czartoryska. That the collection survived at all must be regarded as extraordinary, but the fact that it survived with two of the greatest masterpieces of Western art is nothing short of a miracle. Its history is an accurate reflection of the story of Poland over the last 200 years and reveals the same irrepressible spirit and resilience.

The Czartoryski family was one of the two or three most eminent in Poland. Princess Izabela was married in 1761 at the age of 15 to Prince Adam Kazimierz Czartoryski, a bookish intellectual who allowed his wife free rein. She

was not a beauty but a woman of sensibility and great charm, with curiosity, imagination and a passion for travel. In Paris she met Benjamin Franklin and Jean-Jacques Rousseau (in whose company she found herself tongue-tied) and became intimate with Marie-Antoinette, but by the 1790s, with the second partition of Poland, her thoughts and energy turned to patriotic fervour. Under the Russian occupation the Czartoryski family saw their country estate at Puławy ravaged, and when they returned in 1796 Princess Izabela hit on a novel and effective way of continuing the cause of Polish freedom by other means: a national pantheon and shrine of Polish history and endeavour. She built a hall of memory in the park at Puławy, in the form of an enlarged version of the temple of the Sibyl at Tivoli on a romantic bluff overlooking a tributary of the River Vistula. It was opened to the public in 1801 and inscribed above the entrance was 'The Past to the Future'. As the political and military situation deteriorated further, the temple became the refuge for many national treasures. There were military banners, a casket containing relics from royal tombs, and many objects of a talismanic nature to Polish history.

As the museum filled up, the need for more space prompted the creation of the 'Gothic House', which owed

The Temple of Sibyl at Pu?awy

The Gothic House at Pu?awy

Raphael
Portrait of a Youth, c. 1515
oil on board
75 × 59 cm

something to Princess Izabeła's travels in England and Scotland and her interest in the Ossianic legend. It was more international in flavour and contained among other things, 'Shakespeare's chair', stones from Petrarch's house, a nail from the Bellerophon and so on, and bore an inscription from Virgil: 'Objects weep tears and, though dead, can still arrest the heart.' The fame of Princess Izabeła's project spread and people began to send her objects, both authentic and dubious, from all over Europe, including such items as George Washington's teacup and William Tell's crossbow bolt. Amid all these memorabilia many important works of art slipped in as illustrative of historical events. Generał Sokolnicki sent some important

manuscripts, but it was the Princess's own son, Prince Adam Jerzy, whose contribution will be chiefly remembered. In 1801 he sent her two paintings he had acquired in Venice – a *Portrait of a Youth*, possibly a self-portrait, by Raphael, and *The Lady with an Ermine,* by Leonardo da Vinci.

Princess Izabeła decided, after some head-scratching, that the two paintings *could* be accommodated in the scheme on didactic grounds, because although the Raphael sitter was unknown, the artist was famous enough to qualify for entry as 'an achiever'. The Leonardo was easier because she believed it to represent the mistress of Francis I of France, *La Belle Ferronière*, and he was a monarch whom the Francophile princess revered.

In 1830 disaster struck in the form of a Polish insurrection. The rebels proclaimed Prince Adam as their leader, but when the uprising failed, the Russians sacked Puławy. The Prince was forced into exile in Paris, and Princess Izabela retired to their estates in the Austrian sector, where she died four years later. Fortunately the majority of the objects in the museum had been spirited away in time to many friendly neighbours, both aristocratic and peasant, and – amazingly – survived to be eventually reunited. Meanwhile, in Paris, through the suggestion of the painter Delacroix via his friend Chopin, Prince Adam was able to acquire the most beautiful of all *hôtels particuliers*, the Hôtel Lambert, which became the international focus of Polish patriotism and liberty for the next century. Here were slowly gathered many of the displaced items from Puławy in what became the home of the collection until 1876. The element of make-believe at Puławy had been replaced in Paris by the realities of life for Polish patriots in exile.

The grandchildren of Princess Izabela, Prince Władysław and his sister Izabela, took up where she had left off and extended the collections at the Hôtel Lambert to include Greek, Roman and Egyptian artefacts. Prince Władysław also bought most of the medieval Schatzkammer material found in the collection today. History intervened again with the Franco-Prussian War of 1870, when the family moved to London with the smaller items from the collection, but by 1874 matters had sufficiently eased in Poland for the city of Kraków to offer Prince Władysław the old Arsenał building if he would consider returning the collection to Poland. He took the bait, acquired some adjoining properties and engaged Viollet-le-Duc's son-in-law Maurice Ouradou to create the curious Gothic-Renaissance building that opened in 1876 and remains the home of the collection today. A period of calm and consolidation followed, only to be interrupted by the First World War, when the most valuable objects, including the Rembrandt, Raphael and Leonardo, were shipped off to Dresden under the protection of the Saxon royal family. They returned in 1920 to a newly independent Poland and 19 years of peace until the convulsions of the Second World War. This proved to be far the most dangerous moment in the history of the collection.

In 1939 Prince Augustyn Czartoryski sent the collection for safe-keeping to his estate in Sieniawa, where the Germans arrived on 15 September. Initially they looted

The 'Augury Shield'
16th century
repoussé iron

Reliquary casket
c. 1250
Limoges

'Shakespeare's chair'
bronze and wood

the jewels but left the paintings, until Dr Kajetan Mühlmann was sent by Göring to Poland to find pickings for his personal collection. Mühlmann selected 85 items from the Czartoryski collection but was overruled by Hitler's own representative looking for masterpieces for the Führer's projected museum at Linz. He took the three famous paintings to Berlin. As the museum remained a long-term dream, the Nazi governor of Poland, Dr Hans Frank, took the paintings back in 1943 to his apartment in the Wawel at Kraków. They followed him in 1945 on his flight through Silesia until he was eventually arrested by the Americans at his villa at Schliersee, near Neuhaus. They found the Leonardo and the Rembrandt but not the Raphael, which has never been recovered and remains the greatest missing work of art from the Second World War.

The museum lost over 800 objects during the war, but peace brought fresh anxieties. It was still a private collection and had to adapt to the necessities of Communism. For a time the Rembrandt and the Leonardo were moved to Warsaw and the collection was incorporated into the National Museum. Things eased in the 1960s and by 1991, after a court ruling, the collection reverted to Prince Adam Karol Czartoryski, who created the foundation that owns the museum today.

The sprawling collection remains primarily a Polish shrine. It opens on the first floor, where most, but not all, of the rooms are dedicated to themes from Polish history. There are the shields of national heroes from Puławy, miniatures of the Jagiellon and Vasa dynasties of rulers, superb Polonaise carpets, as well as Turkish booty, which includes an important collection of armour. There is the sixteenth-century Italian shield known as the 'Augury Shield', showing the Emperor Constantine's victory in adopting Christianity, which was presented to Sobieski before his expedition to Vienna. The Treasury displays much of Prince Władysław's collection of decorative arts, with fine ivories, Limoges, enamel caskets, maiolica and silver. There is a room dedicated to Jean-Pierre Norblin, the family's French court painter, and further rooms of Polish heroes. The most curious are the galleries containing the sentimental objects from the Gothic House and the Temple of the Sibyl. Here are not only Shakespeare's but also Rousseau's chair, Voltaire's quill, the rosary of Cardinal Mazarin and so forth. One delightful corner charts the close relationship between the family and Chopin. The greatest surprise of the collection lies across a 'bridge of sighs', a large, spacious, rather modern gallery of antiquities, mostly the result of Prince Władysław's and his sister's purchasing.

The main object of pilgrimage for most non-Polish visitors will be the second floor, with its painting collection. This is eclectic and uneven. It contains a mixed bag from the Italian Renaissance through the Dutch

171

Leonardo da Vinci
Lady with an Ermine, c. 1490
oil on panel
53 × 39 cm

American soldiers with Leonardo's *Lady with an Ermine* in 1945

Rembrandt van Rijn
Landscape with the Good Samaritan
1638
oil on panel
46 × 66 cm

seventeenth century up to Polish and French eighteenth-century painting, with works by – or attributed to – Bouts, Ghirlandaio and Magnasco, among others. It also contains the two masterpieces, which outshine everything else.

The first description I ever read of Leonardo's *Lady with an Ermine (c.* 1490) was in Cecil Gould's 1975 book on the artist: 'She is of a kind familiar in the twentieth century – the highly intelligent, highly sophisticated, attractive, slightly neurotic young woman, who holds a responsible job with men as her subordinates. Everyone knows she is the mistress of a prominent statesman … She is often to be seen at high level parties, a glass of champagne in one hand, a cigarette in the others, and three or four men around her.' I wondered then if he was talking nonsense, but when I first saw the painting in 1994 my first reaction was that the portrait does accept this description. The easy sophistication of the pose makes it one of the first of all modern portraits. One might prefer to see the ermine as the badge of the girl's individual personality, but it is there as a symbol of chastity. Strangely the painting was not accepted as an autograph Leonardo until the beginning of the twentieth century. Today it vies with the *Mona Lisa* to be considered as his greatest portrait.

The Rembrandt *Landscape with the Good Samaritan* (1638) is one of a tiny handful of oil-painted landscapes by the artist. The stormy scene with shafts of light penetrating the gloom – 'like good deeds in a naughty world', as Shakespeare might have put it – is rendered in an extraordinary colour range, with yellow greens against dark browns and orange highlights. It is a dramatic imaginary world and one of Rembrandt's most mesmeric paintings. It was the first important object in the collection bought by the painter Norblin at auction in Paris in 1774, and brought to Poland the same year. If for nothing else these two great paintings justify a visit to Kraków.

The Czartoryski Collection is by any standards eccentric, and its history has certainly been more dramatic than most. Today Puławy is the Institute of Cultivation, Fertilisation and Soil Science, but the dream of Princess Izabela of a national shrine was more than realised.

CALOUSTE GULBENKIAN MUSEUM

LISBON

The Museu
Calouste Gulbenkian

Calouste Gulbenkian
in Egypt

The Gallery of French
18th-century Decorative Arts

Of all the founders of the museums in this book – with the exception of the artists Canova and Picasso – Calouste Gulbenkian was the most famous (and controversial) in his lifetime and the only one who walked the international stage. As the most feared oil tycoon of the 1930s, he could afford virtually anything he wanted, but he was a collector of extraordinary discrimination. The Calouste Gulbenkian Foundation in Lisbon, which became after many vicissitudes the home of his collection, falls naturally into two halves, an eastern wing, with an emphasis towards the arts of Islam, and a western wing, with an emphasis towards France in the eighteenth century.

The museum is full of masterpieces, but equally striking is the congruence that unites the secondary works of art. It is a museum where Iznik plates, Persian manuscripts, Mughal carpets and French bookbindings seem to have been born out of the same desire to transmute the designs of nature into art. It is no surprise to learn that Gulbenkian was the creator of several beautiful gardens. There are few small museums outside America that manage convincingly to show Eastern and Western art equally in an absorbing display and where the transition is both natural and complementary. This suggests brilliant collecting and good museum management.

Everybody agrees that the founder was a most formidable human being. Born in 1869 at Scutari in Turkey, Gulbenkian came from an Armenian family of minor Istanbul bankers. He was educated in England and lived in Paris until the Second World War, when he withdrew to Portugal, but the Middle East was the source of his fortune. As he once explained, his father advised him when he was young, ' "Calouste, do not look up; look down", so I looked down and I found oil.' He negotiated in 1920 a 5% share of the newly discovered oil fields in

Head of Sesostris III
Egyptian, 1872–1853 bc
obsidian
height 12 cm

Footed bowl
Persian
late 12th or early 13th century
Minai ware
diameter 20 cm

Iraq. This gave him an income of several million dollars, which he was to spend the rest of his life protecting. He became known as 'Mr Five Per Cent' and considerably added to his celebrity by living a reclusive life in a large fortified house on the Avenue d'Iéna in Paris, surrounded by treasures that few saw. He generally referred to these treasures as 'my children' but when asked why he never showed them to anybody, he famously replied that Orientals didn't unveil the women in their harem.

Gulbenkian's most brilliant purchases were from the Russian government between 1928 and 1930, when he managed to acquire treasures from the Hermitage. His patience and discretion enabled him to succeed where others failed and he carried off, among other things, the *Portrait of Hélène Fourment* by Rubens, two great Rembrandts and Houdon's statue of *Diana* (1780), as well as extremely important eighteenth-century French silver and furniture.

From the mid-1930s Gulbenkian did in fact begin to share his collection and made loans to the National Gallery and the British Museum in London, and later the National Gallery in Washington and some French museums. Any of them might have become the eventual home of the collection or part of it but for Gulbenkian's desire to avoid tax after his death and the advent of the Second World War. In 1940, a few days before the German arrival in Paris, Gulbenkian left the city and settled temporarily in Vichy, before moving to Lisbon, where he was to live for the rest of his life in the Hotel Avis. He died in 1955 and left his collection and fortune to a foundation based in Lisbon, which remains the richest of its kind outside America. Gulbenkian's lawyer Dr José

Perdigão had succeeded in overcoming formidable obstacles, and the museum we see today is largely his work. Gulbenkian was very conservative in architectural matters and it is doubtful whether he would have liked the brutalist-style museum building, by Albert Pessoa and others, opened in 1969. Unlike many buildings of this period, however, it has stood the test of time well and makes an appropriate background for the Islamic sections and a neutral, if slightly sombre, setting for the French decorative arts.

The collection opens with a room of Egyptian art, where Gulbenkian's taste for elegance is immediately evident with beautifully crafted small statues and objects. There is one exceptional piece, the *Head of Sesostris III* (1872–1853 BC) carved in one of the hardest known substances, obsidian, to protect the immortal remains in the afterlife. A room of Greek and Roman coins and medals, and a full-scale Assyrian relief from Nimrud, lead the visitor into the main gallery of Eastern art. This is a room of delights, where everything is of outstanding quality. First the eye is drawn to the Persian ceramics, largely from the twelfth to the fourteenth centuries, reaching the very high level of quality seen in the *Footed Bowl* of the Seljuk period (late twelfth- to early thirteenth-century). It is impossible to see the

ceramics in isolation from the superb manuscripts and their bindings, although generally of a later date, and of course the carpets. These were a special interest (and the first) of Gulbenkian, and they are so beautiful they cry out for attention. There is one Mughal floral carpet (seventeenth century) from Lahore, almost certainly made by Persian craftsmen, where the colours are so vividly preserved and the design so delicate that the garden becomes alive in the museum.

With Persian carpets and manuscripts Gulbenkian tended towards the Safivid dynasty (1501–1732), a period when, interestingly, it is believed that book illustrators became involved in carpet design and the introduction of silk greatly extended aesthetic possibilities. The collection continues with Turkish ceramics, mostly Iznik, which follow Gulbenkian's favourite Islamic garden theme. Typical are the *Tiles* (c. 1580) of tulips and hyacinths under a blossoming fruit tree, which resemble similar panels in the Topkapi Palace in Istanbul. Perhaps the most striking Turkish objects are the group of patterned silks and velvets from the sixteenth-century Ottoman period, mostly from Bursa, with rich and varied patterns in crimson and russet, with gold and silver.

Separating the Islamic art wing from Western art is a room of Qing Dynasty (eighteenth-century) Chinese ceramics, which appear very gaudy after the restrained elegance of their Persian and Turkish counterparts.

Western art opens with ivories and illuminated manuscripts; these include the beautiful English manuscript known as the *Gulbenkian Apocalypse* (c. 1270). The painting collection follows, with two fragments by Rogier van der Weyden and Dierick Bouts's *Annunciation* (c. 1420), one of the prizes of Gulbenkian's Russian negotiations. The Italian Renaissance section has paintings by (among others) Ghirlandaio, Cima and Carpaccio, but perhaps the most important works of art are the tapestries for the Gonzaga family of Mantua, entitled *Children Playing* (c. 1540), to the designs of Giulio Romano. These give some idea of the sumptuously rich surroundings of a great Renaissance court and remain the masterpieces of the brief and brilliant tapestry production in Mantua in the sixteenth century. There is an equally important mid-sixteenth-century Flemish tapestry of *Vertumnus and Pomona,* in a superb state of preservation.

The painting collection comes into its own in the seventeenth century, with Van Dyck's *Portrait of a Man* (1621) and Rubens's *Portrait of Hélène Fourment* (c. 1630–32), his second wife. Painted shortly after Rubens's remarriage in 1630, when he was 53 and she was 16, the portrait expresses the artist's pure delight in flesh and blood. Its brightness and joy are particularly evident as it hangs next to Gulbenkian's two great dark Rembrandts from the Hermitage. The *Portrait of an Old Man* (1645) is one of Rembrandt's moving studies of old

Mughal Carpet, Lahore
17th century
wool, cotton and silk
736 × 278 cm

Tile panel, Turkish
Iznik c. 1545
fritware
60 × 159 cm

Wall hanging, Turkish
Bursa, 16th century
silk velvet and silver thread
188 × 29 cm

Tapestry after cartoons
by Giulio Romano
Children Playing, c. 1540

Peter Paul Rubens
Portrait of Hélène Fourment
1630–32
oil on panel
186 × 85 cm

Rembrandt van Rijn
Pallas Athene, c. 1660
oil on canvas
118 × 91 cm

age, with an almost biblical drama, while next to it hangs one of the same artist's most personal and mysterious creations, the painting described as *Pallas Athene* (c. 1660) but also sometimes identified as Alexander the Great, Mars, Minerva and even as the artist's son Titus. Few works by Rembrandt have attracted such debate. Its shadowy androgyny has never been satisfactorily explained, although it is reasonable to suppose that the origin of the idea lies in Venetian painting and Giorgione.

There are further Dutch paintings by Ruisdael, van der Heyden and Jan Weenix, but the next highlight of the collection is the outstanding group of French eighteenth-century decorative arts. This includes silver, bronzes, textiles, porcelain, bookbindings and, above all, furniture, which is simply spectacular. There are pieces by many great makers, but the *ébéniste* who holds centre stage is undoubtedly Charles Cressent. The museum holds the greatest collection of his work outside the Residenz in Munich. He was the son of a sculptor, and a talented sculptor himself. In 1719 he was appointed the *ébéniste* of the regent, the Duc d'Orléans. His work has an extraordinary vitality and originality, and this is

Charles Cressent
Medal Cabinet, c. 1750
oak with exotic wood
marquetry and bronze
191 × 143 × 52 cm

Charles Cressent
Commode, c. 1745–9
oak and pine with exotic
wood marquetry, bronze
and marble
88 × 148 × 63 cm

Martin Carlin
Writing Table, c. 1772
oak, with exotic
wood marquetry,
porcelain and bronze
73 × 67 × 39 cm

immediately evident in the *Pair of Bookcases* (c. 1725) and above all in the *Pair of Medal Cabinets* (c. 1750), which have a Roman vigour and reveal what a great artist Cressent was. The bronze centrepieces show three putti minting coins, and each cabinet has 12 flanking medals of Roman emperors. Equally original are the *Pair of Commodes* (c. 1745–9), with lively bronze decorations of children pushing a monkey on a swing. These amazing bronze sculptures inevitably got Cressent into trouble with the furniture guild as he was finishing them in his own workshop.

If Cressent was the *ébéniste* for the regent, it was Riesener who was the favourite of Louis XV and Louis XVI, and there is here one of his famous roll-top desks. This example, as usual with superb marquetry, was made in 1773 for the Countess of Provence's chamber at Versailles. There are many other royal pieces in the collection, but one in particular deserves mention: the *Writing Table* (c. 1772) by Martin Carlin, with exquisite Sèvres porcelain plaques covering the entire surface, made for Madame du Barry's rooms at Versailles and which later Marie-Antoinette gave to her sister. Something Marie-Antoinette did not give away were the

extraordinary *Pair of Candelabra* (1788) by Pierre-Philippe Thomire that were made for her bedroom at the Petit Trianon.

Further masterpieces by Cressent, Carlin, Jacob, Dubois, Weisweiler, Riesener – to name only a few – make this museum something of a Mecca for lovers of French furniture. When it came to silver, Gulbenkian's taste ran to the grandest and most elaborate examples of silversmiths' art in Paris between 1750 to the 1780s, notably by Antoine-Sébastien Durand and François-Thomas Germain. These include the *Pair of Tureens* (1761) made by Germain for the Empress Elizabeth I of Russia. The eighteenth-century French paintings include Fragonard's ravishing *Fête at Rambouillet* (c. 1770) as well as very good examples by Lancret and Nattier. Best known are the two Hubert Robert paintings from the Hermitage showing the re-landscaping of the park at Versailles. Another Hermitage piece, and one of Gulbenkian's greatest purchases, is the sculpture of *Diana* (1780) by Houdon.

Collectors often have a weakness for a particular artist and allow themselves more works than they strictly need.

Lord Hertford and Greuze is a good example. With Gulbenkian it was Francesco Guardi. There is an entire room with 19 of his Venetian views and they are all of high quality. Even if you feel you have seen them all before, there is one that catches the eye – *The Rialto Bridge after the Design by Palladio* (c. 1770). There is a small group of English paintings. Gulbenkian had the conventional millionaire's taste of the time, fuelled by Lord Duveen, for Gainsborough, Romney and Lawrence, who are all present, but also good examples by Turner and a large, unexpected Burne-Jones: *The Mirror of Venus* (1875).

The French nineteenth-century painting collection has a very good group of Barbizon paintings, seven works by Corot and a substantial, rather conservative, group of Impressionist paintings by Manet, Monet, Renoir, Degas and others. The collection ends with a room of the work of René Lalique, the only contemporary artist Gulbenkian commissioned and befriended. One of the few pieces not bought directly from the artist was the *Dragonfly Pectoral* (c. 1897–8), perhaps his masterpiece, which so fascinated visitors to

Francesco Guardi,
*The Rialto Bridge after the
Design by Palladio*, c. 1770
oil on canvas
61 × 92 cm

Hubert Robert
*Felling the Trees at Versailles,
The Basin of Apollo*, c. 1775
oil on canvas
67 × 102 cm

René Lalique
Dragonfly pectoral, c. 1897–8
gold, enamel, chrysoprase,
chalcedony, moonstones and
diamonds
23 × 26 cm

the Paris 1900 exhibition and which Gulbenkian lent to Sarah Bernhardt. The elegant refinement of the jewels and glass by Lalique takes the visitor back to where he started, in the Egyptian room, and there is a pleasant feeling of having turned a full circle.

The archives of the Gulbenkian Foundation reveal the extraordinary trouble Gulbenkian took to inform himself about works of art. He would take copious notes about things he saw and, where possible, write these on the back of a postcard of the object. He was not one to trust to dealers, and his most constant refrain in life was 'check, check, check'. This scholarly attention to detail, combined with an Oriental *douceur de vivre* and the skills of one of the greatest negotiators of the twentieth century, have made the Gulbenkian one of the finest small museums in the world.

SALVADOR DALÍ THEATRE—MUSEUM

FIGUERES

'Here I am', said Dalí at Figueres shortly before he died, and that is nothing less than the truth. For anyone who wants to see or understand the phenomenon that was Dalí, this converted theatre in the town of his birth is the place to visit. It was General Franco, of all the unlikely people, who accurately forecast to Dalí: 'You will convert it into a Mecca of Western art.' Western art is an open question, but a Mecca it certainly is, as this hugely popular museum in some years has attracted more visitors than even the Prado.

The Dalí Theatre–Museum lies in the pleasant town square of this otherwise ugly town, an hour and a half north of Barcelona. The façade of the building is an attractive early nineteenth-century structure with all the clumsy elegance of a provincial opera house, and enhanced by some Dalíesque decorations. Inside, Dalí has created his own theatre of entertainment, loved by the public, viewed cautiously by the critics, a people's palace, popular, fun, teasing, and – above all – kitsch.

The story of the creation of the museum demonstrates all Dalí's qualities of unpredictability, imagination, charm and sheer zest, not to mention his extraordinary love–hate relationship with authority. He was the court jester who delights and infuriates in equal measure. Dalí was born in Figueres in 1904, the son of a radical local notary and a devout Catholic mother. He showed early talent and at 14 had his first collective exhibition in the foyer of the theatre, which, as he told a crowd years later at the opening of the museum, meant that the site must have been predestined. To British television in 1973 he was even more emphatic about its talismanic qualities: 'All my early remembrances and erotic events happened exactly in this place, and, for this, this is the most legitimate place for my museum to exist.' Apart from these adolescent stirrings, things did not really get going artistically for Dalí until he

went to the Real Academia de Bellas Artes de San Fernando in Madrid, where he was to meet Federico García Lorca and Luis Buñuel. He was expelled from the Bellas Artes in 1923 and returned to Figueres, where he was imprisoned for a month for revolutionary ideas. Surprisingly, he did military service at Figueres in 1927 and a year later went to Paris, where he joined the Surrealist movement. Above all, he got to know Gala, the wife of the Surrealist poet Paul Eluard. The movement had been founded in Paris in 1924 by the French poet André Breton to tap the creative and imaginative forces of the

The main entrance to the museum, with the Geodesic Dome

Salvador Dalí
Christ of Limpias, 1982
mixed media
height 52 cm

Salvador Dalí
Retrospective Bust of a Woman
1970 (original 1933)
painted bronze
70 × 50 × 35 cm

mind at their source in the subconscious. Freud lay at the bottom of the movement, and it was later said that Dalí would speak about him in the way a Christian might speak about the Apostles.

Dalí left Paris with Gala, scandalising nearly everybody, especially his family. She was Russian, many years older than Dalí, and provided the strength, both erotic and emotional – not to mention the practical sense, ambition and ruthlessness – that enabled him to develop. Gala was described by Reynolds Morse, who knew them both well, as 'part tiger, part martyr, part mother, part mistress and part banker'. She out-Dalíed Dalí, and their relationship developed a strongly sado-masochistic element. Towards the end of his life, when he had installed her in Púbol Castle, where she could entertain young lovers, he proudly told a reporter he needed her written permission to enter the premises. For all this, she remains shadowy, as she never spoke publicly about Dalí. The theatre–museum project to some extent provided Dalí with a distraction from his part rejection by her. She remained ambivalent about the project.

Dalí's relationship with his home town was virtually non-existent while his life took him around the world, and Gala had said publicly that she disliked the place. This might have remained the situation, but in 1960 Figueres elected a new mayor, Ramón Guardiola, a lawyer who felt it was odd that the local museum possessed nothing by its most famous son. The omission was generally put down to Gala's meanness, but the locals regarded Dalí as half mad anyway. Guardiola approached him, suggesting a room might be devoted to him in the local museum, but the message came back that he wanted a whole museum, and furthermore that he had identified the site: the old theatre. Since Dalí's teenage show the building had been gutted by fire in the Spanish Civil War as a result of Franco's Moorish troops billeted there lighting fires. It stood as a roofless ruin. 'It's the sort of luck only I could have', Dalí told the press, 'just to think that at the end of the Civil War, a bomb should fall on the municipal theatre, turning it into what Marcel Duchamp called a "ready-made".' The idea was inspired, as a use was at the time being sought for this ruinous structure.

The mayor recognised the opportunity but it was a further 14 years before it could open, and even then it was only half-way to completion. Dalí said that if Figueres

The Torre Galatea

Salvador Dalí
Galarina, 1944–5
oil on canvas
64 × 50 cm

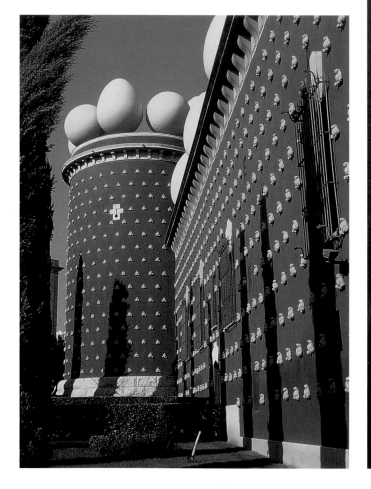

restored the building, he would endow it with works of art. A committee was formed, and in August 1961 an exotic bullfight launched the fundraising. That same evening Dalí stood in the remains of the ruined theatre and made an announcement to the world, which not for the first or last time was to ring alarm bells for the mayor and his committee. First, said Dalí, the theatre must remain open to the sky; second, it would contain only photographic reproductions, which would be better than the real thing,

even though they were covered in plastic to protect them from the elements. It would be, said Dalí, the only Surrealist museum in the world. But it soon became clear that nobody else shared this vision and neither the local council nor the ministers in Madrid would support the museum unless there was a substantial donation of original works. Gala did not help matters by saying to Guardiola: 'Let others buy works and give them to the museum, that's how things are done nowadays.' She

Salvador Dalí
Poetry of America, 1943
oil on canvas
117 × 79 cm

Salvador Dalí
The Spectre of Sex Appeal,
1932
oil on canvas
18 × 14 cm

added teasingly that unless this was done she would send six anarchists to blow it up.

Matters rumbled on very slowly, full of misunderstandings and red tape. Finally in 1970 the money was approved and things started to move in earnest. The project had gone as high as General Franco himself, who had even given Dalí an audience. A young architect was chosen, Emilio Pinero, and Dalí was delighted when he made a virtue out of necessity. Realising that he had to put a roof at least over the stage, the architect came up with the geodesic dome, which became the emblem of the museum. In the meantime Dalí had bought Gala her castle and had become more and more deeply involved in the museum and its design.

By 1974 the museum was ready to be opened, even though it remained light on content. A suitably theatrical opening ceremony took place. Gala came down from Púbol to join Dalí, who was showing his years. Everyone agreed that the museum needed more substance, and Dalí must have known this himself, as he later said: 'Between Paris and New York, Gala and I have a hundred works of great quality to give to the museum. What is happening is that we hand them over one by one, for if they are given all at once, no one enjoys it, but if we give them slowly, then they will appreciate it.' The strategy worked, for the Spanish State went into overdrive and Dalí was visited first by the Catalan Prime Minister and then by King Juan Carlos and Queen Sofía, who brought out the latent monarchist in him.

In 1982 Gala died, and Dalí made a point of looking unmoved at her funeral. 'Look, I'm not crying', he said. Despite the relative coolness of the previous years, he continued to venerate her memory in the museum. He named the extension the Torre Galatea, and then set up the Fundació Gala–Salvador Dalí as a vehicle for donating his works to the Theatre–Museum. Eventually a great many important paintings came to Figueres, including *The Spectre of Sex Appeal* (1932), *Portrait of Picasso* (1947) and *Poetry of America* (1943). But above all it is images of Gala that dominate, in many forms. Certainly the most famous is *Galarina*, painted in 1944–5, which Dalí compared to a Vermeer and claimed to have spent 540 hours completing.

Salvador Dalí,
*The Face of Mae West That Can
be Used as a Drawing Room*
1974 (original 1934–5)

Salvador Dalí
Rainy Cadillac (4th version)
original 1938

It is a brassy, blatantly sexy image, which arrests the viewer and better than any description explains their relationship.

Inside, the museum is a bit like walking into a cross between a funfair, church, toyshop and brothel all at once, which is probably exactly what Dalí intended. Entering the museum, you come to the open roofless auditorium, where you are greeted by the *Rainy Cadillac*, also known as the *Taxi Pluvieux*, one of Dalí's black Cadillacs thought to have been owned by Al Capone, with a giant statue of Queen Esther as a figurehead. It has a bizarre system to make it rain inside the car once 5 pesetas are fed into a slot. This seaside-pier approach to art pervades Figueres,

culminating in the Mae West Hall and the *pièce de résistance* of the museum, *The Face of Mae West that Can be Used as a Drawing Room.* This consists of *Sofa-Saliva-Lips*, a red sofa that, along with some baroque ornamental items, can be viewed from up a small staircase, through a reductive lens, to form the image of the actress.

It would be futile to attempt to describe the thousands of objects in the museum; some are very funny, some odd, some beautiful, but the whole is infinitely greater than the parts. The visitor is whirled around one corridor after another in a sort of cumulative hallucinogenic dream: niches of kinetic sacred sculpture with choral music,

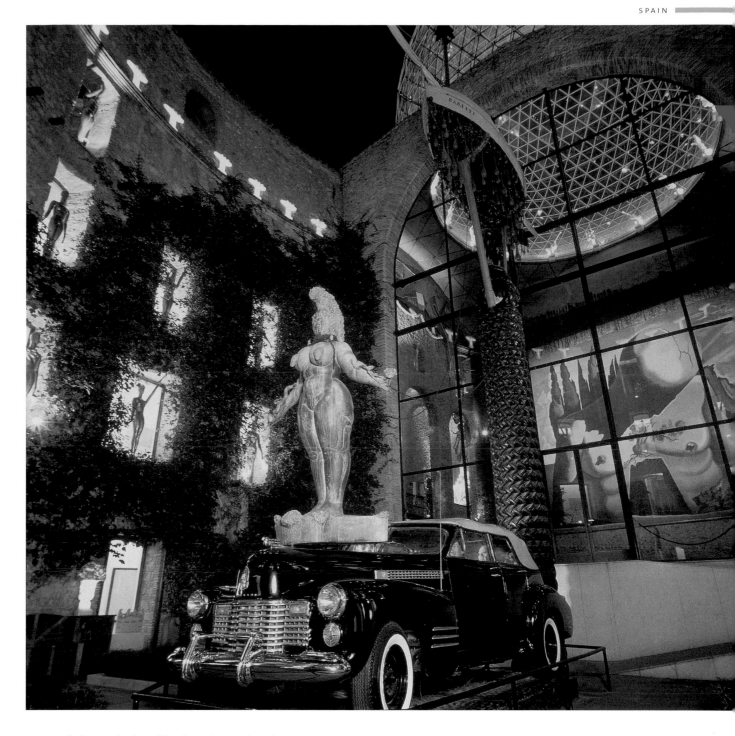

rooms of other artists' work both ancient and modern, anything bizarre and arresting. It represents entertainment of a high order, standing in counterpoint to most of the museums in this book, a funfair devised by an irrepressible clown, half mad, half genius, with a mission to shock.

When he opened the museum, Dalí said: 'I want it to be the spiritual centre of Europe. From today the spiritual centre of Europe is situated in the perpendicular centre of the cupola of the museum.' Perhaps he already had plans for his own burial, for that was exactly where he was laid to rest when he died in 1989.

OSKAR REINHART COLLECTION
WINTERTHUR

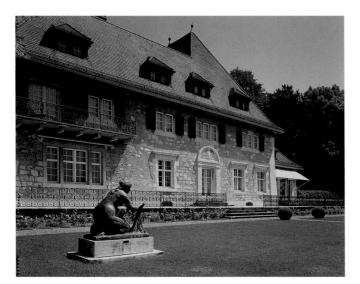

'An ensemble of outstanding achievements in painting, selected by a man with great taste and knowledge, who happens to be very rich' was how Douglas Cooper described the Oskar Reinhart collection in the Villa 'Am Römerholz' at Winterthur.

Oskar Reinhart was that very rare thing, a professional private collector. He devoted his life and fortune to art collecting with a view to public benefaction. The result of Reinhart's devotion may be seen in two museums he left behind in his home town of Winterthur. The first was a comprehensive museum of Swiss and German art from the eighteenth century to the twentieth, which is housed in a fine classical building in the centre of town. The second group, with which we are concerned, he treated as his private collection, and may still be seen in the Villa 'Am Römerholz', built by the Geneva architect Maurice Turrettini in 1915, which Reinhart bought and extended in 1924. Although it contains a group of carefully chosen Old

Master paintings, the heart of the collection is French nineteenth-century painting, reaching a climax in Cézanne and Van Gogh. It is an enjoyable collection, formed with unusual subtlety by a very intelligent collector with a taste for sensual paintings, one who never allowed this to override his art-historical instincts.

Oskar Reinhart was born at Winterthur in 1885, the youngest son of Theodor Reinhart, head of the great Swiss trading company Volkart. He had an artistic childhood. Although small, Winterthur had an unusual number of avant-garde collectors, and Oskar's own father collected Swiss and German art. Oskar was one of four brothers known as 'the art boys': Georg, the eldest, collected European and Asiatic art; Hans was a poet; Werner was musical and patronised, among others, Stravinsky and Schönberg. Oskar grew up determined to collect and, although he had no formal art-historical training, his interest was captured by the famous Berlin Impressionist

The Villa 'Am Römerholz'

Oskar Reinhart in India
c. 1910

Oskar Reinhart hanging
pictures, 1955

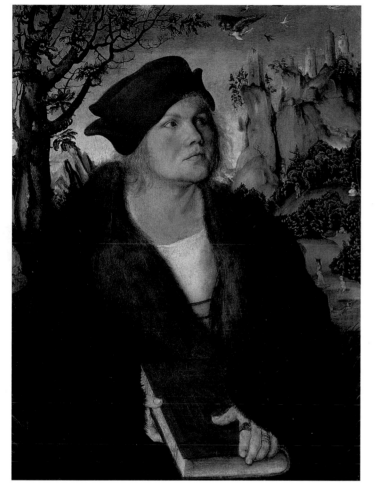

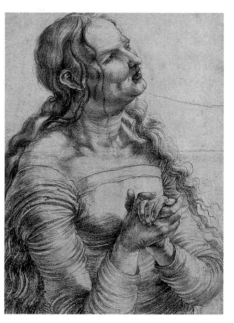

Lucas Cranach the Elder
Portrait of Johannes Cuspinian,
1502
oil on panel
60 × 45 cm

Mathias Grünewald
Mourning Woman with
Clenched Hands
c. 1515
chalk
41 × 30 cm

exhibitions of Hugo von Tschudi. He avidly read the works of Julius Meier-Graefe, who elevated the Impressionist school into mainstream art history and traced its antecedents. His studies of Delacroix, Corot, Courbet and others had an enormous influence on the young Reinhart. In the meantime Oskar joined the family firm and was dispatched for spells in England and India. He started a print collection, frequented the great print-rooms of Europe and in his letters home begged for more time and money to pursue his artistic interests. By the time his father died in 1919 he had over 3,000 prints, and with the wealth he inherited he started to buy paintings and 'found the courage to move on to the heavyweights'.

In 1924 Reinhart withdrew from the family business to devote himself to art collecting; he wrote, 'I cannot describe the feeling of peace that has come over me since I took the big decision and looked clearly into the future. I have seldom felt so alive.' His first painting purchases

were two Renoirs, which he later exchanged. There is no particular pattern in the growth of the collection. Reinhart decided early on which artists he wanted and made lists of them, and even of the actual paintings that he wished to acquire. He kept notes when he visited collections, which enabled him to be well prepared, as in the case of the Danish financier Wilhelm Hansen. When Hansen ran into financial trouble, Reinhart was immediately on the scene, having already done his research, and he carried off the greatest prizes.

The collection today is hung much as Reinhart left it. At its heart is the large top-lit gallery – adjoined by six or seven modest rooms – where the paintings are hung, sometimes but not always chronologically, in a manner to stimulate rewarding comparisons. The comparative approach serves this collection well, and to see Poussin, Constable, Van Gogh, Courbet and Rubens hanging together becomes enjoyable and enriching.

The collection opens with fifteenth- and sixteenth-century Northern painting and a Renaissance room that contains two unforgettable portraits, Lucas Cranach the Elder's portraits of *Johannes Cuspinian* and his wife, *Anna Putsch* (both 1502). Cuspinian was an important humanist poet and philosopher and no doubt responsible for the erudite symbolism, but what is novel is the direct relationship of the sitters to their landscape, which opens a new chapter in the history of portraiture. There is a delicate Holbein, *Portrait of an English Lady* (c. 1533–6),

Pieter Brueghel the Elder
Adoration of the Magi in the Snow
1567
oil on panel
35 × 55 cm

Francisco de Goya
Still-Life with Salmon, c. 1808–12
oil on canvas
45 × 62 cm

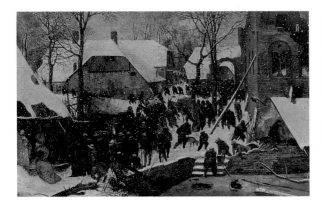

and Mathias Grünewald's large chalk drawing *Mourning Woman with Clenched Hands* (c. 1515). Apart from being the most important surviving Grünewald drawing, it is of unusual interest as five years later the artist used it for the central figure of St Mary Magdalene in the *Crucifixion* panel of the Isenheim altarpiece.

From the Netherlands there is a tender *Pietà* by Gerard David and a fine Metsys portrait, but the most arresting painting is Pieter Brueghel the Elder's *Adoration of the Magi in the Snow* (1567). The most memorable seventeenth-century painting is Poussin's *The Holy Family* (1632), a fresh and light-hearted painting from his early Roman years. Eighteenth-century France is represented by, among other things, four paintings by Chardin, including *The House of Cards* (c. 1735).

The collection comes into its own with the nineteenth century. Oskar Reinhart owned two of Goya's rare still lifes. *The Still Life with Salmon* (c. 1808–12) has none of the traditional decorative elements of still-life painting, and stands comparison with Rembrandt's *Flayed Ox* (Louvre), in which the inanimate acquires an intensity beyond its subject matter. France of the early nineteenth century is represented with portraits by David and Ingres, but the centrepiece is Géricault's *Madman*, one of five surviving paintings the artist made of insane patients, the origin and purpose of which have often been debated. His friend Dr Georget was a pioneer in the humane treatment of insanity, but from everything we know about Géricault he would have painted them anyway and they represent his late masterpieces.

Delacroix is shown in all his brilliant complexity. There are nine oils, starting with the *Scene from the Greek War of Independence* (1826), a subject that fired his imagination.

influence on French art. The Corot collection is a
corrective to those used to seeing his landscapes through
the gauze of his late style. There are three figure paintings
by Corot and six rather Italianate landscapes from the
Stony Chestnut Wood of c. 1830–35 right up to the
Dunkerque Fishing Port, painted as late as 1873. Corot's
Realist contemporary Courbet is well represented with ten
paintings. There is the fascinating early work *The
Hammock* (1844), painted when Corot was still under
academic influence. We see the crucial change of direction
in the study for the revolutionary *Stone-breakers* (1849),
where subject matter and manner were about as shocking
as could be imagined for the Salon audience and earned
him the reputation of being a *peintre socialiste*.

In 1924 Reinhart wrote, 'I have a passion for Daumier,
Delacroix, and Courbet. Daumier should have a special
place in my collection.' And so he does: he is the artist who
is

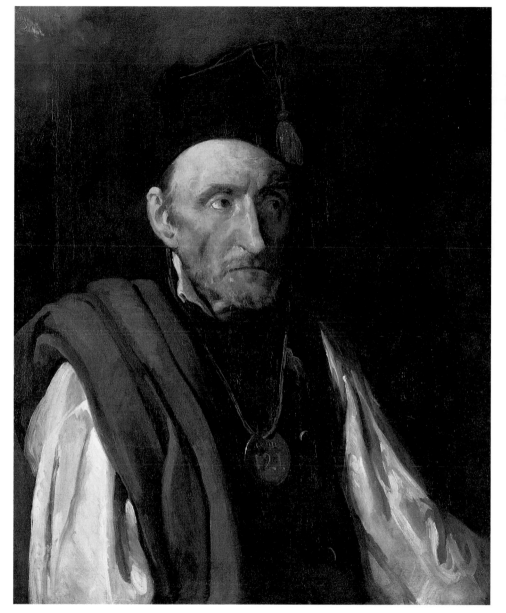

Delacroix's pessimism is present in *Tasso in the House of
the Insane* (1839) – a painting that Van Gogh much
admired – and *The Death of Ophelia* (1844), and his love of
violent scenes in *Fighting Lion and Tiger* (1854) and
Moroccan Artillery Practice (1847).

The collection is particularly strong in Corot and
Courbet, but Reinhart anticipates the next phase of the
collection with John Constable's *Branch Hill Pond,
Hampstead (1825),* which is interesting because it was
painted for a French art dealer, Claude Schroth, and thus
raises the intriguing question of the British painter's

best represented in it. This Parisian artist who Baudelaire said 'each morning keeps the populace of our city amused' is here in prints, drawings and watercolours as well as nine rare oil paintings. Typical is the wonderful watercolour *A Third-class Carriage* (c. 1865), which shows how – like Goya – Daumier could be serious and funny at the same time.

Renoir is at the heart of Reinhart's collection and he allowed himself the most charming and appealing of the artist's works. There is the early rather detailed *Calla Lily and Greenhouse Plants* (1864), which reminds us that Renoir started life as a porcelain painter. We see an astonishing transformation with his *La Grenouillère* (1869). Monet and Renoir spent several months together that year – the decisive moment in the development of Impressionism, when their styles became almost

Honoré Daumier
A Third-class Carriage, c. 1865
watercolour, gouache
and conté crayon
23 × 33 cm

Pierre Auguste Renoir
La Grenouillère, 1869
oil on canvas
65 × 92 cm

Pierre Auguste Renoir
Calla Lily and Greenhouse Plants
1864
oil on canvas
96 × 130 cm

Vincent Van Gogh
The Sick Ward, 1889
oil on canvas
73 × 92 cm

indistinguishable. Monet wrote to Bazille, 'I have indeed a dream, a picture of bathing at La Grenouillère … Renoir, who has been spending two months here, also wants to do this picture.' The result is a painting that is the embodiment of Impressionism at its most attractive. Curiously, Reinhart bought only one Monet, the freezing *River Seine with Ice-floes* (1881). His other Renoirs are charming rather than great, but mention should be made of *The Garden at Fontenay* (1874) and the large sensuous nude *Sleeping Woman* (1897).

There are three paintings by Manet: the sketchy *Departure of the Steamship for Folkestone* (1869), a portrait of 1873, and the important *Au Café* (1878). Manet enjoyed these rather ambiguous bar scenes and *Au Café* started life as part of a huge canvas that included the *Beer Waitress* (National Gallery, London). Manet kept cutting up the two

canvases until he arrived at this surprisingly satisfying composition. Degas makes only one appearance in the collection, and rather shyly at that. Degas half-opens a door and we see the ravishing *Dancer in her Dressing Room* (1878–9). Toulouse-Lautrec also makes a sole appearance, though with the anything but shy The *Lady Clown Cha-u-Kao* (1895).

The collection reaches its climax with Cézanne and Van Gogh. For Van Gogh there is a perfectly chosen group of late Arles works: two fine 1888 landscape drawings and a *Portrait of Augustine Roulin* (1888), but the masterpieces are undoubtedly the two paintings he made of the Arles hospital in 1889. One is the interior *The Sick Ward*, a subject full of meaning for Van Gogh at that time, and the other is *The Courtyard,* a more cheerful painting, which Van Gogh described as 'replete with flowers and the

greenery of springtime'. The Cézanne group is similarly well chosen but covers a broader spectrum of the artist's career, including two portraits (one self-portrait) and a glorious series of still lifes culminating in the majestic *Still Life with Faience Jug and Fruit* (c. 1900). For landscapes, there is the remarkably fresh *Pilon du Roi* (1887–8) and the monumental *Château Noir* (c. 1890). Cézanne's watercolours are among his greatest works and there are two particularly good examples, *Women Bathing* (1895–1900) and *Mont Sainte Victoire* (c.1904–6).

Although the Van Gogh and Cézanne groups essentially complete the collection, there are one or two postscripts, notably Picasso's *Portrait of Fernández de Soto* (1901), and a small collection of sculptures by Rodin, Maillol and Renoir.

In 1951 Reinhart opened the remarkable Swiss-German collection to the public as the Oskar Reinhart Foundation. He also welcomed invited visitors to his personal collection in the Römerholz, usually on a Thursday afternoon. He understandably didn't like it if people asked to see the latter and showed no interest in the former, and

Vincent Van Gogh
The Courtyard, 1889
oil on canvas
73 × 92 cm

Paul Cézanne
Still Life with Faience Jug and Fruit
c. 1900
oil on canvas
74 × 101 cm

Pablo Picasso
Portrait of Fernández de Soto
1901
oil on canvas
61 × 46 cm

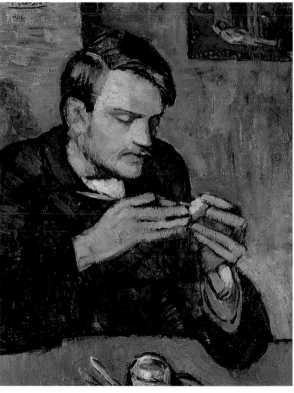

was known to have refused them entry for that reason. He even enjoyed playing pranks on his visitors, one of which has become legendary. A group were invited to view the collection and he greeted them as the butler, apologising that their host had been called away, and amused himself by listening to their comments. Reinhart died in 1965 and the villa was formally opened as a museum five years later. However the ghost of this attractive man is still very much alive in his collection. One of the visitors who came to see the collection while its owner was still alive was Paul

Valéry. He signed the guest book with the words, 'I am enchanted by my visit to Winterthur. Everyone has talked to me of this marvellous collection but it speaks for itself a hundred times more eloquently than anyone else.'

E.G. BÜHRLE FOUNDATION

ZURICH

'He was a lonely man [who] often stayed at his office until dawn, unless he happened to be host to a Chief of State, or a Government Minister … And they would come from all over the world. Every once in a while he would invite me, almost shyly, to walk over to the neighbouring building with him and look at his collection. … Was it then that his innermost being was brought alive when he felt the magical touch of art?' The question was posed by the painter Oskar Kokoschka, who had painted Emil Bührle's portrait in 1952. The description is characteristic, if a little overdone. All recollections of Bührle seem to involve midnight visits to the house next door, where he kept the bulk of his extraordinary art collection in a higgledy-piggledy fashion and there it remains to this day, tidied up but no less of a revelation.

There were two turning-points in Emil Bührle's life. The first he describes in a lecture on the growth of his collection: 'In the autumn of 1913 I saw for the first time in the Nationalgalerie in Berlin those magnificent French paintings, which to the annoyance of the Kaiser had been acquired by that Swiss genius Hugo von Tschudi, the Director of the Galerie. The atmosphere of these pictures, above all the lyrical quality of a landscape by Monet of the country round Vétheuil, completely overwhelmed me. It was at that moment that I determined that, if I were ever in a position to do so, I would hang on my walls, just such paintings by Manet, Monet, Renoir, Degas and Cézanne.' Bührle succeeded, to an extent that he could never have imagined, in fulfilling this dream, and these artists remained at the core of his collection, with one major addition, Van Gogh.

Born in 1890 at Pforzheim, Baden, in Germany, Bührle grew up in Freiburg interested in technical matters, but also developing a love of poetry and art, so that in 1910 he entered the University of Munich to study literature and art history. He had begun a literary dissertation when the First World War began. The war was the second turning-point of his life and, as he put it, 'turned an unworldly aesthete and philosopher into a man accustomed to looking reality squarely in the eye, making quick decisions, acting upon them and taking responsibility for others'.

At the end of the war he joined a machine-tool factory in Magdeburg. He married Charlotte Schalk, the daughter of a prominent local banker, and in 1924 the company sent him to run a debt-ridden machine-tool works in Oerlikon, near Zurich. His energy and vision turned him into a great industrialist. He became an obsessive businessman who seemed to require no sleep and whose only relaxation was to buy art. Bührle compared it to a stone dropping into a quiet pond, which creates a circle and then a second and a third. The stone had dropped in 1913, but the first circle did not rise to the surface until 1934, when he bought a Degas drawing and a Renoir still life. In no time this circle expanded to Manet, Monet, Van Gogh and Cézanne. New circles formed with the Fauves and then extending back to Delacroix and Daumier. 'Finally', as Bührle put it, 'the Dutch and Flemish painters needed space. More circles on the water led me to follow the French stream back as far as the eighteenth century. The striking kinship between the Impressionists and the Venetians carried me on to Canaletto, Guardi and Tiepolo.'

Bührle was a man of unusual energy, and although the collection grew in fits and starts, it was formed with astonishing speed, mostly between 1946 and Bührle's death in 1956. His earliest purchases were from the Aktuaryus Gallery in Zurich and then Siegfried Rosengart in Lucerne. His two main advisers, however, were to be Fritz Nathan (who also gained the trust of Oskar

Emil Buhrle with some of his
collection, 1950s

Reinhart) and Arthur Kauffmann, whom he had first
encountered as a fellow cavalry officer during the First
World War. When Bührle had difficulty in making
decisions about buying paintings, it was usually
Kauffmann's opinion that settled the matter. Bührle
would also buy on his business trips abroad, and he made
characteristic midnight visits to dealers such as
Marlborough in London and Wildenstein in New York.

Such was his appetite that his secretary described
Bührle buying works of art by the dozen and then turning
to him with a sigh, saying, 'I need a guardian, don't you
think?' Although an art historian by training, his choices
were governed by personal preference, and he was partial
to forming groups of his favourite artists. Bührle
particularly liked works that had a painterly quality and a
strong sense of brushwork. His method of deciding on a
work of art was to place it on a ledge in his library, known
in the family as *Le Banc des Accusés*, for anything between
a couple of days and a week. He would invite opinions,
and listen to them very carefully before invariably making
his own decision.

In 1940 he bought the villa next door to where he lived,
largely to store his collection, and this is the home of the
Foundation today. Bührle never paid much attention to
hanging arrangements, and his paintings were all over
the place like postage stamps. He preferred to scramble
backwards and forwards from one room to the next,
finding something different to admire each time. After his
death many of the finest items of the collection were
gathered and hung together in one 'room of masterpieces'
downstairs; it serves as an introduction to Bührle's taste.

Here is his trilogy of portraits by Cézanne, 'the focal
point of my collection'. Cézanne was such a slow and
exacting portraitist that few submitted to his sittings, but

Paul Cézanne
The Boy in the Red Waistcoat
c. 1890
oil on canvas
80 × 64 cm

Paul Cézanne
Self-portrait with Palette, 1884
oil on canvas
92 × 73 cm

Claude Monet
Poppies near Vétheuil , 1879
oil on canvas
71 × 90 cm

Edgar Degas
*Portrait of Count Lepic and his
Daughters* c. 1871
oil on canvas
65 × 81 cm

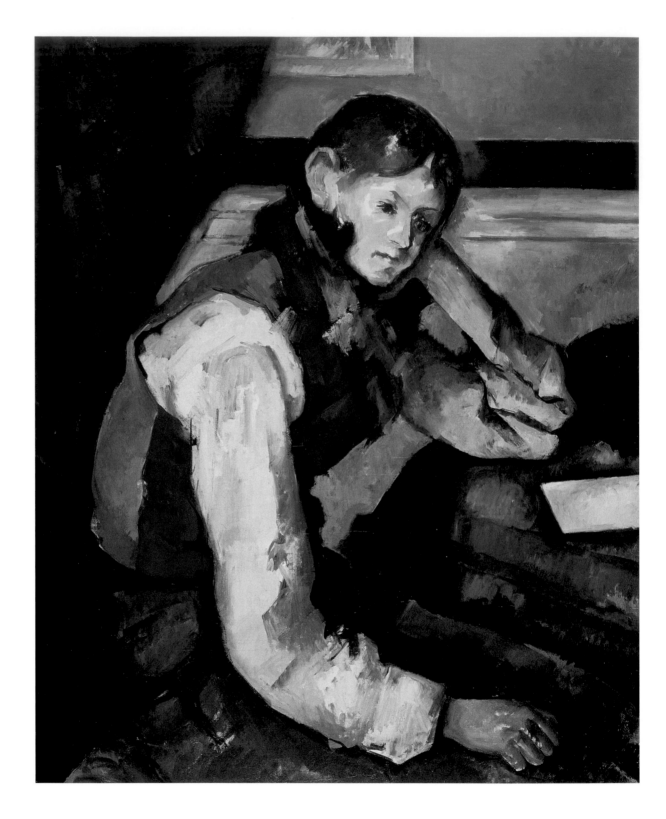

his wife, Hortense, who began as his model, had little choice. He painted her 25 times but the portrait in the Bührle collection (c. 1886–8) has special interest as it was owned by Leo and Gertrude Stein, in whose collection Picasso saw it and described it as 'that beautiful likeness'. The most famous of the Cézanne portraits, and almost the emblem of the collection, is *The Boy in the Red Waistcoat* (c. 1890). When it was exhibited at Vollard's gallery in 1895, the critic Gustave Jeffroy said it could 'withstand comparison with the most beautiful figures in painting'. The sitter was an Italian model whom Cézanne sometimes used, and although the artist is more interested in compositional problems, the portrait is unusually romantic. 'The result of art is the figure', said Cézanne, which is surprising given that he approached his sitters as if they were still lifes. When he came to his own *Self-portrait with Palette* (1884), he was uncompromising in his severity. This is the most monumental of all the self-portraits, and the only one to show Cézanne as an artist with palette and easel.

Purchasing *Monet's Poppies near Vétheuil* (1879) was a direct fulfilment of his Berlin dream in 1913, when he had seen a similar Monet, and it is a good example of the artist at the height of his Impressionist style. If landscapes were Monet's medium, then the human form was Degas's real theme, and we have here the *Portrait of Count Lepic and his Daughters* (c. 1871), in which the artist has abandoned the studied pose and gone on to the balcony to achieve an

unfinished and snapshot impression. Degas never painted strangers, but Renoir had no choice and the most bewitching portrait in the room is his *La Petite Irène* (1880), which Bührle was able to buy directly from the sitter when she was a very old lady and had become Comtesse Irène de Sampieri.

The most exotic painting in the room is Van Gogh's *Blossoming Chestnut Tree* (1890), strongly influenced by Japanese art and once owned by his friend Dr Gachet. Van Gogh usually painted blossom as a symbol of life and rebirth, but this time it was to no avail as by July of the same year he was dead. His friend Gauguin was urged by Vollard to paint flower pictures, and in 1901 he produced *Still Life with Sunflowers on an Armchair*. In case the dealer was expecting an Impressionist painting, Gaugin had warned him, 'I do not copy nature … With me everything happens in my exuberant imagination and when I tire of painting figures (which I like best) I begin a still life and finish it without any model.' Finally there is Pissarro's *Versailles Road at Louveciennes* (1870), an important painting from the moment when the artist began to paint in a pure Impressionist style.

The rest of the collection is spread over two floors of the villa. There is an important room with eight works by Manet, and we see him in all his moods. The most celebrated is *The Swallows* (1873), a dazzling *plein-air* painting, showing great freedom of brushwork and a more colouristic approach, no doubt as a result of his contact with the Impressionists. This was too much for the Salon, which rejected it, prompting the then unknown poet Stéphane Mallarmé to leap to the artist's defence. One of the most delightful Manets is the late *Garden at Bellevue* (1880).

There is a room of Van Gogh with two sombre paintings from his Dutch period, *The Old Tower* (1884)

Pierre Auguste Renoir
La Petite Irène, 1880
oil on canvas
65 × 54 cm

Edouard Manet
The Swallows, 1873
oil on canvas
65 × 81 cm

Edouard Manet
Oloron-Sainte-Marie, 1871
oil on canvas
42 × 62 cm

Edouard Manet
The Garden at Bellevue, 1880
oil on canvas
91 × 70 cm

Vincent Van Gogh
The Sower, 1888
oil on jute
73 × 93 cm

Vincent Van Gogh
The Bridges at Asnières, 1887
oil on canvas
52 × 65 cm

and *Peasant Woman* (1885), and two paintings from 1887 showing the decisive change brought about by his arrival in Paris and his search for a style. These are a *Self-portrait,* and *The Bridges at Asnières* (1887), which shows any number of influences on the artist, from Japanese prints to Signac. Van Gogh made an odd impression in Paris and Pissarro prophetically said that he 'would either go mad or leave the Impressionists far behind'. He was right on both counts, and we see the full power of this lonely genius in *The Sower* (1888). The inspiration may come from Millet and Hiroshige but he has turned their serene and symbolic images into something much more primitive and disturbing. The real subject is the southern sun, on which Van Gogh trained his restless northern eye.

Other rooms contain many more works from the first and second 'circles' of Bührle's collecting, two late Gauguins, several other works by Renoir, Seurat, Sisley, Monet, Degas, Toulouse-Lautrec (including the liberated *Two Friends* of 1895) and strong groups of Bonnard and Vuillard. There are also groups of Matisse, Rouault, Vlaminck, Derain, Braque, up to a 1917 Italian-period Picasso. The oil sketches by Delacroix are superb and there are equally good examples of Ingres, Courbet, Daumier,

Géricault and Corot. Perhaps the most memorable of the early nineteenth-century paintings is Goya's *Procession in Valencia* (1810–12), which, like so much in Goya, manages to convey both the solemn and the absurd.

From Bührle's outer 'circles' there are several Old Master paintings, mostly seventeenth-century Venetian and Dutch. Outstanding among them is the Frans Hals *Portrait of a Man* (1660s), a painting of strong brushwork that appealed to Bührle, along with a Rembrandt-like Aelbert Cuyp *Thunderstorm over Dordrecht* (c. 1645) and a cool Saenredam, an interesting choice given its highly finished, linear quality. The same could be said for the two Canalettos, formerly in the Buccleuch collection. As a young man in Freiburg, the first art he learnt to appreciate was medieval sculpture and this taste remained with him all his life. The Foundation contains a collection of – mostly fifteenth-century – northern European sculpture.

The character of the collection today remains intimate and private. There are few places where you can see in such a small space so many masterpieces of French nineteenth-century art. Even the cloakroom has two paintings by Redon. When Bührle died in 1956, the

Jean-Baptiste-Camille Corot
Woman Reading, 1845–50
oil on canvas
42 × 32 cm

Francisco de Goya
Procession in Valencia, 1810–12
oil on canvas
105 × 126 cm

collection consisted of 320 items, and although he had left
no plans, his heirs decided that a foundation should be
formed in his memory and asked Arthur Kauffmann to
make a division. He chose 168 paintings and 30 sculptures
to be exhibited. As Bührle himself so eloquently put it,
'I was ceaselessly determined – throughout my life – to
gather such paintings around me; Monet's enchantment
has held me enthralled and I wanted to have Cézanne,
Degas, Manet, Renoir close to me on my walls. And I have
succeeded, for now they are here.'

Aelbert Cuyp
Thunderstorm over Dordrecht
c. 1645
oil on panel
77 × 107 cm

BEYELER FOUNDATION
BASEL

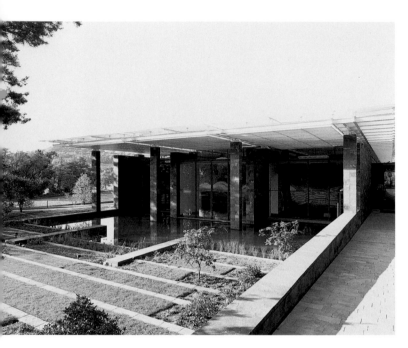

'No other dealer has sold so many outstanding works by the masters of modern art to museums in Europe, America, Asia, etc. in the last 40 years', said Bill Rubin, Director of the Museum of Modern Art, New York, about Ernst Beyeler. Beyeler is one of the most successful post-war art dealers in Europe and his collection and foundation sprang directly from his gallery work in Basel, where he has concentrated on the twentieth century. At first he kept things simply because he was unable to sell them, and when he could, he would start to hold them back anyway. Being Swiss, Beyeler was cautious and preferred to deal in 'proven' artists, and the Beyeler Foundation follows suit.

The desire to create a foundation was not immediate. Ernst and Hildy Beyeler had retained over the years a substantial group of works, many of which they had lent to the Kunstmuseum Basel, where they might have stayed. But in 1989 they lent their collection – which they had never thought of in those terms – to the Centro de Arte Reina Sofía in Madrid. Surprised by the favourable reaction, they began to consider ways of improving the collection and of looking after its future. The idea of a foundation developed and the Beyelers identified a site, the Berower Park in the village of Riehen, near Basel, which the local community happily endorsed. For an architect they went straight to Renzo Piano, on the strength of his Centre Pompidou building in Paris and the Menil Museum in Houston.

This was an inspired choice because what Piano created was a museum that is about as perfect as can be imagined for this collection. In Piano's own words, 'seeing the site in Riehen, I thought, it's so beautiful and the artworks are so profound, one needs to be very quiet. Only silence can allow one to become fully aware of the unfathomable depths of these works of art. The building became what it had to be: almost discreet.' Piano nicely cut off the busy road with service areas, and the museum overlooks a pleasant meadow. A long low building of reddish porphyry stone from Patagonia, impeccably finished with a high-tech flat roof that lets the light in, the architecture remains subservient to the works of art and provides an attractive, appropriate and very restful setting. The collaboration between the two men worked well, and Beyeler described his participation in the planning in the spirit of Baudelaire's *'luxe, calme et volupté'*.

Born in Basel in 1921 to a railwayman father, Beyeler's awareness of art as a child came from seeing Phaidon art books on Cézanne, Van Gogh and Michelangelo. After a false start dealing in antiquarian books, he turned to graphics, Japanese woodblocks and Dürer prints before discovering where his true interests lay, namely in the art of the twentieth century. From the outset his taste has always been cerebral, and although it developed with the century, the twin deities of the collection always remained Picasso and Paul Klee. Léger's battle-cry 'The pretty is the enemy of the beautiful' is one of Beyeler's favourite quotations and might be the motto of his collecting.

The Beyeler Foundation gives a superb overview of classic twentieth-century art within the confines of painting and sculpture, although it makes no attempt to be systematic or complete. It has particular strength in the first half in the century and a preference for groups of works that explain an artist's development. The key date for Beyeler is 1907, the year everything changed, with Picasso's *Les Demoiselles d'Avignon*, and this remains the starting point for any exploration of the collection.

When I asked Ernst Beyeler which work of art he would choose to save from his collection, it was Picasso's 1907 *Femme (Époque des Demoiselles d'Avignon)*. The subtitle says it all. When Picasso first began to show his bewildered friends *Les Demoiselles d'Avignon*, the revolutionary canvas showing five prostitutes that heralded the birth of Cubism, they were almost unanimous in their failure to understand it. Derain remarked that 'one day we shall find Picasso has hanged himself behind his great canvas'. Undaunted, Picasso continued his experiments using Iberian, Egyptian and Negro elements in what Alfred Barr describes as 'postscripts' to the great work. *Femme* is one of them, and gradually those around Picasso began to understand that this was the birth of a new art. The human form remained at the centre of his experiments, but to take his mind off *Les Demoiselles d'Avignon* Picasso also turned his attention to still life. He had included a small arrangement of fruit at the foot of the *Demoiselles,* and between the autumn of 1907 and the spring of 1908 he painted a series of deceptively simple-looking paintings that pick up where Cézanne left off. The Beyeler collection has a good 1907 example.

Picasso's development between 1907 and 1913 is brilliantly shown, from experimental Cubism through to collage. There is the 1910 *Femme Assise dans un Fauteuil*,

Pablo Picasso
La Mandoliniste, 1911
oil on canvas
100 × 69 cm

Pablo Picasso
Buste de Femme au Chapeau
1939
oil on canvas
55 × 46 cm

Pablo Picasso
Verre, Bouteille, Guitare ('Ma Jolie')
1914
oil and sand on canvas
80 × 64 cm

and we see the process develop in *La Mandoliniste* (1911) to the point where the analysis of form is so uncompromising that the figure has ceased to be a recognisable person. There is a Braque of the same year, *Femme Lisant,* which is almost identical; this is not surprising as the two painters spent the autumn of 1911 together in Céret. The following year we can observe Picasso and Braque play with *papier collé.* Braque

evidently thought of them first, and here is his *Verre, Bouteille et Journal* (1912), to be compared with Picasso's *Bouteille sur une Table* of the same year. Cubism reaches its climax in the Beyeler collection with Picasso's *Ma Jolie* (1914) and we next see the artist in a very different light in his monumental classical *Tête de Femme* (1921). There are two large still lifes from 1926, but the main theme after this in the Picasso collection is Dora Maar, of whom there are several important paintings.

Of all Picasso's wives and mistresses Dora Maar is the one who exerts the strongest fascination. Dora, Picasso's 'Weeping woman', who was there during the creation of *Guernica*, was an extraordinary mixture of love, intelligence and pride. We see her oval face and those dark eyes, whose colour nobody could quite describe, in three 1938 works and observe a visual shorthand that Picasso developed: head in profile, receding chin and mane of hair. The most direct is the 1939 *Buste de Femme au Chapeau*, but by 1944 in *Femme en Vert* only the mane of hair remains recognisable, and already Dora was being replaced in Picasso's affection by a younger mistress. When asked about them later, Dora Maar said: 'They're all Picassos, not one is Dora Maar … Do you think I care? Does Madame Cézanne care?'

As luck would have it, we can also see Madame Cézanne in one of the most intriguing rooms in the Beyeler Foundation, representing the precursors of modern art. 'For me', says Beyeler, 'the signposts to modernity were set up by Van Gogh, late Monet, Degas and Cézanne', and he gives us well-chosen examples of all of them, as well as of Rodin and Rousseau. There is *Madame Cézanne au Fauteuil Jaune* (1888–1900) and also Cézanne's *Sept Baigneurs* (c. 1900) and *Sous-bois* (1900–02) as well as some watercolours. There are Monet's *Rouen Cathedral* (1894)

Fernand Léger
The Level Crossing, 1912
oil on canvas
94 × 81 cm

Pablo Picasso
Femme en Vert, 1944
oil on canvas
130 × 97 cm

Fernand Léger
Contraste de formes, 1913
oil on canvas
81 × 65 cm

and *Le Bassin aux Nymphéas* (c. 1917–20), a vast mysterious triptych, kept in a room by itself, with a view on to the pond and garden so that the visitor can enjoyably ruminate on what Monet called the 'fugitive effects of nature'.

The heart of the museum is the room devoted to Fernand Léger and Piet Mondrian. With Léger we can observe the critical years of his development between 1912 and 1914, a period he described as 'the battle for liberation from Cézanne'. *The Level Crossing* (1912) is still a landscape, although fragmented, and gradually we observe the arrival of the conical and cylindrical forms of 1913 (or 'tubism', as Léger's Cubism was known) in *Nature Morte aux Cylindres Colorés* (1913) and above all in

Piet Mondrian
Eucalyptus, 1912
oil on canvas
60 × 51 cm

Piet Mondrian
Composition No. VI, 1914
oil on canvas
95 × 68 cm

Piet Mondrian
Tableau No. 1, 1921–5
oil on canvas
75 × 65 cm

Contraste des Formes (1913). This was Léger before he became mechanical, and there is a freshness and vitality sometimes missing in his later machine-like compositions, which are also represented right through to the 1950s.

The Mondrian collection charts the development of the artist's style in Paris between 1912 and 1938. It starts with the almost monochromatic *Eucalyptus* (1912) and we observe the adoption of an 'overall' pattern of horizontal and vertical lines in *Composition No. VI* (1914), one of his series based on Paris street façades. Then come the 'grid paintings' with their regular divisions, starting with *Tableau No. 1* (1921–5), through to the three 'white' paintings from the 1930s, where line and colour are reduced to the minimum.

Beyeler's other favourite painter was Paul Klee, and he handled the David Thompson collection, the largest collection of this artist's work ever formed, which he mostly sold on to Düsseldorf (though he kept a representative holding, to which he added). There are 21 of his works in the Beyeler collection, and we see him from his deceptively naïve *Die Kapelle* (1917) through to the haunting *Gefangen* (1940), painted when Klee was on the brink of death, gazing across the void. 'Art does not reproduce the visible but makes visible', said Klee, and music, humour and mystery are all present in these delicate, fascinating works, which defy easy analysis.

Beyeler's own second choice of a painting he would rescue is Kandinsky's *Improvisation 10* (1910), an important work in the development of abstract art. He

Paul Klee
Die Kapelle, 1917
watercolour and white
tempera on paper
29 × 15 cm

Paul Klee
Gefangen, 1940
oil on canvas
55 × 50 cm

Wassily Kandinsky
Improvisation 10, 1910
oil on canvas
120 × 140 cm

sold it once to a lady who had never heard of the artist and then years later bought it back from her. When he tried to resell it, nobody wanted it, and so he kept it and it became the first important painting in his collection. Giacometti was a personal friend of Beyeler and a room is devoted to his work, which is largely a realisation of the abortive Chase Manhattan Plaza scheme. There is *Grande Tête* (1960), which represents the artist observing *L'Homme qui marche II* (1960). Where is he walking? Towards the monumental *Grande Femme III* and *Grande Femme IV* (both 1960). Matisse also has a room, but he was probably too 'pretty' for Beyeler and one feels his heart was not in it, though there is a good group of the late *gouaches découpées*.

Other heroes of the collection are Max Ernst, Joan Miró and Jean Dubuffet (the only contemporary artist to whose work Beyeler ever owned exclusive rights), all of whom are shown in impressive groups. The 1960s and beyond

Alberto Giacometti
L'homme qui marche II, 1960
bronze
height 189 cm

Francis Bacon
*In Memory of
George Dyer* (detail)
1971
oil on canvas
198 × 147 cm

Roy Lichtenstein
Painting in Landscape, 1984
oil on canvas
127 × 152 cm

Mark Rothko
Red (Orange), 1968
oil on canvas
233 × 176 cm

Picasso and Beyeler
at Mougins, 1969

to a taxi.' Beyeler chose 45 and was allowed to buy 26, including *Le Sauvetage* (1932), still in the collection today. Beyeler was an admirer of late Picasso and the foundation has several examples from the 1960s, including *The Rape of the Sabines* (1962).

Uniquely as far as this book is concerned, I was able actually to meet the founder of the museum. Ernst Beyeler met me in his gallery, a discreet town house in Basel. Tanned, elegant and understated, he spoke with pride of his foundation and the hope that it will continue to grow. He told me that of the three souvenirs of a long, successful career – the clients, the art and the artists – it was the last that was the strongest and happiest memory. He singled out his friendship with Giacometti and mentioned Francis Bacon, but I was left in no doubt that the hero of his life was Picasso.

are represented by Robert Rauschenberg, Andy Warhol, Georg Baselitz, Mark Tobey, Mark Rothko, Roy Lichtenstein and many others, including an outstanding group of Francis Bacon paintings and his triptych *In Memory of George Dyer* (1971).

The most important event in Beyeler's life was his meeting with Picasso in 1957. The artist had been impressed by Beyeler's catalogues and the dealer was invited to meet him. Eventually, after several visits, Beyeler asked if he could buy something. 'Yes, yes', said Picasso, but nothing happened. Beyeler persisted and finally Picasso did something he had hardly ever done before; he opened a room and invited the dealer to take what he wanted. Observing Beyeler's hesitation, Picasso said, 'Do what Vollard did! He came to my studio in 1900, asked what the prices were, and promptly pulled some pieces of string from his pocket … and carried them down

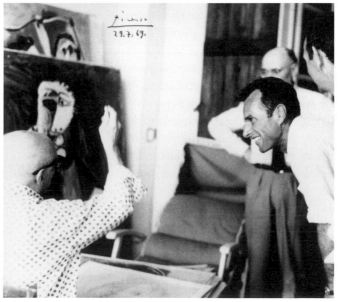

ASHMOLEAN MUSEUM

OXFORD

The Ashmolean Museum

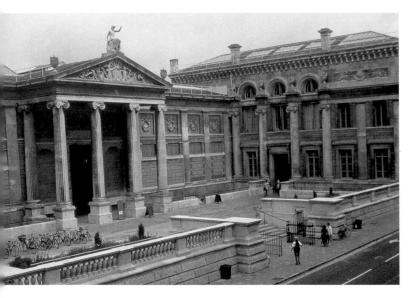

The Ashmolean has a fair claim to be the oldest public museum in Europe. In the words of Germain Bazin, the French historian of museums, 'to Oxford befell the honour of having the first great museum organised as a public institution with a pedagogical purpose'. Venerable though it is, the history of the Ashmolean has been far from serene. Of all the museums in this book it has undergone the greatest change. Having suffered several depletions, absorbed several amalgamations and almost faced extinction, we can look with admiration on its survival; it may sometimes have been hanging by a thread, but hang on it did until new momentum propelled it to its present distinction. If Elias Ashmole came back today, he would look with astonishment (and pleasure) at the museum that bears his name, though it has virtually no resemblance to what he founded. Oxford kept alive the name of Ashmole because it represented the birth of an idea.

Elias Ashmole was not in fact even the founder of the collection. That was John Tradescant the Elder, gardener to Robert Cecil, 1st Earl of Salisbury, and later to the Duke of Buckingham, who died in 1638. Tradescant's passion for plants led him to the Netherlands, Paris, Muscovy and North Africa, but his acquisitive urge did not stop with new specimens. He formed a cabinet of curiosities in his house at Lambeth, known as 'The Ark', containing coins, shells, stuffed animals and arms and armour. After his death his son John continued to augment the collection and encouraged visitors and thus, in an informal way, the museum was born, a source of both revenue and knowledge.

Elias Ashmole (1617–1692) was a man of parts, a grammar school boy who rose to become a herald, a courtier and – despite an obsession with astrology – a founder member of the Royal Society. 'A most ingenious gentleman', as Pepys described him, he was quick to spot a good thing, and when he met John Tradescant the Younger in 1650 and saw the museum, he was sufficiently impressed to finance a catalogue of the collection, *Musæum Tradescantianum*. It was probably in gratitude for this act that Tradescant on his death left the museum to Ashmole. Litigation and acrimonious relations withthe widow followed, in which Ashmole revealed a ruthless streak. His own collecting tended in the direction of books, manuscripts and coins. He was regarded as sufficiently expert to catalogue the coins at the Bodleian Library at Oxford, an institution that was to be of great importance in the story of the Ashmolean. Elias Ashmole had first encountered Oxford during the Civil War, becoming a member of Brasenose College, and in 1675 he began negotiations to hand over the combined collection to 'my honoured mother, the University of Oxford'.

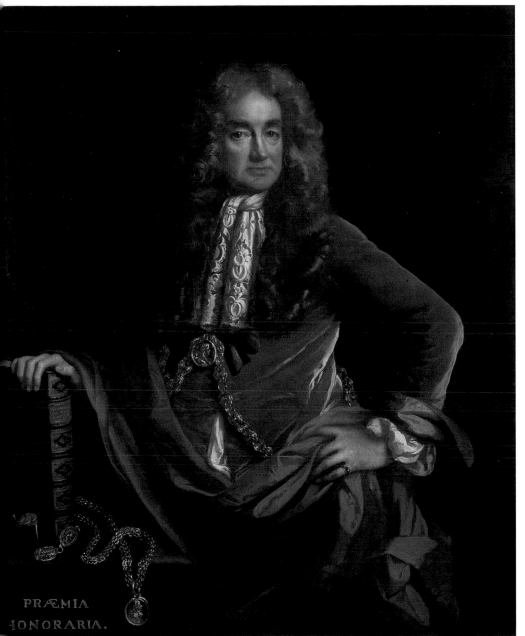

PRÆMIA
HONORARIA.

John Riley
Portrait of Elias Ashmole
c. 1681, oil on canvas
124 × 101 cm

important for the future of the collection were the far-sighted statutes that Ashmole drew up, defining the museum's didactic purpose as part of the natural history and chemistry teaching of the university. To this end, the museum was fitted out with a laboratory for experiments. Ashmole also desired that in future all rarities given to the university should be deposited in his museum, a hope that was ignored for two centuries but spectacularly redeemed from the end of the nineteenth century.

The opening of the Ashmolean was an important event in English intellectual life. The first curator was Dr Robert Plot, the first Oxford professor of chemistry, and the museum represented an extension of learning from libraries and books. Early visitors, then as now, were 'exceedingly courted' for a donation, and for a while the museum flourished and the collections grew. During the eighteenth century the museum's fortunes were very up and down (more often down), depending on the energy of the keepers, usually pluralists with other responsibilities within the university. The collection's most famous specimen, the dodo, perished beyond repair, and has been ever since a symbol of the museum's temporary decline. Rescue came in the nineteenth century in several stages, first zoological and then archaeological. Up to this point the works of God had almost completely supplanted the works of man in the museum, but in 1829 Sir Richard Colt Hoare gave an important collection of Anglo-Saxon material, a significant event that opened an archaeological tributary down which the museum was eventually to go.

Around 1860 the Ashmolean hit the rapids. The pace quickened, the river split in several directions and the very survival of the museum was in doubt. First, the manuscripts and coins were transferred to the Bodleian Library, an institution that had been run by the university

Ashmole secured the future of the Tradescant collection, not only by keeping it together but also through his influence and shrewdness. First he forced a commitment out of the university and made it a condition that the university should build an appropriate 'repository'. This was achieved in 1683, when the Duke of York, in a very modern kind of royal duty, came down to Oxford to open the delightful small building on Broad Street, built by a local mason, Thomas Wood. It still stands today. Equally

in somewhat baleful parallel; at times it had even considered amalgamating the two institutions. The natural science faculty removed the geological and mineral collection to what became known as the University Museum of Natural History, opened in 1860. Ethnographic material continued to pour into the Ashmolean, but this was siphoned off to the newly founded Pitt Rivers Museum in 1886. During this period the Ashmolean might have become extinct but for its growing archaeological collection, and on this narrow foundation was built the museum as we know it today. In 1884 Arthur Evans, one of the heroic figures of English archaeology, became Keeper of the Ashmolean, an appointment as crucial in its way as that of Sydney Cockerell to the Fitzwilliam Museum at Cambridge.

At this point we must return to the Bodleian Library, which had for two centuries been the repository for the university's works of art, such as the Arundel marbles, the collection of plaster casts and about 200 oil paintings, mostly academic portraits. By 1839 these objects had grown to the point that they needed separate

arrangements and Oxford announced an architectural competition for the new university galleries, which would also include the Taylor Institution for the study of modern languages. C. R. Cockerell won, and produced the magnificent Grecian building which opened its doors in 1845. There had been rumblings for some time in Oxford about rationalising its various museums. That this actually happened was due largely to a determined benefactor, C. D. E. Fortnum (1820–1899), who promised to give £10,000 and his remarkable collection of maiolica, bronzes and other works of art to the university, on condition that a new museum would be established. He pointed out that there were several collections and buildings now in Oxford and a separation must be made between art and nature. He and Arthur Evans joined forces and the result was the museum we recognise today.

Oxford decided to cannibalise the university galleries building and extend it at the back for the archaeological collections. The two elements were united in 1908 as the Ashmolean Museum of Art and Archaeology. In the same year Evans resigned to return to his Knossos excavation in

'Shoemaker' pelike
baked clay, height 40 cm

Amazon torso, from the
Arundel marbles

Crete, but his work in establishing the new museum at Oxford was complete. There were separate keepers for the two departments, which had quite distinct characters. Visitors commented on the exquisite good taste of one half of the museum, which stood in stark contrast to the cheerful lack of taste of the other.

Although it was the art side that was eventually to absorb the greater resources and become the main focus of the museum, the archaeological side was initially more important to the university as a teaching tool for the newly established professorship of classical archaeology, and it must be said that it attracted spectacular material. Here are not only some of the best results of Evans's excavations at Knossos but also the finds of many of the great names of British archaeology, including artefacts from Flinders Petrie's Egyptian excavations, Leonard Woolley's work in the Near East, Max Mallowan's at Nimrud in Iraq and, most recently, Kathleen Kenyon's in Jericho and Jerusalem. Today it holds the most interesting collection of archaeological material in Britain outside the British Museum. It is particularly strong in English artefacts, and

the museum's Minoan, Mycenaean and Cycladic collections are the best outside Greece. Although greatly improved in presentation, the archaeological side still has the air of the schoolroom compared with other parts of the museum.

Today you enter the museum through the hall Cockerell designed for the Arundel marbles, which were long the most famous treasures of the university. While they are not great masterpieces, as the first significant collection of antique sculpture in England, formed by Thomas Howard, Earl of Arundel (1585–1646), they have always assumed great historical importance. Outstanding among the antiquities is the collection of Greek painted pottery and, as so often happened at Oxford, the great specialist in the field – in this case Professor Sir John Beazley – gave his own collection. The heart of the Western art collection is the first-floor Italian Renaissance room, dominated by the elegant collector portrait by Alessandro Allori, which nicely captures the spirit of the museum. The two most celebrated paintings are Uccello's *The Hunt in the Forest* (1460s) and Piero di Cosimo's *The Forest Fire* (c. 1505), two of the greatest masterpieces of the Florentine Renaissance.

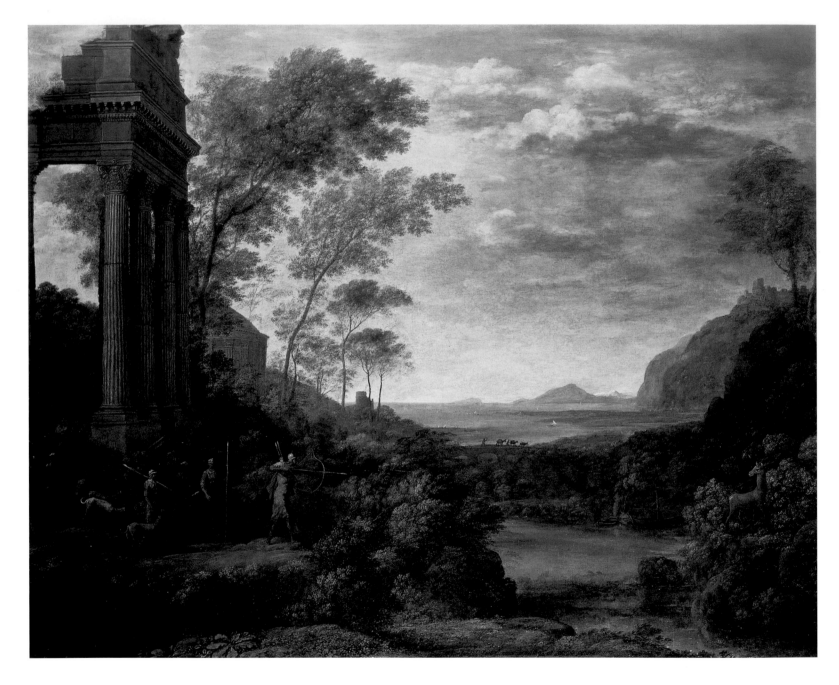

Claude Lorrain
Ascanius and the Stag, 1682
oil on canvas
120 × 150 cm

Nicolas Poussin
The Exposition of Moses
1654, oil on canvas
150 × 204 cm

Raphael
*Heads and Hands of Two
Apostles*, c. 1515–20
black chalk
49 × 36 cm

Works by Titian, Tintoretto and Bronzino are the supporting cast of this most distinguished room, with cabinets of bronzes, terracottas, ivories and medals. The Uccello was one of 40 notable Italian paintings given in 1850 to the then university galleries by The Hon. W.T.H. Fox-Strangways, later 4th Earl of Ilchester, a pioneer English collector of Italian primitives during the 1820s. There is an equally important gallery of Baroque paintings, with Poussin's *Exposition of Moses* (1654) from the Orléans collection and the elegiac Claude Lorrain *Ascanius and the Stag* (1682) – 'a dream-like poem of old age' that was Claude's last painting.

The good collection of eighteenth-century British paintings is shown with a Grand Tour emphasis, and the nineteenth century with a preponderance of works by the Pre-Raphaelite Brotherhood. Oxford played a significant role in this movement particularly through Thomas Combe, the university printer, who was a staunch patron, and John Ruskin, who left many of his own drawings to the museum, as well as a group of watercolours by J.M.W. Turner. Samuel Palmer is rather a speciality of the museum. French Impressionism and the British twentieth-century school are both well shown in small domestic examples, and here you will find, among others, Manet, Toulouse-Lautrec, Bonnard, Courbet and Van Gogh, and from Britain the collection is particularly strong in Sickert and the Camden Town group. The Camille Pissarro collection and archive deserve special mention, with 14 paintings and 400 drawings.

The European ceramics include a group of important specialist collections of maiolica, delftware and Worcester. In two areas the Ashmolean is of world-class importance: first, coins (which would have delighted Ashmole), and second, Old Master drawings. The museum holds the greatest collection of Raphael drawings in the world and

John Everett Millais
*The Return of the Dove
to the Ark*, 1851
oil on canvas
85 × 55 cm

Camille Pissarro
Le Jardin des Tuileries, 1899
oil on canvas
65 × 92 cm

an almost equally important collection of Michelangelo. This was largely the result of a body of subscribers purchasing for the university in the 1840s a portion of the collection of Sir Thomas Lawrence, one of the greatest collections of drawings ever assembled.

The most recent department to be opened was that of Eastern art, which spreads wherever it can find space along the ground floor of the museum. Strongest in Chinese art, Sung (particularly greenware) and Ming dynasties, there is also an intriguing gallery of modern Chinese screen paintings. Many notable and scholarly benefactors contributed to make the collection strong not only in Chinese but also Japanese and Islamic ceramics. The main casualty of the Eastern art department was the cast collection, mostly from the Chantrey bequest, which once had pride of place in the museum but today is relegated to a specially built cast gallery that houses all 900 pieces.

There is a Founder's Room, with a portrait of Ashmole looking suave and very much at home and two

wonderfully descriptive portraits of John Tradescant, father and son, looking like country cousins who would be happier back among their plants and shells. There is a delightful room near by of surviving Tradescant artefacts, put together like the medieval reliquary of a great cathedral: curiosities from a remote past held in sacred trust. The most famous of these is Powhatan's Mantle, a North American Indian wall hanging of great antiquity and primitive beauty.

Today the Ashmolean flourishes. C. R. Cockerell's great building, architecturally brilliant though it is, has always made an awkward museum and has been made even more so by its extensions. Groaning with great works of art and bursting at the edges, the Ashmolean at times seems almost crushed by the weight of so many objects from so many centuries and so many civilisations. It is *par excellence* a scholars' museum – 'a collection of collections', and it remains a fascinating, heterogeneous, slightly bewildering but lovable museum whose future will no doubt will be as extraordinary as its past.

Sr John Tradescant Junr
in his Garden.

Thomas de Critz(?),
*Portrait of John Tradescant the
Younger in his Garden* 1683, oil
on canvas
107 × 86cm

Powhatan's Mantle
North American wall hanging

FITZWILLIAM MUSEUM

CAMBRIDGE

The Fitzwilliam Museum

The Greek Gallery, looking through to Ramesses III

Titian
Venus and Cupid with a Lute-Player
mid-1550s to mid-1560s
oil on canvas
150 × 197 cm

The Fitzwilliam is the art museum of the University of Cambridge. Unlike its older sister in Oxford, it is recognisably still the museum created by its founder, the 7th Viscount Fitzwilliam of Merrion (1745–1815), for 'the increase of learning'. It has been fortunate not only in the founder's magnificent bequest, which has endured the test of time, but also in an extraordinary series of Directors and benefactors that has resulted in

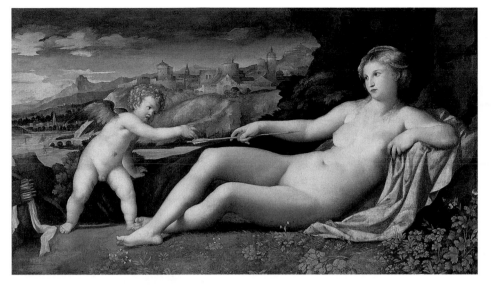

Palma Vecchio
Venus and Cupid, c. 1523–4
oil on canvas
118 × 209 cm

Paolo Veronese
Hermes, Herse and Aglauros
c. 1576–84
oil on canvas
232 × 173 cm

the most perfect museum of its size in England. In addition it is housed splendidly in the finest Neo-classical building in Cambridge, a great classical temple standing sentinel at the edge of the historic university that Arthur Balfour, arriving in the town as an undergraduate, called 'the symbolic gateway into a new life'.

The founder comes over as an attractive, scholarly and modest figure. The only portrait of any distinction that survives of Lord Fitzwilliam was painted for his tutor by Joseph Wright of Derby, when Fitzwilliam was at Trinity Hall, and it is typically understated. It is astonishing, but characteristic, that in a great age of portraiture so distinguished a collector should not have had his portrait painted on his own account. Music, which was perhaps his first passion, took Lord Fitzwilliam to Paris in 1775 to take harpsichord lessons from Jacques Duphly, and he remained an ardent Francophile all his life. However, the following year his father died and he was forced to return to England, where he inherited the viscountcy, along with estates in England and Ireland.

As a collector and Grand Tourist, Lord Fitzwilliam's tastes are recognisably those of his time. Contrary to his character, he had a taste for grand theatrical Italian paintings, in particular by the Venetians. His greatest moment came with the dispersal of the Orléans Collection. From this princely hoard, which so enriched English collections, he secured seven paintings, of which three – Titian's *Venus and Cupid with a Lute-player* (mid-1550s to mid-1560s), Veronese's *Hermes,*

Horse and Aglauros (c. 1576–84) and Palma Vecchio's *Venus and Cupid* (c. 1523–4) – are indisputably masterpieces. His purchases of Dutch and Flemish paintings were good rather than great, and included the large portrait of a military figure then attributed to Rembrandt. To balance this, however, he formed the most important collection of Rembrandt's etchings in England at that time. His eye and precision as a collector of engravings, and his skill in obtaining the best impressions, immediately gave the museum a print room of international importance. Lord Fitzwilliam was also an outstanding collector of books and music, and his bequest included 139 medieval illuminated manuscripts. He played and composed for the harpsichord and left behind one of the finest musical collections outside the British Library, which includes the great compilation of Tudor music the Fitzwilliam Virginal Book.

Lord Fitzwilliam died in 1816 and time was left for the income from his bequest to accrue so that by 1834 there was enough to announce a competition for a museum building. The winner was George Basevi,

Sydney Cockerell in the manuscript room

Head of Jupiter
c. 1st or 2nd century AD
terracotta
height 15 cm

Head of Ammenemes III, c. 1800 BC

whose Neo-classical design with its late Roman swagger has been so much admired since. The museum opened its doors in 1848. In its earliest days the emphasis was on Classical art, and in particular on acquiring casts of the most recent archaeological discoveries. This was driven by the teaching needs of the university and might easily have played a dominant role, as happened at the Ashmolean. Eventually, however, the cast collection was consigned into a separate building, which became independent.

Among the early Directors of the museum (from 1894 to 1908) was the polymath M. R. James, a distinguished scholar and specialist in medieval manuscripts who also wrote a good ghost story, *Canon Alberic's Scrapbook*, about collecting manuscripts for the museum at an abbey in France. But in 1908 a thunderbolt hit the

Fitzwilliam in the form of a young new Director, Sydney Carlyle Cockerell. This larger-than-life figure, who has claims to be one of the greatest museum directors of all time, had caught the end of both the Arts and Crafts movement and the Pre-Raphaelite Brotherhood, and had not only been a friend of Ruskin but also secretary to William Morris at the Kelmscott Press. In his own words, when he arrived at the Fitzwilliam, 'I found it a pig-sty; I turned it into a palace.' He found the place utterly chaotic, with good and bad pictures of all schools mixed together and stacked on the walls from floor to ceiling. Objects were muddled together, and anything might have been found – except, as Cockerell pointed out, fossils, for which the dons of the university made very adequate substitutes. He brought about a revolution, so that by 1936 Bernard Berenson was able

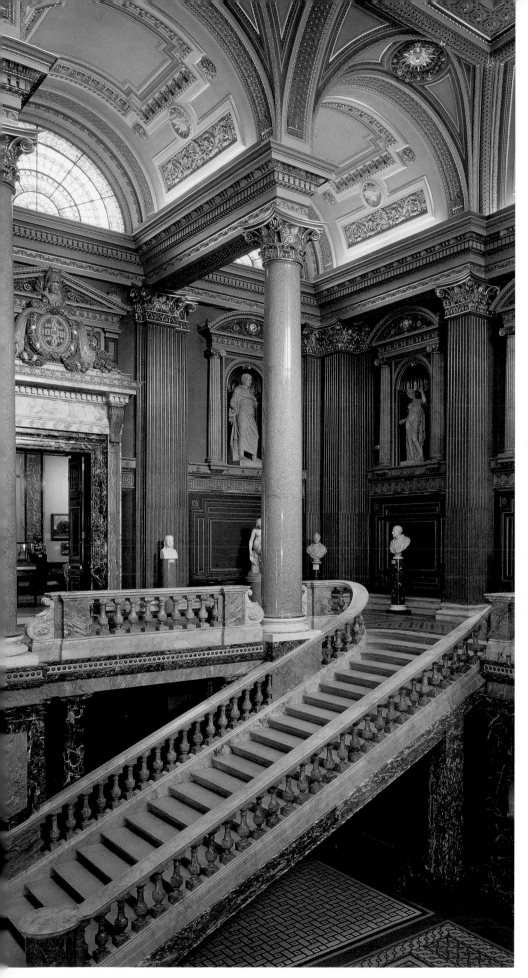

The main entrance hall

The British Gallery

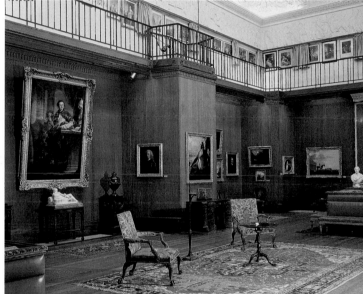

to write to his wife: 'Cockerell has transformed it from the dismal miscellany it used to be into one of the finest museum buildings existing, with lighting and arrangement, not to speak of contents, every bit as good as the so famous one at Rotterdam.'

What did he do? First, he rearranged the pictures in single lines and within their schools in a display that was so authoritative that it has remained essentially the hang to the present day. Then he opened the museum on Sundays, against fierce opposition that it might encourage meetings of the opposite sexes. He pulled away the ropes, brought in furniture, carpets and flowers, and created something close to a country-house ambience. He appointed honorary keepers for the various departments at the museum, who gave their knowledge and often their collections. This remains

stand on its own feet. Fortunately Cockerell was more than up to the challenge, and by far his greatest achievement was the astonishing series of legacies and benefactions that he attracted.

Cockerell was, as one contemporary put it, 'a scrounger of genius'. He would never admit the possibility of refusal and, having selected his victim (usually a millionaire with no children), would invite himself for dinner. When Cockerell retired, the

François-Xavier Fabre
Allen Smith Seated above the
River Arno Contemplating Florence
1797
oil on canvas
69 × 89 cm

Nicholas Hilliard
Henry Percy, 9th Earl of
Northumberland
c. 1595
gouache on vellum stuck
to a playing card
50 × 60 mm

effective to this day, for as recently as 1984 the Honorary Keeper of Korean Art, G. St G. M. Gompertz, gave one of the most important collections of Korean ceramics outside South-east Asia. In 1909 Cockerell established the Friends of the Museum, which at that time was a great innovation, based on *Les Amis du Louvre*. He secured great loans, particularly from the Royal Collection, and these often led to donations. He divorced from the Museum of Classical Archaeology, after a hard-won battle that changed the direction of the museum permanently. Although Cockerell's determination to display only great works of art is close to the spirit of our own time, by alienating the cast collection he severed the museum from the academic departments of the university, with consequent implications for funding. The museum became a luxury item for the university rather than a resource for research and teaching, and as such was expected to

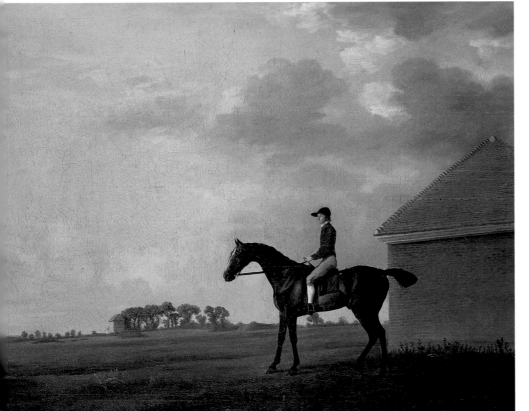

George Stubbs
*Gimcrack, with John Pratt up,
on Newmarket Heath*
1765–6
oil on canvas
100 × 127 cm

great ironies that such a committed and lifelong socialist became the most ardent and effective collaborator and seducer of rich men. The results were splendid, with great benefactions from the Courtauld family, important works of art and Classical antiquities bequeathed by Charles Shannon and Charles Ricketts, gifts of paintings and other works of art by Charles Fairfax Murray, and above all the Marlay Bequest.

In 1912 Charles Brinsley Marlay died and left his estate to the museum. 'It was I who landed this big fish', said Cockerell typically. The Marlay Bequest brought a huge cache of paintings, drawings, engravings, furniture, books and other works of art, but above all money for the museum to expand. Smith and Brewer designed the two-storey extension known as the Marlay Wing. It was completed in 1922, very much ahead of its time, with many humanising elements. Queen Mary came to see the museum and when someone congratulated Cockerell on his new wing he replied, 'Wing? No – just a feather!'.

The museum today is very much as Cockerell left it. The richness of the entrance hall takes the visitor by surprise. Three architects contributed to the hyper-Corinthian luxury of this interior masterpiece: Basevi, Cockerell himself and finally E. M. Barry, who created its High Victorian sumptuous marble appearance. At the top of the stairs lies the main gallery of seventeenth- and eighteenth-century English paintings, which is the heart of the museum, a magnificent room lit by a spectacular lantern and dominated by Batoni's *Portrait of Charles, 7th Earl of Northampton*. The room contains outstanding portraits by Van Dyck, Reynolds, Gainsborough and Hogarth, and Stubbs's fine horse portrait of *Gimcrack, with John Pratt up, on Newmarket*

Chancellor of the university said, 'there is no collector in the world who feels his treasures are safe so long as Sir Sydney is in the land.' Thomas Hardy, who gave him two important manuscripts, said it was better than big game shooting, but others felt that their end must be near when they received a call from the Director of the Fitzwilliam. A fellow of Jesus College remembered the first words he ever heard Cockerell speak: 'So I called on the Duke; he was a dying man then.' It is one of the

Heath (1765–6), for which the recent Director the late Michael Jaffé resorted to Cockerellian methods and went fund-raising with a bucket to Newmarket racecourse.

Italian paintings form the core of the collection. The early Renaissance paintings are displayed in the Marlay Gallery, its walls covered in faded Japanese gold paper, with cabinets for maiolica, bronzes and coins. One of the most appealing paintings in the collection is to be found here, Domenico Veneziano's *Annunciation* (c. 1445), as well as *The Story of Cupid and Psyche* by Jacopo del Sellaio, which Marlay owned. The most important group of paintings, and the cream of the founder's bequest, hang in the Courtauld Gallery: the Orléans Titian, Veronese and Palma Vecchio. In addition there is Titian's *Tarquin and Lucretia* (1571), painted for Philip II of Spain, given by Fairfax Murray, and a remarkable Salvator Rosa, *L'Umana Fragilità* (c. 1656),

not to mention masterpieces by Guido Reni, Van Dyck and Rubens.

The collection of twentieth-century British paintings is outstanding, and there is a surprisingly good collection of French Impressionist paintings, centred on the Maynard Keynes bequest to King's College, on permanent loan to the museum. The lower galleries contain the porcelain collections, with particular strengths in English and continental porcelain, and the justly famous collection of Classical sculpture. There is also the Rothschild Gallery, a medieval treasury

Salvator Rosa
L'Umana Fragilità, c. 1656
oil on canvas
197 × 131 cm

Domenico Veneziano
Annunciation, c. 1445
tempera on panel
27 × 54 cm

containing illuminated manuscripts, ivories, enamels and textiles. One outstanding aspect of the museum, not obvious to the casual visitor, is the comprehensive collection of European drawings, particularly strong in Italian, French and English examples.

Everything at the Fitzwilliam gives an impression of quality and pleasure. With little money for purchases available from the university, the museum has relied on an extraordinary sequence of friends and benefactors, in which it has been fortunate. With the setting up of the History of Art Department at the university, it rediscovered its didactic function, but it retains the atmosphere of a grand private collection. This is appropriate since the museum remains essentially the creation of two men, very different in character and temperament but united in their philanthropic desire to see Cambridge have a great museum.

DULWICH PICTURE GALLERY

LONDON

The Dulwich Picture Gallery in its nucleus was intended to form a Polish national gallery in Warsaw. That it became the first public picture gallery in England and ended up in a leafy suburb of south London was due to a series of unlikely events and even less likely characters. What they created was one of the finest collections of European Baroque paintings, housed in a building that by general consent is one of the most perfect and influential small museum buildings in existence.

In 1769 a Frenchman, Noel Desenfans, arrived in London to make his fortune. He taught languages, married a minor heiress and began to dabble in picture dealing. Desenfans certainly had the gift of the gab and rapidly made himself known to the artistic establishment, who regarded him with amused scepticism. He preferred to present himself as a gentleman amateur, which he thought – probably correctly – would make him more acceptable to the English, although there was a question mark over his connoisseurship. Sir Joshua Reynolds, weary of Desenfans's pretentions, played a joke on him by having his assistant Marchi copy a Claude with the intention of fooling him, which it did. But Desenfans had two allies for whom he could do no wrong. The first was a Parisian *marchand amateur*, Jean-Baptiste-Pierre Lebrun, husband of the painter Elisabeth Vigée, who was not only a role model for Desenfans but also supplied him with tasty morsels from the French art market to sell in London and divide the profits. These included such masterpieces as Murillo's *Spring as a Flower Girl,* Poussin's *Triumph of David* and Watteau's *Les Plaisirs du Bal.* Desenfans's other protégé was Francis Bourgeois, a younger man of Swiss ancestry, whose genius as a painter Desenfans was determined to promote. Desenfans paid for his travel, apprenticed him to the painter De Loutherbourg, whose

The garden front and mausoleum

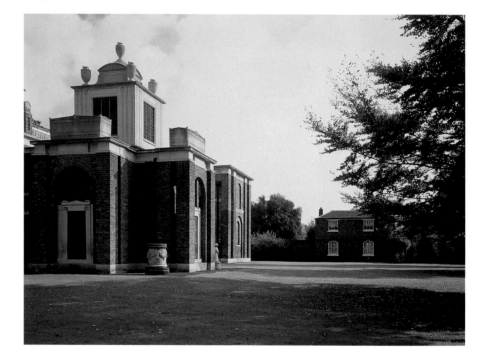

manner he pastiched, and vigorously championed him in the newspapers until, with the slenderest of talents, Bourgeois was elected a Royal Academician in 1793.

In 1786 Bourgeois moved into a house in Charlotte Street in London's West End with Desenfans and his wife, and from here the two men promoted themselves and assiduously entertained anybody who could help them. They bought and sold together, and even if people didn't take them very seriously, the pair certainly prospered. In 1790 came their big break. Prince Michael Poniatowski, brother of the King of Poland, was on a visit to London and suggested to Desenfans that he should give up dealing to devote himself to collecting Old Master paintings on behalf of King Stanislaus Augustus, 'to promote the

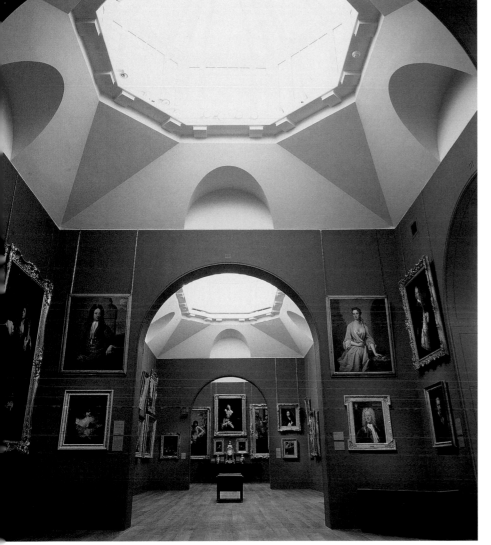

Interior enfilade

progress of the fine arts in Poland'. One can only guess at the pleasure this suggestion brought Desenfans, who was created consul-general and a colonel of the Royal Guard, while his friend Bourgeois received a Polish knighthood, which was recognised by George III. The fact that he soon found himself obliged to give the Polish Ambassador financial assistance might have alerted him to the fact that all would not be plain sailing. However, he set to work and was able thanks to the dispersals caused by the French Revolution to use his extensive contacts among émigré circles to assemble an important group of paintings by Poussin, Murillo, Rembrandt, Van Dyck and Rubens.

By 1795 Desenfans claimed to have spent £9,000 on these purchases, when disaster struck. Poland was

partitioned by Russia, Prussia and Austria and the King lost his throne. Desenfans's first instinct was to do whatever he could to recoup his money by selling the collection back at cost to the abdicated king in Italy or even the Tsar of Russia. Finally in 1802 he had an auction in London. Fortunately for us a combination of the French wars and Desenfans's childish remarks in the catalogue about English connoisseurs ensured that the buyers stayed away. At this point Desenfans and Bourgeois almost fell out. Bourgeois it seems had developed the idea of keeping the collection together and was even adding to it. Around 1803 Desenfans poured his heart out to Benjamin West, explaining that he was 'at the eve of parting with Sir Francis … I am forc'd to take these steps I am now about, if I will not Be reduced to Beggary '. Despite this *cri de coeur* they did not part, and when Desenfans died in 1807 he left the paintings to Bourgeois; he appears even to have expressed the dying wish to keep the collection together.

Over the next few years Bourgeois investigated the possibility of creating a gallery in the Charlotte Street house but his landlord, the Duke of Portland, rejected the idea. The British Museum was briefly considered, but Bourgeois felt he could not rely on the aristocratic trustees and chose instead the more reliable institution of Dulwich College. This then sleepy school had been founded in 1619 by the actor–manager Edward Alleyn and even had a picture gallery, described by Horace Walpole as 'a hundred mouldy portraits'. Bourgeois died in 1811, leaving 350 pictures, of which the best 56 were the 'Polish purchases'. He left an endowment for a special building, which would incorporate a mausoleum for Desenfans and eventually his wife, and for himself, and specified that the architect should be his old friend Sir John Soane. Although money was short, Soane rose to the challenge, describing the

Guido Reni
St Sebastian, 1630s
oil on canvas
225 × 162 cm

Canaletto
*Old Walton Bridge over
the Thames*, 1754
oil on canvas
49 × 77 cm

mausoleum-cum-museum as his 'favourite subject'. He created a most original building, unornamented and built in unfaced brick. Its interior arrangement became very influential, placing the galleries in an enfilade of alternate rectangular and square rooms, broken by regular arches and all toplit. Although the building has been much tampered with, partially destroyed and rebuilt after the Second World War, it is still possible to appreciate the originality of Soane's design.

The gallery opened in 1817 and an early visitor was the German art historian Dr Waagen, who wrote: 'In none of the galleries which I have hitherto seen in England did the pictures agree so little with the names given to them, nor is so much excellent mixed with much that is indifferent and quite worthless.' Although the limited space today means that only the excellent find wall space, Waagen's criticism was probably directed at the sixteenth-century Italian school holdings, which were weak, with the exception of a pair of tiny panels by Raphael of *St Anthony* and *St Francis* (c. 1502) and Veronese's fragmentary *St Jerome and a Donor* (c. 1563). There is, however, a superb group of Italian Baroque paintings by Ludovico Carracci, Guercino, Salvator Rosa and Carlo Dolci, crowned by two great works by Guido Reni. His dramatic *St Sebastian* (1630s) was a Victorian favourite and was given the prime position at the climax of Soane's enfilade, to which after a long period of fashionable neglect it has now been

restored. There is also Reni's late *John the Baptist* (c. 1636–7), which was probably the most expensive picture Desenfans bought, at 1,000 guineas. There are some fine eighteenth-century Italian paintings, notably by Giam Battista Tiepolo, whose work was rare in England at that time – unlike Canaletto, who is represented by *Old Walton Bridge over the Thames* (1754).

The very good group of four Murillos was for a long time the best showing of his work in England. The great number of copies in existence attests to the popularity of *Spring as a Flower Girl* (c. 1670), although the *Two Peasant Boys and a Negro Boy* and *Invitation to a Game of Argolla* (c. 1670) probably had more influence on English art and especially on Gainsborough and Reynolds. These Murillos failed to please everybody, however; John Ruskin, who was a local boy, said they revealed the artist's 'mere delight in foulness'.

For many the glory of Dulwich is the French school collection, and here Desenfans was in his element. He collected no fewer than five fine Poussins. The earliest is the lyrical *Venus and Mercury* (c. 1627), and we observe the search for a more heroic style in *Rinaldo and Armida* (c. 1628–30). Poussin is at his most classical, not to say mathematical, in *The Triumph of David* (c. 1631–3), and finally we see a return to a warmer, more elegiac style in *The Nurture of Jupiter* (1636–7). There are two large paintings by Poussin's follower Charles le Brun, and a fine

Bartolomé Esteban Murillo
Two Peasant Boys and a Negro Boy
c. 1670
oil on canvas
168 × 110 cm

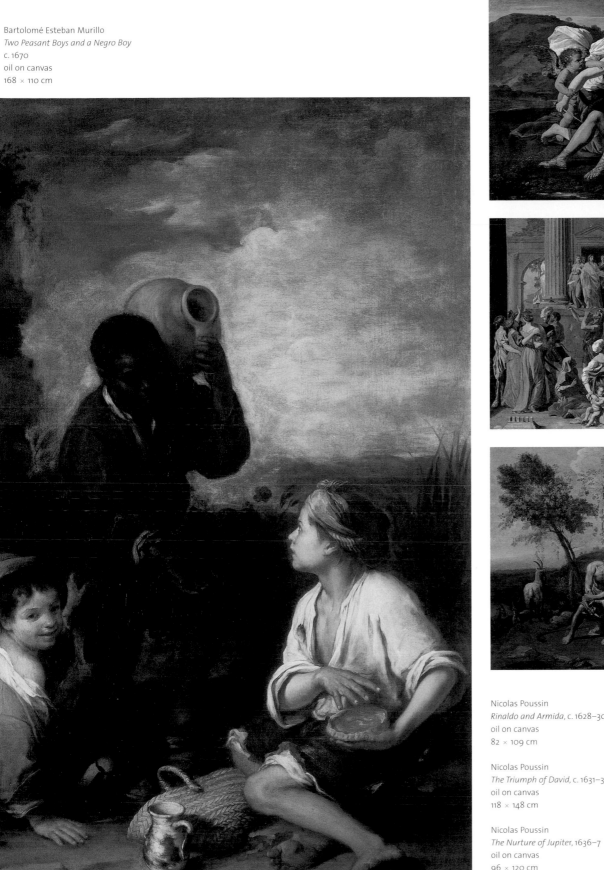

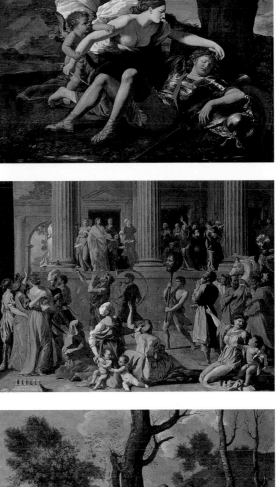

Nicolas Poussin
Rinaldo and Armida, c. 1628–30
oil on canvas
82 × 109 cm

Nicolas Poussin
The Triumph of David, c. 1631–3
oil on canvas
118 × 148 cm

Nicolas Poussin
The Nurture of Jupiter, 1636–7
oil on canvas
96 × 120 cm

231

Antoine Watteau
Les Plaisirs du Bal
c. 1716–17
oil on canvas
53 × 65 cm

Claude: *Jacob with Laban and his Daughters* (1667). The most appealing French painting is Watteau's *Les Plaisirs du Bal* (1716–17), his best in England. All the tremulous delights of this artist are present in this painting, which John Constable said, 'looks as if painted in honey – so tender and so delicious … this inscrutable and exquisite thing would vulgarise even Rubens and Paul Veronese.'

Numerically the largest section is that of the Dutch and Flemish painters. There are several Rubens oil sketches and one great painting: *Venus, Mars and Cupid* (c. 1635). The Dutch Italianate landscapes are outstanding, with particularly grand examples by Aelbert Cuyp, Jan Both, Adam Pynacker and Wouwermans. It is the Rembrandts, however, that draw the visitors to Dulwich. There is small early panel *Portrait of Jacob III de Gheyn* (c. 1632), which

has the unenviable distinction of being the most stolen painting from any museum, having notched up four kidnaps. Rembrandt's *A Girl at the Window* (1645) was owned by the seventeenth-century French theorist Roger de Piles, who dwelt at length on its illusionistic qualities in his *Cours de peinture par principes*. Finally there is the late *Portrait of a Young Man* (1663), sometimes identified as the artist's son Titus, perhaps on account of his doleful appearance.

All the pictures mentioned (except the Canaletto) were left by Bourgeois. The only section of Dulwich where this is substantially not the case is the British school. The college's own collection of English portraits was greatly enhanced in 1835 by the William Linley bequest, which included four family Gainsboroughs and three Lawrences.

Rembrandt van Rijn
A Girl at the Window, 1645
oil on canvas
82 × 66 cm

Sir Peter Lely
Young Man as a Shepherd
c. 1658–65
oil on canvas
91 × 76 cm

Aelbert Cuyp
Herdsmen with Cows, c. 1645
oil on canvas
101 × 145 cm

This was supplemented in 1911 by further outstanding English paintings from Charles Fairfax Murray, which included Hogarth, Soldi, Gainsborough and Lely's unusual *Arcadian Nymphs by a Fountain* (c. 1650). The English, as Lely discovered, preferred portraits; so, undaunted, he produced the beautiful *Young Man as a Shepherd* (c. 1658–65) in the same vein.

In its earliest days Dulwich was the only public gallery of its kind in London and so visitors flocked, and, apart from Waagen and Ruskin, they were generally impressed. Dulwich is a most agreeable suburb and is still surrounded by greenery. 'There is so much air', said the painter Wilkie, and it became a favourite place to meet members of the opposite sex. The poet W.B. Yeats conducted a love affair at 'Dulwich Picture Gallery and in railway trains'. In the twentieth century the college, which was by now a prominent public school, with P. G. Wodehouse among its alumni, valiantly did its best with the gallery, despite partial destruction in the Second World War, burglaries and cash shortages. In 1994 Dulwich College formally handed over responsibility to independent trustees. Today the gallery is beautifully hung and arranged, and more popular than ever with visitors. Desenfans and Bourgeois achieved in death what eluded them in life: admiration and recognition for what D.H. Lawrence accurately described as 'such a splendid little gallery – so little, so rich'.

SIR JOHN SOANE'S MUSEUM

LONDON

Sir John Soane's Museum

Many eccentric and artistic Englishmen have created their own paradise, a showcase for both their collection and their often highly original notions of a picturesque dwelling. Beckford's Fonthill remains only a memory, Walpole's Strawberry Hill has lost its collection and been disfigured, but Sir John Soane's Museum, which was the smallest and last of the three, remains in its purity as Soane left it. To enter is to step into a russet, mottled Regency world, half modern, half antique, a veritable temple to eccentricity. The roots are classical but the manner is entirely English. Hogarth's mob rubs shoulders with the Apollo Belvedere, and the ancient and modern merge like so many layers of an archaeological site. Soane was first and foremost an architect, and any description of his remarkable museum must principally be a description of its architecture, to which all else is subservient.

We cannot be certain exactly when Soane decided to turn his house at 12 Lincoln's Inn Fields into a museum, but the germ of the idea must be connected with the purchase of the house next door, No. 13, in 1808, and the sale of his country house Pitshanger Manor, in Ealing, two years later. Underlying this was disillusionment with his two sons, who he had earnestly hoped would carry the torch of his profession. He had bought Pitshanger to encourage in his elder son John a taste for art, but neither he nor his brother George took the bait. Alas, they were to prove a bitter disappointment at every level. So far as the elder Soane was concerned, they were feckless, made disappointing marriages, and George even took to attacking his father in print. We, however, may be grateful, since the result of Soane's misfortune was the rebuilding of his London house and the creation of a museum that proved to be both a distraction for the present and a solution for the future.

Soane's disappointment in his sons was more keenly felt because he did not start with their advantages in life. He was born the son of a bricklayer in 1753 and entered the office of the architect George Dance the younger at the age of 15. Although he moved to the office of Henry Holland in 1757, the relationship with Dance was crucial on his career. Dance taught him a sense of the poetry of architecture, and bequeathed to him the rudiments of a modern classical style. Soane later paid homage to his master by placing the cabinet containing Dance's architectural drawings in the middle of the North Drawing Room.

The defining experience of Soane's life was his trip to Italy, between 1778 and 1780, on a Royal Academy scholarship, where he came under the patronage of the Earl–Bishop of Derry and met Piranesi. On returning to England he set up his own practice in 1780 and three years later married Elizabeth, an heiress through her uncle George Wyatt. Wyatt died in 1790 and left the young couple wealthy enough to start collecting. The bequest also enabled Soane two years later to buy 12 Lincoln's Inn Fields, a seventeenth-century house that he set about demolishing and rebuilding.

Sir Thomas Lawrence
Portrait of Sir John Soane
1829
oil on canvas
138 × 110 cm

When in the summer of 1808 Soane bought the house next door, No. 13 (which is today the heart of the museum), the original motive was to extend his burgeoning office at the back. He made space for a room for architectural models and statuary, but four years later decided this was not enough, and for the next 25 years Soane was rebuilding, rearranging and perfecting what had become his hobby and obsession. One may feel sorry for Mrs Soane, who spent so much of her life surrounded by dust and noise. She died in 1815, but the building continued.

Today the main body and entrance of the museum is in

No. 13. The exterior is a great surprise. Soane fronted his new façade, situated in a row of dark brick late Georgian houses, with a projecting loggia that appears very modern and is sometimes described as having an Art Deco appearance, and he put some Gothic pedestals from Westminster Hall between the windows. All this got him into trouble with the District Surveyor, William Kinnaird, whom Soane described as behaving impudently. A court action followed, which Soane won.

As you enter the museum, the main room of the house is on your right; it comprises the dining room and library,

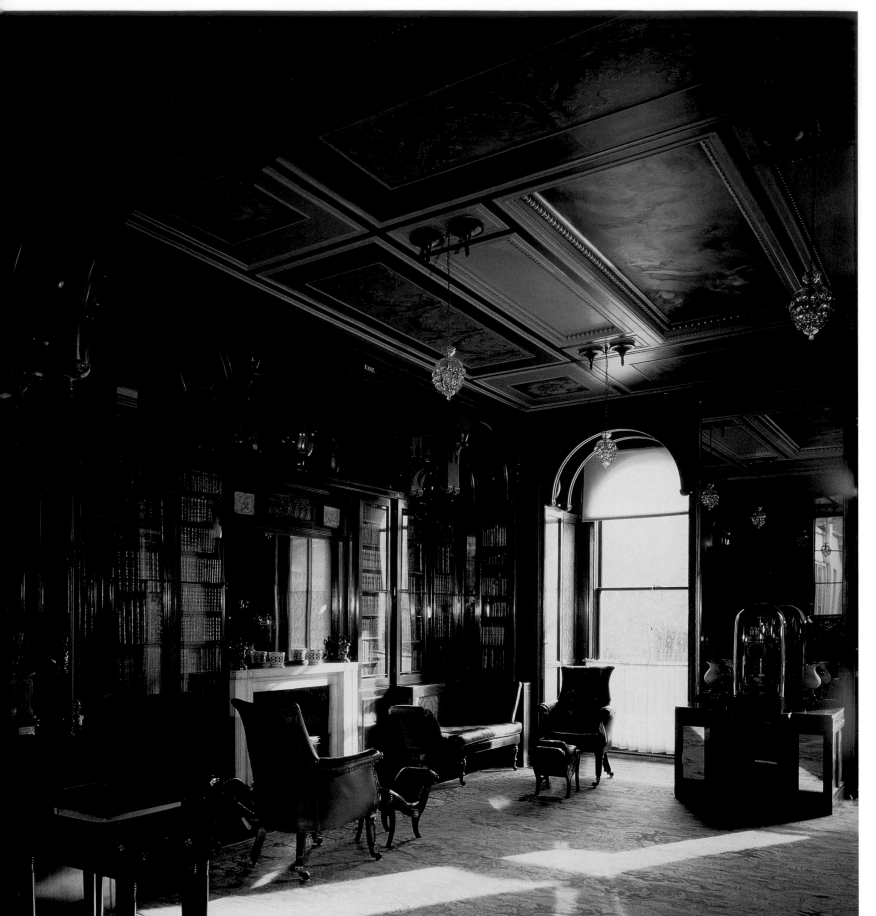

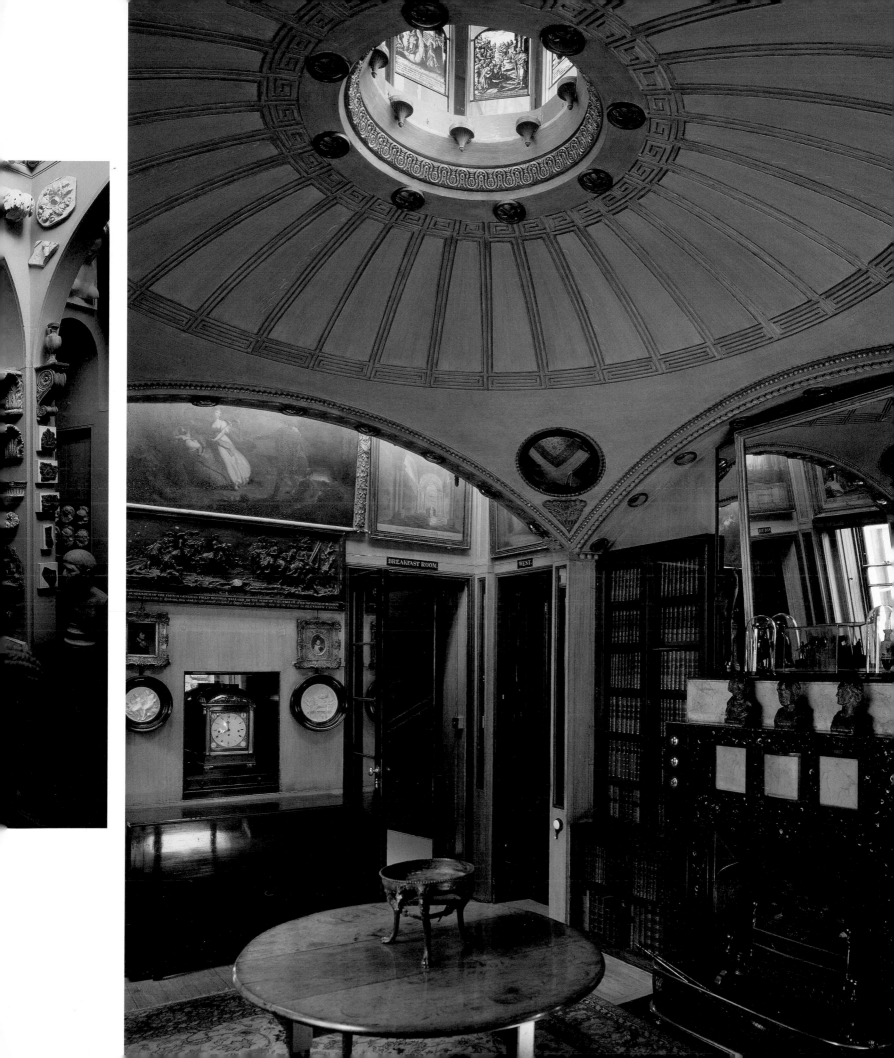

architecture. The Crypt is a marmoreal space dominated by the sarcophagus of Seti I, which Soane acquired for £2,000 after the British Museum rejected it. The effect is funereal and shadowy, reflecting the belief at that time that the Temple of Death was the most poetic reflection in architecture.

If the area adjoining the Dome, with its amazing assembly of gods, urns, fragments and men, is the most startling space in the museum, its most successful room – the Breakfast Parlour, with its floating shallow dome set on arches, is a brilliant light space marked by Soane's typical incised lines and simple patterns under a lantern.

One other room deserves a mention: the Soane family Drawing Room on the first floor. It is rather a shock after the mahogany, plaster and fireworks downstairs to enter this light, spacious, vivid yellow, first-floor room, which no doubt owes its comparative simplicity to Mrs Soane. It contains the portrait of the two Soane boys by William Owen, and adjacent is the cabinet of George Dance's drawings and one of the great treasures of the museum, *Van Tromp's Barge Entering the Texel in 1645,* by Soane's friend J. M .W. Turner.

What are the other treasures in the museum? First must rank the Hogarth series, but the real importance of the museum lies hidden, in an enormous collection of architectural drawings by mostly British architects, including 57 volumes containing 9,000 drawings from the office of Robert and James Adam. This remains one of the key study collections for the history of British architecture. The greater part of the painting collection is by contemporary British artists and Royal Academy colleagues, notably Sir Joshua Reynolds, and a host of lesser-known artists, such as Edward Bird, William Hamilton, A.W. Callcott, Francis Bourgeois and George

Jones. Generally Soane did not collect Old Masters, but there are a few exceptions: Watteau's *L'Accordée du Village,* and three paintings by Canaletto, including a major work, *The Riva degli Schiavoni, Looking West.*

Towards the end of his life Soane decided to formalise the future of his museum and in 1833 obtained a special Act of Parliament enabling him to leave his house to the nation as a museum, with a stipulation that nothing should be removed or added. By this time Soane was indisputably the father of his profession, and this status was recognised by a touching scene that took place in the house in 1835, two years before his death. The chief members of the architectural profession came to the

Joseph Mallord William Turner
Van Tromp's Barge Entering the Texel in 1645
1831
oil on canvas
90 × 122 cm

Antoine Watteau
L'Accordée du Village, 1715
oil on canvas
63 × 92 cm

Canaletto
The Riva degli Schiavoni, Looking West
1736
oil on canvas
126 × 205 cm

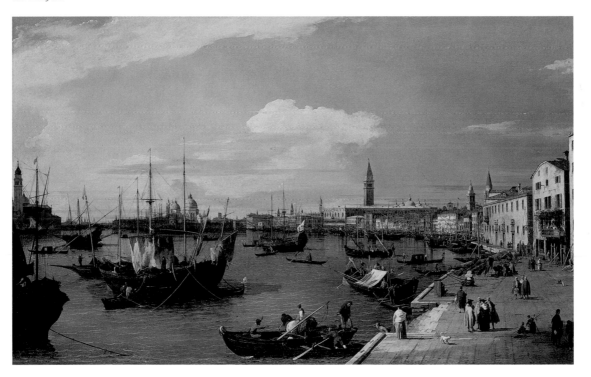

house, read a letter from the bedridden Duke of Sussex, followed by a formal address, and presented to Soane a gold medal in recognition of his services to architecture. Overcome with emotion, he asked his solicitor to reply, and he proposed there and then to endow a charity for distressed architects and their families. That evening a gathering and ball in his honour took place at the Freemasons' Hall, which all present felt did justice to England's greatest living architect.

Soane was content since his aim had always been to bring architecture to the same noble level as painting and sculpture. His museum was intended as an expression of their interrelationship: 'architecture is the Queen of the Arts ... Painting and Sculpture are her handmaids.' He wanted it to be an inspiration, both practical and poetic, and in this it must be judged a success. Soane remains an architectural deity to both traditionalists and modernists, and the house in Lincoln's Inn Fields is his monument.

BOWES MUSEUM

BARNARD CASTLE

The Bowes Museum is neither small nor great, but it deserves its place by virtue of surprise. In fact, it would be true to say that it is the very incongruity of this museum that qualifies it for entry. There are several museums in Europe whose locations are surprising, but none is quite as improbable as that of the Bowes. Imagine a small market town in a northern county of England where farmers chatter in pubs and sheep outnumber men. Leave this pleasant but unremarkable town, called Barnard Castle, by a minor road, and there, breathtakingly out of scale with its surroundings, stands the Bowes Museum like a vast Rothschild château that has fallen out of the sky.

Enter, and you are taken back to Paris of the 1860s and surrounded by fine examples of French decorative arts and the most important English collection of Spanish paintings outside London. How did such an assemblage come to be here? The short answer lies with a rich, illegitimate, local landowner, standing slightly outside his peers, who married a French actress but had no children.

John Bowes was born in 1811, the son of the 10th Earl of Strathmore by a local girl, Mary Milner, whom the earl married on his deathbed in an attempt to secure an inheritance for his son. Lengthy and expensive court cases followed, which gave John Bowes a life interest in the family's Durham estates and Streatlam Castle, which lay a couple of miles outside Barnard Castle. He was to live at Streatlam all his life when he was not in London or Paris. It would be easy to exaggerate the social stigma attached to Bowes, who appears to have led a remarkably conventional life – Eton and Cambridge, followed by the House of Commons and success on the turf. He won the Derby four times, was Liberal MP for South Durham and perpetually anxious about money. Although 'rich on paper', he always lived with huge mortgages and when he

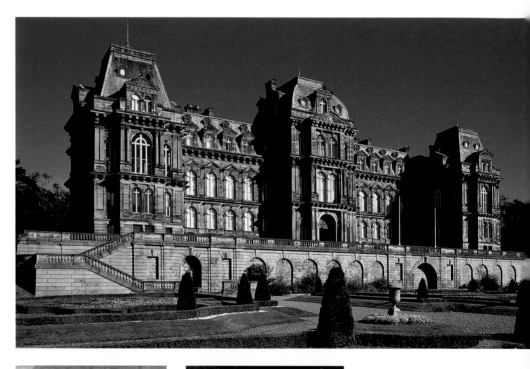

The Bowes Museum

J.E. Feyen
Portrait of John Bowes, 1863
oil on canvas
200 × 181 cm

Anthony Dury
Portrait of Josephine Bowes
1863
oil on canvas
196 × 128 cm

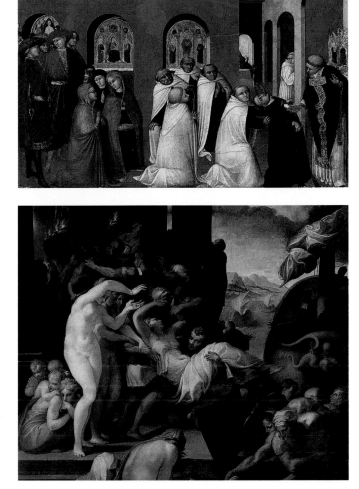

Sassetta
A Miracle of the Eucharist
c. 1425
tempera on panel
27 × 41 cm

Fontainebleau School
The Rape of Helen, c. 1530
oil on canvas
156 × 189 cm

Master of the 'Virgo inter
Virgines', Central panel
of the *Crucifixion* triptych
1490s
oil on panel
219 × 196 cm

later came to create the museum, it strained his finances to breaking point. What marked Bowes out from his contemporaries were his francophilia and his passion for the theatre. In 1847 he gave up parliament and went to live in Paris. There he bought a theatre company, started an affair with one of its actresses, Josephine Coffin-Chevallier, and took the unusual step of marrying her.

Until his marriage John Bowes had been a fairly conventional Grand Tour collector, many of whose swans turned out to be geese, although occasionally it was the other way round. A 'Fra Angelico' today is identified as a Sassetta predella panel, *A Miracle of the Eucharist*, painted in Siena around 1425. Two other early, and rather more daring, purchases include a Fontainebleau School painting of *The Rape of Helen*, the best of its kind in England, and a huge *Crucifixion* by the Master of the 'Virgo inter Virgines'. Once Bowes had married Josephine, the emphasis changed towards France. He bought her the Château Du Barry at Louveciennes, formerly given by Louis XV to his mistress, and together they started buying the French decorative arts that today form the core of the collection. Josephine was herself a painter who exhibited regularly at the Salon and she liked to collect paintings, mostly by her Salon contemporaries; the museum has over 150 examples. Josephine's main interests were tapestries, embroideries and ceramics, and she laid the foundations for a fairly comprehensive collection of European ceramics from the sixteenth century to the nineteenth.

The decision to create a museum appears to have come from Josephine and to be connected with the sale of the château in 1862. The proceeds were used to buy plots of land on the outskirts of Barnard Castle, and the furniture was stored. They engaged a French architect, Jules Pellechet, and over the next 15 years they bought

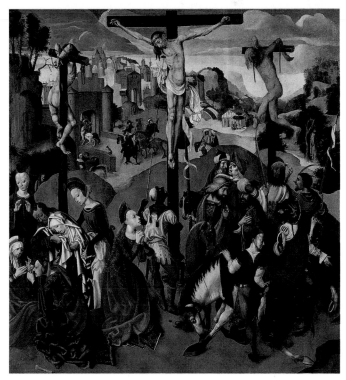

prodigiously and right across the board – paintings, curios, decorative arts – attempting an almost encyclopaedic assemblage of European artefacts. At a time when the Italian Renaissance was the most fashionable collecting period, Bowes and his wife recognised that this was unaffordable and sought out areas that were to some extent undervalued or at least within their budget. Indeed the museum is, more than anything else, a microcosm of what was available in Paris during the 1860s at the lower end of the market. Generally they did not like to spend more than £10 on any item, but occasionally stretched to £100, and even on one occasion to £200 for the eighteenth-century mechanical silver swan that remains the most popular item in the collection. It could be argued that the Bowes Museum seen in a certain light is a poor man's Wallace Collection, but the aims of the two collections were quite different. The founders of the Wallace, quite apart form being vastly richer, were pleasure-seeking voluptuaries surrounding themselves with beautiful objects. Bowes's aim was more didactic and educational. He rarely bought more than one example of any painter or craftsman, and seldom went over-budget.

The heart of the museum is taken up with French decorative arts, and a series of well put-together period

rooms has been constructed along the lines of the Victoria and Albert Museum. The founder's bequest has been augmented by judicious purchases and some allocations by the British government. The best of the French seventeenth and eighteenth centuries was already becoming too expensive for Bowes. Despite that, he put together a fine collection of tapestries and some good paintings, including Boucher's *Landscape with a Water-mill* (1743). The most important eighteenth-century pieces in the museum came later: a lady's writing table by Martin

Detail of embroidered fabric
c. 1725–50
coloured silk on glazed cotton

George Jacob
Chair for Hôtel Marboeuf, 1790
beechwood, painted and gilded
height 96 cm

Martin Carlin
Lady's writing table, 1765
porcelain and tulip wood
height 80 cm

Monbro *fils ainé*
Cabinet, c. 1855
earthenware, ebony and
hardstone
height 163 cm

Isaac Ware
Panelling from Chesterfield
House, London
c. 1750

Carlin, mounted with Sèvres porcelain dated 1765, and a royal table from the Trianon made by Jean Francis Oeben and bearing the mark of the Garde-Meuble of Marie-Antoinette. Undoubtedly the most exotic eighteenth-century piece of furniture is a chair made in 1790 by Jacob under the direction of Dugourc, which manages to reflect both contemporary chinoiserie taste and to foreshadow the Empire style.

John and Josephine Bowes were probably more in their element and certainly within their budget when they came to the nineteenth century. This was the heart of their personal collection, and for years the large quantity of Louis XV and Louis XVI Revival furniture – and in particular their voracious taste for Boulle revival – lay under a critical cloud. It has been said their taste reflects what was typically found at the Paris exhibition of 1867, and this is probably true. In fact, this exhibition seems to have been something of a hiccup for the growth of the collection, as Bowes appears to have been gripped by a panic to fill the museum. Although still only at the planning stage, the scale was none the less evident, and Bowes went on a bargain-buying spree of contemporary tat from around the world. He quickly saw his mistake and thereafter concentrated on Europe.

One of John Bowes's collecting interests was French Revolutionary and Napoleonic-period portraits, of which there are a great many, even lining the stairs; one can only wonder what the locals, who probably still had baleful memories of the Napoleonic wars, made of it all. Between these and Josephine's collection of contemporary Salon paintings the museum contains the largest collection of French paintings in Britain. Josephine bought small examples by Boudin, Fantin-Latour, Courbet and Monticelli, among the 75 contemporary artists represented. She saw the beginning of Impressionism just before her early death in 1874, but appears to have been unmoved by it.

Interestingly, Bowes did not collect English art, which he probably felt was well represented in other places. The collection of English decorative arts, beautifully displayed against very good period panelling, has been acquired entirely since Bowes's death. Excellent purchases of eighteenth-century panelling from Gilling Castle by Matthew Ward and an important Isaac Ware room from his Rococo masterpiece Chesterfield House are the highlights of several well laid-out rooms from the sixteenth century through to a High Victorian room by J. S. Middleton in 1865, trembling on the edge of the Arts

Luca Giordano
The Triumph of Judith, c. 1703
oil on canvas
71 × 103 cm

El Greco
The Tears of St Peter, 1580s
oil on canvas
108 × 90 cm

Francisco de Goya
Interior of a Prison, 1810–12
oil on tin
43 × 32 cm

and Crafts style. There are several important pieces of English furniture, including a bookcase of around 1810 with Egyptian motifs designed by Thomas Hope for Deepdene.

The Old Master painting collection has an element of hit-and-miss about it, which no doubt accurately reflects what collections of the 1860s were really like. There were some very good hits. Apart from the Sassetta, there is a Luca Giordano (*The Triumph of Judith*), a portrait by Trevisani of the great patron *Cardinal Pietro Ottoboni* and a Tiepolo sketch for the destroyed Palazzo Archinto in Milan. The great surprise of the collection, however, is the group of 78 Spanish paintings. These are mostly by little-known artists, but contain an important El Greco (*The Tears of St Peter*) and a Goya (*Interior of a Prison*). It is chiefly thanks to their agent Benjamin Gogué, who negotiated the Spanish paintings from the Conde di

Quinto collection, that these two are in the collection at all, as he wrote in 1862: 'Although these two [Goya and El Greco] do not appeal to you as masters, I think you might as well take one of each of them for your collection.' On that didactic basis they accepted them, no doubt because the Greco cost only £8.

In 1869 Josephine Bowes had laid the foundation stone of the museum: 'I lay the bottom stone, and you Mr Bowes will lay the top stone', which sadly she did not live to see. John Bowes, deeply affected by her death, soon gave up collecting to concentrate on the enormous logistical task of finishing the museum and setting up the exhibits. He did not live to see his museum opened either. He died in 1885 and it was not until seven years later that the museum was ready. After his death the trustees performed heroic feats with tiny resources. Eventually the museum passed into local government ownership, and the

Queen Mother (who was descended from John Bowes's uncle the 11th Earl of Strathmore), became patron of its Friends and lent a collection of royal millinery.

Why did John Bowes do it all? The size of the museum suggests an over-anxious desire to leave a monument on the part of a man excluded from inheriting his father's earldom and with no heirs. Perhaps more important, as a

Liberal MP for the area, John Bowes, strongly encouraged by his wife, felt the educational value of such a museum, and the coming of the railway to Barnard Castle had made it possible to locate it close to his country house but within reach of several large northern towns. And Bowes was right because, although the museum was hopelessly under-funded from the start, and throughout its history has lurched from one crisis to another, the neighbourhood has staunchly stood by its huge white elephant. The talk in the pubs may still be about farming, but there the Bowes Museum still proudly stands, and more full of treasures than at any time in its history.

WALLACE COLLECTION

LONDON

'The Wallace Collection is two things: the finest collection of French eighteenth-century art in the world and the happy ending to a human drama, a drama of mania, greed and hate like a Greek tragedy.' Although today the Louvre might dispute the first of Cyril Connolly's claims, there is no disputing the second. The players in this human drama hang over this collection like ever-present ghosts: their frailties, their tastes and their triumphs are there for all to see. Immensely and at first intimidatingly grand though it is, the atmosphere of the Wallace Collection is also intimate. Today it is housed at Hertford House, a fine nineteenth-century mansion where the contents of staterooms hang alongside those of the boudoir. We can only begin to understand the strange and complex characters involved through the art they collected.

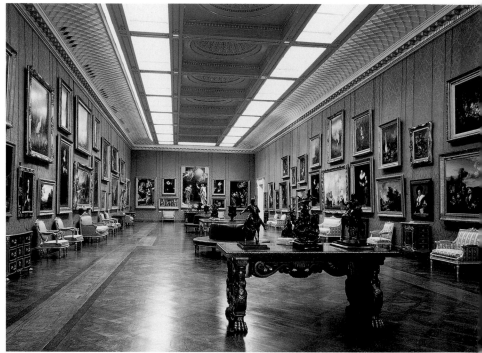

The story begins in 1769, when a former Italian dancer, the Marchesa Fagnani, arrived in London. She had affairs with two very rich men, the rakish 4th Duke of Queensberry (known as 'old Q') and George Selwyn, and gave birth to a daughter, Maria, known as Mie-Mie. Unusually, both men claimed to be Mie-Mie's father and left her their fortunes. She married in 1798 the 3rd Marquess of Hertford, the first collector in our story. The Seymour-Conway family, who were made Marquesses of Hertford, were until that time conventional aristocrats and diplomats; they commissioned the Reynolds portraits and bought the Grand Tour Canalettos. The 3rd Marquess was something different: intelligent, cynical and, with the

The Wallace Collection

The Long Gallery

The 4th Marquess of
Hertford with Madame
Oger and Richard Wallace
at Bagatelle

addition of Mie-Mie's money, rich beyond belief, he was a close friend and artistic adviser to the Prince of Wales, and ended up as the devil's worst Regency rake. 'No man ever lived more despised or died less regretted', said one contemporary; but he must have also had considerable glamour because several novelists felt compelled to introduce him into their books. He became Balzac's Lord Dudley, Disraeli's Lord Monmouth and, most famously, Thackeray's Lord Steyne. As a collector, his main interest was Dutch seventeenth-century paintings, of which he bought wonderful examples both on behalf of the Prince Regent and himself. That he had taste and a good eye there is no denying. In one respect the Prince Regent was his adviser. He encouraged Lord Hertford to buy eighteenth-century French furniture and Sèvres, a prophetic direction because more than anything else the Wallace Collection was to become the supreme example of English Francophile taste. It was left to his son the 4th Marquess to accomplish this.

The marriage to Mie-Mie, despite her millions, was not a success, and in 1802 she was driven to Paris to escape her husband. With her she took her eldest son, Richard (later the 4th Marquess). Soon after their arrival his younger brother Lord Henry was born, a minor collector who was later to found the French Jockey Club. The 4th Marquess was the main collector of the family, and the collection as we see it today bears his personality. Brought up by his mother, the only human being to whom he ever showed unselfish love, he tried soldiering, politics and diplomacy but by the age of 30 had given up public life and settled next door to his mother at 2 rue Laffitte. In 1842 the 3rd Marquess died after a lurid visit to a brothel and left his eldest son with a personal fortune in excess of £2 million. Neurotic, hypochondriac and increasingly reclusive, the most famous description of Lord Hertford was given by the critic Charles Yriarte: 'He lived a withdrawn life, always seemed to be ailing, never entertained, opened his door only to a few intimate friends and since he was absolutely indifferent to all movements and life, would not even have drawn back his curtains to see a revolution go past in the street.' He came alive only through collecting, and this is most vividly revealed by his letters to his agent Samuel Mawson. Although he craved anonymity, he preferred to buy in the public saleroom, which was the stage for his epic battles in forming the greatest collection of the time. Only the Rothschilds could compete, and even they were outbid. Although he bought enough works of art to fill several palaces, his preferred dwelling was the Château de Bagatelle, the small pleasure pavilion built by the Comte d'Artois on the edge of the Bois de Boulogne that he bought in 1835. He owned several houses in London and great estates in England and Ireland, which he seldom if ever visited. Most of his purchases he never even bothered to unpack.

Lord Hertford followed his father's taste in collecting the best seventeenth-century Dutch paintings but ignored the growing fashion for the Italian Renaissance. Where he was altogether extraordinary, and well ahead of his time, was in his passion for the French *ancien régime* in all its works, and it played to both his strengths and weaknesses as a collector. His taste was for pretty things. On the other hand, he missed opportunities. Mawson once offered him a Murillo of an old man and he replied, 'I have no doubt it is fine, as you say so. But I confess I do not much like the portrait of an old man, however fine it may be: it is not pleasing … I only like pleasing pictures.'

As a young man, Lord Hertford had an illegitimate son, who became known as Richard Wallace. He was brought up in Paris by his grandmother Mie-Mie and at a suitable age – unaware of his parentage – was appointed secretary to the 4th Marquess. Wallace was to spend his entire life as secretary and adviser to his father. He had a humanity and generosity of spirit lacking in his forebears. His philanthropy during the Franco-Prussian War was

legendary and to this day Parisians enjoy the 30 public fountains he gave to the city, which still bear his name. Wallace's own collecting followed a different direction: medieval and Renaissance precious objects and armour.

Wallace's collections today occupy much of the ground floor of Hertford House. There are two galleries reflecting his taste for *Schatzkammer* material: Venetian glass, French ivories, Italian bronzes, German silver, Limoges, porcelain, coins and medals. He particularly liked Italian maiolica, and there are several outstanding pieces, including the wine cooler made for Cosimo I de' Medici by Flaminio Fontana in 1574, for which Wallace paid a princely £4,500 in 1876. The oriental armour was mostly

Flaminio Fontana
Wine cooler made for Cosimo I
de' Medici, 1574
tin-glazed earthenware
(maiolica)
40 × 71 cm

Antoine-Robert Gaudreaus and
Jacques Caffièri, Commode
c. 1739
height 89 cm

Boulle wardrobe
surmounted
by a clock, 1715
height 302 cm

Jean-Henri Riesener
Roll-top desk
1769
height 140 cm

collected by the 4th Marquess as part of the fashionable
Orientalism following d'Aumale's conquest of Algeria in
1830. The Marquess enjoyed the Oriental paintings of
Decamps and Vernet, and in the same exotic spirit he
collected armour, mostly Indian but also Middle Eastern
and Ottoman. The European armoury, apart from the
great European royal collections, is the most important in
the world. This was the result of Wallace's buying *en bloc*
two of the finest collections available: the Nieuwerkerke
and Meyrick collections. There are many outstanding
historical pieces: the swords of Cosimo de' Medici and
Henry, Prince of Wales, and Henry IV's dagger, presented
by the city of Paris.

The ground floor also introduces us in four rooms to the
eighteenth-century taste of the 4th Marquess and two of
the great themes of the collection, French furniture and
Sèvres porcelain. Perhaps only half of the furniture he
owned is in the collection today but what remains is quite
extraordinary and only equalled by the Louvre. There is
the great bravura commode (c. 1739) made by Antoine-
Robert Gaudreaus and Jacques Caffiéri, which – unknown
to Lord Hertford, who loved French royal provenances as
a sure guarantee of quality – was supplied for Louis XV's
bedroom at Versailles. Lord Hertford loved clocks and
there are over 40 in the collection, but none is more
fantastic than the 1750 astronomical clock. For those who
like Boulle, there are princely examples from an early
cabinet (c. 1665–70), when he was still using exotic wood
marquetry, through to the great elephantine wardrobe
surmounted by a clock (1715). The quality of the furniture
on the first floor is similar. There is another astonishing
commode attributed to Gaudreaus with chinoiserie dragon
mounts, a roll-top desk made by Riesener for the Comte
d'Orsay (1769) and three secretaires he made for Marie-

Sèvres inkstand given
by Louis XV to his daughter
Marie-Adélaïde, 1758
porcelain
width 38 cm

Eugène Delacroix
Execution of Doge Marino Faliero
1825–6
oil on canvas
146 × 114 cm

François Boucher
Portrait of Madame de Pompadour
1759
oil on canvas
91 × 68 cm

Jean-Antoine Watteau
Rendez-vous de Chasse
c. 1717–20
oil on canvas
124 × 189 cm

Antoinette at the Petit Trianon, as well as superb pieces by Leleu, Weisweiler, Dubois and others.

The Sèvres collection is almost without peer and, as Connolly put it, 'in its vitrines sings like a coral reef seen through a glass-bottomed boat'. Everyone will have their favourite piece or colour. I used to wonder which piece I should like to be given and plumped for the inkstand given by Louis XV to his daughter Marie-Adélaïde. You can apply the same test to the snuff boxes, but as has been often pointed out, Lord Hertford's taste for polish and elaboration led to an uncertain response to contemporary art. Most of the paintings on the ground floor are eighteenth-century, particularly by Desportes and Oudry, but in one room there are nineteenth-century paintings, of which Lord Hertford was a voracious collector. In general his taste was that of the conventional and sentimental visitor to the Salon, but here are some of his best purchases of historical paintings by Delaroche and Bonington. He owned 11 oils and 25 watercolours by

Bonington, and it was possibly his influence that led Lord Hertford to purchase Delacroix's *Execution of Doge Marino Faliero*, painted when the two artists were briefly sharing a studio in 1825–6.

Lord Hertford is revealed as a voluptuary in his taste for Boucher, whose paintings on the staircase mostly represent mythological inhabitants of heaven, such as the two great canvases of *The Rising and the Setting of the Sun* (1752–3). Few are as perfect as his *Portrait of Madame de Pompadour* (1759), which is the epitome of *ancien régime* elegance. The first floor continues the Marquess's unrivalled collection of eighteenth-century French paintings and in this field his taste for pleasing pictures led him to buy masterpieces. The seven Watteaus are among the glories of the collection. The gods have come down to earth and turned into gallants. We are in the world of the enchanted picnic, where pleasure is a branch of poetry, whether it is flirting in *Harlequin and Columbine* (c. 1716–18), playing music in *Les Charmes de la Vie*

Emile-Jean-Horace Vernet
The Wounded Trumpeter, 1819
oil on canvas
53 × 64 cm

Jean-Honoré Fragonard
The Swing, 1767
oil on canvas
81 × 64 cm

(c. 1718) or simply resting, in *Rendez-vous de Chasse* (c. 1717–20). The Marquess cheerfully bought Pater and Lancret with the same enthusiasm, but after Watteau it is Fragonard who holds centre stage, with a group of seductive paintings of which the most famous is *The Swing* (1767). A 'gentleman of the court' commissioned Fragonard to paint his mistress on a swing being pushed by a bishop, and to place himself in the picture where he would be in a position to see her legs: the result was the most tasteful saucy picture ever painted without recourse to nudity. Lord Hertford bought no Chardin but had a decided weakness for Greuze, owning 20 of his paintings. Beyond the eighteenth century lie more French nineteenth-century painters, dominated by Vernet, Decamps, Meissonier and Delaroche. Many of these paintings have achieved great popularity, such as Meissonier's *Halt at the Inn* and Vernet's *The Wounded Trumpeter* (1819), but as Kenneth Clark observed, Lord Hertford sometimes failed to recognise 'that between a

silk shirt of Watteau and a satin doublet by Meissonier lay the whole secret of art'.

The climax of the collection is the Great Gallery, and whatever reservations have been expressed about Lord Hertford as a collector must be silenced by this dazzling gallery of masterpieces. The seventeenth and eighteenth centuries dominate, but there is one lonely masterpiece from the sixteenth century, an unusual and brilliant purchase by the 3rd Marquess, Titian's late *Perseus and Andromeda* (c. 1554–6), painted for Philip II. Wallace, ignorant of its importance, later hung it above his bath. There are several paintings by Rubens, including his great *Rainbow Landscape* (c. 1638), a hymn of joy celebrating the verdant Flemish landscape near his own Château de Steen. Having ruthlessly outbid the National Gallery, which owned the pair, Lord Hertford had the painting delivered to Hertford House and never saw it again. There are serious examples of French seventeenth-century painting, three major works by Philippe de Champaigne, a

Rembrandt van Rijn
Portrait of the Artist's Son Titus
c. 1657
oil on canvas
68 × 57 cm

Frans Hals
Laughing Cavalier, 1624
oil on canvas
83 × 67 cm

galleries of smaller Dutch paintings. Best known of the great Dutch pictures in the gallery are Rembrandt's moving and doleful *Portrait of the Artist's Son Titus* (c. 1657) and Frans Hals's *Laughing Cavalier* (1624), in which – as has often been pointed out – only the eyes smile. The cause of this picture's extraordinary fame was probably the bidding battle that took place with James de Rothschild, in which Hertford paid six times the estimate. At one end of the gallery is a glorious group of English paintings with one of Gainsborough's most appealing

portraits: *Mrs Robinson as 'Perdita'* (1781), which the Prince Regent gave to the 2nd Marquess.

Lord Hertford died in 1870 at Bagatelle as the Prussian army approached Paris. He left Richard Wallace everything except his entailed family properties. Wallace's generosity to the city of Paris during the siege and the Commune had earned him the Légion d'Honneur, but the events may have persuaded him to move himself and the greater part of the collection to London. With the Marquess dead, he married his French mistress of 30 years

Thomas Gainsborough
Mrs Mary Robinson as Perdita, 1781
oil on canvas
234 × 153 cm

Richard Wallace
aged 70

and began to extend Hertford House. While it was being rebuilt Wallace took the progressive step of lending the collection to the new Bethnal Green Museum in the heart of London's poor district, the East End, where an astonishing five million people came to see it. Wallace became a public figure in England, Queen Victoria made him a baronet in 1871 and the Prince of Wales went to shoot with him at Sudbourne Hall. But in 1887 his only (illegitimate) son died, leaving Sir Richard disconsolate and in 1890 he returned, alone, to Paris, where he died in his father's bed at Bagatelle. It was left to Lady Wallace, who spoke no English, to fulfil what Wallace had intended and leave the great accumulation of works of art at Hertford House to the English nation.

Lady Wallace's will stipulated that nothing should be added or sold, and so the collection remains today much as Sir Richard left it. To the late Victorian public the main revelation was the French painting of the *ancien régime*. Taste and fashion have generally followed the 4th Marquess in his passion for the visible remains of pre-Revolutionary *douceur de vivre*. Today the first thing that strikes the visitor to Hertford House is the splendour, the overwhelming sense of opulence. It is too rich to take in everything on one visit and a decision must be made to look at either Sèvres, furniture or paintings. A visit to the Wallace Collection leaves behind many *souvenirs*; everything is of a quite extraordinary quality, the Great Gallery is probably the best of its kind in the world, and what is certain is that nowhere in the world, outside France, will you see such a magnificent collection of French art.

COURTAULD INSTITUTE GALLERY

LONDON

The north block of Somerset
House, seen from the
courtyard

Count Antoine Seilern

The Courtauld Institute Gallery was for years the
Cinderella of London collections. And yet, despite living
in a cramped and joyless home, this Cinderella was
showered with gifts and bequests, though she had
nowhere to put them. But then along came a prince –
the British government – with a great eighteenth-
century palace – Somerset House – and the result is
for all to enjoy.

As a collection the Courtauld is extraordinary and
rather un-English. It contains one of the finest groups of
Impressionist paintings in the world and a collection of
Old Master paintings that largely reflects continental
European taste. If the story has resemblances to
Cinderella, then the real text for the collection is the story
of wise men bearing gifts, because the Courtauld's
formation and character are primarily the product of
three enlightened private collectors who saw the need for
a British institute of art history and a collection to go with
it. They were Samuel Courtauld, Lord Lee of Fareham
and, later, Count Antoine Seilern.

Although the institute and gallery bear Samuel
Courtauld's name and most people go there to see his
Impressionist paintings, the real founder was Arthur Lee,
Viscount Lee of Fareham. It was he who had the idea of
establishing an institute for teaching art history under the
wing of London University, and approached Courtauld,
among others, who became the main benefactor. Lord Lee
(1868–1947) is a rather odd figure to try and understand
today. Soldier, politician and administrator, he was a
figure of the establishment who liked to dabble in the art
world, where he was generally resented. He did much
good, however, and is best known for giving Chequers
and its collection to the nation as a country residence for
the British prime minister, and through his energy the

Peter Paul Rubens
Descent from the Cross, 1611
oil on panel
115 × 76 cm

Courtauld Institute was established in 1932. Lord Lee was also a serious collector of paintings and he gave his collection to the newly formed institute, which included the Rubens sketch for the Antwerp *Descent from the Cross,* and several outstanding English portraits, including Hans Eworth's *Allegorical Portrait* of Sir John Luttrell (1550).

Samuel Courtauld (1876–1947) is a puzzle. A successful and hard-working textile manufacturer with a strong sense of liberal idealism, he appears a rather grey and austere figure until you consider the art he purchased. As is common with young Englishmen, his interest in art was not deeply awakened until he went to France and Italy and began to appreciate how dead English art had become. He recognised that the Old Master tradition was most alive in the modern French school. At first it was the more sensual earlier painters – Manet, Monet, Renoir and Degas – that attracted his attention and he was greatly stimulated by seeing the Hugh Lane collection exhibited at the Tate Gallery in 1917. This education was completed five years later at the Burlington Fine Arts Club exhibition, where he discovered Cézanne and Seurat, who were to become his favourites. In 1921 he became chairman of Courtaulds, which gave him the financial freedom that enabled him over the next decade to form his collection.

Courtauld was not in the first wave of English collectors of Impressionist paintings and did not start to buy seriously until 1923, when prices were beginning to rise and it was becoming more difficult to find the best paintings. What he managed to acquire, however, was simply astonishing and as a collection it has a very attractive character. In purchasing, Courtauld appears to have been his own man, though he sought advice from the dealer Percy Moore Turner and was deeply influenced by the views of the critic Roger Fry.

Claude Monet,
Autumn Effects at Argenteuil, 1873, oil on canvas
55 × 74 cm

Edouard Manet
Banks of the Seine at Argenteuil, 1874
oil on canvas
62 × 103 cm

Let us look at one or two highlights from the collection. Nowhere can be more closely associated with Impressionism than Argenteuil, where between 1872 and 1876 Sisley, Renoir, Manet and Pissarro went to join Monet, who was the guiding spirit of the place. We have his 1873 *Autumn Effects at Argenteuil,* in which the real subject is the shimmering reflections in the water. Manet arrived the following year, already a successful painter and, apart from sorting out Monet's housing problems, painted a number of pictures including *Banks of the Seine at Argenteuil,* which shows a strong Impressionist influence. Emulating his younger friend, Manet started to paint outdoors more and adopted a brighter palette, but he did not give up his figures, and this one probably represents Monet's wife, Camille, and their son Jean.

Renoir spent 1874 mostly in Argenteuil, painting alongside Monet and Manet, but at the beginning of the year in Paris he painted one of his masterpieces, *La Loge,* which shows the model Nini and the artist's brother

Pierre Auguste Renoir
La Loge, 1874
oil on canvas
80 × 63 cm

Edgar Degas
Two Dancers on the Stage
1874
oil on canvas
61 × 46 cm

Edmond in a theatre box. It was exhibited in the famous 1874 exhibition alongside Monet's *Impression, Sunrise* and is one of the most satisfying of all Renoir's paintings. Osbert Sitwell said that it showed that in a different era Renoir would have been a great court painter. This judgement certainly applies to Renoir's portrait of the dealer *Ambrose Vollard* (1908), which is a direct derivation from the collector portraits of the Italian Renaissance.

Degas is well represented by, among other paintings, *Two Dancers on the Stage* (1874), in which movement was never more delicately captured. It was probably the first of his paintings to come to England, bought the same year from Durand-Ruel by Captain Hill of Brighton. The Gauguins are majestic. There is a letter from Gauguin to his agent in Paris in which he describes *Nevermore* (1897): 'I wished to suggest by means of a simple nude, a certain long-lost barbarian luxury. The whole is drowned in colours which are deliberately sombre and sad ...'. The subject is mutability, and the title and the raven in the painting refer to Edgar Allan Poe, despite Gauguin's odd denial. *Te Rerioa* ('The Dream') of 1897 Gauguin intended to be ambiguous, and it still keeps us guessing today. It was Roger Fry who persuaded Courtauld to buy this painting which, as he put

Paul Gauguin
Te Rerioa ('*The Dream*')
1897
oil on canvas
95 × 130 cm

Vincent Van Gogh
*Self-portrait with
Bandaged Ear*, 1889
oil on canvas
60 × 50 cm

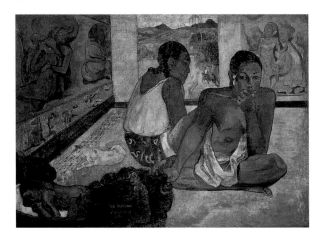

it, 'is I suspect *the* masterpiece of Gauguin'.

Forever associated with Gauguin's famous visit to Arles is Van Gogh's *Self-portrait with Bandaged Ear* (1889), one of the most emotionally loaded images of this crisis-ridden painter and one of the tiny handful of paintings that are recognised by anyone without the slightest interest in art. In the same year Van Gogh painted *The Crau at Arles: Peach Trees in Flower* (1889) and if we wonder at the unpromising subject matter, the artist explained it in a letter to Paul Signac: 'Everything is small … the gardens, the fields, the orchards and the trees, even the mountains, as in certain Japanese landscapes, which is the reason why the subject attracted me.'

Courtauld owned ten Cézannes and his taste developed in this direction. There is *Mont Sainte Victoire* (c. 1887); for Cézanne painting this mountain became almost a ritual act of worship. He was more challenged by *Le Lac d'Annecy* (1896), where the scenery reminded him of 'the albums of young lady travellers', and he produced a monumental uncompromisingly Poussinesque landscape which looks more like a detail of a painting blown up. In a different

Paul Cézanne
Le Lac d'Annecy, 1896
oil on canvas
65 × 81 cm

Georges Seurat
Young Woman Powdering Herself
c. 1888–90
oil on canvas
95 × 79 cm

Paul Cézanne
Mont Sainte Victoire, c. 1887
oil on canvas
67 × 92 cm

vein, *The Card Players* (c. 1892–5) looks back to the peasant genre subjects of the seventeenth-century Le Nain brothers. Courtauld also had a particular fondness for Seurat and there are 11 of his paintings in the collection. Most have that diffused, impersonal, almost mathematical quality of *The Bridge at Courbevoie* (1886–7), so it is a surprise to meet in the flesh his large, busty mistress Madeleine Knobloch in *Young Woman Powdering Herself* (c. 1888–90). But the lady who steals the show at the Courtauld is without doubt Manet's barmaid in *A Bar at the Folies-Bergère* (1881–2), whom David Piper described as 'that blonde with a fringe and absent pop-eyed hazel gaze'. This slightly ambiguous depiction of a barmaid was Manet's last great work and is what draws most visitors to the gallery.

In 1931 Courtauld's wife died and he established the fledgling institute at his house by Robert Adam in Portman Square, while the collections were eventually moved to a cramped purpose-built gallery in Woburn Square, where

Edouard Manet
A Bar at the Folies-Bergère
1881–2
oil on canvas
96 × 130 cm

they remained one of London's best-kept secrets.
Amazingly, given the lack of space, further bequests
swelled the collection at an astonishing rate: two very
important groups of drawings and prints from Robert Witt
and William Spooner, and the collection of mostly
Bloomsbury paintings belonging to Roger Fry. Then came
the Gambier-Parry collection of Italian gold-ground
paintings, acquired in the mid-nineteenth century,
including the *Coronation of the Virgin* (c. 1395) by Lorenzo
Monaco and Bernardo Daddi's *Crucifixion* polyptych
(1338). The Courtauld collections still remained
unbalanced in quality, but in 1978 came one of the greatest
benefactions ever made to a British gallery and one to give
a qualitative balance to the collection between its Old

Bernardo Daddi
Crucifixion triptych, 1338
tempera on panel
height 87 cm

Francesco Mazzola
Parmigianino
Virgin and Child, c. 1524–7
oil on panel
63 × 51 cm

Peter Paul Rubens
*The Family of Jan
Bruegel the Elder*
1613–15
oil on panel
124 × 94 cm

Masters and its Impressionist paintings. This was the remarkable collection of Count Antoine Seilern.

This princely hoard included 32 paintings and 23 drawing by Rubens, over 40 works by Giam Battista Tiepolo, 6 drawings by Michelangelo and 30 by Rembrandt, and paintings by among others, Daddi, the Master of Flémalle, Parmigianino and Pieter Bruegel the Elder. It was the collection of a scholar and perfectly suited to the didactic needs of a teaching institute.

Seilern (1901–1978) came from an old Austrian aristocratic family and in his youth followed the traditional sporting pursuits of his background. His mother's family had a fortune derived from a German-language newspaper in New York, which gave him a margin of wealth to study and collect. At the comparatively late age of 32 he enrolled at Vienna University and came under the benign influence of the great art historian Johannes Wilde, on the staff of the Kunsthistorisches Museum. Wilde guided Seilern towards scholarship and Ludwig Burchard pointed him towards Rubens. The result was a scholarly assemblage, strongest in Italian and Flemish schools, that was already impressive in 1939, when Seilern moved to London and relinquished his dual Austrian nationality for British. The collection continued to grow during the war, and shortly afterwards

Giam Battista Tiepolo
Saint Paschal Baylon's Vision of the Eucharist
1767
oil on canvas
64 × 39 cm

it found a home at 56 Prince's Gate. About the same time Wilde came to London and became Deputy Director of the Courtauld Institute, thus beginning the relationship that ended in the bequest in 1978, when the Count died.

At the heart of the Seilern collection is Rubens. There are several groups of sketches, including a number for his great decorative project in the Jesuit church at Antwerp. There is also the *Landscape by Moonlight* (1637–8), which the artist kept for his own enjoyment and which later belonged to Sir Joshua Reynolds. The most celebrated work by Rubens in the collection is *The Family of Jan Bruegel the Elder* (1613–15), in which he pioneered an image of family life so informal and satisfying that this type of portrait has endured into our own century. Tiepolo is the other hero of the Seilern collection and there are the surviving *modelli* for Tiepolo's last major commission for seven altarpieces for the church of the Discalced Franciscans at Aranjuez. They were commissioned in 1767, but Tiepolo's Baroque style was soon out of date and they were painted over by Mengs and others, so the *modelli* provide our main knowledge of the commission.

With the Seilern bequest, the old gallery space became totally inadequate, but fortuitously Somerset House, the eighteenth-century government palace built by William Chambers, was becoming available, and it offered the opportunity to join the Courtauld Institute with the collections. For years the home of the Inland Revenue and the Registrar of Births, Deaths and Marriages, Somerset House was emerging from its own Cinderella period. Originally built between 1776 and 1801 to house government departments, it contained a suite of beautiful rooms over two floors on the north Strand range, designed to accommodate the Royal Academy. This was

moved out to Burlington House in 1837 and it was thoroughly appropriate that these rooms should become the new Courtauld Institute Gallery, opened in 1990. It has certainly been a happy use of a great building, which now also contains the Gilbert collection of silver. The courtyard has been reclaimed for pleasure with ice-skating in winter, while in summer children play among the ingenious waterworks.

Today the Courtauld Institute Gallery makes an interesting counterpoint to most English collections, since its strengths are unusual in England and its weaknesses, such as Dutch paintings, are well represented elsewhere. Art historians will delight in Seilern's Rubens sketches, but for most people the principal draw will be Courtauld's paintings. He formed not only the finest collection of Impressionist and Post-Impressionist paintings put together in England, but one of the most enjoyable assemblages anywhere.

ILLUSTRATION CREDITS

Scala Publishers would like to thank all the museums included for their kind assistance in the preparation of this book, and especially for granting permission to reproduce images as follows:

Academy of Fine Arts All images courtesy of the Gemäldegalerie der Akademie der Bildenden Künste Wien, except Josef Danhauser, The Scholar's Room, courtesy of Österreichische Galerie Belvedere, Vienna.

Museum Mayer van den Bergh All images courtesy of the Museum Mayer van den Bergh, Antwerp.

Louisiana Museum All images courtesy of the Louisiana Museum of Modern Art, Humlebæk, Denmark: Calder, Slender Ribs, © ARS, NY and DACS, London 2003; Calder, Little Janey Waney, © ARS, NY and DACS, London 2003; Picasso, Woman and Piper III © Succession Picasso / DACS 2003; Dubuffet, Les Implications Journalières © ADAGP, Paris and DACS, London 2003 ; Bacon, Man and Child © Estate of Francis Bacon 2003. All rights reserved, DACS; Heerup, Mask © DACS 2003; Giacometti, Six Venetian Women © ADAGP, Paris and DACS, London 2003.

Musée Fabre All images courtesy of Musée Fabre, Ville de Montpellier.

Musée d'Unterlinden All images courtesy of © Musée d'Unterlinden Colmar, photo O. Zimmermann.

Musée Condé All images courtesy of Musée Condé, Chantilly: Raphael, The Madonna of Loretto and Orléans Madonna and Poussin, The Massacre of the Innocents all © Photo RMN – Harry Bréjat; Gros, The Plague-stricken of Jaffa, © Photo RMN.

Musée Jacquemart-André All images courtesy of Institut de France – Musée Jacquemart-André.

Musée Gustave Moreau All images courtesy of Musée Gustave Moreau, Paris: photograph of Moreau by Eliza de Romilly © Photo RMN – R. G. Ojeda; photograph of the museum façade and the dressing-room in Moreau's apartment © Photo RMN – R. G. Ojeda; Moreau, The Suitors, The Unicorns, The Apparition and Jupiter and Semele all © Photo RMN – R. G. Ojeda; photograph of the Main Gallery and the iron staircase leading to the second floor © Photo RMN; Moreau, The Life of Mankind © Photo RMN – C. Jean; photograph of the bedroom in Moreau's apartment © Photo RMN – Daniel Arnaudet.

Musée Marmottan All images courtesy of Musée Marmottan, Paris: photograph of Paul Marmottan © Bibliothèque Marmottan/Bridgeman Art Library; Monet, Impression: Sunrise © ADAGP, Paris and DACS, London 2003; Monet, Pont de l'Europe Gare Saint-Lazare © ADAGP, Paris and DACS, London 2003; Monet, Parliament, Reflections on the Thames © ADAGP, Paris and DACS, London 2003; Monet, Nymphéas © ADAGP, Paris and DACS, London 2003; Monet, Nymphéas © ADAGP, Paris and DACS, London 2003; Monet, Japanese Bridge © ADAGP, Paris and DACS, London 2003.

Musée Picasso All images courtesy of Musée Picasso © Succession Picasso / DACS 2003, except De Stael, Large Concert © ADAGP, Paris and DACS, London 2003.

Schlossmuseum All images courtesy of Siftung Weimarer Klassik und Kunstsammlungen: Beckmann, Young Men at Sea © DACS 2003; Monet, Rouen Cathedral © ADAGP, Paris and DACS, London 2003.

Schloss Wilhelmshöhe All images courtesy of Staatliche Museen Kassel, Gemäldegalerie Alte Meister (Museum Schloß Wilhelmsöhe).

Glyptothek All images courtesy of Staatliche Antikensammlungen und Glyptothek München.

Lenbachhaus All images courtesy of Städtische Galerie im Lenbachhaus, Munich: Kandinsky, Railway near Murnau © ADAGP, Paris and DACS, London 2003; Kandinsky, Red Patch II © ADAGP, Paris and DACS, London 2003; Kandinsky, Study for Composition VII © ADAGP, Paris and DACS, London 2003; Kandinsky, Improvisation 26 (Rowing) © ADAGP, Paris and DACS, London 2003; Munter, Portrait of Marianne von Werefkin © DACS 2003; Jawlensky, Portrait of the Dancer Alexander Sakharov © DACS 2003; Klee, Fruit on Red © DACS 2003.

Galleria Borghese All images courtesy of Archivio Fotografico Soprintendenza Speciale per il Polo Museale Romano.

Galleria Doria Pamphilj All images courtesy of Arti Doria Pamphilj s.r.l.

Accademia Carrara. All images courtesy of Archivio Fotografico Accademia Carrara Pinacoteca.

Canova's House and Cast Gallery All images courtesy of Concessione Fotografica del Lascito Fondazione Canova di Possagno TV Italia, except Cupid and Psyche © Photo RMN – C. Jean.

Museo Poldi Pezzoli All images courtesy of Milano Museo Poldi Pezzoli; © Jürgen Backer.

Ca' Rezzonico All images courtesy of Ca' Rezzonico, Musei Civici Veneziani. Giam Battista Tiepolo, The ceiling of the Nuptial Allegory Room © Photo Scala 1997; Longhi, The Rhinoceros © Photo Scala 2001; Guardi, The Nuns' Parlour at San Zaccaria © Photo Scala 1990; Guardi, Ridotto of Palazzo Dandolo © Photo Scala 1990; Giandomenico Tiepolo, The New World, © Photo Scala 1997; Giandomenico Tiepolo Two Men and a Woman Walking © Photo Scala 2001.

Mauritshuis All images courtesy of the Royal Cabinet of Paintings, Mauritshuis, The Hague.

Kröller-Müller Museum All images courtesy of Collection Kröller-Müller Museum, Otterlo, The Netherlands: Monet,The Artist's Boat © ADAGP, Paris and DACS, London 2003; Mondrian, Composition No. 10 (Pier and Ocean) © Piet Mondrian 2003; Mondrian/Holtzman Trust c/o Beeldrecht, Hoofddorp & DACS, London; Gris, Still Life with an Oil Lamp © ADAGP, Paris and DACS, London 2003; Oldenburg, Trowel © DACS 2003; Dubuffet, Jardin d'Email © ADAGP, Paris and DACS, London 2003.

Princes' Czartoryski Museum All images courtesy of the Princes'Czartoryski Foundation at the National Museum in Kraków.

Museu Calouste Gulbenkian All images courtesy of the Calouste Gulbenkian Museum, Lisbon: Lalique, Dragonfly Pectoral, © ADAGP, Paris and DACS, London, 2003.

Teatro–Museu Salvador Dalí All images courtesy of © Salvador Dalí, Gala–Salvador Dalí Foundation, Figueres 2003/ DACS, London 2003.

Oskar Reinhart Collection All images courtesy of Oskar Reinhart Collection 'Am Römerholz', Winterthur, Switzerland: Picasso, Portrait of Fernandez de Soto © Succession Picasso / DACS 2003.

E.G. Bührle Foundation All images courtesy of Foundation E.G. Bührle Collection. Monet, Poppies near Vétheuil, © ADAGP, Paris and DACS, London 2003.

Beyeler Foundation All images courtesy of Fondation Beyeler, Riehen/Basel:Picasso, Femme (Époque des 'Desmoiselles d'Avignon') © Succession Picasso / DACS 2003; Picasso, Buste de femme au Chapeau © Succession Picasso / DACS 2003; Picasso, La Mandoliniste © Succession Picasso / DACS 2003; Picasso, Verre, Bouteille, Guitare ('Ma Jolie') © Succession Picasso / DACS 2003; Picasso, Femme en vert, © Succession Picasso / DACS 2003; Léger, The Level Crossing © ADAGP, Paris and DACS, London 2003; Léger Contraste des formes © ADAGP, Paris and DACS, London 2003; Mondrian, Eucalyptus © Piet Mondrian 2003 Mondrian/Holtzman Trust c/o Beeldrecht, Hoofddorp & DACS, London; Mondrian, Composition no VI, © Piet Mondrian 2003 Mondrian/Holtzman Trust c/o Beeldrecht, Hoofddorp & DACS, London; Mondrian, Tableau No. 1 © Piet Mondrian 2003 Mondrian/Holtzman Trust c/o Beeldrecht, Hoofddorp & DACS, London; Klee, Die Kapelle © DACS 2003; Klee, Gefangen © DACS 2003; Kandinsky, Improvisation 10, © ADAGP, Paris and DACS, London 2003; Giacometti, l'Homme qui marche II © ADAGP, Paris and DACS, London 2003; Bacon, In Memory of George Dyer © Estate of Francis Bacon 2003. All rights reserved , DACS; Lichtenstein, Painting in Landscape © The Estate of Roy Lichtenstein/DACS 2003; Rothko, Red (Orange) © Kate Rothko Prizel and Christopher Rothko/DACS 1998.

Ashmolean Museum All images courtesy of the Ashmolean Museum, Oxford.

Fitzwilliam Museum All images courtesy of the Fitzwilliam Museum, Cambridge.

Dulwich Picture Gallery All images by Permission of the Trustees of Dulwich Picture Gallery

Sir John Soane's Museum All images by Courtesy of the Trustees of Sir John Soane's Museum: all photographs of the museum © Martin Charles

The Bowes Museum All images courtesy of The Bowes Museum, Barnard Castle.

Wallace Collection All images by kind permission of the Trustees of the Wallace Collection.

Courtauld Institute Gallery All images courtesy of the Courtauld Institute Gallery, Somerset House, London.

While every effort has been made to ensure that this list of acknowledgements is comprehensive, the publishers would be grateful to be advised of any omissions, which are purely accidental.

Scala Publishers
London
2003`

INDEX